MAX BEERBOHM

CARICATURES

MAX BEERBOHM
CARICATURES

N. John Hall

Yale University Press
New Haven and London
1997

Printed in Singapore

LIBRARY OF CONGRESS CATALOGING-IN-PUBLICATION DATA

Hall, N. John.
Max Beerbohm caricatures / N. John Hall
p. cm.
Includes bibliographical references and index.
ISBN 0-300-07217-1 (cloth)
1. Beerbohm, Max, Sir, 1872-1956 — Themes, motives.
2. Celebrities — caricatures and cartoon. 3. English wit and humor. Pictorial.
I. Title
NC1479.B37H35 1997
741.5'942—dc21 97-`3693
 CIP

CONTENTS

ACKNOWLEDGMENTS

I am grateful, first, to Mrs Eva Reichmann and her literary advisor, Sir Rupert Hart-Davis, for granting permission to reproduce the caricatures and to quote Beerbohm texts. I am also deeply indebted to Sir Rupert's *Catalogue of the Caricatures of Max Beerbohm*, a book that has facilitated much of my work.

I am equally indebted to Mark Samuels Lasner, Beerbohm scholar and collector *par excellence*, whose sage advice and library of original drawings and reproductions have been of enormous help throughout this undertaking. Mark's name will figure most prominently in the Picture Credits.

Parts of this book were read in manuscript, to my great advantage, by Lawrence Danson, Stephen Gill, John Glavin, David Gordon, David Greetham, W. Speed Hill, Gerhard Joseph, Daniel Lowenthal, and Malcolm Warner; Mickie Grover and Mark Samuels Lasner, with special generosity, read the whole thing.

Max's drawings are to be found chiefly in museums, libraries, and galleries, and I wish to thank the following officers of those institutions with whom I have had personal contact or correspondence: Lieschen A. Potuznik and Adrienne Jeske of the Art Institute of Chicago; J. J. L. Whiteley and Anne Steinberg of the Ashmolean Museum, Oxford; Chris Beetles of Chris Beetles, Ltd., English Watercolours, London; Eve Poland of the British Museum; Brian Souter and Mrs A. C. Wheeler of Charterhouse School; Tessa Trethowan, Jane Brodie, and Alexander Hope of Christie's, London; John Bidwell of the Clark Library, University of California, Los Angeles; James Tyler and Julia Parker of Cornell University Library, Rare and Manuscript Collections; James Cummins, Bookseller, New York; the Marquess of Salisbury and Robin Harcourt Williams, Hatfield House, Herts; Leslie A. Morris and Jennie Rathbun of the Houghton Library, Harvard University; K. A. Hook and Shirley Hunt of King's College, Cambridge; Margaret Baube and Rebecca Campbell Cape of the Lilly Library, Indiana University; John Burgass and Fiona Wilkes of Merton College Library, Oxford; Marie McFeely and Adrian Le Harive of the National Gallery of Ireland; Philip Jago and Ieva Kanepe of the National Gallery of Victoria, Melbourne; Tim Moreton, James Kilvington, Jo Copeland, and Joanne Harris of the National Portrait Gallery, London; Ted Teodoro of the Arents Collection, the New York Public Library; Jo Ellen McKillop Dickie and Margaret Kuli of the Newberry Library, Chicago; James C. N. James-Crook of Phillips Auctioneers, London; Christabel Briggs and Godfrey Pilkington of the Piccadilly Gallery, London; William L. Joyce, Alexander D. Wainwright, and Jennifer L. Bowden of Princeton University Library, Department of Rare Books; Mark R. Farrell of the Robert H. Taylor Collection, Princeton University Library; Nicholas C. Storey of the Savile Club, London; Susan Kent of Sotheby's, London; John Corr and Christopher Webster of the Tate Gallery; David Coleman and Wendy Trenthem of the Harry Ransom Humanities Research Center, University of Texas; Danielle C. McClellan of the Beinecke Library, Yale University; Isabel Sinden and Joanna Wallace of the Victoria and Albert Museum.

I am thankful to the following for their photography: Claire Granpierre of the CUNY Graduate School Art Slide Library; Frank Perez and Luis Garcia of Duggal Color Projects, New York; Rodney Todd-White & Son, Photographers, London; Anne-Marie Ehrlich of E.T. Archive, London; James Dee, New York; J. W. Thomas, Photographs, Headington; and Al Benn-Ness and Malkie Yadaie of Ben-Ness Photo & Labs, New York.

Other thanks are due to Mary Ann Caws, Marsha Cummins, Richard de Peyer, Mortimer Frank, Julius Goldstein, James R. Kincaid, Edward Maggs, Bernard Mandelbaum, Joyce Mullan, Ira Nadel, Joan Richardson, Anna Gruetzner Robins, Raymond Shapiro, James B. Sitrick, Linda Sherwin, John Sutherland, and Robert Tracy.

At the CUNY Graduate School, I am grateful to Professor Joseph Wittreich and the Ph.D. Program in English for providing me with three very capable graduate assistants: Paul Collins, Steven Torres, and, most especially, Julia Miele Rodas, who worked on almost all phases of the book, from library research and fact checking to manuscript reading (the entire thing) and proof reading.

I acknowledge generous support from the PSC-CUNY Research Award Program, and, at Bronx Community College, the support of President Carolyn Williams, the late Dean Carl J. Polovczyk, Neil Grill, and Carin Savage.

At home, I am grateful for assistance and wise advice from my wife, Marianne.

At Yale University Press London, John Nicoll patiently and knowledgeably supported the project from the start, from the very idea of the book through to major matters such as the number of plates (well over 200) and the number of colour plates (80). Only occasionally did he have to rein me in: when asked if I might make all the colour plates full-page size, he replied, "We don't even do that for Fra Angelico." He allowed me as author to play a considerable role in the design of the book – "the fun part", as he put it. Evidently such concessions are rare among publishers of art books. He even permitted me a crack at the dust jacket (he deemed my first attempt "fine, if the book were being published in 1960"). Others who helped the book through the press at Yale included Sue Jackson, copyeditor, and Sally Salvesen. The result, thanks to these people is, I believe, a book attractive enough to have (perhaps) pleased the ever fastidious Max.

Edmund Wilson, after meeting Max in 1954, wrote of Max's art, "It is a kind of Divine Comedy that he has been working at all his life." Wilson also said:

> He's quite sure of himself. He knows the value of what he has done, both as a writer and as an artist. He doesn't give a damn about having all his caricatures collected and published, as I suggested to him they ought to be. He doesn't even know where many of them are. He knows very well that somebody else will have to worry about all that someday.

It has been a privilege to be one of those who, following Rupert Hart-Davis, have "worried" about the caricatures of Max Beerbohm.

<div style="text-align: right;">

NJH
New York City
Great Barrington, Mass.

</div>

PICTURE CREDITS

INTRODUCTION

It is to be hoped that when Mr Beerbohm's work is completed, it will be made into the foundation of an "Illustrated History of England" for his period, which then – thanks to his unfailing eye for the centre of a situation, and his gift for fixing it in a memorably comic form – will live with incomparable vividness in the minds of a delighted posterity.

<div align="right">

Edward Marsh
The Blue Review June 1913

</div>

There is a pleasant difficulty connected with Max Beerbohm that won't go away. Was he primarily a caricaturist? Or was he primarily a writer of prose? There is no answer, really, except that he was primarily neither, that he was equally accomplished as writer and caricaturist. This book deals with the caricatures, but it were well to remind readers of his stature as a prose stylist. If the best judges of writing are other writers, it can safely be asserted that they have heaped more praise and less dispraise upon Max Beerbohm than any comparable writer of his time. Virginia Woolf, to take but one authority, spoke of Max the essayist as the "prince of his profession", someone who brought "personality" into that genre for the first time since Montaigne and Charles Lamb. Privately, she wrote to Max, "If you knew how I had pored over your essays – how they fill me with marvel – how I can't conceive what it would be like to write as you do!"*

At the same time, Max – he is always called simply "Max" and it is thus that he signed his drawings – has long been regarded as the foremost caricaturist of his day. By 1904, the year of his second published book of caricatures, *The Poets' Corner*, and of his second one-man exhibition, the *Athenaeum* was calling him "our one and only caricaturist". By 1913 *The Times* confidently acclaimed Max "the greatest of English comic artists". Bernard Berenson later called him "the English Goya". Edmund Wilson deemed Max "the greatest caricaturist of the kind – that is, portrayer of personalities – in the history of art". Sir Rupert Hart-Davis, writing in 1972, judges Max "without equal among British caricaturists". Assessments of this kind are debatable, but for the most part critics place him as a caricaturist just about where writers place him as a prose writer – at the very top. Nonetheless, I suspect that Max's two-fold

eminence has worked against his reputation. Many hesitate to believe in double genius, exceptions like Blake and Rossetti notwithstanding. However, Max's talent as prose writer should not work against him as caricaturist in this book, because it draws as much as possible on his writings in describing the individuals and situations caricatured. One would be hard put to find another graphic artist who could write on anything like Max's level and who at the same time frequently wrote about the subjects of his art. Moreover, Max presents an additional and curious phenomenon: the remarkable similarities – *mutatis mutandis* – between his drawings and his prose. These similarities are difficult to "prove", but I believe they can be shown, laid before the viewer/reader: Max's sister arts display a comparable economy, wit, cleverness, understatedness, clarity, beauty, sophistication, and occasional outlandishness. The juxtaposition in this book of excerpts from his writing – essays, criticism, fiction, and letters – with his drawings should exhibit Max's apparently equal virtuosity as writer and caricaturist.

In some cases Max's prose is already present, in the captions – those "little imperishable niggles at the bottom of the pictures". The "perfectly achieved combination of pictorial situation and literary caption" may be, as Osbert Lancaster says, Max's "unique contribution to the art of caricature". In these drawings, the congruence of styles is immediately apparent. Furthermore, such was Max's adeptness with captions that they can be amusing even without the caricature. Max did only one drawing, now lost, of A. C. Benson, Cambridge man of letters, author of more than a hundred volumes, best known for his sentimental, self-indulgent, pointless essays. Max's caption reads, "Mr Arthur Christopher Benson vowing eternal fidelity to the obvious". A 1908 caricature (not reproduced in this book), titled "A Nightmare", shows Henry James "subpoena'd, as psychological expert, in a *cause célèbre*". James is in the witness box and the cross-examining Counsel is saying: "Come, sir, I ask you a plain question, and I expect a plain answer!"

* Why then is he not better known as a writer? One answer could be Max's own, that he worked for a highly select audience - by his (ironic?) estimate, about 1,500 people in England and another 1,000 in America. But a more satisfactory explanation is the dominance of the novel, and Max, though his one novel, *Zuleika Dobson*, has long been a classic in Britain, was chiefly an essayist.

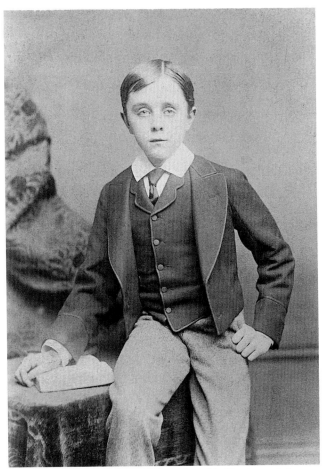

Fig. i. Max Beerbohm. Aged 13 or 14. Photograph by
A. Bassano, London, 1886.

Henry Maximilian Beerbohm was born in London on 24 August 1872. His father, Julius Ewald Edward Beerbohm, a native of Memel on the Baltic Sea, a man of Dutch, Lithuanian, and German origin,* had come to England about 1830 and set up as a prosperous corn merchant. He married an English woman, Constantia Draper, the daughter of a Lloyd's of London clerk. She had four children, and died at the age of 32, whereupon Julius married her sister Eliza. She in turn had five children, three of whom survived. Max was the last of Julius's children, born when his father was 62.

The oldest Beerbohm son, born in 1850 and named Ernest – Max never knew him – emigrated and became a sheep farmer in the Cape Colony, where he is said to have married a "coloured lady". Max's second oldest half-brother, Herbert Beerbohm Tree, 19 years his senior, became one of London's foremost actor/ managers (plates 63 and 211). The third half-brother, Julius (plate 181), author of a book about his travels in

Patagonia, was a *bon vivant*, dandy, poet, and unsuccessful speculator. Little Max idolized both brothers, had a loving relationship with his mother, and maintained a lifelong affection for his sisters, one of whom became an Anglican nun.

From 1881 to 1885, Max attended the day-school of a Mr Wilkinson in Orme Square. Mr Wilkinson, Max said, "gave me my love of Latin and thereby enabled me to write English well". Mrs Wilkinson taught drawing to the students, the only lessons Max ever had in the subject. In 1885 he entered Charterhouse school, where, in spite of his aversion to athletics, he seems to have been reasonably happy. Nonetheless, he later wrote, "My delight in having been at Charterhouse was far greater than my delight in being there...I always longed to be grown-up!" At Charterhouse he found pleasure and escape in reading, especially Thackeray (who had himself gone to Charterhouse and was also an illustrator). Max began to think about becoming a professional writer. And he took to drawing caricatures, of other boys, of the schoolmasters, and of public figures, especially the Prince of Wales, later King Edward VII.

In 1890 Max went up to Merton College, Oxford. He loved Oxford. "Undergraduates", he wrote, "owe their happiness chiefly to the consciousness that they are no longer at school. The nonsense which was knocked out of them at school is all put gently back at Oxford or Cambridge." It was Oxford during the heyday of Oscar Wilde's aestheticism and the Whistlerian ideal of art for its own sake. Max found "this little city of learning and laughter" the perfect place for the development of his dandyism, his aesthetic pose, his distinctive spectator persona. And then Will Rothenstein (plates 107–10) arrived from Paris to draw portraits of Oxford "characters" and chose to include an undergraduate – Max. Rothenstein became one of his closest friends, and the means through which Max met many artists and writers in London. At Merton he also met Reggie Turner (plates 9 and 10), two years his senior at the college, another lifelong friend, and a connection with Robert Ross (plate 123), Oscar Wilde (plates 1–5), and Lord Alfred Douglas (plate 7). Max left Oxford in 1893, without taking his degree.

Max's career as a professional caricaturist began in 1892, when he was 20. He had shown to one of his sisters – which is unknown – a series of "Club Types". She showed them to the editor of the *Strand* magazine, where their publication soon followed, dealing, Max said, "a great, an almost mortal blow to my modesty". In London, Rothenstein introduced him to publisher John Lane, who was about to launch the *Yellow Book*. Max contributed essays to its first and later issues and to other publications. He drew caricatures for *Pick-Me-Up*, *Sketch*, and the *Pall Mall Budget*. Then, in 1896, he published a collection of essays, disarmingly called *The*

* Speculation that Max Beerbohm was of partly Jewish descent rests on skimpy evidence: the oddness of his name, the fact that his father came from Eastern Europe, that many of his closest friends, including Will Rothenstein and Reggie Turner, were Jewish, and that his wives were Jewish. Max himself, asked if he were Jewish, said he could not claim that honour: "I should be delighted to know that we Beerbohms have that very admirable and engaging thing, Jewish blood. But there seems to be no reason for supposing that we have."

Works of Max Beerbohm, and a collection of drawings, *Caricatures of Twenty-Five Gentlemen*. He was famous at 24. He became immensely popular in London's literary and artistic circles and a much sought-after guest at dinner parties and country house weekends. He was both amusing and highly "amusable", a trait he much valued in others. (In an essay written in 1918 Max would divide mankind into "two great classes: hosts and guests...I am one of the guests".)

Max never made much money. Aside from freelance writing and drawing, he held only one regular job in his lifetime: from 1898 to 1910 he was drama critic for the *Saturday Review*, a position he got on the recommendation of his predecessor, George Bernard Shaw (plates 76–82). Max's first column explained how singularly unfit he was for the position, but in time he grew into an able, discerning, and demanding critic of the London theatre.

His personal life was peculiar. For a time in 1893 he had a sentimental crush on a happily unobtainable fifteen-year-old music hall star, Cissie Loftus. His next involvement was more serious. In 1895, while acting as his brother's press secretary in America, he became vaguely engaged to Grace Connover, an actress in his brother's theatre company. Max nicknamed her Kilseen (for killing scenes on stage). The "engagement" lingered for six years before dying out.

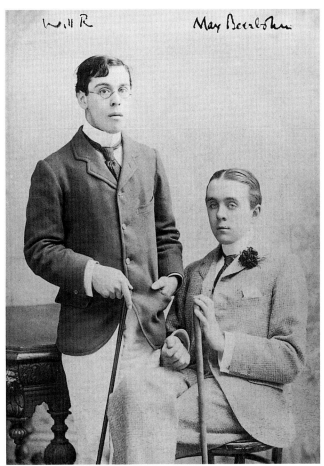

Fig. ii. Max Beerbohm and Will Rothenstein, 1893.
See plates 107–10 of Rothenstein.

Next, in 1903, Max became briefly engaged to Constance Collier, another actress, successful, glamorous, a leading lady from Herbert's company (and rumoured to have been his mistress); she broke off the engagement a few months later. In 1904 Max met an American actress, Florence Kahn, and was much taken by her. By 1908 they were officially engaged. In 1910 Max married Florence, quit his post at the *Saturday Review*, and went to live the rest of his life in the Villino Chiaro, a small house on the coast road overlooking the Mediterranean at Rapallo in Italy (see his watercolour of Florence on the terrace of the Villino, plate 94, one of his few "straight" drawings). Max and his wife seem to have had a thoroughly happy life together.

There has been considerable speculation about Beerbohm's sexuality. His biographer, David Cecil, calling him a "gentle amorist", writes, "His romances were not passionate affairs: physical languor and a dislike of drama combined to keep them on the light, cool side. But they were romances all right, not sexless friendships." Rupert Hart-Davis, editor of Max's *Letters* and compiler of the *Catalogue* of his caricatures, thinks that Max's marriage was never consummated. He bases his conjecture on the following excerpt from a letter Max wrote to Florence in 1908:

> ...I like you better than any person in the world. But the other sort of caring is beyond me. I realise quite surely now that I shall never be able to care in that way for any one. It is a defect in my nature. It can't be remedied.

Hart-Davis concludes, "Max was a natural celibate and I doubt whether he ever had a sexual experience of any kind"; Hart-Davis also suspects that Florence was "as undersexed as Max and accepted his confession with relief". That his "theory" may be wrong, Hart-Davis readily admits. The fact is, we simply do not know much of Max's private life.*

By the time Max married, retired from London, and settled in Italy, his position as England's foremost

* Evidence that Max was a (celibate) homosexual is also inconclusive. All his life he was very close with homosexual men, and as a young man moved easily in a circle that included Reggie Turner, Robert Ross, and, at times, Oscar Wilde and Lord Alfred Douglas; he supportively attended the Wilde trials, and was sympathetic to Wilde always. Furthermore, there are homosexual overtones to his early correspondence with Turner: "You need not, by the way, be jealous of Alfred Douglas as he does not peculiarly fascinate me." On the other hand, he wrote to Ross from New York in 1895 only half-jokingly imploring him "not to look after Reggie Turner while I am away. He is very weak and you, if I remember rightly, are very wicked...Also keep Bosie away from him (give my love to Bosie). Bosie is more fatal to Reg than you – if anything. All this is quite serious. I really think Reg is at rather a crucial point of his career – and should hate to see him fall an entire victim to the love that dares not tell its name." The letter is balanced, non-judgmental, playful, yet self-distancing. And 25 years later he was still keeping his distance, refusing to review Frank Harris's biography of Wilde and complaining of the "Sodomitic cesspool [probably the involvement of male prostitutes]...that was opened in 1895".

essayist and caricaturist was firmly in place, and had been for some time. The influence of Oscar Wilde on his prose, the constant paradoxes, the showiness, the over-cleverness had for the most part disappeared. It was not that Max could not do that kind of thing well; typical is his pronouncement in an essay written in 1894 about the 1880s: "To give an accurate and exhaustive account of that period would need a far less brilliant pen than mine." But by the turn of the century, or even somewhat earlier, Max had found a surer, more distinctive voice: he had settled down to producing what can now be called classic Maximilian prose, writing that was unchallenged in its clarity, its grace, its adroitness, and its singular capacity to delight his readers. Yet Max's writing attained even greater success, with the completion of his only novel, *Zuleika Dobson* (1911), and with the publication of his parodies in *A Christmas Garland* (1912), a book of short stories, *Seven Men* (1919), and various collections of essays and theatre criticism.

Similarly, his drawing also took a turn in the late 1890s. He remarked that as he got older (on into his twenties), he found that his two arts – his "two dissimilar 'sisters'" – were growing more like each other: his drawing had become "more delicate and artful...losing something of its pristine boldness and savagery", while his writing, "though it never will be bold or savage, is easier in style, less ornate, than it used to be". His drawing became more subtle, more intricate, more under-stated, the general softening of tone owing much to the addition of light colour washes, something Will Rothenstein had urged on him.

His reputation grew, as evidenced in the increasingly adulatory reviews given his exhibitions and books of caricatures. His first public showing was at the Fine Art Society's exhibition in 1896, "A Century and a half of English humorous art, from Hogarth to the Present Day", to which he contributed six caricatures, including those of George Meredith (plate 8) and Frank Harris (plate 14). His first one-man show was given him by Robert Ross at the Carfax Gallery in December 1901, followed by others in 1904, 1907, and 1908. He participated in four group shows at the New English Art Club, between 1809 and 1911. Thereafter, he exhibited his work exclusively at the Leicester Galleries (see plate 128), in one-man shows in 1911, 1913, 1921, 1923, 1925, 1928, 1945, 1952, and, posthumously, in 1957. Almost the only complaint heard among the reviewers was the occasional one that he was not a draughtsman, but the objection was almost always followed by a retreat. One reviewer in 1913 said, "There is, of course, a negligible sense in which [Max] is no draughtsman. He does not, perhaps cannot, and probably does not care to make his figures stand on their feet, or sit in their chairs; yet he is a master of expressive line." In 1926 another reviewer put the case thus:

Fig. iii. "Max – With apologies to all concerned". Max in Whistlerian pose; photograph by Filson Young, 1916. See plate 103.

...in terms of aesthetics Mr Beerbohm is not a draftsman at all; he has a delicate sense of color, decorative felicity...but he has never learned to draw. It is only through sheer cleverness that he is able to hold the parts of his figures together, and he invariably comes to grief over the human foot. All his characters descend to shapeless clods. For his own purposes, however, his drawing is consummate, and that is all that can be asked of an artist. He has a genius for likenesses; better than anyone else he understands how to convey the attitudes of his subjects; and his point of view is no less penetrating than original. Add to these humor without venom and refined imagination and you have lifted caricature into the realm of art.

After 1910 Max lived contentedly in Rapallo, "this lovely place", as a reclusive English gentleman (he never took the trouble to learn Italian). He returned to England only during the two world wars, and occasionally on personal business, chiefly to arrange exhibitions with the Leicester Galleries. Around 1930 he gave up caricaturing: "I found that my caricatures were becoming likenesses. I seem to have mislaid my gift for dispraise. Pity crept in. So I gave up caricaturing, except privately."

In 1935 Max began broadcasting for the BBC, reading essays, always as a "voice from the past". He continued to do so, fourteen broadcasts in all, right through to the year of his death. Rebecca West said, "I felt... that I was listening to the voice of the last civilized man on earth. Max's broadcasts justify the entire invention of broadcasting."

In 1939 King George VI offered him a knighthood, and Max, who had early declared in print that he "craved no knighthood" and who had so satirized the royal family, gratefully accepted. The irony of it pleased him. Always the dandy, he took special care with his dress. After the ceremony, he wrote to a friend, "My costume yesterday was quite all right... Indeed, I was (or so I thought, as I looked around me) the best-dressed of the Knights, and quite on a level with the Grooms of the Chamber and other palace officials. I'm not sure that I wasn't as presentable as the King himself – *very* charming though he looked."

In 1942 Max was given an honorary degree by his Alma Mater, Oxford (see his pictorial and prose comments on the 1907 awards, plate 186). In 1943 he was invited to give the Rede Lecture at Cambridge, where he spoke on the modern writer he most admired, Lytton Strachey (see plates 54–6). In 1945 his old College, Merton, made him an honorary fellow.

But in many ways Max remained out of step with the times, remained a voice from the past. The works of D.H. Lawrence, for example, gave him little pleasure. Although willing to admit Lawrence's "unquestionable genius", Max thought his prose "slovenly" and the man himself "afflicted with Messiahdom". When shown a copy of Joyce's *Finnegans Wake* shortly before being made Sir Max Beerbohm, he leafed through it and remarked, "I don't think he will get a knighthood for that!" When Edward Marsh wrote to Max to ask if he would allow the Contemporary Art Society to commission Graham Sutherland to paint his portrait, Max declined, telling Marsh that although he had in his time been "a ruthless monstrifier of men", he was, like the proverbial bully, a coward. Privately, he told Samuel Behrman that in Sutherland's portrait of Somerset Maugham – which Marsh in his letter had held up as a masterpiece – "Maugham looks... as if he had died of torture." Max would have nothing to do with modern psychology or the theories of Freud: "I adored my father and mother and I adored my brothers and sisters. What kind of complex would they find me the victim of? ... They were a tense and peculiar family, the Oedipuses, weren't they?" In 1955 the National Broadcasting Company in New York offered Max considerable money to do a series of television talks. A representative of the company visited him in Rapallo: "You see, Sir Max, it will all be very simple. Our people will come and arrange everything. You will sit, if you like, where you are sitting now. You will simply say, 'My dear friends, I am very happy to be here addressing you.'" Max replied, "Do you wish me to start with a lie?" The scheme came to nothing.

Florence died in 1951. "I wish she could have lived as long as I", Max wrote to an old friend. "But I am grateful for the forty years of happiness that she gave me." After his wife's death, Elisabeth Jungmann, formerly the personal secretary of the German writer Gerhart Hauptmann, became Max's secretary and companion. In 1956, Max married her just before his death, to insure that under Italian law she would inherit all his possessions.

Max Beerbohm died at Rapallo on 22 May 1956. His body was cremated, and the ashes sent to London, where they were buried in St Paul's Cathedral.

This book reproduces 213 of Max's drawings, most of them portraits. The selection process was not easy because, for one thing, Max drew more than 2000 formal caricatures. My choices were dictated not merely by

Fig. iv. The Villino Chiaro, Rapallo, Italy.
Max's home, 1910–56.

what I may have thought of as his "best" caricatures, but by the importance or prominence of the subject – something much more to the fore in caricature than in other genres of art – and by the availability of good photographs. The caricatures have been brought together in chapters by categories: writers, theatre people, artists, politicians, royalty, miscellaneous individuals, subjects from the past, and self-portraits. Each chapter has a loosely chronological order.

The vast majority of the drawings reproduced here come from what may be called Max's middle period, roughly 1900 to 1930. A good sampling from the earlier and, in Max's words, more "savage", more "bold" period is also provided: see, for example, the caricatures of Oscar Wilde (plates 1–5), Aubrey Beardsley (plates 95–7), Will Rothenstein (plate 107), Rudyard Kipling (plates 21 and 22), self-portraits (plates 207 and 208). Also included are examples of post-1930 drawings, done when Max thought his caricature had come perilously close to portraiture: see John Masefield (plate 57), Ezra Pound (plate 60), E. M. Forster (plate 59), Winston Churchill (plate 139). Of course, what I have called Max's long "middle" period was hardly uniform in style and produced many "monstrous" versions of his subjects, even as it gradually softened and became more "realistic".

All the caricatures, except where noted otherwise, are executed, as Hart-Davis writes, "in pen or pencil, or a combination of the two. The great majority have some added water-colour, varying from a light wash here and there to a complete colouring." Hart-Davis may or may not be correct in judging Max "primarily a water-colour artist". Certainly, seeing Max's work only in black and white fails to prepare one for the difference colour makes (except when the only colour added is a light gray). Eighty caricatures are here reproduced in colour. People today often think his watercolours "faded" or "washed out", and sometimes they are, but for the most part the soft, delicate, subtle colours are Max's doing. He won't shout. His gentle colours fit nicely with the quiet hilarity of the drawings.

An intriguing feature of Max's caricatures that this book illustrates is their power to make us believe we know pretty well just what a person looked like. And there is also a sense that one knows something of the personality of an individual of whom one knows little or nothing. Part of this power comes from Max's consistency. A subject once caricatured is immediately recognizable in another version, and many cross-references among plates are given here. Still, consistency cannot explain the magic. One drawing can be sufficient. We take pleasure in the portrait even when we are unable to compare the caricature with some conventional likeness,

a painting or photograph that supposedly shows what the person "really" looked like. When Max has managed, as he put it, to "boil a man down to essentials", when he has come up with what he called "a proper synthesis", we feel somehow familiar with that man or, very occasionally, that woman. This collection brings together caricatures of 230 people, some as well known as Oscar Wilde, George Bernard Shaw, James Whistler, Rudyard Kipling, Winston Churchill. Others are half-forgotten, and some would be completely forgotten but for the fact that Max "got" them.

Max frequently insisted that caricature was simply the exaggeration of the physical aspects of the human body. He begins his 1901 essay "The Spirit of Caricature" by describing caricature as "the delicious art of exaggerating, without fear or favour, the peculiarities of this or that human body, for the mere sake of exaggeration". One must always be alert to Max's irony, and elsewhere in the essay and in his other statements about caricature we find ideas that go considerably beyond this simple definition. For example, in 1903, he admitted to E. F. Spence that he hoped to get at the "soul" of a man, but through the body: "When I draw a man, I am concerned simply and solely with the physical aspect of him ...[But] I see him in a peculiar way: I see all his salient points exaggerated (points of face, figure, port, gesture and vesture), and all his insignificant points proportionately diminished... In the salient points a man's soul does reveal itself, more or less faintly... It is... when (and only when) my caricatures hit exactly the exteriors of their subjects that they open the interiors, too." (Compare these words with E. H. Gombrich's dictum that the caricaturist "shows how the soul of the man would express itself in his body if only matter were sufficiently pliable to Nature's intentions".)

Discussing "salient points" in the 1901 essay, Max said that the true caricaturist portrays them as they appear to his "distorted gaze", that he does not "make conscious aim at exaggeration. He does not say, 'I will go for this "point" or that'... He exaggerates instinctively, unconsciously." Max believed that the caricaturist should never draw from the life because he would be "bound by the realities of it" and could not "suborn his pencil to magnify or diminish the proportions, to add or abate one jot... It is only in recollection of his subject that the unconscious process of exaggeration begins to work." His manner of operation was to "stare professionally" at a person for a few moments and then go home and draw him. He explained further to a friend in 1907:

I cannot imagine a worse thing befalling anyone than to see the streets peopled with my creations. It has never befallen *me*. Not that in drawing people I con-

sciously exaggerate or distort them. I draw every man just exactly as I *remember* him. But when I next *see* him he looks something very different from my portrait, and quite his own bright self.

And in 1942, on the occasion of a dinner given him by the Maximilian Society, honoring his 70th birthday, he said of his caricatures:

I can't even guess how I did the earlier ones. They are so very violent, though I myself was never that. The distortions are so monstrous and so libellous. And yet that was how I *saw* my subjects, not in their presence, but afterwards, in my memory, when I sat down to draw them. And with most of them I was personally acquainted. I marvel that they did not drop my acquaintance. None of them seemed to mind. As time went on, somehow my memory of people's appearance became less tricksy. I began to remember people more or less exactly as they were, and was obliged to put in the exaggerations consciously...and I have now meekly – but with great regret – laid aside my pencil.

Already in 1901, Max summed up his theory of caricature:

The perfect caricature (be it of a handsome man or a hideous or an insipid) must be the exaggeration of the whole creature, from top to toe. Whatsoever is salient must be magnified, whatsoever is subordinate must be proportionately diminished. The whole man must be melted down, as in a crucible, and then, as from the solution, be fashioned anew. He must emerge with not one particle of himself lost, yet with not a particle of himself as it was before...And he will stand there wholly transformed, the joy of his creator, the joy of those who are privy to the art of caricature...The perfect caricature is not a mere snapshot...it is the epitome of its subject's surface, the presentment (once and for all) of his most characteristic pose, gesture, expression.

E. H. Gombrich has very much the same notions of caricature:

All artistic discoveries are discoveries not of likenesses but of equivalences which enable us to see reality in terms of an image and an image in terms of reality...What we experience as a good likeness in a caricature...is not necessarily a replica of anything seen. If it were, every snapshot would have a greater chance of impressing us as a satisfactory representation of a person we know. In fact only a few snapshots will so satisfy us. We dismiss the majority as odd, uncharacteristic, strange, not because the camera distorts, but because it caught a constellation of features from the melody of

Fig. v. Max Beerbohm. A BBC photograph, probably from the 1940s.

expression which, when arrested and frozen, fails to strike us in the same way the sitter does.

The claims that Max made for caricature are in accord with those made by seventeenth-century theorists, most notably their insistence, as Gombrich summarizes it, that a caricature "may be more true to life than a mere portrayal of features could have been. A caricature may be more like the person than he himself is."

Max liked to say that he mocked what he loved, and he was a friend of almost all of the people caricatured in this book, and an admirer, of sorts, of those who were beyond his circle, like King Edward VII, or of an earlier time, like Tennyson. And he had countless other friends, all of whom he repeatedly caricatured. For that matter, he seems to have caricatured *everybody*, anyone who had any kind of public life. As Edmund Gosse told a fellow writer whom Max had just caricatured: "I feel it my duty to tell you that something has happened to you that sooner or later happens to us almost all. Max has got you. We don't like it and you won't like it, but you must pretend you do. You can console yourself at any rate with the thought that it will give uncommon pleasure to your friends."

Occasionally Max's caricatures did bring on him the charge of making "good men" ridiculous. Max countered:

Caricature implies no moral judgment on the subject. It eschews any kind of symbolism, tells no story, deals

with no matter but the personal appearance of its subject. Therefore, the caricaturist, though he may feel the deepest reverence for the man whom he is drawing, will not make him one jot less ridiculous than he has made another man whom he despises. To make the latter ridiculous gives him no moral pleasure: why should it give him any moral pain to make ridiculous the former? He imports into his vision of the former nothing which is not there: why should he subtract anything from his vision of the latter?... "But," you might urge, "when he finds that the result is pain to his subject's friends and joy to his subject's enemies, he ought to desist from his art." Maybe, if either the pain or the joy were reasonable, were justified. But they are not. Both are foolish.

His apologia denies the hostile impulse that most people see in caricature. While it is true that in his caricatures Max apparently felt no qualm at making friends and "good men" ridiculous, he did take moral pleasure in attacking men and ideas that he despised, like Hall Caine and his self-promotion or Kipling and his jingoism. David Cecil writes that Max's caricatures offer "an image of his model's whole personality, mental and physical, [and]... a judgment on it".

In his caricatures Max preferred economy of line. His goal was "to have the whole thing as absolutely simple as I can". Again, "In every work of art elimination and simplification are essential. In caricature they are doubly so. For a caricature is a form of wit, and nothing so ruthlessly chokes laughter as the suspicion of labour." In discussing the work of William Morris, Max ironically admitted the achievement of Morris's "gloomy complexity", but stated his own preference in visual arts for "a lightness and severity, blitheness and simplicity". Max also kept his caricatures small, insisting that caricature could not abide a large surface: "...even as brevity is the soul of wit, so is a small scale not less necessary than an air of spontaneity to the perfect caricature". Big canvases and oil paints, he said, fit only "seriously serious" art.* But for a serious art that has frivolity as its aim, the proper media are plain paper, pen or pencil, and "a little water colour".

Max derided the "foolish convention of a head invariably bigger than its body", which had become for the man in the street practically the definition of caricature, a convention so strong that "it affected even Pellegrini, Daumier, and other masters ... In a caricature of a tall man the head ought to be not magnified but diminished." But some subjects, like A.C. Swinburne and Theodore Watts-Dunton, *had* small bodies, which, along with large heads, constituted "salient points".

Max said that the "perfect caricature is in itself a beautiful thing". His explanation was enticingly simple:

> The beauty of a work of art lies not at all in the artist's vision of his subject, but in his presentment of the vision. If the ladies on the chocolate-boxes were exactly incarnate, their beauty would conquer the world. If Daumier's senators and deputies were exactly incarnate, life would be intolerable. Yet no discreet patron of art collects chocolate-boxes; and that series by Daumier is one of the loveliest and most precious things in the whole world. The most perfect caricature is that in which, on a small surface, with the simplest means most accurately exaggerates, to the highest point, the peculiarities of a human being, at his most characteristic moment, in the most beautiful manner.

In Max's day the term *beautiful* was not as problematic as it is today, but it is worth recalling that his contemporaries, at least after his drawing caught on, continually used the word *beautiful* in reference to his drawings – along of course with witty, sharp, cruel, wicked, naughty, clever, murderous, etc. And yet, *beauty* is not a term often used in regard to caricature. Whatever our admiration for the caricatures of, say, Low, Scarfe, Hirschfeld, or Levine, *beautiful* is not a word that leaps to mind with reference to them. Max's style, especially when he employs colour, is delicate, understated, beautiful. It seems to have come from nowhere. He has had countless admirers among other graphic artists, but no followers, no inheritors of his style. His was a unique talent.

* The actual sizes of the original drawings reproduced in this book range from very small works such as "Fitch", $5\frac{5}{8} \times 3\frac{3}{4}$ inches (plate 68) and "The Best Talker in London", $5 \times 4\frac{5}{8}$ inches (plate 16) to a handful of fairly large drawings such as "The Red Cross Sale at Christies", $15 \times 30\frac{1}{4}$ inches (plate 125) and "The Birthday Surprise", 13×23 inches (plate 46); but most of the drawings fall into a middle size, with many approximtely 7×12 inches, such as "Had Shakespeare asked me..." (plate 15), "Mr Lytton Strachey" (plate 56), and "Rossetti's Courtship" (plate 199).

I

THE LITERARY LIFE

From the early 1890s, Max Beerbohm was very much a part of the London literary scene. He knew all the personages caricatured here, and many more; and, for the most part – with notable exceptions, such as Hall Caine and Rudyard Kipling – he liked them and was liked by them. When he turned professional writer himself, his idol was Oscar Wilde. Then, as the years passed, he added, though never without qualification, new writers to his pantheon: Thomas Hardy, Maurice Maeterlinck, Arnold Bennett, G. K. Chesterton, Edmund Gosse. At the forefront was Henry James. In later days, after James's death, Max came to regard Lytton Strachey as the leading prose writer then living – a distinction many in the literary world reserved for Max himself.

OSCAR WILDE

Without question, the "largest artistic personality" in England from roughly 1885 until his disgrace in 1895, was Oscar Wilde (1854–1900). And his was the largest literary and artistic influence on the young Max, who first met Wilde at a dinner given by Max's older brother Herbert in 1889. Then, in 1892–93, came closer personal acquaintance, strengthened by Max's association with Reginald Turner and Robert Ross, friends of Wilde.

Max's very first published article was "Oscar Wilde by an American", appearing in the *Anglo-American Times*, 25 March 1893. It consisted, Max told Reggie, "of fulsome praise of the Master and filthy abuse of his disciples". Reggie must read it: "Behold, high and sheer into the air rise the walls of the Temple of Fame: against them is a ladder placed and on the first rung of it rests my foot." Wilde told Max the piece was "incomparably brilliant" and that "he knew no other undergraduate who could have written it, that I had a marvellous intuition and sense of phrase, that I must take to literature alone, and that my style was like a silver dagger. I am becoming vainer than ever."

About this same time in 1893, Wilde's original French edition of *Salome* appeared: "It has charmed my eyes from their sockets", Max told Reggie. "In construction it is very like a Greek play, I think; yet in conception so modern that its publication in any century would seem premature... If Oscar would re-write *all* the Bible, there would be no sceptics." Wilde himself got off some fine lines on Max, saying, presciently, that the "gods have bestowed on Max the gift of perpetual old age". And the author of *The Portrait of Dorian Gray* (a story Max retold in his own way in *The Happy Hypocrite*) also asked a mutual friend, "When you are alone with [Max], does he take off his face and reveal his mask?"

Max's great delight in Wilde's prose continued. In 1905, ten years after Wilde's downfall and five years after his death, Max wrote an article, "A Lord of Language", which urged that Wilde's use of this phrase for himself was no idle boast:

> Except for Ruskin in his prime, no modern writer has achieved through prose the limpid and lyrical effects that were achieved by Oscar Wilde... The words sing. There is nothing of that formality, that hard and cunning precision, which marks so much of the prose that we admire, and rightly admire. The meaning is artificial, but the expression is always magically natural and beautiful. The simple words seem to grow together like flowers.

And yet, Max had, all along, his reservations about Wilde himself. As early as April 1893 Max was becoming worried about the Master, telling Reggie Turner: "I am sorry to say that Oscar drinks far more than he ought: indeed the first time I saw him, after all that long period of distant adoration and reverence, he was in a hopeless state of intoxication. He has deteriorated very much in appearance: his cheeks being quite a dark purple and fat to a fault." (See plate 3.) And 60 years later, Max would say, "As Oscar became more and more successful, he became... arrogant. He felt himself omnipotent, and he became gross not in body only – he did become that – but in his relations with people. He brushed people aside; he felt he was beyond the ordinary human courtesies."

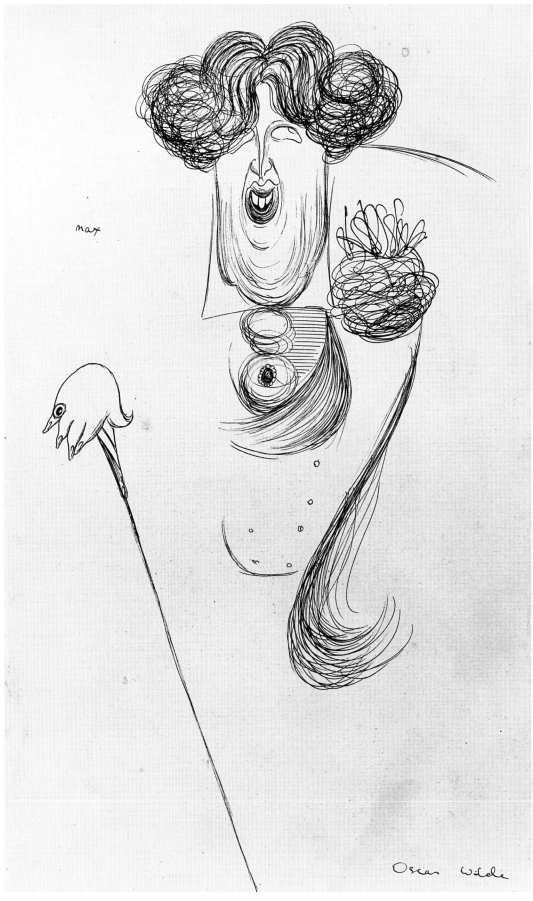

1. Oscar Wilde. [1894]

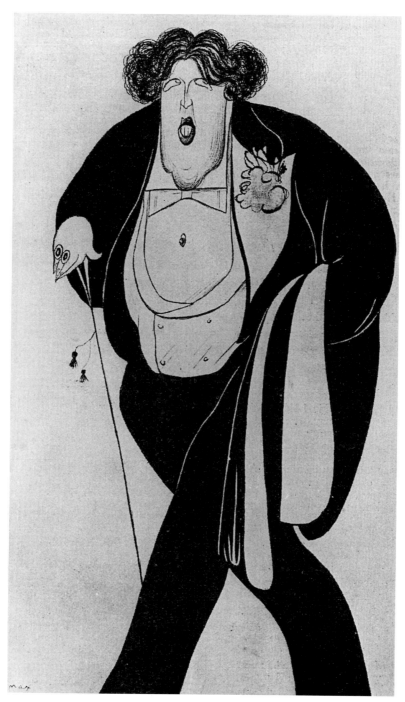

2. [Oscar Wilde. c.1894]

The caricature opposite (plate 1) is perhaps the best known image of Oscar Wilde. It was originally published in *Pick-Me-Up* on 22 September 1894, at a time when Wilde was hugely successful. After his disgrace the following year, Max regretted being so merciless. In 1911 Max supplied a milder caricature for Stuart Mason's *Bibliography of Oscar Wilde*, saying that the *Pick-Me-Up* drawing "showed only the worse side of [Wilde's] nature... I hardly realised what a cruel thing it was: I only realised that after Oscar's tragedy and downfall." In 1953 Max told Samuel Behrman how one day he was in the office of the police inspector who had arrested Oscar, hoping for news or for "amelioration" of some kind: "The walls were covered with a grisly collection of criminal souvenirs – oh, knives and pistols and bludgeons... and there among them, as though it were evidence against the inspector's latest malefactor, was one of my own caricatures of Oscar. I hadn't realized till that moment how wicked it was. I felt as if I had contributed to the dossier against Oscar."

Plate 2, so similar to plate 1, was probably also from the year 1894.

3. Oscar Wilde. 1894

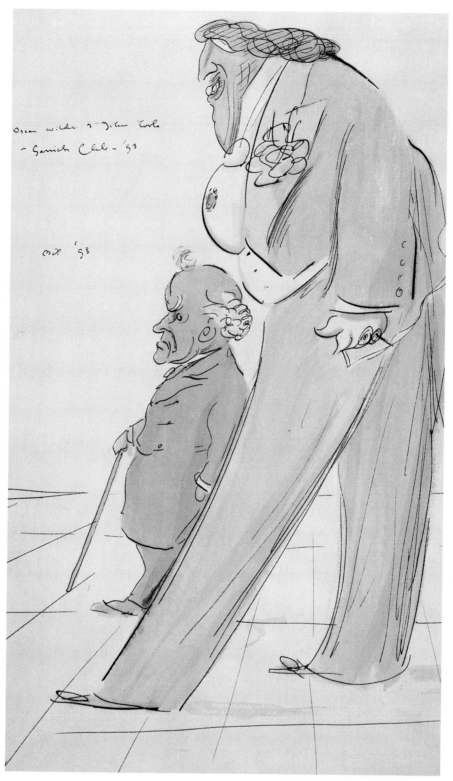

4. Oscar Wilde & John Toole – Garrick Club – '93. 1898

Victorian London's foremost comic actor, John Toole (1832–1906), was described by Max as "the volatile low-comedian – the little man with the elastic face and the eyeglasses, the odd gambols and catch-words, the ridiculous high spirits". Here he is all seriousness, his tiny frame accentuating Wilde's bulk. Lawrence Danson observes that "the funny-man Toole [is] as sober as can be, the artist Oscar idiotically grinning". The green carnation was a badge of identity among Parisian homosexuals.

MARQUIS OF QUEENSBERRY
and LORD ALFRED DOUGLAS

5. At the First night – 1892. 1895

The caricature above is drawn on the endpaper of Max's "improved" copy of *Lady Windermere's Fan* (produced 1892, published 1893). Max did not attend the opening of that play, but he saw Wilde at the first night of *A Woman of No Importance*, produced by Max's brother Herbert at the Haymarket Theatre in April 1893. After the performance, Wilde came before the curtain and said only, "Ladies and Gentlemen, I regret to inform you that Mr Oscar Wilde is not in the house." Max reported to Reggie Turner: "The first night was very brilliant in its audience...Balfour and Chamberlain and all the politicians were there. When little Oscar came on to make his bow there was a slight mingling of hoots and hisses, though he looked very sweet in a new white waistcoat and a large bunch of little lilies in his coat." Max observed, in Wildean fashion, "The piece is sure of a long, of a very long run, despite all that the critics may say in its favour." Attending again on the second night, Max saw, in the Royal Box, the Prince of Wales, later King Edward VII (plates 153–60). The Prince told Wilde, "Do not alter a single line", leading him to rhapsodize, "What a splendid country where princes understand poets."

John Sholto Douglas, eighth Marquis of Queensberry (1844–1900) and his third son, Lord Alfred "Bosie" Douglas (1870–1945), were key players in the drama of Oscar Wilde's life. Lord Queensberry, originator of the Queensberry rules for boxing, was brutal, litigious, and militantly atheistic. Appalled that his son should be involved with Wilde, Queensberry wrote Alfred threatening to disown him if this "most loathsome and disgusting relationship" did not cease: "I should be quite justified in shooting [Wilde] at sight... Your disgusted so-called father, Queensberry." Alfred fired back a telegram: "WHAT A FUNNY LITTLE MAN YOU ARE." Queensberry's mood was made even fiercer when, in October 1894, his eldest son and heir, Drumlanrig, committed suicide, apparently out of fear of being blackmailed over his homosexual relations with Lord Rosebery (plate 130), then Foreign Secretary

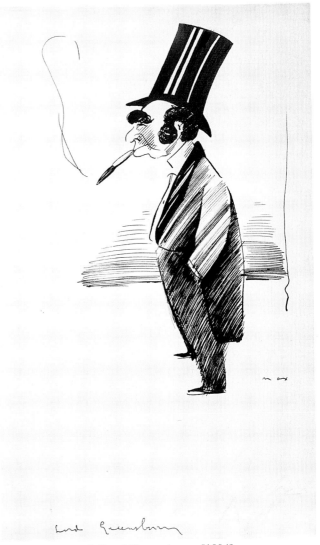

6. Lord Queensberry. [1894]

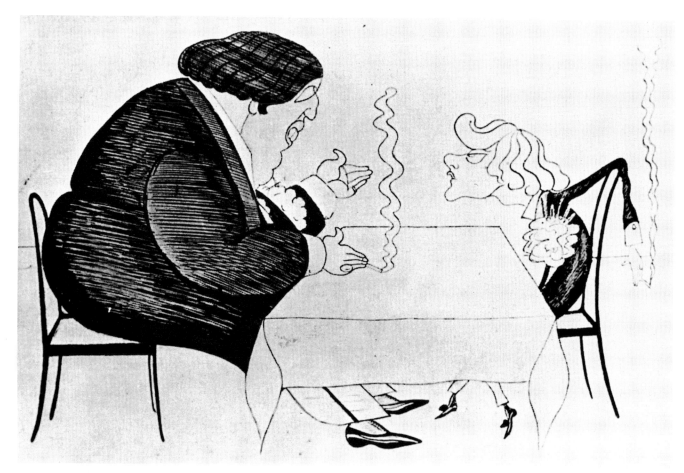

7. [Oscar Wilde and Lord Alfred Douglas]

under Gladstone. Meanwhile, Wilde and Douglas continued their stormy love affair. The "consuming passion" of Wilde's life, Bosie was moody and changeable, a young man with a ferocious temper. Max, through Wilde, got to know Bosie. The three of them dined together a number of times (doubtless the source of plate 7), and, in 1893, Max said he found Bosie "rather charming – a very pretty reflection of Oscar – and we get on very nicely". He also described Bosie as "obviously mad (like all his family I believe) and... pretty and clever and nice". A year later Max pronounced him "very charming, always beautiful and seldom sober". When Wilde's last play, *The Importance of Being Earnest* was presented on 14 February 1895, Queensberry planned a demonstration, but the police were alerted and he "was forced to content himself with leaving a bouquet of vegetables at the stage door". He then left a card at the Albemarle Club, "To Oscar Wilde posing Somdomite". Wilde foolishly sued Queensberry for libel. With barrister Edward Carson (plate 149) brilliantly acting for the defence, the judge and jury ruled for Queensberry. Revelations at the trial led to Wilde's arrest for indecency and sodomy. Max attended that trial:

Oscar has been quite superb [Max wrote Turner]. His speech about the Love that dares not tell his name was simply wonderful, and carried the whole court right away, quite a tremendous burst of applause. Here was this man, who had been for a month in prison and loaded with insults and crushed and buffeted, perfectly self-possessed, dominating the Old Bailey with his fine presence and musical voice. He has never had so great a triumph.

The trial ended in a hung jury; a second trial led to Wilde's conviction and a sentence of two years imprisonment with hard labour.

Early in 1900 the old Marquis of Queensberry died, having first "gathered his strength to spit" at Percy, his second eldest son and heir to the title. Douglas spent his great fortune lavishly, but refused to help Wilde, who had been released from prison in 1897. Oscar Wilde died in Paris on 30 November 1900, attended by Turner and Ross. Max wrote to Turner: "I suppose really it was better that Oscar should die. If he had lived to be an old man he would have become unhappy. Those whom the gods, etc. And the gods *did* love Oscar, with all his faults."

GEORGE MEREDITH

Novelist and poet George Meredith (1828–1909) presented a twofold allure for Max. For one thing, Max entertained an absolutely extravagant – one might almost say preposterous – regard for Meredith's early novels, leading him to make embarrassing comparisons with Shakespeare. Max did a brilliant prose parody of Meredith, imitating the obscure paragraphs, the clipped, witty dialogue, the clever sentences that leap from the page (Max's narrator says of his hero that "Suspicion slid down the banisters of his mind, trailing a blue ribbon"). Additionally, Meredith was a surviving member of Rossetti's circle, a group that so fascinated Max – Swinburne, Ruskin, Tennyson, Browning, Whistler, Morris, Burne-Jones. Meredith had for a time lived with Rossetti in his house at 16, Cheyne Walk, Chelsea, and Max drew a caricature of Meredith, a fanatic for exercise, vainly exhorting the very sedentary Rossetti to "come forth into the glorious sun and wind for a walk to Hendon and beyond".

Max contrived a number of visits to the aged, deaf, and partly paralyzed Meredith. He found him "florid and splendid like his books". Max jotted down his impressions:

Olympian – Battered statue of Jupiter. Blurred outlines – eyes dim, but magnificent – same with mind...extraordinarily agile...mind still working – image chasing image...just like writings...English gentleman – squirearchic... Talked of *laughter* – Said *I* had it – Quoted an article of mine at great length...Splendid old age – Serene – And yet sad – lonely – Self-conscious...This loveable being's modesty. His look up and down at me as I stood up – slim and agile. Appealing – jest – sly look – saw you laughing – then roared – body thrown back...rugged Northern nature – Take a joke as a wave takes a boat – just shoulder it away – with a fine rolling gesture of arm...

One of Max's visits took place just a week or two before the old man's death in May 1909. Max wrote: "Meredith was charming again. He seemed a little older than last year, but was just as full of talk and laughter. He seemed to have felt the death of Swinburne deeply...He said he himself would soon be 'under the grass with the Prussians walking over him'. Also that three years of Prussianizing would do England a lot of good. He also had a scheme for a raid on France, to capture five hundred or so of French women, to brighten the breed of the future."

When Meredith died, a dispute erupted: various people demanded he be buried in Poets' Corner, but the Dean of Westminster Abbey denied the request because Meredith had advocated five-year contracts for marriage. Nevertheless, the Dean, somewhat inconsistently, permitted a memorial service in the Abbey, upon which Max's comment was "What a nation, or at any rate what a Dean!" Max attended the service, and observed other attendees: Holman Hunt, Ellen Terry, Thomas Hardy, Henry James, J. M. Barrie. Outside the Abbey a little girl approached Max, thinking he was Barrie, and asked for an autograph. Max obliged, writing in her book, "Aye lassie, it's a sad day the noo, J. M. B."

Of Meredith's passing, Max wrote:

Shrewd and good as many of the appreciations of Meredith have been, I have seen only one that properly stated Meredith's magnitude. The professional critic is always a little afraid of saying anything which might lead to an accusation of "gush". After Meredith died, it was reserved for an amateur critic, Sir Ray Lankester [plate 185], to write the essential thing of him: that he was, with the sole exception of Shakespeare, the greatest man in our literature. This and that of our writers has had this and that gift as signally as Meredith. But only in Shakespeare has there been such a variety of endowment; only in him a range so ample, depths so many...No wrong has been done to Meredith himself. No honour we could pay him could be in proportion to his greatness. He loses nothing by not being in the Abbey...the loss is ours.

The drawing reproduced here (plate 8, opposite) was drawn for *Vanity Fair* in 1896, and is executed somewhat in the manner of Carlo Pellegrini ("Ape") and Leslie Ward ("Spy"), the style featured in that publication. It was the first of nine drawings which Max made for the magazine, of which two others, those of George Bernard Shaw (plate 81) and Maurice Maeterlinck (plate 120) are reproduced in this book. The Meredith drawing seen here, unlike the Shaw or Maeterlinck, is a reproduction of Max's own drawing, not of the chromolithographic version in the Magazine, where the colouring is somewhat harsh compared to the softness of the original. See also Max's version of "Spy" (plate 106), which deliberately mimics the colouring typical of *Vanity Fair* drawings.

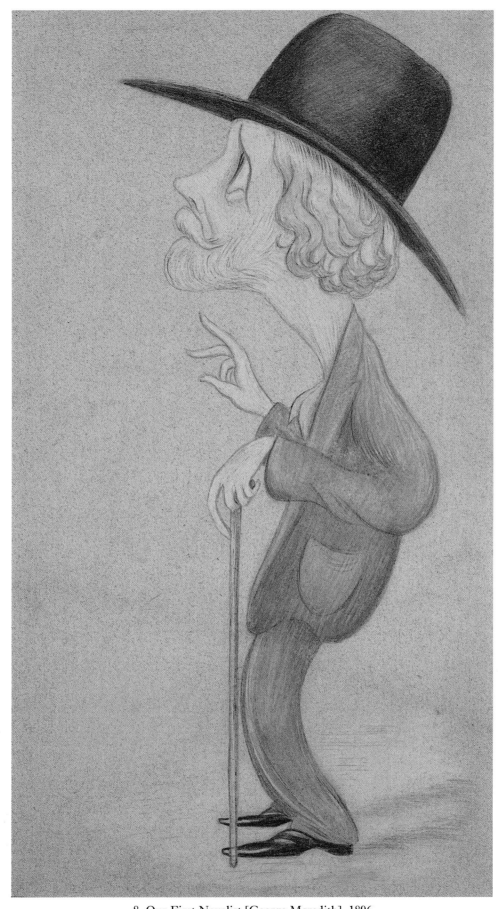

8. Our First Novelist [George Meredith]. 1896

REGINALD TURNER

Journalist and novelist "Reggie" Turner (1869–1938), though commonly believed to be the illegitimate son of Edward Lawson (Lord Burnham [plate 173]), was much more probably, as Hart-Davis convincingly argues, the son of Burnham's uncle, Lionel Lawson, wealthy part-owner of the *Daily Telegraph* and owner of the Gaiety Theatre. His mother may have been a French actress, Miss L. Henrie, who acted in the Gaiety Theatre. Turner was a loyal friend of Wilde: he was with him when arrested; and together with Robert Ross, he met Wilde at Dieppe on his release from prison and, again with Ross, was with him at his death. Turner took a degree at Merton College, Oxford in 1892, and was later called to the Bar, but never practised. He preferred the life of a writer, and was fortunate in being supplied with more than ample means on which to live, because he was never a successful author. Max seemed to be the only one who thought Turner's novels were any good. Turner liked to say that while for most authors first editions were rare, in his case second editions were.

That Reggie was Max's closest friend, the "dearest of all my friends", is attested to in their lifelong correspondence. (Turner lived mostly abroad; Max's *Letters to Reggie Turner* were edited by Rupert Hart-Davis in 1964.) The two young men met as undergraduates at Merton, and Max judged him, all his life, to be the wittiest, most amusing man he had ever met, and one of the most generous and kind. Turner was forever sending people gifts, including a "staggering" cheque as a wedding gift to Max and Florence. Others corroborate Max's opinion: Osbert Sitwell spoke of Turner's charm, his clever conversation, his "brilliant" jokes. Somerset Maugham said he was "the most amusing man I have known". Harold Acton called him "one of the kindest and wittiest of men...His wit had the lightest butterfly touch." Max in his essay "Laughter" disguises Turner as Comus, Milton's invented god of revelry: "His face is a great part of his equipment. A cast of it might be somewhat akin to the comic masks of the ancients; but no cast could be worthy of it; mobility is the essence of it. It flickers and shifts in accord to the matter of his discourse; it contracts and it expands; is there anything its elastic can't express?" Max tells how Turner was an incomparable mimic, and a talker who could break into "ludicrously adequate blank-verse" or even rhyme, as the subject demanded. When once talking in his comic mode, no appeal would move him to let up, as his listeners grew "piteously debilitated" with laughter. Max, in a passage about the delights of being a good listener – as he himself preeminently was – says the people he most enjoyed listening to were Oscar Wilde, Henry James, Charles Brookfield (1857–1913, playwright and novelist), and Turner.

Turner was considered stunningly ugly. Sitwell said, "The ugliness of his appearance at first took strangers aback, yet it was not unsympathetic and even possessed a certain distinction. It was a hideousness hard to describe, because the features and the whole face were rather formless. Out of a chaos of sallow skin and wrinkles shone two quick but contemplative, amused but rather melancholy, blue eyes." Acton said he was "small, quietly dressed, with a sallow complexion, thick purplish lips and perpetually blinking eyes". Max, when asked what his friend Turner thought about the huge noses Max gave him, replied that "when you exaggerate as much as that, there can be no offence in it".

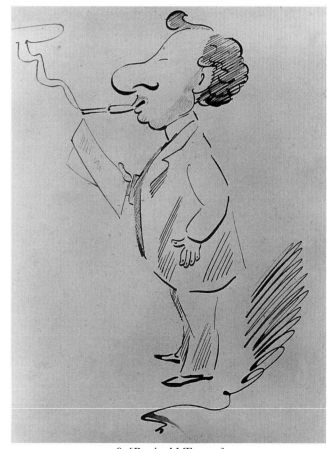

9. [Reginald Turner]

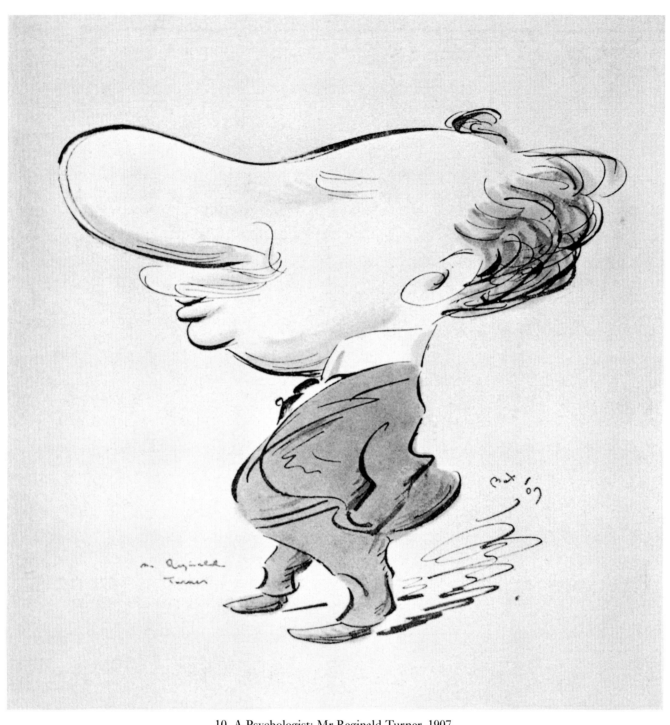

10. A Psychologist: Mr Reginald Turner. 1907

RICHARD LE GALLIENNE

Poet and belletrist Richard Le Gallienne (1866–1947) was one of the 1890s "Decadents", a group including Henry Harland, Arthur Symons, Lionel Johnson, and associated with publisher John Lane of the Bodley Head. Max met them through Will Rothenstein (plates 107–10). Max did not think much of Le Gallienne's work, though he admired, for purposes of caricature, what David Cecil called "his thin Pre-Raphaelite countenance under its spreading cloud of hair". Max himself noted that Le Gallienne's face and hair – seen clearly in the group portrait "Some Persons of 'the Nineties'" (plate 62) – amounted to "a mixture of Dante and Beatrice". Cecil sees this drawing, like so many of Max's caricatures, offering not just his models' "mental and physical" personality, but a judgment thereon: "Le Gallienne's cloudy fuzz of hair hiding his ineffective face expresses Max's view of his cloudy ineffective art."

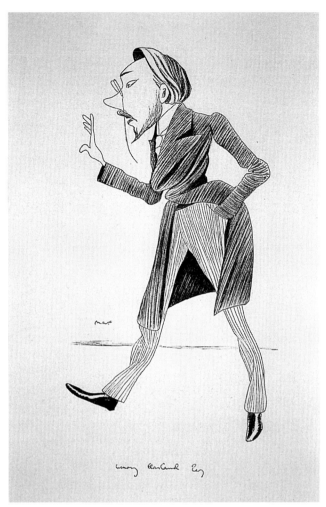

12. Henry Harland Esq. [1896]

HENRY HARLAND

American journalist and novelist Henry Harland (1861–1905), though he claimed St. Petersburg as his birthplace, a youth in Rome, and degrees from the Sorbonne and Harvard, was born in New York and educated at City College of New York. After settling in England, he helped found, in 1894, the *Yellow Book*, which he edited until its demise three years later. Max's first essay in the *Yellow Book*, "The Pervasion of Rouge," brought him considerable notoriety, and launched him on his career as a writer.

Max spoke of Harland – pictured here in a characteristically energetic moment – as "the most joyous of men and the most generous of critics, [who] hated to talk of anything about which he couldn't be enthusiastic." (Accordingly, Harland had little to say of "that absurd creature" Enoch Soames [see plate 61].) The reproductions here of Le Gallienne and Harland, and also those of Harris (plate 14), Kipling (plate 21), and Rosebery (plate 130) are from the wood engravings in Max's first published book of drawings, *Caricatures of Twenty-Five Gentleman* (1896).

11. Richard Le Gallienne. [1896]

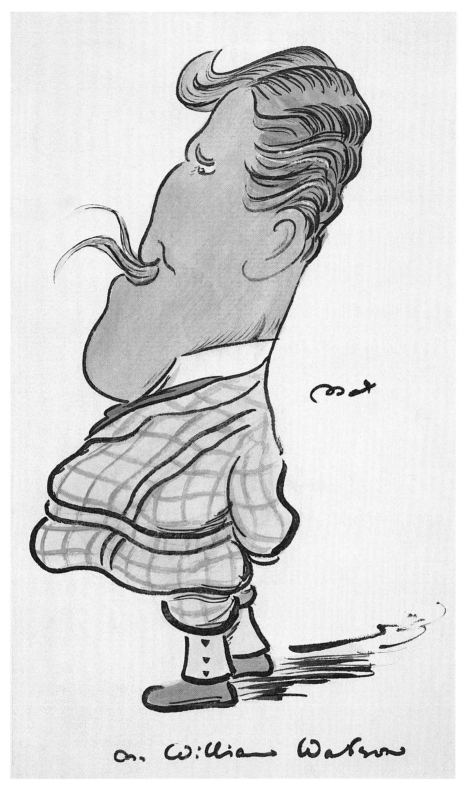

13. Mr William Watson

WILLIAM WATSON

A "poet in the heroic mode", William Watson (1858–1935) was a sturdy admirer of Britain's past poets. Intensely patriotic and imperialistic, he came very near being named Poet Laureate in 1913 but lost out to Robert Bridges.

In one of Max's caricatures of Watson (not reproduced here), he is seen instructing his Muse: "Don't look out of the window at Nature. And don't think of *me*. Think hard of Milton and Wordsworth; and also of Liberty – but only in the national sense, mind you."

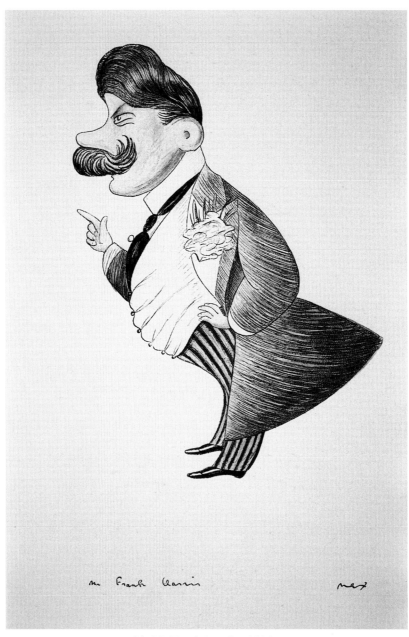

14. Mr Frank Harris. [1896]

FRANK HARRIS

Arriving in London via the U.S. and Europe in 1882, the Irish-born Frank Harris (1856–1931) became editor of the *Evening News*, the *Fortnightly Review*, and, eventually, the *Saturday Review*, for which he hired Max to write. The two men collaborated on a play, an adaptation from the French called "Caesar's Wife", produced at Wyndham's Theatre in March 1902. In 1914 Harris fled London to New York and became a German propagandist during the war; later he lived in Nice, where he wrote *My Life and Loves* (1923), his "pornographic" autobiography.

Max, along with many others, prized Harris as an editor and a talker. And Max liked Harris, in spite of serious reservations about his character. Harris was an inveterate philanderer: "Women like men to be confident", Max said, "and Frank did not lack confidence." In fact, Max considered him an egomaniac: "When you believe yourself omnipotent, it is hard...to reconcile yourself to mere potency. Like all deeply arrogant men, Harris possessed little or no sense of reality." An inveterate liar, Harris told the truth, Max said, only "when his invention flagged".

In 1920 Max annotated the above 1896 drawing from *Caricatures of Twenty-Five Gentlemen*: "Not forcible enough in pose. The right arm should have been outstretched and the fist clenched. F.H. was always far more dynamic than he looks here." However, as John Felstiner remarks, the figure "already looks preened and inflated like a jaunty rooster, as if to signify Harris's sexual activity and self-confidence".

When, in early 1914, Harris, in reduced circumstances, was editor of a second-rate magazine, *Modern Society*, he was sued for libel. Harris so flagrantly insulted the judge that he was summarily put into Brixton Prison for contempt. Max wrote him a letter, but not to "condole" with him:

> You have always enjoyed adventures of all kinds and come out of them smiling, and will very soon come out of this one...and meanwhile the Café Royal [Harris was permitted to have his meals sent in] will have been allowed to minister to you as it has ministered to you for so many years; and as for the brief confinement of your actual body – you, with your intellect and imagination, will have been much more free and at large, really, than the rest of the population of Great Britain.

Max then drew this caricature, "The Best Talker in London, with one of his best listeners" (plate 16) and gave it to Harris for publication in *Modern Society* on the stipulation that it not be used as the cover or as a poster. Harris agreed but immediately had posters made. Max got hold of them and threw the lot into the Thames.

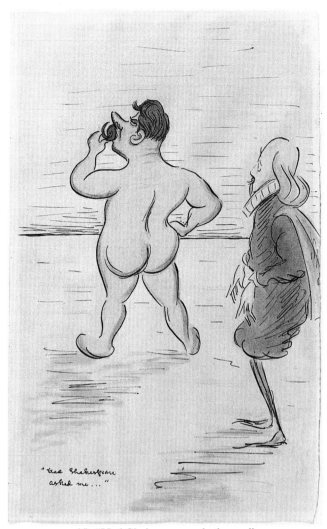

15. "Had Shakespeare asked me..."

Harris was obsessed with Shakespeare, on whom he wrote and lectured extensively – one of his lectures was called "Shakespeare, Shaw, and Frank Harris". Max wrote a parody of Harris called "Shakespeare and Christmas" in which Harris explains that Shakespeare's "unconquerable loathing of Christmas" derived from the fact that his wife, Anne Hathaway, was born on Christmas Day. Known as "The Voice", Harris had, according to Max, a marvellous speaking voice, "like the organ in Westminster Abbey, and with infallible footwork". During a large luncheon in 1896 Max heard Harris's booming tones exclaiming: "Unnatural vice! I know nothing of the joys of unnatural vice. You must ask my friend Oscar Wilde about them. But, had Shakespeare asked me, I should have had to submit!" Whereupon Max drew the caricature "Had Shakespeare asked me..." (plate 15, above).

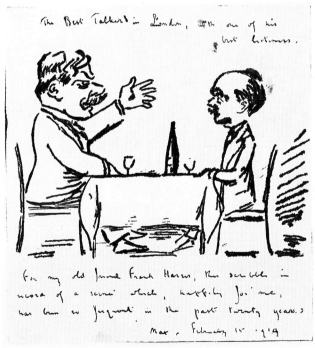

16. The Best Talker in London,
with one of his best listeners. 1914

For my old friend Frank Harris, this scribble in record of a scene which, happily for me, has been so frequent in the past twenty years. Max. February 15, 1914

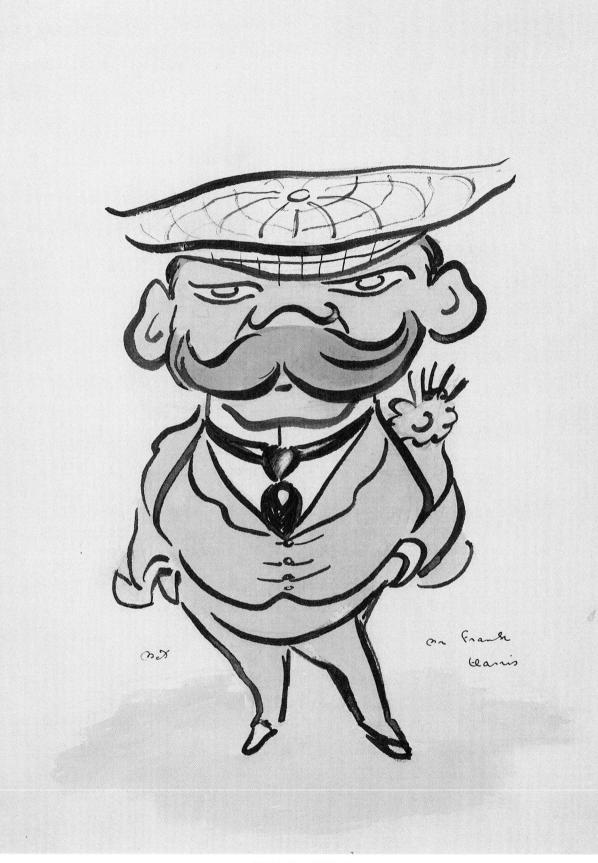

17. Mr Frank Harris

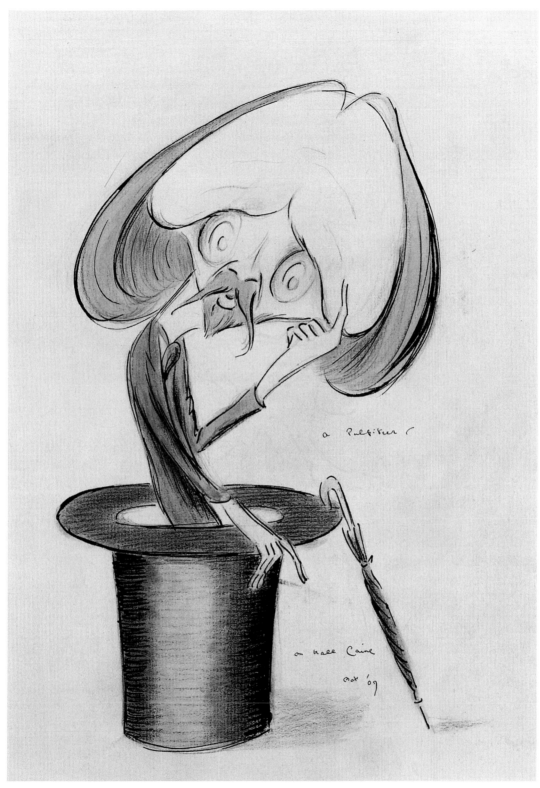

18. A Pulpiteer – Mr Hall Caine. 1907

HALL CAINE

Novelist and playwright Hall Caine (1853–1931) was the object of Max's harshest satire. Caine had a connection with the great Victorians: in 1881, Caine had come to live with Rossetti at 16 Cheyne Walk, Chelsea, as a kind of secretary during the last year of the ailing painter's life

(see plate 205). Max disliked the self-serving memoir that Caine published immediately after Rossetti's death; and he disliked Caine's later novels and plays. Caine, Max said, "rushed. . . into the market-place and chartered a cart and a trumpet and the biggest big drum that

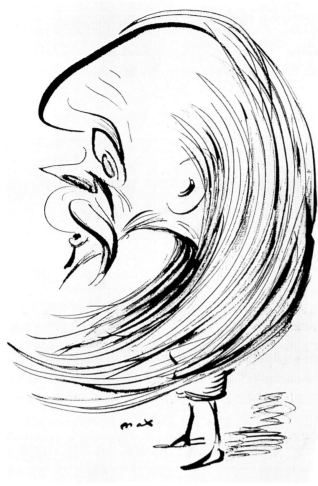

19. [Hall Caine. c. 1909]

ever was made...His popularity was enormous; but he had cheapened his work as well as his reputation". Max "persecuted" Caine in articles and caricatures. He prefaced his murderous slating of *The Christian* in 1897 by protesting that Caine's preliminary puffings of his novel were not, as some had alleged, a disgrace to literature: "One should be grateful to any man who makes himself ridiculous."

Having beleaguered Hall Caine for years, Max was embarrassed in 1902 to meet unexpectedly, at his brother Herbert's house, the man himself. Caine in person was an enthralling spectacle: "That great red river of hair which, from its tiny source on the mountainous brow, spread out so quickly and flowed down so strongly and gushed at last in such torrents over the coat-collar...His eyes, in their two deep caverns beneath the lower slopes of Mt. Brow, shone wondrously when he talked. His whole body seemed to quiver as though too frail for the powerful engines installed in it."

At their meeting Caine frankly told Max how much suffering the caricatures had dealt him, especially one drawing (plate 20). "It showed Hall Caine", Max explained, "with frenzied eyes and hair, bearing a sandwich-board on which his name was inscribed in lavish

capitals. It had been reproduced on a small scale in one of the English papers. But...[Caine] went to lecture in America, and, into whatsoever city he entered, always that presentment stared him in the face. It cropped up, with nerve-shattering iteration, in every local paper, often magnified to the scale of a full page...It pursued him, it wore him down."

Max dutifully said how sorry he was to have caused pain. But he did not leave off.

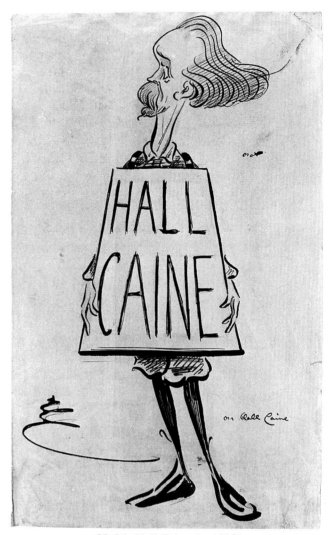

20. Mr Hall Caine. [c. 1898]

RUDYARD KIPLING

In 1907, Rudyard Kipling (1865–1936) became the first Englishman to win the Nobel Prize for literature, and thereafter many considered him the foremost English writer of his time. But for Max Beerbohm, Kipling was his *bête noire*, a man of talent who wasted it. Max proudly counted himself as one of that "acute and upright minority" of "haters of Mr Kipling's work".

Max complained to Holbrook Jackson that in his book *The Eighteen Nineties* – dedicated to Max – Jackson had overrated Kipling: "To me, who get the finest of all literary joy out of Henry James...the sort of person that Kipling is, and the sort of thing that Kipling does, cannot strongly appeal – quite the contrary. I carefully guard myself by granting you that Kipling is a genius...The *schoolboy*, the *bounder*, and the *brute* – these three types have surely never found a more brilliant expression of themselves than in R. K....But as a poet and a seer R. K. seems to me not to exist, except for the purpose of contempt." In a similar vein, Max inscribed the title page of one of Kipling's books: "By R. K. the Apocalyptic Bounder who can do such fine

things but mostly prefers to stand (on tip-toe and stridently) for all that is cheap and nasty."

Max loathed "the triple odour of beer, baccy, and blood" – the "manliness" – which he found exuding from Kipling's pages. In reviewing a theatre production of an early Kipling novel, *The Light that Failed*, adapted for the stage by Julia Constance Fletcher writing under the name "George Fleming", Max wickedly suggested that "Rudyard Kipling" might also be a pseudonym for a woman. In *The Light that Failed*, Max says the hero, and Kipling, dote on the military as typifying "in its brightest colours, the notion of manhood, manliness, man. And by this notion Mr Kipling is permanently and joyously obsessed." In novels written by men, Max contends, "virility is taken for granted"; in the novels of (inept) woman writers, the male characters are constantly acting in a "manly" fashion, while "in ever-present dread of a sudden soprano note in the bass".

Max plagued Kipling in caricatures, articles, and in a brilliant, cruel parody in *A Christmas Garland*, in which a Kiplingesque policeman arrests and manhandles Santa

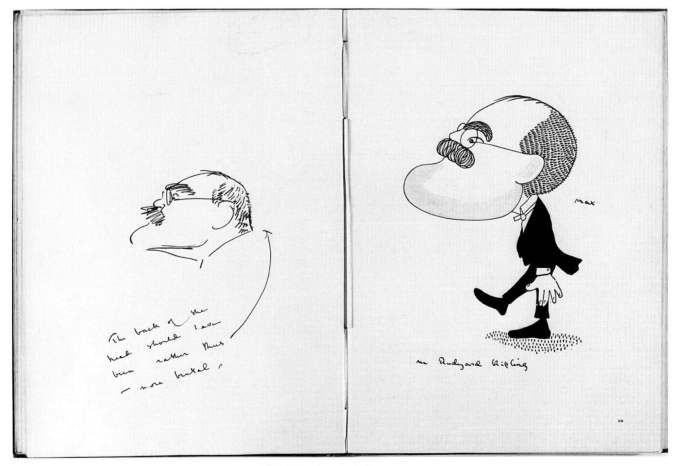

21. Mr Rudyard Kipling. [1896]
[*The woodcut reproduction of Kipling in* Caricatures of Twenty-Five Gentlemen (1896), *Max's first book of caricatures, and his "correction" on the facing page in 1920: "The back of the head should have been rather thus – more brutal."*]

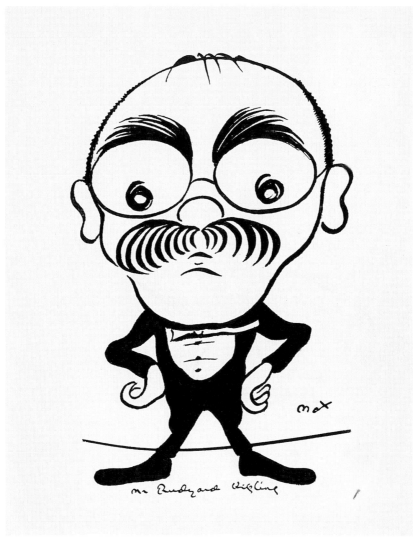

22. Mr Rudyard Kipling. [1898]

Claus, whom he has caught emerging from a chimney. In his drama criticism, Max would insert gratuitous attacks on Kipling wherever he could: we read, for example, that had Kipling been a Frenchman, he would still be a mere journalist, known only as "a particularly virulent Anti-Semite, Chauvinist, and fulminator against '*perfide Albion*.'" Again, "Signally precocious in artistic execution, [Kipling] has always been signally backward in intellectual development. As a young man he took exactly the same kind of interest in soldiers and sailors and steam-engines as most of us take between the ages of five and ten. Last year [1903] I was amused to find that he had just reached the undergraduate stage: he was trying his hand at literary parodies...these parodies, so dull and feeble that no undergraduate editor would have accepted them on their merits, were blazoned forth, day after day, as a special feature of a newspaper that has a huge circulation among quite grown-up persons."

In old age, Max felt almost guilty for his attacks: "Friends of his and mine kept telling me that he was pained and shocked by what I wrote, but I couldn't stop.

As his publication increased, so did my derogation. He didn't stop; I *couldn't* stop. I meant to... Why did I go on persecuting him?...But...I had to do it. He was a great genius who didn't live up to his genius, who misused his genius."

Plate 21 (previous page), an early caricature, shows Kipling as shortish, with a large head on a puny body. Although Max ridiculed the "foolish convention" by which some caricaturists invariably drew a large head on a small body, Kipling was one of those, who, like James Stephens (plate 37) and Paolo Tosti (plates 177 and 213) actually had small bodies and large heads. Another "point", probably the most salient, and featured in Max's usual profile-style caricatures of Kipling, was the huge jutting jaw. Max also was much concerned with the back of Kipling's head. He felt this early drawing amiss on this point. He got it right in "Scenes from the Lives of the Poets" (plate 23, above). That drawing shows Kipling composing "The Absent Minded Beggar", a "banjo melody" of Tommy Atkins, serving his country in the Boer War, a war Kipling staunchly

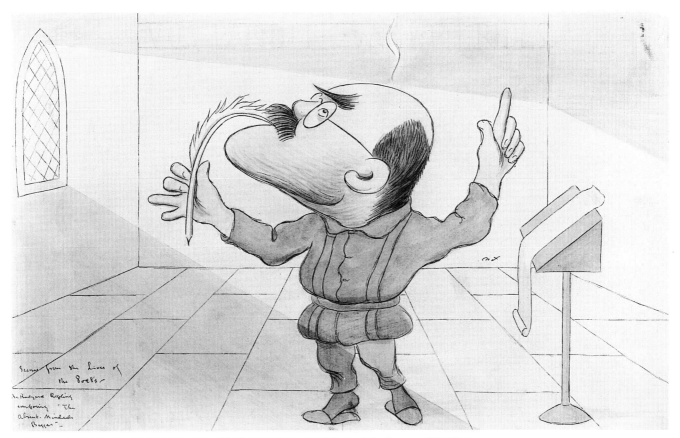

23. Scenes from the Lives of the Poets – [1903]
Mr Rudyard Kipling composing "The Absent-Minded Beggar"

supported, while Max was appalled by it. Max wrote: "Mr Kipling can receive no greater tribute than that his poem has electrified the land without the help of that other Great man ["the Great Macdermott", a music-hall performer who read poems on stage] ...However, why should I be sneering at Mr Kipling? Reaction against him and all his works will set in soon enough. He will not be less under-rated than he has been over-rated."

Plate 22 (opposite) is somewhat exceptional among the many representations of Kipling (twenty-six are listed in the Hart-Davis *Catalogue*) in that it is a frontal, full-face view, sacrificing both the protruding jaw and

the "brutal" back of the head.

Plate 24 (overleaf), representing Kipling and Britannia, his "gurl" – who is wearing Kipling's bowler – taking "a bloomin' day aht, on the blasted 'eath" is the most famous of the Kipling caricatures, and among the best known of all Max's drawings. It first appeared in *The Poets' Corner* (1904). The reproduction here is from the original drawing, rather than the harsher chromolithographic version usually reproduced.

For additional caricatures of Kipling see plates 50, 213, and especially 188 where John Bull, who, though thinking poetry for the most part "*not wholesome*", nonetheless urges Kipling to give him a banjo tune.

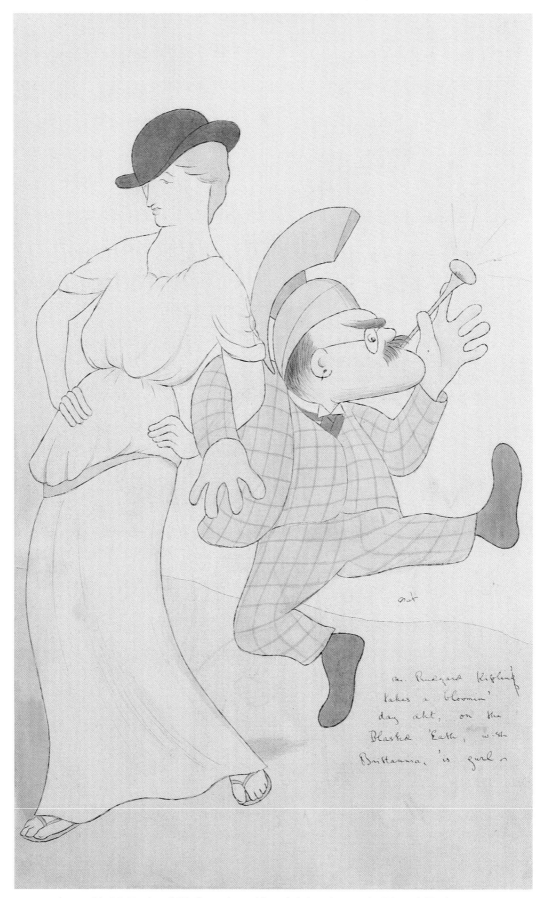

24. Mr Rudyard Kipling takes a bloomin' day aht, on the Blasted 'Eath,
along with Brittannia, 'is gurl. 1904

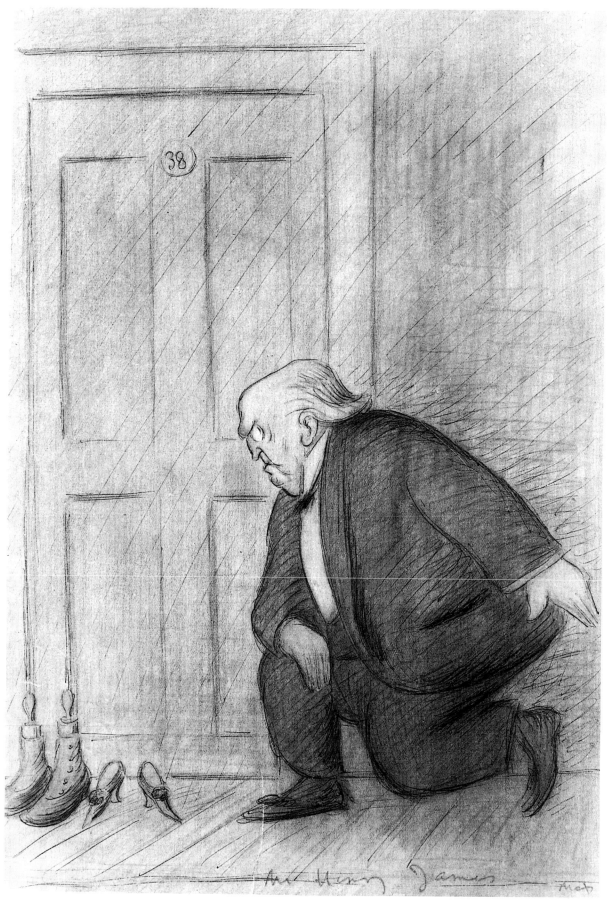

25. Mr Henry James. [c. 1904]

Among the novelists of Max's time, Henry James (1843–1916) was his favourite. And among James's novels, he most admired the late ones, *The Wings of the Dove* and *The Golden Bowl*, even though, like everybody else, he sometimes complained of the difficulties of James's later, more convoluted style. It is this style which Max captured so memorably in his parody "The Mote in the Middle Distance" – perhaps the most well known literary parody in the language. Max feared that James, a friend but not an intimate, might have resented the parody – published in *A Christmas Garland* – but James in fact read it with "wonder and delight", calling the book "the most intelligent that has been produced in England for many a long day". The parodies, James said, were so good that none of the writers satirized there – including Kipling, Wells, Chesterton, Harris, Galsworthy, Hardy, Belloc, Gosse, Shaw, Hewlett, and Moore – could now write "without incurring the reproach of somewhat ineffectively imitating" Max. But whatever fun Max had parodying James's prose, there can be no doubt of Max's devotion to the Master's work:

> You need search heart and brain for epithets to describe the later James – the James who has patiently evolved a method of fiction entirely new, entirely his own, a method that will probably perish with him, since none but he, one thinks, could handle it; that amazing method by which a novel competes not with other novels, but with life itself; making people known to us as we grow to know them in real life.

Max found James in person nearly (though not quite) as fascinating as his books:

> Delightful company – you had to wait – worth it – very literary – enormous vocabulary – great manner, as in books – never smiles – rather appalled by life – cloistral...priest – fine eyes – magnificent head – ...strong voice – holding table.

Max elaborated on James's conversation: "Henry James took a tragic view of everyone, throwing up his hands and closing his eyes to shut out the awful vision. Rocking his chair and talking with tremendous emphasis...His talk had great *authority*...there was a great deal of hesitation and gurgitation before he came out with anything: but it was all the more impressive, for the preparatory rumble."

Of Max's 22 drawings of Henry James, the three reproduced here are especially engaging. That on the previous page (plate 25), of James kneeling at the door of a hotel room, his ear to the keyhole, staring intently at pairs of male and female shoes, is titled simply "Mr Henry James". But the drawing was inspired by an essay James wrote on D'Annunzio, which Max would have read in the *Quarterly Review* of April 1904. The piece closes with a discussion of the emptiness of fiction that isolates the physical from the "act of living":

> Shut out from the rest of life, shut out from all fruition and assimilation, it has no more dignity than – to use a homely image – the boots and shoes that we see, in the corridors of promiscuous hotels, standing, often in double pairs, at the doors of rooms. Detached and unassociated these clusters of objects present, however obtruded, no importance. What the participants do with their agitation, in short, or even what it does with them, *that* is the stuff of poetry, and it is never really interesting save when something finely contributive in themselves makes it so.

In "London in November and Mr Henry James in London" (plate 26), showing James in a London fog, holding his hand up in front of his face, the legend is itself a short brilliant parody of James's famous style.

The drawing of James and Conrad conversing at a party (plate 27, overleaf) can be set against Max's words to Reggie Turner in 1914: "I met old Henry himself several times: he has become one of the stock ornaments of dinner-tables...though he insists on being regarded as a recluse; and, wherever he is, nobody is *supposed* to see him there. All the same, he is in great form, really delightful to be with – though he hasn't a good word to say for anyone." Another time Max described James talking to John Singer Sargent (plates 113 and 114) at a party: "They seemed to chop the sentences out of themselves, with a great preliminary spouting, as of whales. And when you met them at dinner parties, you felt an air of embarrassment about both of them, as if they'd never been out of an evening. And they dined out every night. Whenever I went out, there they were." On still another occasion Max said of James's conversation: "A certain rumbling and circumlocutionizing emerged from him. He was a great hesitater, you know, the greatest of hesitaters. He would have made a great Parliamentarian, because in the House of Commons those who hesitate are valued; a fluent speaker is apt to be considered superficial, while a hesitater, they think, is hesitating because he is deeply pondering the grave issues."

In all Max's caricatures of James, the most prominent "salient feature" was his forehead: it was, Max noted, "more than a dome, it was a whole street!"

26. London in November, and Mr Henry James in London. [c. 1907]
. . . It was, therefore, not without something of a shock that he, in this to him so very con-
genial atmosphere, now perceived that a vision of the hand which he had, at a venture, held
up within an inch or so of his eyes was, with an almost awful clarity being adumbrated . . .

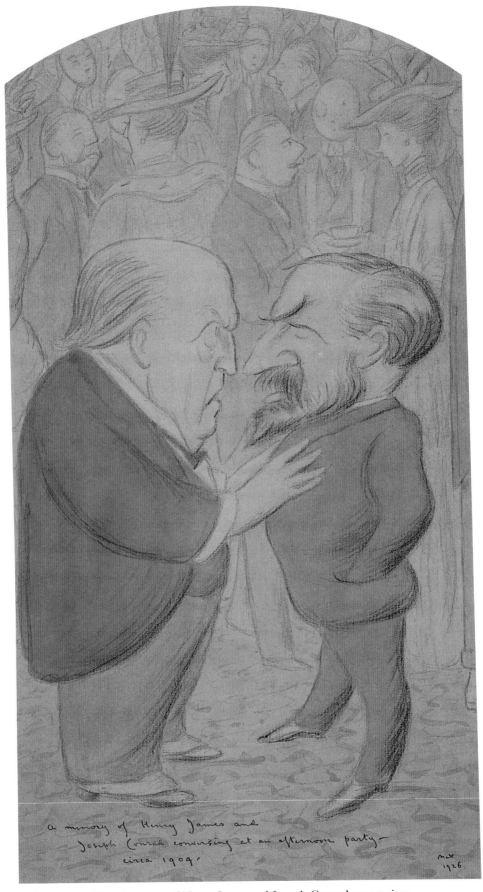

a memory of Henry James and
Joseph Conrad conversing at an afternoon party –
circa 1904.

max
1926

27. A Memory of Henry James and Joseph Conrad conversing
at an afternoon party – circa 1904. 1926

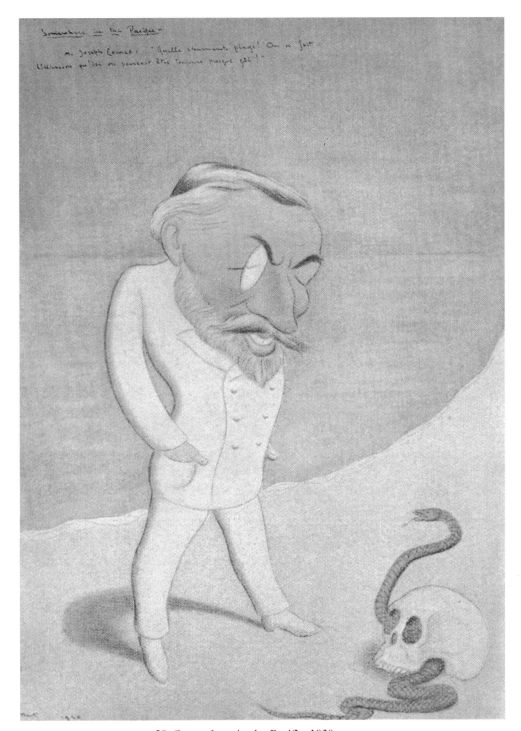

28. Somewhere in the Pacific. 1920
Mr Joseph Conrad: "Quelle charmante plage! On se fait l'illusion qu'ici on pourrait être toujours presque gai!"
["What a charming beach! It gives one the illusion that here one could be forever almost happy."]

JOSEPH CONRAD

Novelist Joseph Conrad (1857–1924) had a tortuously slow rise to public acceptance. By Conrad's own account, Max's parody of his fiction in *A Christmas Garland* in 1912 was for him the sign of arrival. Conrad wrote: "I found myself in very good company. I was immensely gratified. I began to believe in my public existence." On Conrad's death, Max wrote to his widow describing her husband as "a man of great genius whom the world had for many years neglected, whom the world (in its stupid but decent way) had at last made much of, and who (fundamentally sad though I suppose him to have been, like most men of genius) was pleased a little – ironically pleased, but genuinely pleased – by the humdrum worldly success that had overtaken him".

29. Mr Arnold Bennett

ARNOLD BENNETT

Max was a great admirer of the novels of Arnold Bennett (1867–1931), most especially of *The Old Wives' Tale* (1908). On finishing it, Max "felt a real void" in his life and invited the author to lunch: "I know I should like you, in my humble way; and you'd probably like me – *c'est mon métier* to be liked by the gifted: I somehow understand them." On another occasion Max invited Bennett to lunch so that he could "verify" his remembrance of him, "for, in the rough sketches I have done, you come out looking exactly like Apollo's long-lost twin-brother, and though I am sure my memory doesn't deceive me I want to get a different sort of effect. In fact I want to make a 'distortion', and only by seeing you with my eyes can I hope to find some way of making this distortion without altogether losing the likeness."

30. [John Galsworthy]

JOHN GALSWORTHY

Novelist and playwright John Galsworthy (1867–1933), famous as the author of *The Man of Property*, the first and finest segment of *The Forsyte Saga*, was an admired friend of Max's. After Max's parody of Galsworthy was published in *A Christmas Garland*, Galsworthy wrote him asking about what he considered Max's use of a particular phrase ("Because it takes more out of us") which, in the context of the story, seemed exactly, and uncannily, to speak Galsworthy's own thoughts. Max answered, "I think I may claim that I 'divined' it. I don't think it is in any of your books; and I don't think you ever said it to me: you would have adjudged me too frivolous for such a confidence. I must have read it in your eyes – particularly in the unmonocled eye!" Galsworthy wrote back: "You are the nearest approach to the Yogi that our western civilization produces."

Max once described Galsworthy as a "dry man but sympathetic [who] looks very like his manner of writing".

This tiny caricature was drawn by Max on the title page of one of Galsworthy's works, as part of his practice of "improving" copies of books.

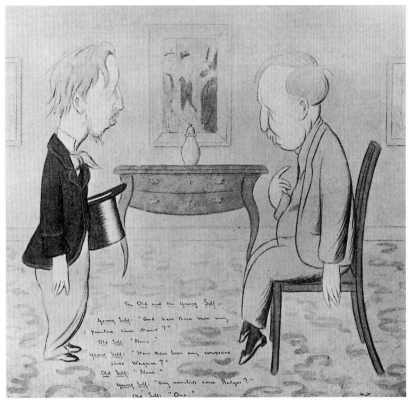

31. [George Moore] The Old and the Young Self. 1924

Young Self: "And have there been any painters since Manet?"
Old Self: "None."
Young Self: "Have there been any composers since Wagner?"
Old Self: "None."
Young Self: "Any novelists since Balzac?"
Old Self: "One."

GEORGE MOORE

George Moore (1852–1933) was once considered the "English Zola". The author of *Esther Waters*, other novels, plays, essays, criticism, and, as Max put it, "many autobiographies", he spent his twenties in Paris and thereafter most of his time in London.

For Max, Moore was "a true eccentric", a man who throve on fervent likes and dislikes, factual gaffes, meandering thought, a lack of logic, a constant admiration for women, and an innocent, unselfconscious appropriation of other writers' material. He had an all-absorbing love of things French, developed during his decade-long residence in Paris. Later in life, after a brief enthusiasm, he suffered disillusionment with the Irish language as a vehicle for literature.

Max thought Moore's real genius was his "vital magic" as a critic: "no one has ever written more inspiringly than he, with a more infectious enthusiasm, about those writers whom he understood and loved, or more amusingly against those whom he neither understood nor liked". Moore's constantly shifting artistic interests arose from his apparent lack of learning: "For him," Max observed, "everything was a discovery". Oscar

Wilde once told Max that Moore was "always conducting his education in public". In a theatre review Max contrasted the learned, sensible criticisms of the "preternaturally Scotch" William Archer (plates 66, 67, and 77) and those of the "very Irish" George Moore:

> Mr Moore, beyond being a creative Irishman, is an unique amazing creature, frank to the verge of unscrupulousness and...almost nude in his *naïveté* ...The crack of the shillelah echoes...A shrill whoop, a twirl in the air, and crack! down goes Mr George Alexander with a fractured skull. Down goes Mr Pinero. Down go Maupassant, Mr Jones, Mr James...but who shall enumerate the prone?

In plate 31, above, where the older Moore decries to his youthful self the lack of artistic accomplishment in recent years (with one exception), he is making what Max called his "one gesture": "The finger-tips of his vague, small, inert, white hand continually approached his mouth and, rising thence, described an arc in the air – a sort of invisible suspension-bridge for the passage of his I-de-a to us."

32. Elegy on *Any* Lady by G. M. [c. 1916]
That she adored me as the most / Adorable of males / I think I may securely boast. / Dead women tell no tales
[*The Latin inscription on the tombstone reads "Here Lies Any Woman"*]

Moore claimed to be irresistible to women. "He was modest", Max explained, and his successes with women, according to Moore, "were not conquests *by* him, they were victories *over* him". His tastes, Max said, were unsnobbish and democratic: barmaids, duchesses, shepherdesses; for Moore even prostitutes "forgot commerce, apparently, when they met *him*". Max (like Sarah Purser, who remarked that "some men kiss and tell, Mr Moore tells and doesn't kiss") thought Moore's prowess with women was mostly talk, a view commemorated in "Elegy on *Any* Lady" (plate 32, above).

Max's drawings of Moore echo his prose description of the man:

There always was an illusory look about him – the diaphanous, vaporous, wan look of an illusion conjured up for us... Limply there hung over his brow a copious wisp of blond hair, which wavered as he turned the long white oval of his face from one speaker to another. He sat wide-eyed, gaping, listening

...His face was a mask of gauze through which Nothing was quite clearly visible. And then, all of a sudden there would appear – Something... *Voilà Moore qui parle! Silence, la compagnie! Moore parle* ...His face... while he talked, had but one expression – a faintly illumined blank. His face...– that face transferred to canvas by so many painters since Manet – always entranced [artists] with those problems of "planes" and "values" in which it abounded. He was always a sort of special *treat* to them.

A treat also to Max, who drew more than 30 caricatures of Moore.

Plate 33, opposite, gives us Moore as art critic: in London he was one of the foremost champions of the French Impressionists, many of whom he knew well. "No one but Ruskin", Max asserted, "has written more vividly than he, more lovingly and seeingly, about the art of painting."

46

33. [George Moore]

34. A Survivor of the Nouvelle Athènes – Mr George Moore
[*The Nouvelle Athènes was a Paris café popular with artists and writers. In his autobiographical* Confessions of a Young Man, *Moore wrote, "I did not go to either Oxford or Cambridge, but I went to the Nouvelle Athènes."*]

Max loved in Moore his

matchless honesty of mind; his very real modesty about his own work; his utter freedom from jealousy; his loving reverence of all that in all arts was nobly done; and, above all, that inexhaustible patience of his, and courage, whereby he made the very most of the gifts he had, and earned for himself a gift which Nature had not bestowed on him: the specific gift of *writing*. No young man...ever wrote worse than young Moore wrote. It must have seemed to every one that here was a writer who, however interesting he in himself might be, never would learn to express himself tolerably...Some of the good writers have begun with a scant gift for writing. But which of them with no gift at all? Moore is the only instance I ever heard of. Somehow, in the course of long years, he learned to express himself beautifully. I call that great.

WILLIAM BUTLER YEATS

Perhaps the greatest of modern poets, William Butler Yeats (1865–1939), leader of the Irish Literary Revival, helped found the Irish Literary Theatre, later re-named the Abbey Theatre, which opened in 1899 with a production of his verse play *The Countess Cathleen*. Max called the play "a poem of exquisite and moving beauty". But, for the most part, Max could not bring himself to appreciate Yeats's work:

My wretchedly frequent failure to find definite meanings in the faint and lovely things of Yeats – my perception of nothing but some sort of mood enclosed in a vacuum far away – has always worried me very much...I often had the pleasure of meeting Yeats, and I liked him. But merely to like so remarkable, so mystic and intense a creature – to be not utterly under his spell whenever one was in his presence – seemed to argue a lack in oneself and to imply an insult to that presence...I always felt rather uncomfortable, as though I had submitted myself to a mesmerist who somehow didn't mesmerise me.

Max wrote to his future wife:

Me [Yeats] drives to excesses of grossest philistinism, sympathetic though I generally am to men of genius. A genius he is of course; and geniuses are generally asinine; but his particular asinineness bores me and antagonizes me.

Ezra Pound called his friend Yeats, in regard to esotericism, "Bit queer in the head...very very very bughouse." In Max's celebrated group caricature, "Some Persons of 'the Nineties'" (plate 62), he has Yeats, the mystic, lecturing Enoch Soames, the diabolist (see plate 61).

In plate 35, opposite, Yeats is welcoming back to Ireland, the land of fairies and mysticism, expatriate George Moore. The books on Yeats's shelf are: *Realism, Its Cause & Cure*; *Half Hours with the Symbols*; *Life of Kathleen Mavourneen*; *Erse without Tears*; *Songs of Innocence*; *Murray's Guide to Ireland*; and *Short Cuts to Mysticism*.

Plate 36 (overleaf) recalls Max's first sight of Yeats, in a theatre, taking his bow as author of a curtain-raiser. At first Max observed only "a long fissure of blackness" between the curtains; this proved to have "streaks of white in the upper portion of this blackness – a white streak of shirt-front and above that a white streak of face; and I was aware that what I had thought to be insubstantial murk was a dress suit, with the Author in it. And the streak of the Author's face was partly bisected by a lesser black streak which was a lock of the author's raven hair...It was all very eerie and memorable."

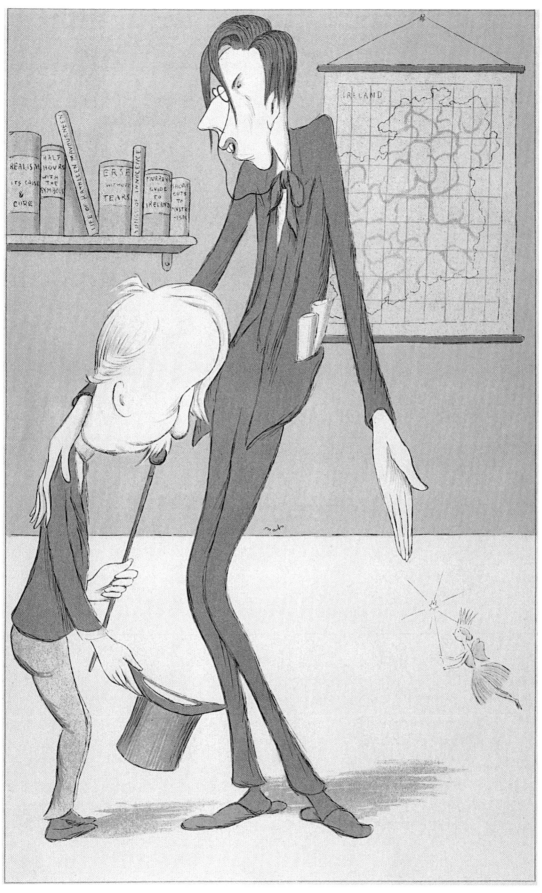

35. Mr W. B. Yeats presenting Mr George Moore to the Queen of the Fairies. [c. 1904]

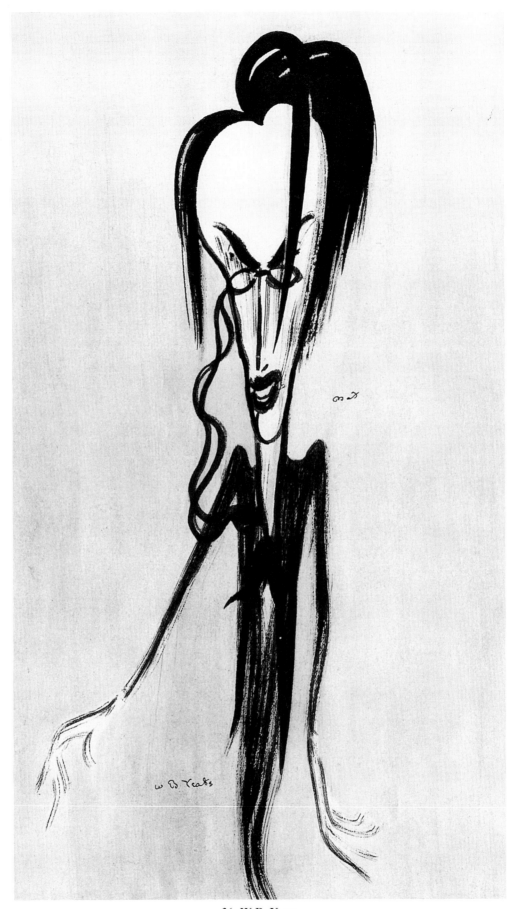

36. W. B. Yeats

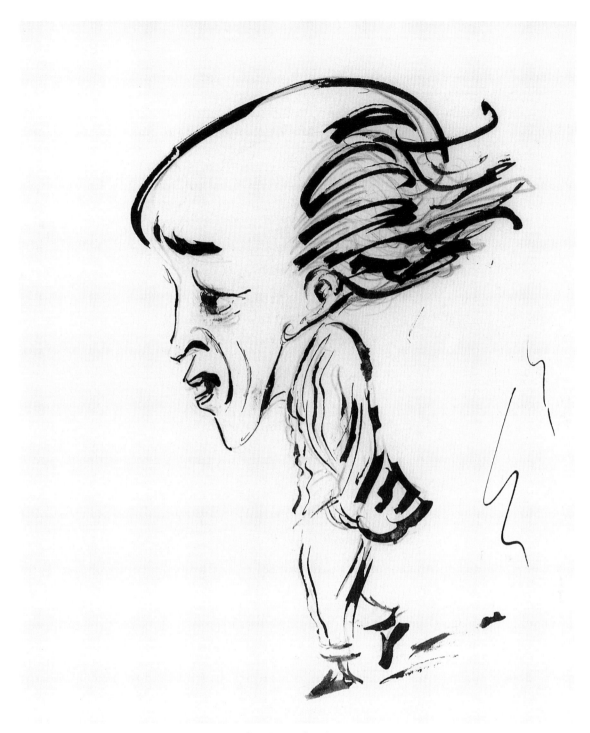

37. [James Stephens]

JAMES STEPHENS

The Irish novelist and poet James Stephens (1880–1950) is best known for his fantasy novels, especially *The Crock of Gold* (1912). James Joyce came to see him as a kind of alter ego: both had the same first name, and Stephen was the name of Joyce's fictional self, Stephen Dedalus; they also shared a common birth date, right down to the hour. Joyce went so far, in the early 1930s, as to make an agreement with Stephens that the latter would finish his "Work in Progress", i.e., *Finnegans Wake*, should Joyce's health, especially his eyes, or his will to continue, fail him.

Stephens was scarcely 4 foot 6 inches. Oliver St John Gogarty wrote that people "often thought of him as a leprechaun and sometimes as a changeling...His lack of inches gave him one advantage. He could cast off the conventions which bound ordinary people and become a gleeman, the most lyrical spirit of his time."

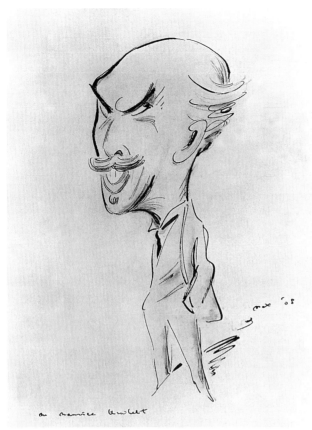

38. Mr Maurice Hewlett. 1908

MAURICE HEWLETT

Entirely forgotten today, Maurice Hewlett (1861–1923), a prolific novelist, poet, and essayist, became famous for a time with his romantic medieval story, *The Forest Lovers* (1898).

Max, who wrote a prose parody of Hewlett in *A Christmas Garland*, gave a mixed estimate of his work, which, he said, had "the fascination of the theatre" except that his characters, while distinctively visualized, lacked life. On the other hand, for "sheer artistry in the use of words", Max thought Hewlett beat "anyone since Robert Louis Stevenson – or Walter Pater". In his Rede lecture of 1943 Max said that he regretted Hewlett was not a humorist; his preciosity was too "robust" and a robust preciosity was "unnatural…a contradiction in terms".

Max knew Hewlett only casually. But one brief, revealing, and somehow compelling sentence, from a letter Max wrote to William Archer in 1919, sums up his view of Hewlett's physical appearance and personal character: "His flashing eye, his soldierly abruptness, and the mild foolishness of what he says, are always a joy."

JOHN MORLEY and LORD ROWTON

John Morley (1838–1923) was editor of the liberal *Fortnightly Review*, 1867–82, and radical editor of the *Pall Mall Gazette*, 1880–83. He sat for many years in the House of Commons, and twice served as Gladstone's Secretary for Ireland. The Prime Minister's close friend and adviser, he fought, like his chief, valiantly but in vain for Irish Home Rule. In 1902 King Edward VII conferred on Morley the Order of Merit, then newly created. In 1908 he was raised to the peerage as Viscount Morley of Blackburn.

Upon Gladstone's death in 1898, Morley, who had previously written lives of Cobden, Cromwell, Burke, and others, undertook to write Gladstone's biography. His *Life of Gladstone* was published to great acclaim in 1903.

Montagu William Corry (1838–1903) met Disraeli in 1865; he became his private secretary in 1866 and, in time, his "inseparable companion" until Disraeli's death in 1881. To Corry, who had been made Baron Rowton in 1880, Disraeli left complete discretionary powers as to the use and publication of his letters and papers. Rowton, apparently feeling unequal to the task, did nothing with the papers (which upon his death were transferred to W. F. Monypenny, who wrote the first two volumes of the Disraeli biography; upon Monypenny's death, G. E. Buckle wrote the remaining four volumes). Instead, Rowton, whom Max characterized as a courtier and "Social Butterfly", devoted himself largely to philanthropy, and particularly to establishing poor men's hostels that provided lodging and food at low prices. Eventually six Rowton Houses were erected throughout London. The term "Rowton House" can still be heard today, referring to working men's lodging houses.

Max said of Morley's *Life of Gladstone*: "How lucky Gladstone was in falling to John Morley! A Buckle or a Monypenny would have blanketed Gladstone for ever. Gladstone's dullness, *and theirs*, combined, would have been utterly fatal to the fact of Gladstone's nobility and grandeur. Nothing noble or grand about dear old Dizzy! Part of his charm is that one feels *no* respect for him."

See also plate 204 for the young Morley introducing his idol, John Stuart Mill, to a sceptical Dante Gabriel Rossetti.

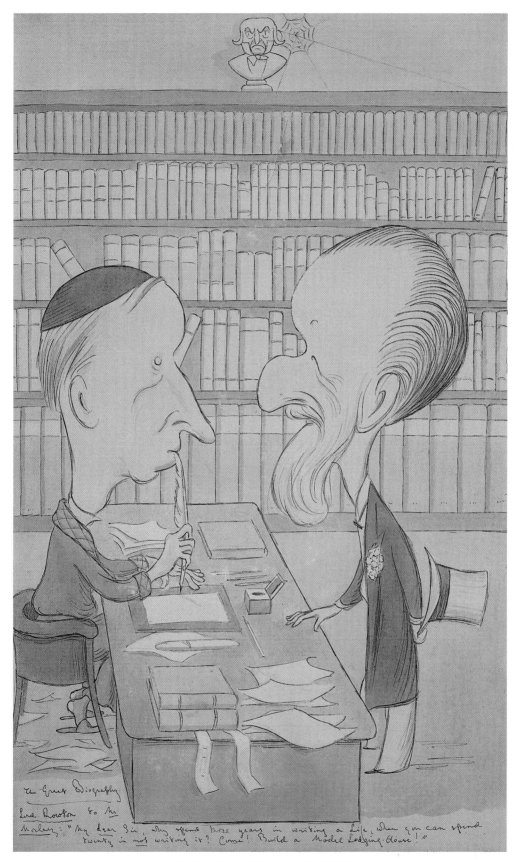

39. The Great Biography. [c. 1901]
Lord Rowton to *Mr Morley*: "My *dear* Sir, why spend three years in writing a Life,
when you can spend twenty in *not* writing it? Come! Build a Model Lodging-House!"

Of Hilaire Belloc (1870–1953), Max said, "He had the conviction that there was only a single lane to Heaven." Or, as he put it another time, "Of course, I can only speak for man; but Mr Belloc knows God's point of view." Belloc, primarily a historian, was a man of combative Roman Catholic views. His social opinions were anti-capitalistic, leaning towards a vague neo-medievalism of craft-guilds. He turned out more than a hundred books, of which *The Path to Rome* (1902) was the most famous. He celebrated (and even bottled his own) wine, was enamoured of everything French, and loved travel – especially in the French countryside. He had a marvellously mannered prose style, a friendly buttonholing of the reader in the midst of airy philosophizing, anecdotes galore, Latin tags, pronouncements dismissive of errors, and a proclivity for spending most of his effort on other than his announced central point; he would assert victory in debate rather than attempt to argue his case. It was a style that Max parodied to a turn in *A Christmas Garland*.

Max once told Belloc: "When you really get talking, Hilary, you're like a great Bellocking ram, or like a Roman river full of baskets and dead cats." Informed that Belloc had been to a cricket match, Max said, "I suppose he would have said that the only good wicket-keeper in the history of the game was a Frenchman and a Roman Catholic." But Max admired much in Belloc's writing: "splendid things abounding" in the midst of "a lot of absolute chaotic rot".

As in this caricature, Belloc had various papal audiences. In June 1919 he wrote to Mrs Raymond Asquith:

> In Rome I saw the Pope [Benedict XV] at some length...I had not seen him since June '16 when I told him the Allies would win, and when he said to me "Etes-vous sûr, Monsieur Belloc?...Parfaitement sûr, Sainteté: archi-sûr" ["Are you sure, Mr Belloc? ...Perfectly sure, your Holiness: absolutely sure]... But he did not believe me. Now he has the air of a man relieved of having at last a comprehensible situation – though he put his money on the wrong horse. The Vatican always does.

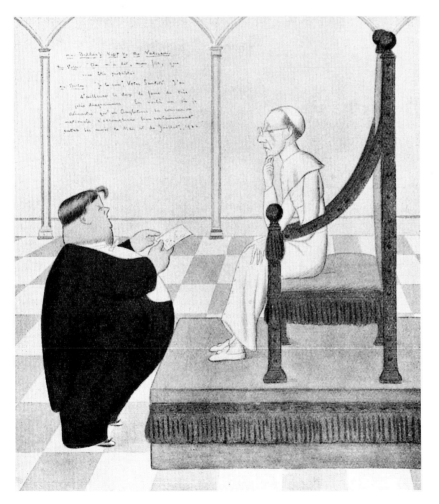

40. Mr Belloc's visit to the Vatican. 1920

The Pope [Benedict XV]: "On m'a dit, mon fils, que vous êtes prophète."

Mr Belloc: "Je le suis, Votre Sainteté. J'ai d'ailleurs le don de faire de très jolis diagrammes. En voilà un où je démontre qu'en Angleterre la conversion nationale s'accomplira bien certainement entre les mois de Mai et de Juillet, 1922."

[*The Pope*: "They tell me, my son, that you are a prophet."

Mr Belloc: I am, your Holiness. I also have the gift of making very pretty charts. And here is one where I show that in England the national conversion will certainly take place between the months of May and July, 1922."]

GILBERT KEITH CHESTERTON

Frequently linked with Hilaire Belloc, G. K. Chesterton (1874–1936) started life as a journalist (he always gloried in the title), and also published more than 100 books: fiction, mysteries, poetry, essays, religious and political works. Chesterton's style, which delighted in antitheses – good/evil, old/new, rational/irrational, folly/wisdom, material/spiritual, always seen from some paradoxical angle – called forth a delicious parody in *A Christmas Garland*. Chesterton, like Belloc, was a leading apologist for Christianity; his religion had always a rollicking, jolly, optimistic, almost prankish note. The ambitious religious and social views of Chesterton and Belloc held little attraction for Max. Of Chesterton's *What's Wrong with the World?* (1910), he said, "very cheap and *sloppy*, though with gleams – gleams of gas-lamps in Fleet Street mud and slush". Nonetheless, in old age Max said of Chesterton and Belloc: "They had blind spots, but they were delightful men. Such enormous gusto, you know, such gaiety, and feeling for life."

In 1902, when Chesterton appeared brilliantly on the London literary scene, Max went out of his way to meet him and wrote down his impressions:

> Enormous apparition. Head big for body – way of sinking head on chest. Like a mountain and a volcanic one – constant streams of talk flowing down, paradoxes flung up into the air – very magnificent.

The caricature reproduced below (plate 41) nicely contrasts Chesterton's huge frame with Belloc's smallish one. In 1922, after years of encouragement from his friend Belloc, Chesterton did convert to Roman Catholicism. Plate 42, overleaf, Chesterton giving an after-dinner speech, evokes, through his enormous girth, a mountainous, volcanic, and "magnificent" spectacle.

41. Mr Hilaire Belloc, striving to win Mr Gilbert Chesterton over from the errors of Geneva. 1907

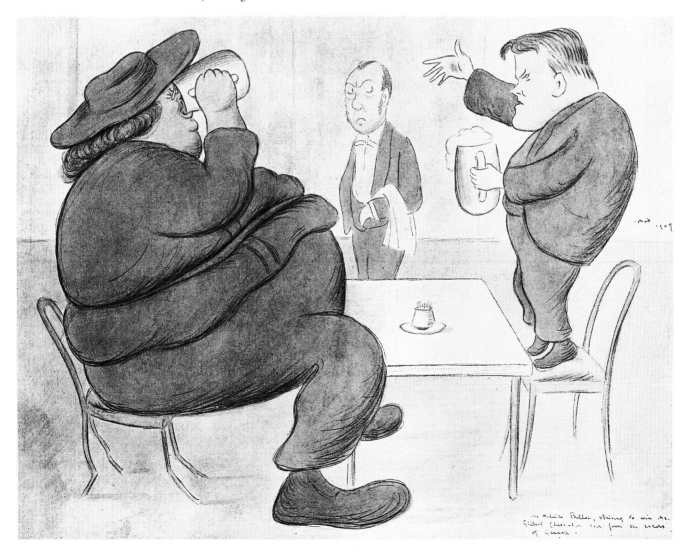

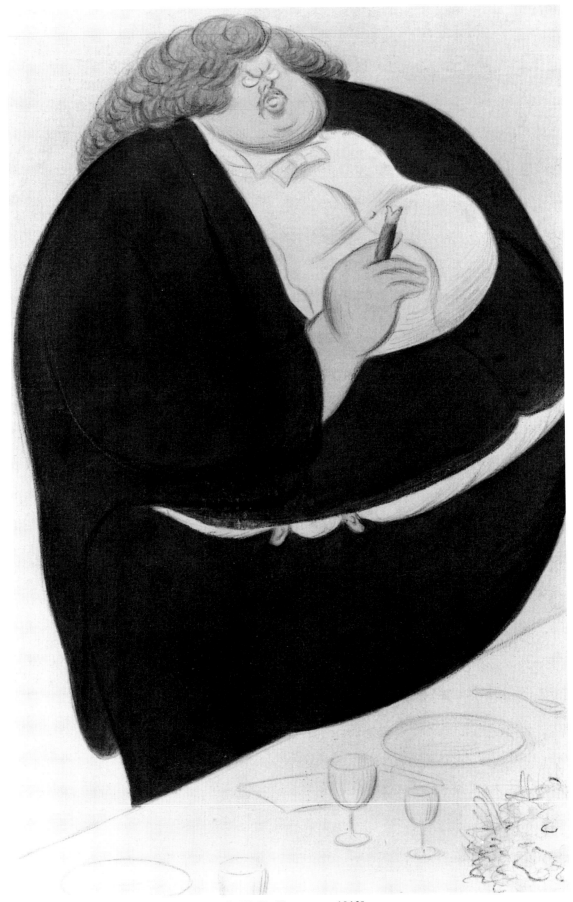

42. [G. K. Chesterton. 1912]

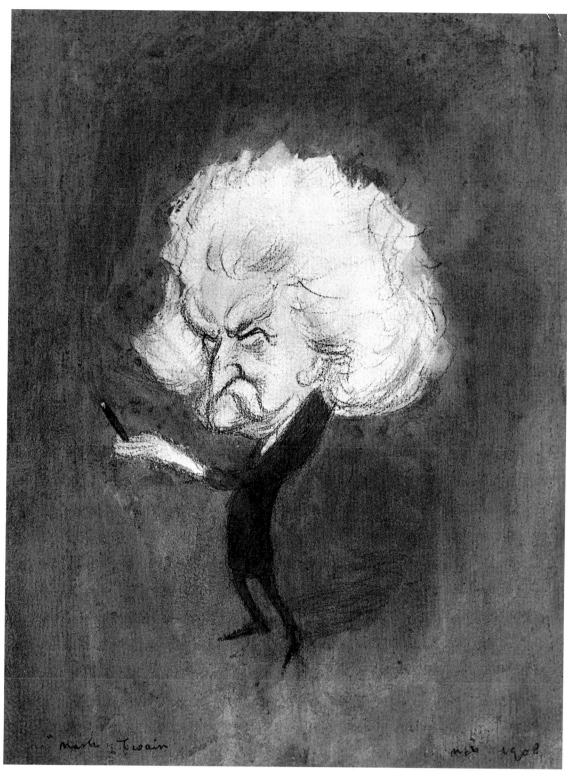

43. "Mark Twain". 1908

MARK TWAIN

Max once met Mark Twain (1835–1915), the celebrated American humorist and writer, through George Bernard Shaw, but, unfortunately, Max made no comment on Twain himself:

> I remember [Shaw's] inviting me to lunch at Adelphi Terrace to meet Mark Twain. Barrie was there, three or four others. At the end of a very agreeable lunch, Shaw jumped up, said he had an appointment with his dentist, and rushed off, leaving us alone with his guest. It was somewhat embarrassing... Might he not have told us in advance that he had an engagement?

But, whatever Shaw's thoughtlessness, the lunch evidently supplied Max with a workable grasp of Twain's "salient features".

EDMUND GOSSE

With nearly 100 books to his credit, Edmund Gosse (1849–1928) was a man who revelled in the literary life. He had countless literary friends and fostered numerous younger writers (plate 45, opposite). In 1925 he was knighted for his contributions to literature. Today he is remembered solely for his masterwork, *Father and Son* (1907), an autobiographical account of his childhood and youth with his father, a rabid member of a fundamentalist sect, the Plymouth Brethren. Gosse's other writings, largely biographical, were marred by carelessness. He was attacked, for example, by William Archer (plates 66 and 67), for inept translations of Ibsen, giving as evidence Gosse's rendering of a passage Archer knew to mean "distinguished himself on the battlefield" as "always voted right at elections". In *A Christmas Garland*, Max wrote a brilliant parody of Gosse's "anecdotal history of authors" that has Gosse unsuccessfully introducing Ibsen to Browning, neither of whom has heard of the other.

In 1896 Max was invited by Gosse to his house in Delamere Terrace, where the likes of Henry James and James Whistler frequently gathered. "My *Works*", Max wrote, "had just been published...I remember that when I received my summons to Delamere Terrace I felt that my little book really had not fallen flat." Gosse and Max became good friends. Gosse mistakenly considered himself Max's literary mentor, and perhaps that is why Max always drew Gosse looking rather like a schoolmaster. In 1925 Max dedicated a collection of caricatures, *Observations*, to Gosse.

In 1906 newspaper czar Lord Northcliffe (Alfred Harmsworth), attempting to compete with the *Times Literary Supplement*, hired Gosse to edit *Books*, a supplement to the *Daily Mail* (plate 44, below; for another caricature of Northcliffe, see plate 174). Gosse enlisted his talented friends as contributors, but, as he put it, "I am an old dog to be set a new trick." His reign lasted one year. Max's caricature plays with the timid side of Gosse, whose caution in literary matters was well known. When, for example, Gosse published a lengthy *Life* of Swinburne, it was much attacked for squeamishness. A. C. Benson said the book was "the life of a fearless and ebullient little man, written by a man in an armchair who is afraid of everyone and everything", and Ezra Pound (plate 60) said it presented "a Swinburne coated with a veneer of British officialdom and decked out for a psalm-singing audience".

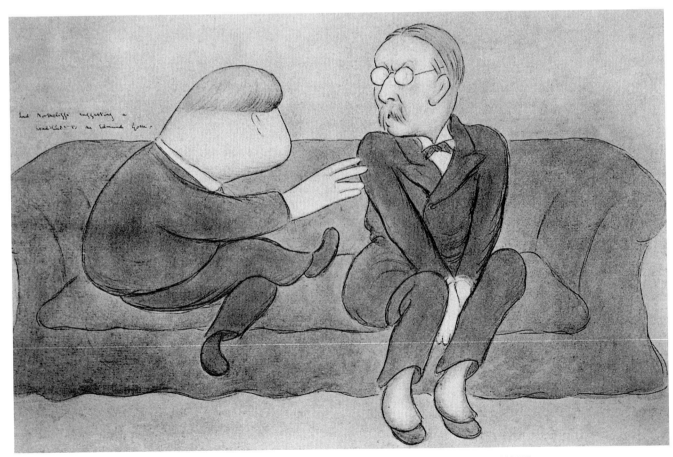

44. Lord Northcliffe suggesting a head-line to Mr Edmund Gosse. [1907]

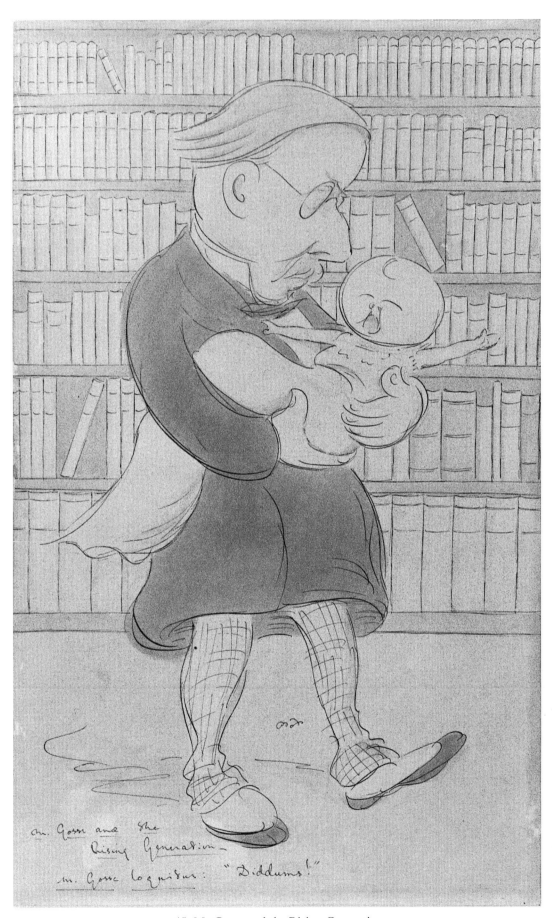

45. Mr Gosse and the Rising Generation
Mr Gosse loquitur: "Diddums!"

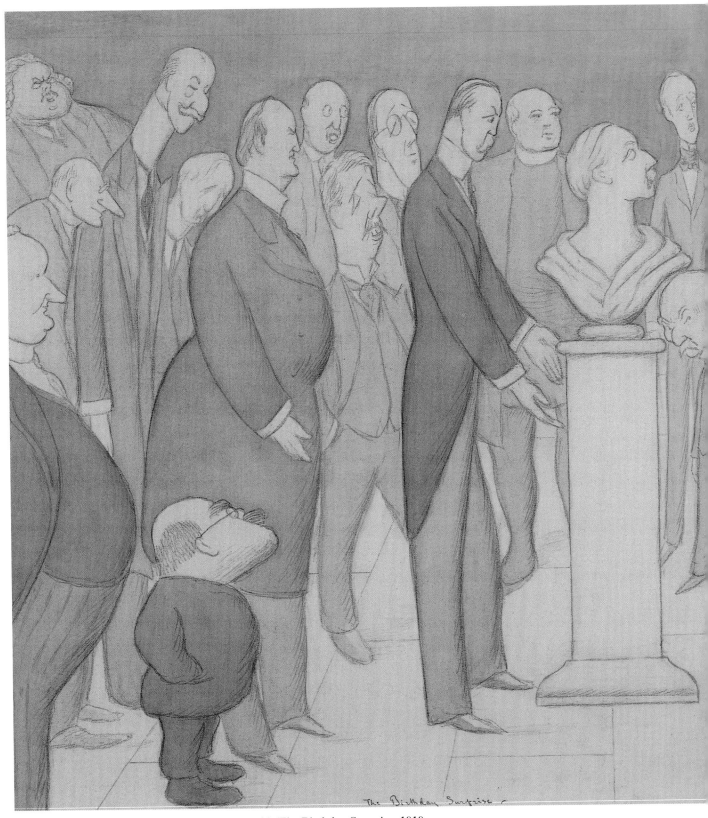

46. The Birthday Surprise. 1919
"This is no moment for coyness or mock–modesty."
For E. G. affectionately from Max

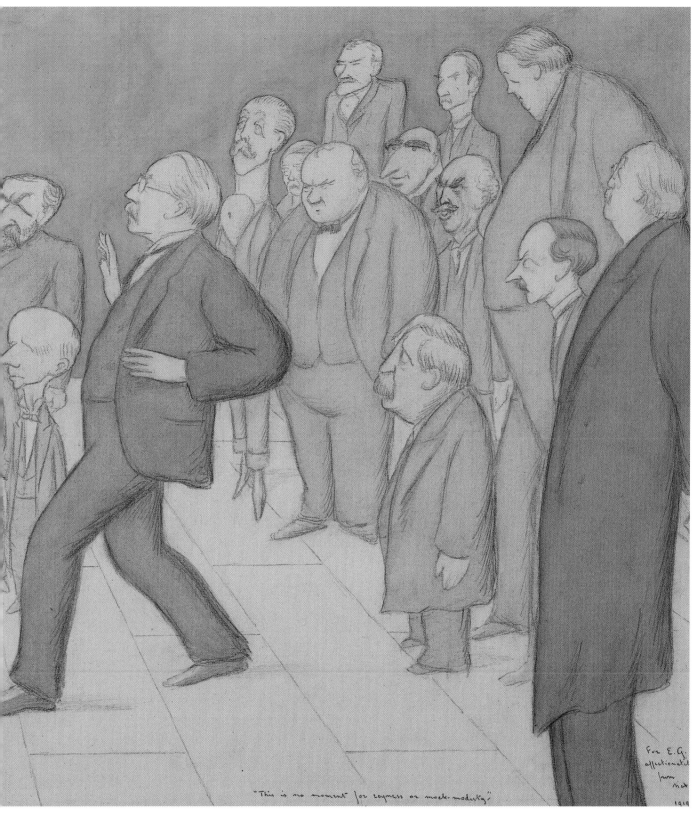

"This is no moment for coyness or mock-modesty."

[*Lord Crewe presents Edmund Gosse with a bust of himself commemorating Gosse's seventieth birthday. The quotation is from Gosse's collective letter of thanks to the "admired and beloved" friends who had given him the tribute. The others in the drawing are Lord Beauchamp, Logan Pearsall Smith, G. K. Chesterton, L. V. Harcourt, George Moore, Rudyard Kipling, Lord Curzon, Maurice Baring, Arnold Bennett, Lord Howard de Walden, Randall Davidson (the Archbishop of Canterbury), Lord Londonderry, Joseph Conrad, Thomas Hardy, John Morley, Lord Spencer, Mr Ryman, Lord Haldane, Sir Frank Swettenham, A. W. Pinero, William Archer, Maurice Hewlett, Austin Dobson, Evan Charteris, Ray Lankester, and Arthur Balfour, in whose house the presentation took place.*]

THE BIRTHDAY SURPRISE
(Previous pages)

Edmund Gosse observed his 70th birthday on 21 September 1919. The family celebration took place at a village in Wales, where Gosse received a letter from friends and admirers promising him a bust of himself in commemoration of his services to literature. The letter was signed first by Lord Crewe, and there followed more than 200 signatures, including Max's. The bust was executed by Sir William Goscombe, RA, a former pupil of Gosse's lifetime friend, Hamo Thornycroft (Lytton Strachey, asked if Gosse were homosexual, replied, "No, but he's Hamo-sexual"). Max promised to do a caricature of the presentation; and Gosse, writing to thank him, said: "What fun it all is...Do bring in two Archbishops with their mitres and their croziers...I can't take it all seriously...What has possessed you all to make such a painted pagan idol of poor old third-rate me?..." Gosse signed the letter "the Notorious Septuagenarian". (In the caricature Max managed only one archbishop, mitreless and crozierless.) The press made much of the coming presentation of the bust. *The Times* printed Lord Crewe's letter and listed all the signers; other papers poured out commendations, speaking of Gosse's "encyclopaedic knowledge", his helpfulness to younger writers, the "universal esteem" in which he was held; one editorial doubted "if a greater tribute to a living man of letters has ever been paid". Of course some dissented: to Lytton Strachey he was "Goose Gosse"; to Virginia Woolf he was "grocer Gosse".

Goscombe completed the bust the following year, in time for the Royal Academy's 1920 exhibition. And finally, on 9 November 1920, at the house of former Prime Minister Arthur Balfour, before a large gathering of notables, Lord Crewe presented it to Gosse. In his reply to the eulogies, Gosse said he felt like the guest of a Roman Emperor, "stifled in roses". As Ann Thwaite, Gosse's biographer, remarks, Max's caricature loses nothing – indeed one can say it gains – by the "impossible assumption" that the bust was a surprise to the sitter. Max's caricature now hangs in the Savile Club, where Gosse and Max were prominent members. The bust itself is in the London Library, with copies in the House of Lords and the Savile Club.

LACUNA

As a supplement to the large Birthday Surprise caricature, Max in 1921 drew "Lacuna". Here, indubitably, was a serious void: why no such bust of George Moore? He looks up woefully at the bust while Gosse, his "interlocutor" in *Avowals* (a book by Moore consisting largely of a dialogue between Moore and Gosse), explains the cause of the problem. Moore would in fact turn 70 in 1922.

47. Lacuna. 1921

Mr Edmund Gosse (to his interlocutor in "Avowals"): "But, my dear Moore, of *course* you will – of *course* they shall! Only, you don't tell us when your seventieth birthday *is!*"

48. Mr H. G. Wells, prophet and idealist, conjuring up the darling Future. 1907

H. G. WELLS

Max was friendly with H. G. Wells (1866–1946), but had no sympathy with his faith in science or his social idealism and utopianism. Samuel Behrman wrote of Max that he "shied away from lunacy not only in its violent forms but also in its milder forms, one of these being utopianism. 'Good sense about trivialities is better than nonsense about things that matter,' he once said. He had a horror of utopians, a suspicion of 'big' ideas". Wells's prose troubled him as well. Writing to Shaw in 1903, Max asked, "Have you ever seen a cold rice-pudding spilt on the pavement of Gower Street? I never have. But it occurs to me as a perfect simile for Wells's writing." In 1921, when Reggie Turner sent Max a copy of Wells's *History of the World*, he replied, only half jokingly, "You *couldn't* have given me a present that I should have hated more."

In plate 48, Wells is conjuring up through a trap door the "darling Future", a grim lady in spectacles holding a geometrical instrument in one hand and "an even grimmer baby" (also wearing glasses) in the other.

49. Mr H. G. Wells foreseeing things. [1931]

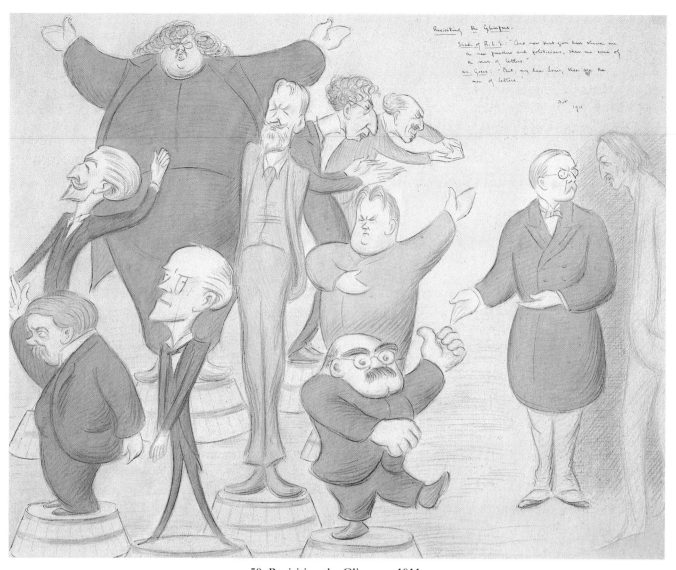

50. Revisiting the Glimpses. 1911

Shade of R. L. S.: "And now that you have shown me the new preachers and politicians, show me some of the men of letters."

Mr Gosse: "But, my dear Louis, these *are* the men of letters."

[*Cunninghame Graham, H. G. Wells, G. K. Chesterton, John Galsworthy, G. B. Shaw, Israel Zangwill, Maurice Hewlett, Hilaire Belloc, and Rudyard Kipling*]

REVISITING THE GLIMPSES

Here (plate 50) we see Edmund Gosse, that omnipresent man of letters and the centre of much of London's literary life, showing the ghost of Robert Louis Stevenson, who had died seventeen years earlier, the current crop of writers. The sentiment of the bewildered Stevenson – surely these are politicians and preachers, not writers – was one Max shared. His view was that literature was an end in itself, and not an excuse for preaching or making political points. All these "new preachers and politicians" were, in Max's view, prostituting their skills, some much more so than others. Certainly Kipling, with his militarism and empire-mongering might have headed Max's list of squanderers of talent, but for George Bernard Shaw (plates 76–82), who, in Max's view, had so much more talent, so much real genius, to squander. But all the writers caricatured here, including Israel Zangwill (1864–1926), a novelist and playwright who proselytized for Zionism, troubled Max's sensibilities – they were not putting their art first. In regard to one of them, at least, Max found his view confirmed from a surprising quarter. He recounted how, sitting at dinner one evening next to Mrs Shaw, he, "after spraying G. B. S. with every variety of praise...murmured, 'But you know, Charlotte, G. B. S. has no aesthetic sense. He is not an artist.' She leapt at this. She said she was always telling G. B. S. that. She said that what he *really* was was a reformer."

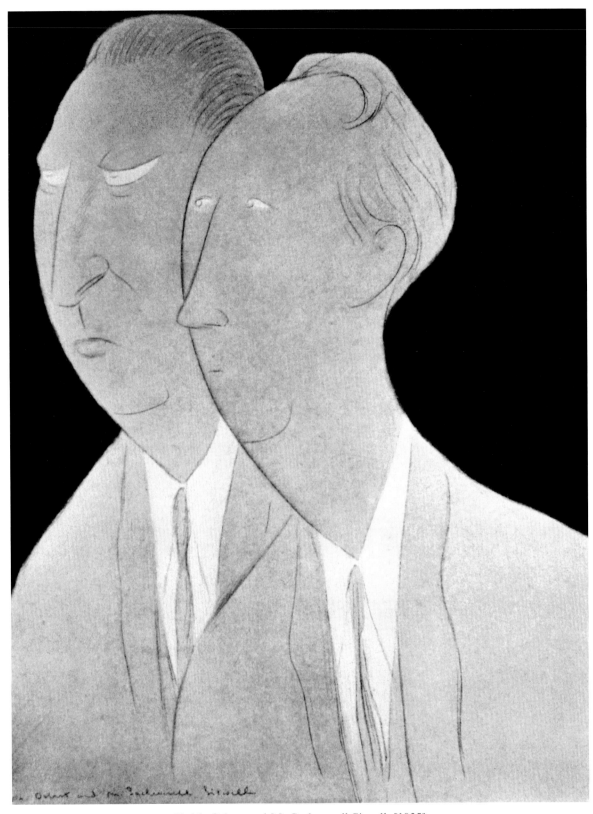

51. Mr Osbert and Mr Sacheverell Sitwell. [1925]

OSBERT AND SACHEVERELL SITWELL

The Sitwell brothers, Osbert (1892–1969), Sacheverell (1897–1988), and their sister Edith, were prolific poets and writers. They came of a wealthy, cultured background, and for a time achieved considerable celebrity. They have been called "a kind of second-class Bloomsbury"; Cambridge critic F.R. Leavis said the Sitwells belonged to "the history of publicity rather than poetry". Max, though giving the brothers highly contrasting features, manages to make them look remarkably alike.

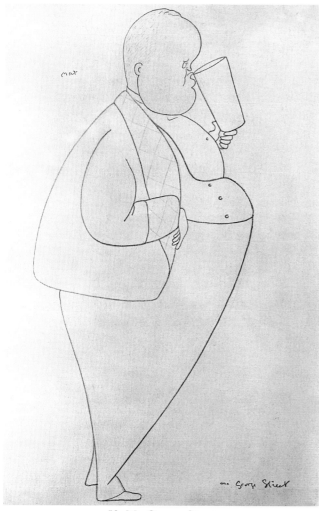

52. Mr George Street

G. S. STREET

Journalist and author George Street (1867–1936) wrote essays, nostalgic books about the 18th century, and one work still read today, *The Autobiography of a Boy*. Street and Max were very old and very close friends. David Cecil calls Street "a variation on a Max theme" in that he was a dandy and a wit, and known for his almost perverse fastidiousness. "I dined the other night with George Street," Max told a friend, "who was very much upset because Chesterton, in some article, had referred to him as 'that brilliant and delightful writer, Mr G. S. Street.'" For many years Max struggled without success to get people to read Street's books. When Street died, Max wrote an appreciation in *The Times* in which he said that Street "was of all the men that I have known the most exquisitely civilized. I never heard him say...one foolish thing, or a dull thing, or an ill-natured thing, or a thing that had not somewhat of the flavour of the very best old dry sherry."

THOMAS HARDY

Novelist Thomas Hardy (1840–1928) wrote works that have become classics, but after the row about the "indecencies" of *Jude the Obscure* (1895), he concentrated exclusively on the ambition of his youth, poetry. Among Hardy's later works was an enormous poetic drama, *The Dynasts* (1903–8), which Max parodied in *A Christmas Garland*.

Max knew and admired Hardy and had great regard for his work, though he occasionally lamented that Hardy, in his desire "to get nearer to actual life, deeper into it", should have concentrated so much on "the Bad, the Ugly, and the False". But of the stage adaptation of *Tess of the d'Urbervilles (1900)*, for example, Max wrote of how dismaying it was to see a book one loved debased:

> "Tess," more than most books, should have been saved from the stage. Some novels, as being merely melodramatic, deserve no better fate than being foisted upon the stage. Others, as containing no melodrama at all, and being, therefore, unlikely to attract the public, are allowed to rest within their covers; but, if they were dramatised, at any rate they would not be degraded so unspeakably as is "Tess." For "Tess," as a book, is full of melodrama. The melodrama in it is made beautiful by the charm of Mr Hardy's temperament. One sees it softened and ennobled through a haze of poetry.

After Hardy's death in 1928, Max wrote to his widow, telling her of his own dear and early memories of her husband from the Savile Club and Gosse's house, memories of his "youthfulness and peculiar modesty and unlikeness to anybody but himself – memories of his very beautiful manners, manners that one admired all the more because something in his eyes betrayed that his thoughts were perhaps a-roving to other and higher matters of his own". But his later memories, Max continued, were dearest: "It was wonderful to see, in [Hardy's] old age, youthfulness merely sublimified, and his idiosyncrasies undimmed and more lovable than ever."

In 1919 Max told Gosse how Mrs Hardy had written to him asking where she could purchase one of his drawings of Hardy "– of whom, says she, my portraits show greater insight than any other portraits of him. This is a great compliment." Max dispatched a caricature to her. The drawing she had especially prized, which was first exhibited at the Leicester Galleries in 1913, is reproduced here (plate 53, overleaf). The drawing Max sent her, inscribed "For Mrs Thomas Hardy – a recollection, not a replica of the drawing she liked", is in the Dorset County Museum.

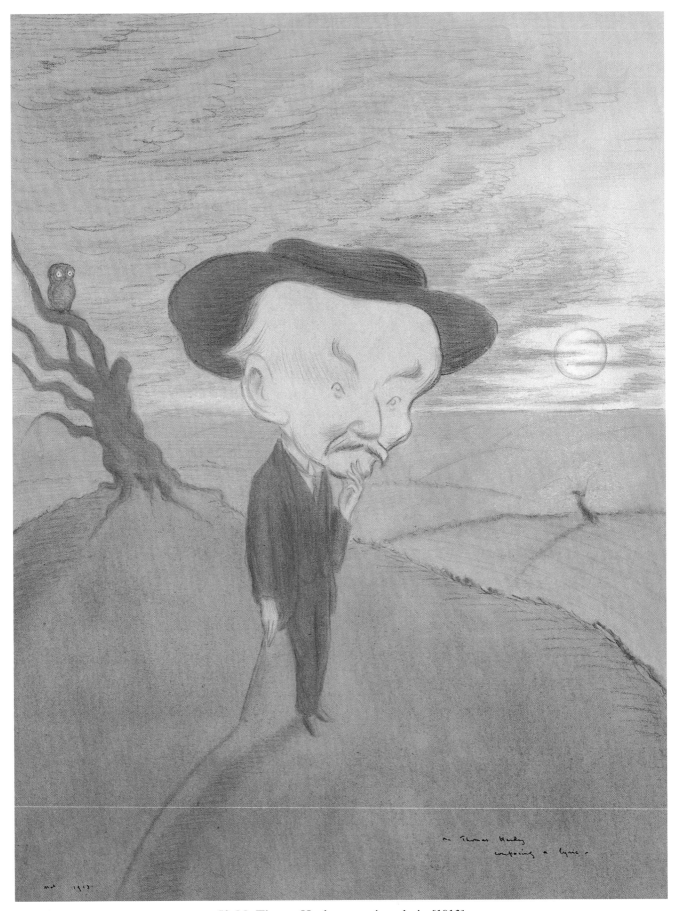

53. Mr Thomas Hardy composing a lyric. [1913]

LYTTON STRACHEY

Celebrated author of *Eminent Victorians* and *Queen Victoria*, Lytton Strachey (1880–1932), was the favourite writer of Max's later years. Strachey was one of the key figures of Bloomsbury, brilliant, witty, eccentric; and openly homosexual at a time when most men kept quiet on the subject. Appearing before a Military Service Tribunal in 1916, pleading conscientious objection to the war, he was asked, "What would you do if you saw a German soldier attempting to rape your sister?" and replied, famously, "I should try and come between them."

When *Eminent Victorians* was published in 1918, Max wrote Strachey thanking him "for the immense pleasure" the book had given him:

> I think it was Goldsmith who said of Burke that he loved "to watch him winding himself into his subject like a serpent." That is the sort of pleasure I too have in studying your method...Each of your essays is *globular* in effect – no angles, no points out-sticking; a lovely rotund unity, shining and unyielding.

Max hoped Strachey would want to say more about Victorian subjects: "There are so many great and little Victorians whom I positively hear clamouring from beneath their marble slabs that you should write about them – a nobly disinterested wish that does them credit, I think."

Learning that Strachey was working on Queen Victoria elated Max. When the book appeared in April 1921, he read it with "wonder and delight". Writing to Reggie Turner, he asked, "Have you read Lytton Strachey's *Queen Victoria*? That I *am* a stoic is proved by my having no jealousy of him at all, though his mind and his prose are so like mine and so exactly like what I should have loved mine to be. For sheer divine beauty of prose, and for clairvoyance of mind in dealing with past personages, and for wit, and for much else, nobody comes within a hundred miles of him."

Max was annoyed by those who called Strachey a debunker. In his 1943 Cambridge Rede lecture on Strachey he said:

> Aren't there in the Elysian Fields two other worthies who have reason to be grateful to the supposed iconoclast? – Queen Victoria and the Prince Consort? The Prince in his life-time had never been popular; and after Sir Theodore Martin's saccharine biography, he had become a veritable mock. I never heard a

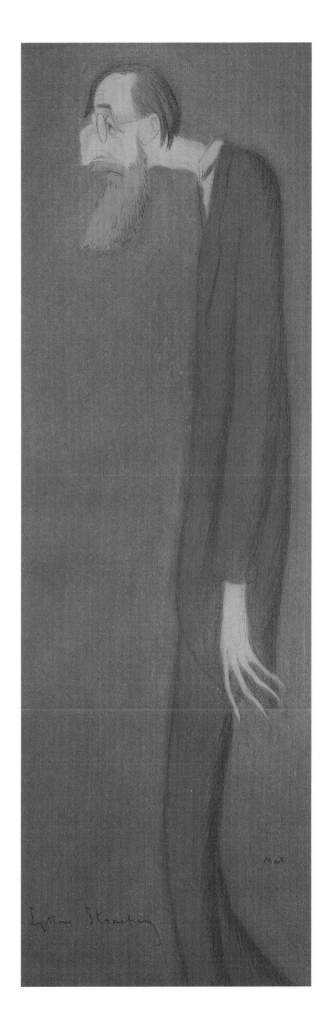

54. Lytton Strachey. [c. 1925]

kind word for him. The Queen, who in my childhood and youth had not only been revered but worshipped, was, soon after her death, no longer in public favour. Her faults had become known, and her virtues were unheeded. This is not so now; and is not so by reason of Lytton Strachey's fully judicial presentment of her with all the faults over which her virtues so very much preponderated. And it is, by the same token, through him that we know the Prince not as just dreadfully admirable, but as someone to be loved and to be sorry for.

Strachey, Max contended, was a writer who, while not a "genius", used his gifts carefully and became "a perfect master of English prose".

In early 1931 Max threatened to resign from the Athenaeum Club if Strachey were not elected. In the event Strachey came in at the top of the poll. Later that same year, Strachey dedicated *Portraits in Miniature* to Max. Strachey's biographer, Michael Holroyd, writes:

> Though they were never close friends, Max looked on Lytton almost as a younger brother. In an age, it seemed to him, that was vulgarizing art, Lytton's good taste remained intact. Max felt that he was to Lytton what Oscar Wilde had been to him... He saw Lytton as a modified edition of himself, someone who had made small advances in the fastidious and refined craft of letters.

Max wrote of how, after living in Italy for two years he returned briefly to London in the spring of 1912 and saw some new faces at the Savile Club:

> There was one that interested me very much; an emaciated face of ivory whiteness, above a long square-cut auburn beard, and below a head of very long sleek dark brown hair. The nose was nothing if not aquiline and Nature had chiselled it with great delicacy. The eyes, behind a pair of gold-rimmed spectacles, eyes of an enquirer and a cogitator, were large and brown and luminous. The man to whom they belonged must, I judged, though he sat stooping low down over his table, be extremely tall. He wore a jacket of brown velveteen, a soft shirt, and a dark red tie. I greatly wondered who he was. He looked rather like one of the Twelve Apostles, and I decided he resembled especially the doubting one, Thomas, who was also called Didymus.

Strachey's unusual appearance, and his "piping" voice, prompted descriptions from his contemporaries, many of them seeming to fit nicely with Max's caricatures.

To a fellow undergraduate at Cambridge, Strachey seemed "a man from a different planet, human, but not of our humanity, who belonged in his speech, gestures, poses and opinions to no recognised category of adolescence or maturity... His ways of standing, of sitting in a chair, or helping himself to bread and butter – briefly everything about him differentiated him from the crowd."

Lady Ottoline Morrell wrote that his small faint voice "appeared to come from very far away, for his delicate body was raised on legs so immensely long that they seemed endless, and his fingers equally long, like antennae".

Osbert Sitwell (plate 51) described seeing his friend Strachey dancing, "...jigging about with an amiable debility...I remember comparing him in my mind to a benevolent but rather irritable pelican."

Cecil Beaton noticed Strachey "peer[ing] at everyone through thick glasses, looking like an owl in daylight. He is immensely tall, and could be even twice his height if he were not bent as a sloppy asparagus. His huge hands fall to his sides, completely limp. His sugar-loaf beard is thick and dark, worn long in the fashion of an arty undergraduate."

Invited by André Gide to attend a conference on moral and literary problems, held at a Cistercian Abbey in France, Strachey "immediately startled" the other attendees "by his resemblance to the Henry Lamb portrait which they had regarded as a caricature".

Having learned that Strachey was writing his book on Queen Victoria, Max explained, "I immediately drew ...a caricature of him in his royal connexion" (plate 55, opposite). And arriving in London in the spring of 1921 to arrange an exhibition, he asked Strachey to visit him so that he might "professionally stare at him" to verify the image he had drawn from memory. It is not surprising that Strachey agreed. In 1907 he had found Max's Carfax caricatures "charming...many of them really beautiful, and some like Blake – all (to my mind) the height of amusement". And in 1917 he was "carried away" by the Grosvenor Gallery exhibition of fifteen *Rossetti and His Circle* caricatures: "[Max] has the most remarkable and seductive genius – and I should say about the smallest in the world". Strachey came to Max at his hotel, where, as he wrote his brother, Max "begged me to turn my profile towards him, and for a minute or two made some notes on the back of an envelope". Back in Italy, Max wrote to Lady Strachey, Lytton's mother, saying how pleased he was to learn that she was not vexed with this caricature of her son: "One does what one can. I have the dubious blessing of having been born a caricaturist; and it is always the men whom I respect most that I caricature with the greatest gusto. This is not a very satisfactory form of homage. But, such as it is, there it is."

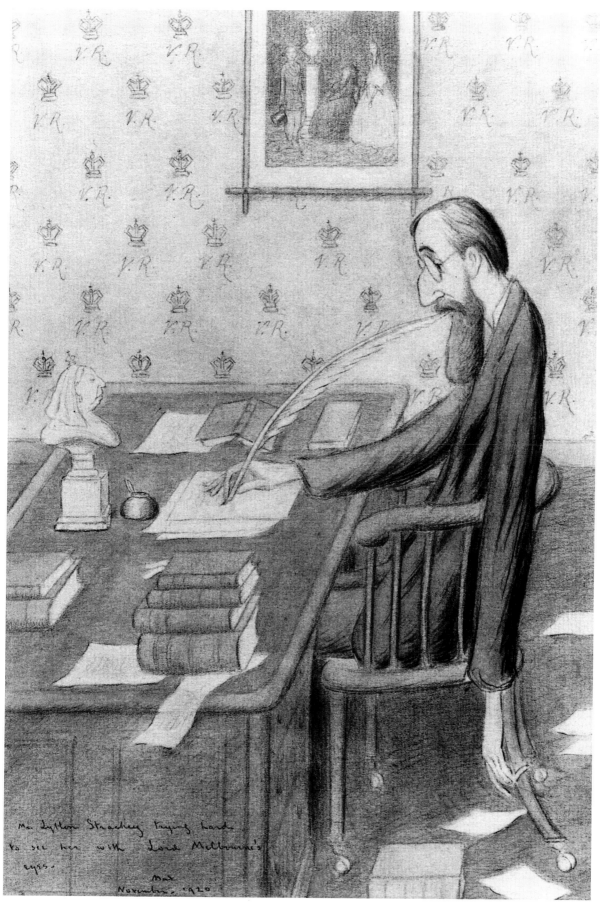

55. Mr Lytton Strachey trying hard to see her with Lord Melbourne's eyes. November 1920
[*Lord Melbourne was the young Queen Victoria's friend and advisor*]

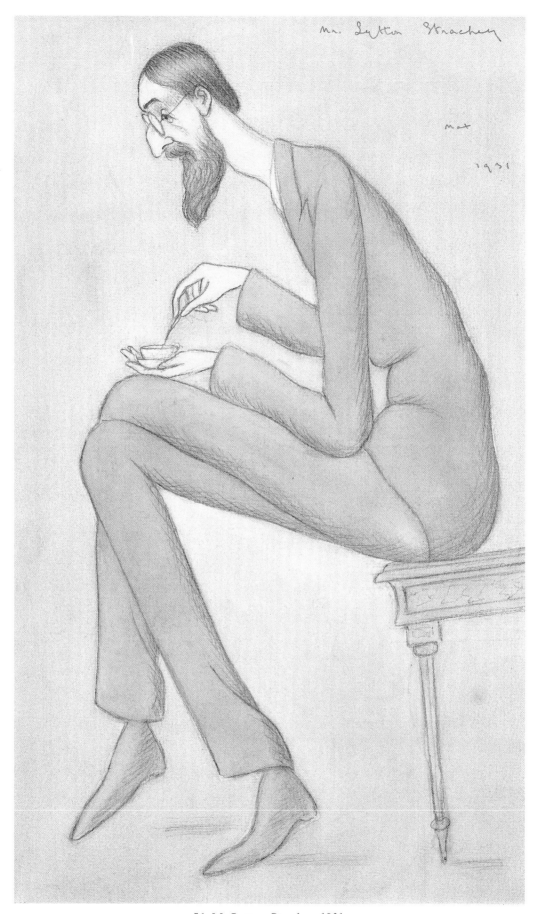

Mr Lytton Strachey

Max

1931

56. Mr Lytton Strachey. 1931

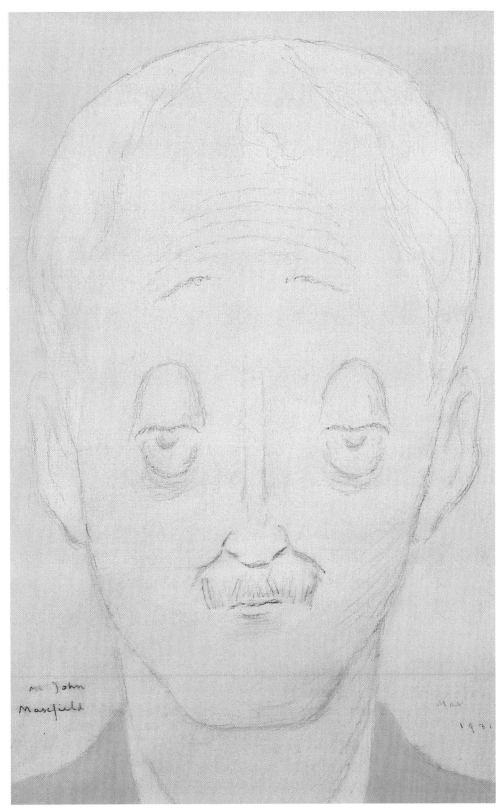

57. Mr John Masefield. 1931

JOHN MASEFIELD

Fiction-writer, playwright, and Poet Laureate John Masefield (1878–1967) was among eight people of whom Max produced caricatures for the *Spectator* in 1931. These late drawings were made shortly after Max said he was giving up cartooning because with age he had become too "kind". As such, all eight drawings are more realistic "portraits" than his usual caricatures. This one (plate 57) is distinctive for embodying only its subject's head. For another *Spectator* drawing, see plate 49 ("Mr H. G. Wells foreseeing things").

ALDOUS HUXLEY

Novelist, essayist, and poet Aldous Huxley (1894–1963) came from a distinguished family: his grandfather was Thomas Henry Huxley, foremost advocate of Darwin's theory of evolution ("Darwin's Bulldog"); his father, Leonard Huxley, was the editor of the letters of Elizabeth Barrett Browning and of Jane Welsh Carlyle and also editor of the *Cornhill Magazine*. Julian Huxley, Aldous's brother, was a prominent biologist and writer. Aldous himself is best known today as the author of *Brave New World* (1932). By the time of Max's 1923 caricature, Huxley had published two novels, *Chrome Yellow* (1922) and *Antic Hay* (1923), plus three volumes of poems, two collections of short stories, and a book of notes and essays.

Huxley suffered from very poor eyesight, and Max supplies him with huge eyeglasses. An old pupil of Huxley's at Eton remembered "...that long, thin body with a face that was far younger than most of our masters' and yet seemed somehow ageless, and, usually hidden by an infinite variety of spectacles, eyes that were almost sightless and yet almost uncomfortably observant". For Max, Huxley's height was of course a "salient feature". Virginia Woolf, an admiring friend of Huxley ("He is detached as a Saint") designated him "that gigantic grasshopper". David Cecil remembered Huxley as "a very distinguished, very long, tall, pale piece of macaroni".

Lytton Strachey described Huxley as looking "like a piece of seaweed" but "incredibly cultured". Such was Huxley's reputation for learning and culture that when he visited Lytton Strachey and Carrington in 1931, Carrington threatened to "put opium in the pies to mitigate Aldous' brilliance". Lytton reported on that occasion, "Aldous is certainly a very nice person – but his conversation tends to be almost perpetually on high levels with a slightly exhausting effect."

Another and later caricature of Huxley (1932), not reproduced here, bears the caption, "No, pardon me, I am *not*. To be disillusioned, one must first have suffered from illusions."

58. Mr Aldous Huxley. 1923

E. M. FORSTER

Novelist Edward Morgan Forster (1879–1970) was one of the original members of the Bloomsbury group. Virginia Woolf said of his early visits to Gordon Square: "I felt as if a butterfly – by preference a pale blue butterfly – had settled on the sofa." Later on, in 1928, Forster still struck her as "timid, touchy, infinitely charming". Lytton Strachey once remarked Forster's "curious triangular face, and a mind, somehow, exactly fitting". Michael Holroyd's description of Forster seems to fit Max's caricature: ". . . the grave and modest sincerity of his manner, and his mild, implacable courtesy suggested at times that he was more intent upon self-communion than on conversation. . . Naturally withdrawn . . . he seemed to combine the bashful demureness of a spinster with the more abstract preoccupations of a don."

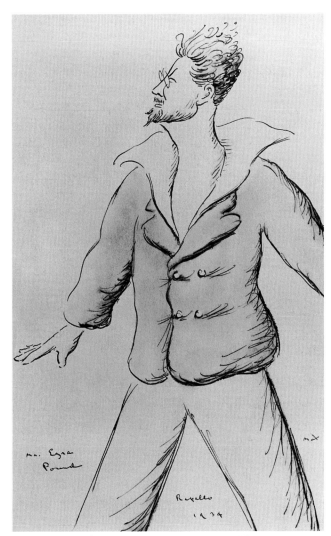

60. Mr Ezra Pound. Rapallo. 1934

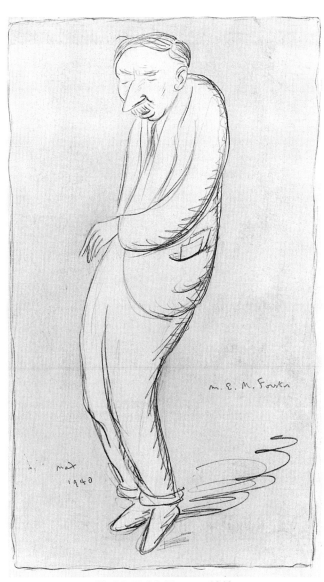

59. Mr E. M. Forster. 1940

EZRA POUND

American poet and critic Ezra Pound (1885–1972) lived most of his life in Europe. Max, on a visit to London in 1914 saw Pound and noted, "A good subject for caricature." The Hart-Davis *Catalogue* lists three caricatures of Pound, dated 1914, 1932, and 1934 (plate 60, above). Pound moved to Rapallo in 1924 and was a neighbour of sorts to Max, although they saw little of each other. Max, writing to a common acquaintance, novelist Phyllis Bottome, said, "He seems out of place here. I should prefer to watch him in the primaeval forests of his native land wielding an axe against some giant tree. Could you not persuade him to return to a country in which there is much more room?" In 1955 Samuel Behrman told Max of an early and anti-Semitic poem, "Brennbaum", which Pound had written about Max Beerbohm. Max was interested but not surprised: "I am not Jewish. I cannot claim that. But then, you know, he was crazy. He greatly admired Mussolini. All that Fascist business!"

SOME PERSONS OF THE NINETIES and ENOCH SOAMES

The caricature reproduced opposite (plate 62), a work done in 1925, recalls an illustrious group of Nineties personages. Most of them can be seen elsewhere in this book in individual caricatures: Richard Le Gallienne, Walter Sickert, George Moore, Henry Harland, Oscar Wilde, Will Rothenstein, William Butler Yeats, Aubrey Beardsley. Also included are John Davidson (1857–1909), Scottish poet and playwright (who died by suicide) and Charles Conder (1868–1909), artist. These two, like all the others, were friends of Max, who himself appears, saucer-eyed, detached, staring forward, not interacting with anyone. The most curious interaction is between Yeats and Enoch Soames, a Catholic Diabolist poet of the Nineties, the hero of the story bearing his name in Max's collection of short stories, *Seven Men*. Yeats was much interested in the occult and would have had plenty to say to Soames, who is just barely visible at the right of the drawing. Except for Zuleika Dobson (plate 189), Enoch Soames is Max's most famous fictional character. Max, as narrator of Soames' story, describes meeting him at the Café Royal:

> He was a stooping, shambling person, rather tall, very pale, with longish and brownish hair. He had a thin vague beard – or rather, he had a chin on which a large number of hairs weakly curled and clustered to cover its retreat. He was an odd-looking person; but in the 'nineties odd apparitions were more frequent, I think, than they are now. The young writers of that era – and I was sure this man was a writer – strove earnestly to be distinct in aspect. This man had striven unsuccessfully. He wore a soft black hat of clerical kind but of Bohemian intention, and a grey waterproof cape which, perhaps because it was waterproof, failed to be romantic. I decided that "dim" was the *mot juste* for him.

While all the others in the drawing became in varying degrees famous, and were of much interest to writers on the Nineties (such as Holbrook Jackson and Osbert Burdett, alluded to in the caption of the drawing), Soames failed to become famous or of interest. Max spends the first paragraph of the story telling how he looked eagerly but in vain in the index of Holbrook Jackson's *The Eighteen Nineties* for "SOAMES, ENOCH". And since Jackson's book brought to light even writers but faintly remembered in 1925, this omission "was an all the deadlier record of poor Soames' failure to impress himself on his decade". Max first met Soames in the company of Will Rothenstein, who is also sketched as in his "pre-professorial days" in "Seen at the Café Royal" (plate 61). Max inserted this drawing into the American

Edition of *Seven Men* and, tongue in cheek, described it as "a page torn from a sketch-book of which I filled several pages to adumbrate Enoch Soames soon after my meeting with that 'dim' personage in '93".

As many people are aware, Soames ends poorly, having made a pact with the Devil exchanging his soul for the opportunity to visit the British Museum as it would be exactly one hundred years later, 3 June 1997. Soames goes to the Reading Room, expecting to find "endless editions, commentaries, prolegomena, biographies" on himself and his work, but uncovers only the "three little pasted slips he had known so well" which list his own books. And in a modern work on late nineteenth-century literature, Soames finds a reference to himself (in phonetic spelling such as Shaw advocated) as "an immajnari karrakter" in a story by Max Beerbohm.

61. "Negations"
Seen at the Café Royal [Enoch Soames, Will Rothenstein]

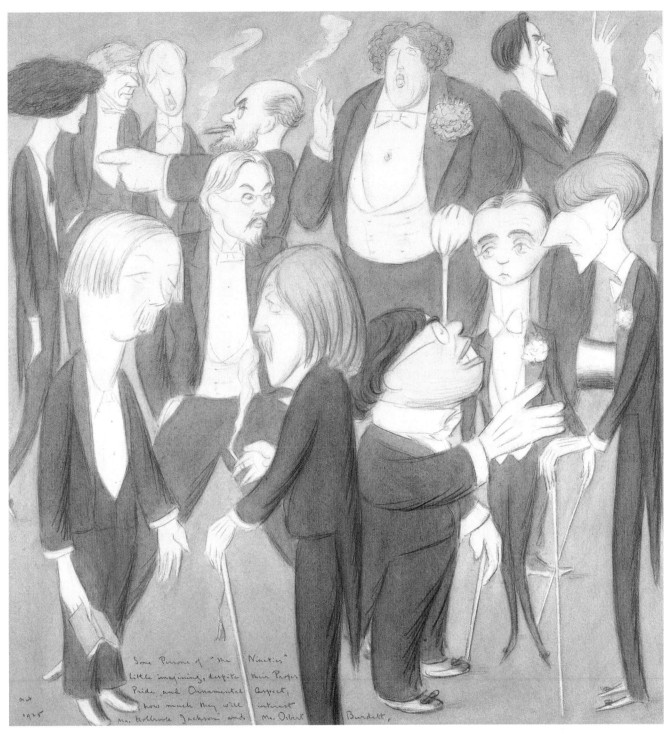

62. Some Persons of "the Nineties" Little imagining, despite their Proper Pride and Ornamental Aspect,
how much they will interest Mr Holbrook Jackson and Mr Osbert Burdett. 1925
[*Left to right: Richard Le Gallienne, Walter Sickert, Arthur Symons, George Moore, Henry Harland,
John Davidson, Charles Conder, Oscar Wilde, Will Rothenstein, Max Beerbohm, W. B. Yeats, Aubrey
Beardsley, and Enoch Soames. The books referred to are Holbrook Jackson's* The Eighteen Nineties
(1913, and dedicated to Max Beerbohm) and Osbert Burdett's The Beardsley Period *(1925).*]

II

THE THEATRE

When George Bernard Shaw gave up his post as drama critic for the *Saturday Review*, he said, famously, that into his place stepped "the incomparable Max". Max's first piece, entitled "Why I Ought Not To Have Become A Dramatic Critic", was, whatever its ironies, disarming. He said that although from his very cradle he had been at the fringe of the theatre world because of his brother, Herbert Beerbohm Tree, he had no great love for the theatre as such, and accordingly he was "appalled" at the thought of going to the theatre under the obligation "to keep my attention fixed, never taking my eyes from the stage except to make a note upon my cuff". Furthermore:

> Most of the elder actors have patted me on the head and given me sixpence when I was "only *so* high." Even if, with an air of incorruptibility, I now return them their sixpences, they will yet expect me to pat *them* on the head in the "Saturday Review".

He consoled himself with the thought that other callings, such as that of porter in the underground railway, were more uncomfortable and dispiriting: "Whenever I feel myself sinking under the stress of my labours, I shall say to myself, 'I am not a porter on the Underground Railway.' "

On the other hand, it was not long before he acquired "a vivid interest" in the theatre and became a smart, witty critic of contemporary drama. Not easily pleased, he wanted "beauty, reality and intelligence" on the stage, and, frequently enough, he seems not to have found them. His praise of what he thought worthwhile was lavish, but his negative criticisms were harsh. Even the classics, so beautiful to read, were often disappointingly staged; of Milton's *Samson Agonistes*, he wrote:

> For good downright boredom, mingled with acute irritation, commend me to the evening I spent last Tuesday in the theatre at Burlington House. The Milton Tercentenary has produced a fine crop of dullness and silliness, but nothing quite so silly and dull as this performance of "Samson Agonistes."

His suggestions that the theatre give Shakespeare a rest and declare an outright moratorium for a number of years on productions of *Hamlet* were not well received.

The world of the theatre is represented here by caricatures of dramatists, actors, managers, designers, critics. Max, with his literary bent, had more admiration for writers of plays than for actors: "the history of the drama . . . is the history of the dramatist's sure eclipse by the actor." But his sympathies broadened as his career as drama critic progressed. Of actor-managers, like his brother Herbert, and like others caricatured here – Henry Irving, Squire Bancroft, George Alexander, Charles Wyndham, and Charles Hawtrey – Max wrote in 1945:

> I would assure you that those idols of ours were even more ardently worshipped than are [cinema stars] . . . The days of the actor-manager are past. No doubt he was not a faultless institution. But he was an impressive and exciting one. There he was, in his own theatre, and giving to that theatre a definite individuality of its own. It was not merely a building, it was a kind of temple, with its own special brand of worshippers. First nights were thrilling, throbbing occasions. People had come not so much to see a mere play as to see their idol in it . . . Actor-managers were kings, in their fashion – in the English, the constitutional fashion.

Max came to believe that we should be tolerant of the actor's faults, especially his love of applause and impatience for immediate honours. Other artists can afford to wait for recognition. The actor must have his rewards immediately.

Max very seldom caricatured actual identifiable women: they were, he said, "uncaricaturable". This was partly due to his old-fashioned sense of propriety: women were not to be subject to the kind of rough treatment he handed out to men. He did a few caricatures of actresses, who, by virtue of being seen in their stage roles, seemed less their own personal selves: see caricatures of Mrs Patrick Campbell, Dorothea Baird, and Mona Limerick (plates 79, 80, 92, and 93).

Max's half-brother, his senior by nineteen years, Herbert Beerbohm Tree (1853–1917) took early to the amateur stage, where in 1876 he adopted the name Tree. He wanted, Max explained, "a shoutable monosyllable" for purposes of applause. Herbert was, of course, also merely translating the second part of "Beerbohm". After he made his professional London debut in 1878, his reputation rose steadily, abetted by his extraordinary versatility as an actor; and in 1887 he became manager of the Haymarket Theatre. In 1897 he moved into his own large, lavish theatre, Her Majesty's. Max told the story that this theatre had a narrow escape "from never existing at all": While in America with Herbert in 1895, Max, acting as his brother's agent, was sent by him to evaluate Paul Potter's stage version of du Maurier's *Trilby*. Max reported back that the play was "absolute nonsense" and could be only a dismal failure in London. Herbert put the matter out of his mind; but having the final night of their stay in New York free, he went to see the play. He immediately bought it, and from the proceeds of the spectacular success of his London production of *Trilby*, starring Dorothea Baird (plate 92) and himself, he built Her Majesty's Theatre. Fifty years later, Max told Samuel Behrman, "I was right about *Trilby*."

Tree, a man of enormous energy, "incessant zeal", and a "large, wholesome appetite for life and art" (Max's words), produced and took the leading roles in an impressive range of plays, from Shakespeare to popular figures like Stephen Phillips (plate 72) and important contemporary playwrights like Ibsen and Maeterlinck (plates 66 and 120). Tree was the original producer of Wilde's *A Woman of No Importance* in 1893, and Shaw's *Pygmalion* in 1914 (a great success, except, in Shaw's view, for "the raving absurdity of Tree's acting... He was like nothing human, and wallowed ecstatically in his own impossibility, convinced that he was having the success of his life"). Towards the end of Tree's career, his "illustrative realism" in "the high Roman fashion" was in eclipse, but he had been for three decades one of London's foremost men of the theatre.

When Max was a very young man, he was invited to Herbert's famous suppers where he met not only theatre people but notable painters, politicians, writers, and patrons of the arts. Of course, Max came to know countless people on his own – he was famous by age 24 – but there is no doubt that Herbert's circle enlarged his own. Still, Max related, "as the gap between our ages was...contracted, each of us found himself...more shy in the presence of the other. An old friend of Herbert's once said to him and me, in the course of a dinner in the 'Dome' of His Majesty's: 'You two, when you are together, always seem to be in an attitude of armed

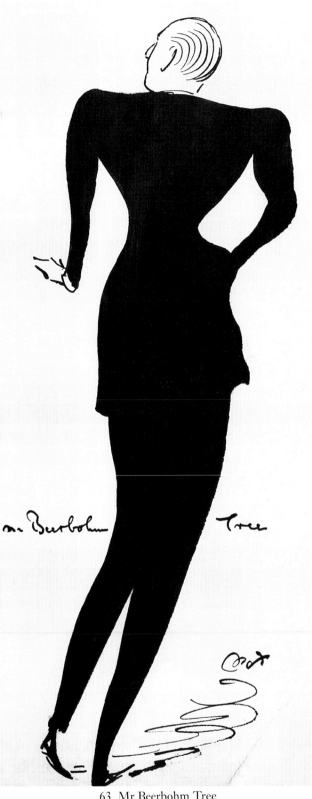

63. Mr Beerbohm Tree

neutrality.' I suggested to Herbert that 'terrified love' would be a truer description."

See also Max's caricature of Tree and himself, "Genus Beerbohmiense" (plate 211).

64. Mr A. W. Pinero

ARTHUR WING PINERO

Playwright Arthur Wing Pinero (1855–1934) rose to the head of his profession in 1893 with *The Second Mrs Tanqueray*. He wrote 54 plays in 55 years, everything from farces and comic operas to serious, Ibsen-inspired dramas. That Pinero was the reigning playwright during Max's days as a young man and as *Saturday Review* drama critic distressed Max greatly. He complained that when Pinero fell under the spell of Ibsen "and began to take life, and his art, and himself, in laudably grim earnest", he made a big mistake, "For he was not a born thinker: his mental processes were vague." It was one thing for a playwright to present a bore on stage and see how he devastates his fellows in a play, but quite another thing to "devastate" his audience: "I implore [Mr Pinero], once and for all, to clear his mind of the delusion that a dull thing expressed at great length becomes amusing." Pinero's "literary style" also annoyed Max:

> In an unlucky moment, years ago, some rash creature hazarded the opinion that Mr Pinero wrote well... The consequence is that Mr Pinero, elated, has been going from bad to worse, using longer and longer words and more and more stilted constructions under the impression that he was becoming more and more literary.

For Max, Pinero's "literary style" amounted to nothing but "the lowest and most piteous form of journalese"; Pinero ought to hire someone "to translate his next MS into passable English".

Pinero's appearance was extraordinary. Except for his huge eyebrows, he was almost hairless. Lytton Strachey spoke of him as "that astounding creature Pinero ...Large red face, immense black eyebrows, rolling eyes, vast nose, theatrical manner, bandanna handkerchiefs ..." Max said that Pinero's eyebrows were like "the skins of some small mammal...just not large enough to be used as mats". Those eyebrows, the magnificent nose, and the bald head attracted Max to make at least 30 caricatures of Pinero. In 1920 he wrote of an early drawing (in *Caricatures of Twenty-Five Gentlemen*) that he had gone badly astray in giving Pinero a "dome-like brow" because "Pinero has *no* top to his head" – as in these two later caricatures. The repetitiousness of Pinero's plays is echoed in the infinity of mirror images in plate 65. Pinero can also be seen in plates 46, 125, and 213.

65. Mr Arthur Wing Pinero. [1903]

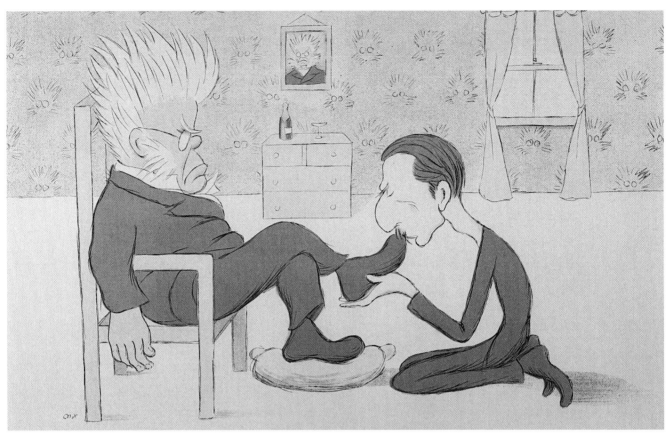

66. Henrik Ibsen, receiving Mr William Archer in audience. [1904]

HENRIK IBSEN and WILLIAM ARCHER

Max, like most knowledgeable people, viewed Ibsen as the dominant force in the theatre from about 1850 to 1890. But for purposes of caricaturing, Max was interested in him chiefly as a man; and, Max insisted, we cannot love Ibsen because his personality "has no magic for us". Ibsen is too aloof from ordinary life; a great artist, yes, but too narrow to be one of the greatest: "Ibsen fails of supreme greatness, because he cannot keep his temper...Sympathy – that is what Ibsen lacks. Out of his exceeding strength, no sweetness has ever come. The baseness of man has always been his theme."

When Ibsen died, Max wrote:

There is something impressive, something magnificent and noble, in the spectacle of his absorption in himself – the impregnability of that rock on which his art was founded. But, as we know, other men, not less great than Ibsen, have managed to be human ...Innate in us is the desire to love those whom we venerate. To this desire, Ibsen, the very venerable, does not pander.

Scotsman William Archer (1856–1924) was perhaps the most influential British drama critic of his day. Much of the improvement in English drama from the nineties onward, away from French farce and from melodrama, has been credited to Archer's criticism, but he is perhaps best remembered as an apostle of Ibsen. His translation of *The Pillar of Society* in 1880 was the first Ibsen play to be produced in London, and Archer was largely responsible for the English-speaking world's appreciation of Ibsen.

Max and Archer were very good friends, although their approaches to drama criticism differed greatly. Max told Archer that, while admiring his "genius for criticism" with its serious, detached approach, his own taste was for the "stimulating prejudices" of critics like George Moore and William Henley – "however disgraceful such a position may be". Archer in his less cool "Ibsen crusade" was more to Max's liking. At the same time, he found Archer a "damaging translator" of Ibsen because of his literal approach: on stage "Ibsen's characters in English talk like books, or at any rate, like newspapers of the better sort."

In the above caricature (plate 66), Ibsen's self-absorption is omnipresent; in the same caricature and in the one opposite, Archer's reverence for his deity is unmistakable. Plate 67 is a rare example of an inconsistent facial feature in Max's work. Archer's nose becomes grandly rounded again in other caricatures of him; see, for example, plate 77.

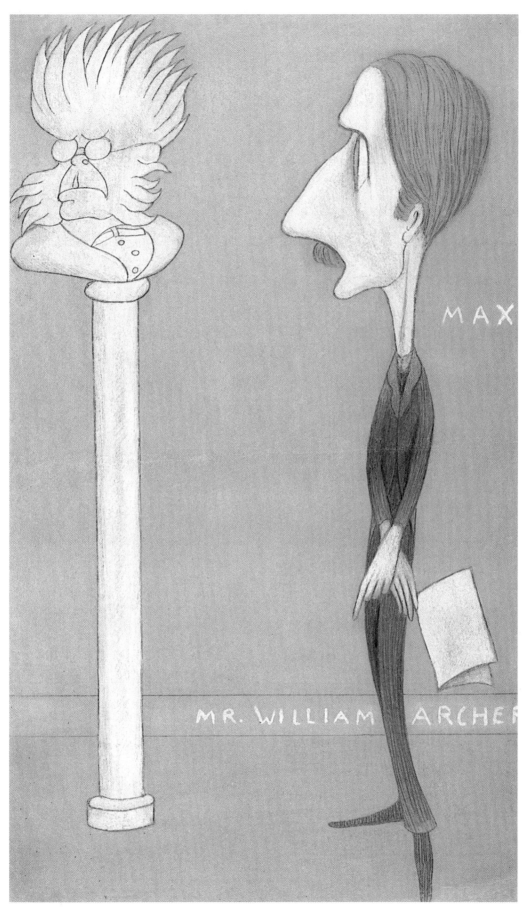

67. Mr William Archer. [1896]

CLYDE FITCH

Max met the popular American playwright, Clyde Fitch (1865–1909), in New York in 1895. "He loves my writing", Max wrote a friend, "which is a bond. I have never seen or read anything of his, which is awkward." The two became fast friends, meeting often on Fitch's annual visits to London.

In a review of Fitch's play *The Truth* (1907), Max said: "Mr Fitch can write witty lines which are amusing to read; but, for the most part, his comedy is of the kind that needs utterance on the stage...He is essentially a man of the theatre. In all of his [plays] have been evident a vitality and gay resourcefulness that set him high above the ruck of ordinary playwrights."

Max caricatured this "brilliant American playwright", as he called him, at least ten times.

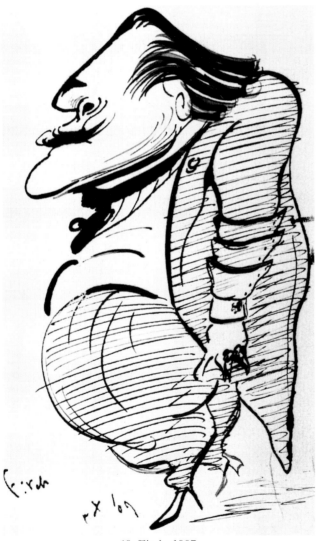

68. Fitch. 1907

EDMOND ROSTAND

The French playwright and poet Edmond Rostand (1868–1910) is best known as the author of *Cyrano de Bergerac* (1898). Max's first proper theatre review – after the initial article arguing that he ought not to be a drama critic at all – was of *Cyrano* (9 July 1898). The play was presented at the Lyceum Theatre, in French, with the famed Coquelin as Cyrano. Paris had declared the work a classic, and Max felt inclined to agree with the French verdict:

> Even if I could, I would not whisk from the brow of M. Rostand, the talented boy-playwright, the laurels which Paris has so reverently imposed on it. For even if "Cyrano" be not a classic, it is at least a wonderfully ingenious counterfeit of one, likely to deceive experts far more knowing than I am.

Max lauded Rostand as a "gifted, adroit artist, who does with freshness and great force things that have been done before; and he is, at least, a monstrous fine fellow." The character of Cyrano will survive "because he is practically a new type in drama". Beauty loved by grotesque is an old theme, Max said, but not grotesque as stage-hero. As for Coquelin in the part of Cyrano (Max knew the actor from Dieppe holidays), "Even if one does not like the play, it will be something, hereafter, to be able to bore one's grandchildren by telling them about Coquelin as Cyrano."

Max felt that *Cyrano* could not be adequately presented in English: it was too "charged with its author's nationality", and "to translate it were a terrible imposition to set anyone...To adapt it were harder than all the seven labours of Hercules rolled into one." When the play was produced in English, in 1900, Max was predictably unhappy with it:

> Cyrano, in the original version, is the showiest part of modern times – of all times, maybe...The English critic, not less than the English actor, is dazzled by him. But, though he shut his eyes, his brain still works, and he knows well that an English version of Cyrano would be absurd. Cyrano, as a man, belongs to a particular province of France and none but a Frenchman can really appreciate him.

In London, the part fell to Charles Wyndham (plate 83). Max, as one who "revelled" in Wyndham's acting, could do nothing but "look devoutly forward to his next production".

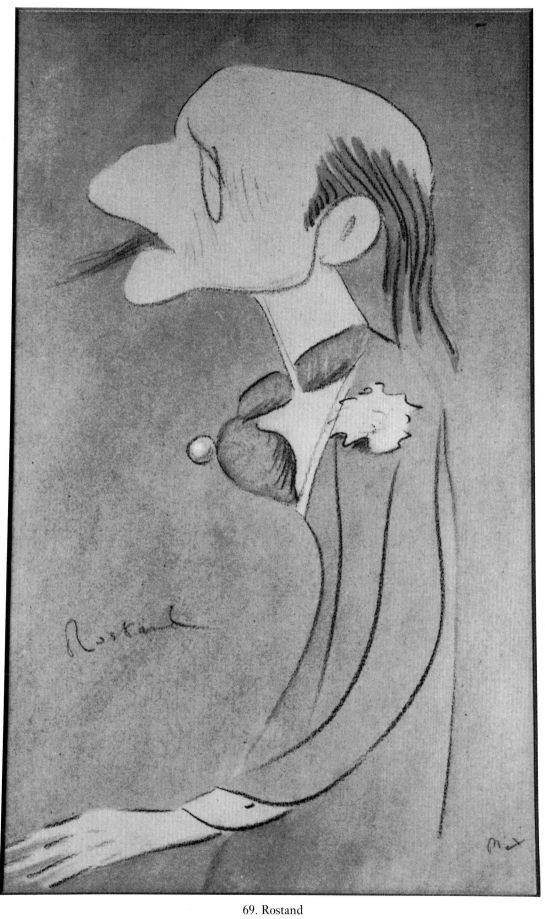

69. Rostand

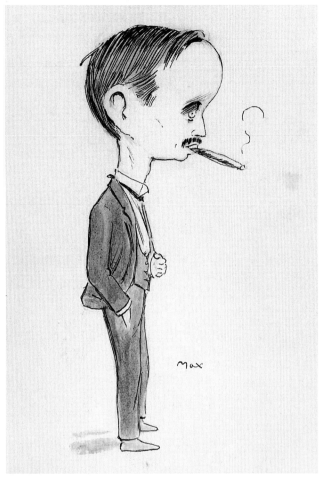

70. [J. M. Barrie]

Of Scottish descent, James Matthew Barrie (1860–1937) moved from journalism to novels, of which his most successful was *The Little Minister* (1891). He then took to writing for the stage; a dramatized version of *The Little Minister* (1897) was a great hit in both Britain and America. So were *Quality Street* (1901), *The Admirable Crichton* (1902), and that perennial favourite since its first appearance in 1904, *Peter Pan*.

Max found Barrie advancing along lines he hoped for in *The Admirable Crichton*, which he called "quite the best thing that has happened, in my time, to the British stage…Mr Barrie has always been able to amuse us. But this is the first occasion on which he has succeeded in making us think. And so he will excuse me for having insisted on the meaning of a play whose chief charm, from first to last, is the uproarious fun of it."

Max, himself a fantasist, was also greatly taken with *Peter Pan*:

To remain, like Mr Kipling, a boy, is not at all uncommon. But I know not any one who remains, like Mr Barrie, a child. It is this unparalleled achievement that informs so much of Mr Barrie's later work, making it unique.

With *Peter Pan*, Max felt that Barrie was seen in his "quiddity undiluted – the child in a state of nature, unabashed".

But at times Barrie's magic lost some of its hold precisely because of its child-centredness. *Alice Sit by the Fire* (1905) opens with a girl just becoming grown up, "putting up her hair" for the first time. Max observes:

Mr Barrie, pained by this hideous crisis, promptly causes a perambulator to be wheeled past by a nurse, …in token that the heavens have not altogether fallen in on him and us…But *toujours bébé*! I conjure Mr Barrie, whose chiefest strength is his unexpectedness, to put aside the one thing that we can always confidently expect of him. Let him, if need be, plunge into one thorough, unmitigated, for-ever-satisfying debauch of babydom. Let him write one play whose whole action passes in a crèche. Let it be whatever kind of play occurs to him – a tragedy, hinging on nettle rash, thrush, teething; or a comedy, hinging on bassinettes, rattles, indiarubber rings; or even a musical comedy, with an orchestra of babies playing no instrument but the coral-and-bells, and with choruses of nothing but crowing and screaming…The success would be such as Mr Barrie can always now command. And the gain to Mr Barrie's future art would be even greater.

But whatever admiration he had for Barrie's work, Max, who felt that the Order of Merit should be given sparingly, was displeased with Barrie's having been so honoured in 1922: "Uncle Max", Alexandra Kahn wrote from Rapallo, "was perfectly furious when he heard it. He thinks it only right to go to men over seventy, and that Barrie has had enough honours. Aunt Florence of course thinks Uncle Max should have had it – and an earldom – and the Nobel prize, and – and – and etc. without end."

Max drew Barrie, a lifelong smoker (he named a book of his collected essays *My Lady Nicotine*), as a youth smoking a cigar; in his maturity he sports a huge pipe. The immediate occasion for Max's 1912 caricature (plate 71, opposite) may have been Barrie's donating a statue of Peter Pan to Kensington Gardens.

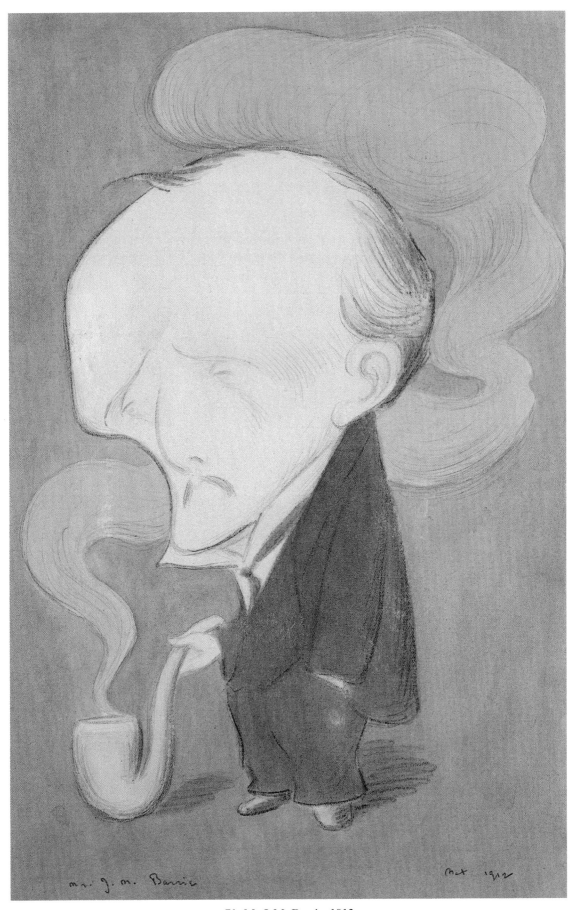

mr. J. M. Barrie

max 1912

71. Mr J. M. Barrie. 1912

72. Mr Stephen Phillips. [c. 1900]

STEPHEN PHILLIPS

A fairly successful poet, Stephen Phillips (1868–1915) dreamed of reviving poetic drama. After Beerbohm Tree gave Phillips's *Herod* a sumptuous production in 1900, the public was eager for his *Paolo and Francesca*. When it appeared in 1902, Phillips was "greeted as the successor of Sophocles and Shakespeare". Max was unimpressed. He felt the British public's attitude towards poetic drama was "We needs must try to love the highest when we see it [Tennyson, *Guinevere*]. Nor must we miss any opportunity of seeing it. It is for our good. Duty calls. Let us not hold back. Courage! Forward! On!" During the height of Phillips's success, Richard Le Gallienne went suddenly to America, prompting Max's quip, "He is waiting for Stephen Phillips to blow over." Phillips did just that, and his decline was swift and conclusive.

73. Mr Sydney Grundy

SYDNEY GRUNDY

Max keenly disliked most of the work of barrister-turned-playwright Sydney Grundy (1848–1914). For one thing, he disapproved of Grundy's practice of continually adapting French plays:

> Now and again [Grundy] has written an original play. But, despite success, he has always forthwith relapsed into adaptation of work done by byegone Frenchmen, evidently deeming such adaptation the safest and wisest course that poor little humble English dramatists can pursue.

Max's caricature may have been inspired by the sight of Grundy coming out on stage after the first performance of *The Degenerates* and, in the words of Max's review, "bowing grimly...look[ing] every inch the relentless accuser we had been led to expect by the title of his ...particularly trite and silly play".

74. [Alfred Sutro]

ALFRED SUTRO

After spending some fifteen years as a wholesale merchant in the City, Alfred Sutro (1863–1933), gave up business to settle for a time in Paris. There, Sutro became good friends with the Belgian writer Maurice Maeterlinck (plate 120) and set up as his English translator. Sutro began also to write plays; and after ten years of trying, his first real success came with *The Walls of Jericho* (1904), followed by a long string of hits that established him as one of England's leading dramatists.

Max was great friends with Sutro. He thought highly of his plays, and also admired him for bringing Maeterlinck, one of his favourite contemporary writers, to English-speaking people. This untitled two-part caricature of Sutro (plate 74), offering front and side views of the same figure, is an arrangement rare among Max's caricatures.

75. Granville Barker. 1907

HARLEY GRANVILLE BARKER

Harley Granville Barker (1877–1946) became pre-eminent with his productions of Shaw at the Royal Court Theatre, in association with John Vedrenne, during the famous Vedrenne-Barker "season", 1904–07. Barker's later productions of Shakespeare were revolutionary, incorporating full, quickly-spoken texts and continuity of action.

In 1918 he married his second wife, the American millionairess Helen Huntington, who considered the theatre vulgar. At her insistence, Barker withdrew from the theatre proper; he had also to break with his old friends, including Shaw, who had considered him almost as a son. Thereafter, Barker devoted himself chiefly to writing notable works of theatre criticism.

Max, a good friend, has here drawn Barker in his library (plate 75), emphasizing his subject's scholarly endeavours, the large forehead bespeaking intellectuality.

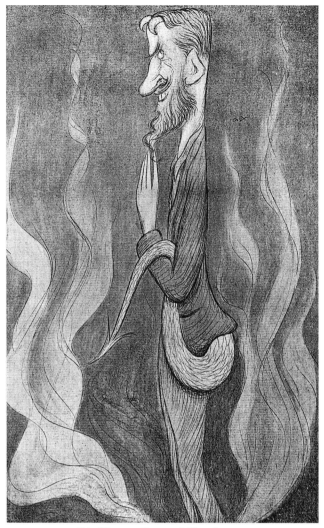

76. [George Bernard Shaw]

men are all disputative machines, ingeniously constructed, and the women, who almost without exception belong to the strange cult of the fountain-pen, are, if anything, rather more self-conscious than the men."

As drama critic for the *Saturday Review*, Max plumped for Shaw, and complained bitterly against West End managers who would not produce his plays. He also attacked Shaw's imitators:

Poor Mr Shaw! Also, poor us! For I think that imitations of Mr Shaw will be more than usually exasperating. He himself sets out not to please, but to exasperate. It is only the pleasure we get from the perfect working of that exquisite machine, his brain, and from the natural ebullience of the crystalline spring, his humour, that prevents us from being exasperated. He would like us to stone him. Instead, we make a pet of him. Were he anyone else, he would have his desire.

But at the same time, Max's reservations about Shaw lingered. And later, a dozen years after retiring from the *Saturday*, when he put together selections from his criticism into two volumes called *Around Theatres*, he wrote in his Epistle Dedicatory of his own "lamentable" vicissitudes in the matter of G. B. S. – "the most salient phenomenon 'around theatres' in my day... Did I love his genius or hate it?"

Of Shaw as a person, Max wrote a friend in 1926: "I entirely understand your feelings about his vagaries. It is very queer that a man should be so gifted as he is (in his own particular line nobody has been so gifted, I think, since Voltaire) and so liable to make a fool of himself. I never read anything of his without wishing that he had never been born *and* hoping that he will live to a very ripe old age! One of the reasons is that he... is entirely free from any kind of malice." A good summary of Max's feelings towards Shaw – the words echo those in letters going back nearly fifty years – comes in Max's account in 1952 to Samuel Behrman:

Well, he had a powerful brain... but he was a cold man. It's true I never had anything but kindness from him. Though I had written, in the *Saturday*, several sharply critical articles about him, it was Shaw who, in the absence of Frank Harris – Harris was on holiday, or whatever, in Athens – approved Runciman's slipping me in, rather, to the post of drama critic. Shaw was not vindictive. There was no element of vindictiveness in him... In his case, it may have emanated... from his absolute conviction... that there was no one living who was worthy of his animosity... He was a coarse man... In his plays, I really

Towards George Bernard Shaw (1856–1950) Max always had conflicting views. His ambivalence with respect to both the man and his work amounted to a love-hate relationship. Reading Shaw, he told a friend, gave him "pleasure mingled with pain... I love his brilliance and his cogency. But the hardness and the *too* great brilliance of the style affect me unpleasantly. I feel rather as tho' he were the squeaking of a slate-pencil on a slate!... G. B. S.... hasn't a spark of poetry in him and has a very faulty visual sense... The book [Shaw's on William Morris] is therefore a mitigated joy – but certainly a joy." Shaw's "philosophy", Max said, rested, "like Plato's Republic, on a profound ignorance of human nature"; Shaw seemed to know nothing of flesh and blood. On the other hand, his humour was irresistible: Shaw "may try, and try again, to be serious, but his nationality will always prevent him from succeeding in the attempt. When he writes seriously, he is always Paddy *malgré lui*." Moreover, in his serious plays "the

enjoy only his stage directions; the dialogue is vortical and, I find, fatiguing. It is like being harangued; it is like being a member of one of those crowds he used to exhort on street corners. He used the English language like a truncheon. It is an instrument of attack...No light and shade, no poetry. His best work, I think, appears in his books of drama and music criticism and his stage directions...[About 1896] Shaw made an immense journey by bicycle to see me, because he had heard that I had done some caricatures. He came to be caricatured. I had indeed done some caricatures, I was beginning to achieve a little reputation as a caricaturist, but I hadn't really, at that time, done anything very good...Still, Shaw would rather have had a presentment by anybody, no matter how incompetent, no matter how malicious, than no presentment at all.

Still, the two men were friends, and their correspondence shows a sprightly bantering: Max would write to Shaw saying how delighted he was to have lashed him into such "engaging sophistries": "Your limitations [like not appreciating Pater] and wrong-headednesses are as dear to me as your powers and right-headednesses." In May 1911 Shaw sent him a postcard pointing out that he had had "that snag tooth nipped off (there was only one, in spite of malicious exaggerations) and replaced by a symmetrical imposture. Your caricatures are now waste paper; and serve you right." (Though Shaw didn't mind being caricatured, his wife is said to have torn up one of Max's drawings.) When Shaw, having contributed to a book of essays on Max's brother Herbert, offered to return his author's fee, Max wrote back: "The money, my dear friend, is yours...This notion...is entirely monstrous – though beautiful, of course. Curb yourself. Or get someone to curb you. Spend a week or two in some nice little private lunatic asylum. Why not come here? My wife and I would watch over you with the greatest care and unfailing presence of mind."

Max said of Shaw's physical appearance that in the early days he was not very attractive: "dead white, and his face was pitted by some disease. The back of his neck was especially bleak – very long, untenanted, dead white. His hair was like seaweed. In those days you were lucky not to see G.B.S. from the back. But in later years, with that wonderful white beard, he became very handsome and impressive looking."

Shaw has 62 listings in the Hart-Davis *Catalogue*, second only to the number of self-caricatures, 97, and those of King Edward VII, 72. Shaw as the Devil (plate 76,

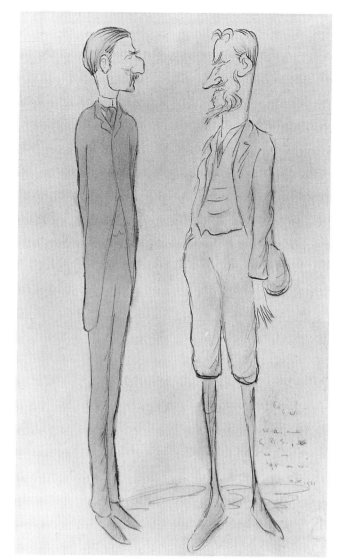

77. W. A. and G. B. S., as in '95 or so. For F. W. 1931

opposite) evokes the hell scene from *Man and Superman*. The late caricature (plate 77, above) of Shaw and "W. A." – critic William Archer, Shaw's friend and avid supporter – is much less severe and exaggerated than it would have been had Max drawn it in the mid-nineties, the time it evokes. However, as Hart-Davis points out, the contrast between Archer, very properly dressed, and Shaw, knickerbocker-suited in Jaeger (woollen material excluding all vegetable fibres as unwholesome), works nicely. For additional caricatures of Archer, see plates 66 and 67. Shaw was of course one of the writers who seem more like "preachers and politicians" than men of letters (plate 50); he was also a member of the "Biassed Deputation" pleading for mercy from Max (plate 213).

MRS PATRICK CAMPBELL and GEORGE BERNARD SHAW

Mrs Patrick "Stella" Campbell (1865–1940) was born Beatrice Tanner, of an English father and Italian mother. In 1884, at nineteen, she married Patrick Campbell, who died in 1900 fighting in the Boer War. After having made her London debut in 1890, she had an enormous success in 1893 in the lead role in *The Second Mrs Tanqueray*, written by A. W. Pinero (plates 64 and 65) and produced by George Alexander (plate 88). This "dark Italian beauty" went on to become one of the most renowned actresses of her time. In 1899 she took on, with more artistic than financial success, the added responsibilities of theatre management.

Max greatly admired Mrs Campbell as an actress, with her "poetry" and "sense of style". He also respected her independence as a manager:

> Mrs Campbell makes no effort to give the public what it wants. Her policy is simply to give the public what she herself likes. As she has no passion for sentimental comedy, or melodrama, or farce, or musical comedy, a thoughtless person might wonder how it is that such a policy has not spelt ruin... For her it has spelt the more difficult word, success. Not so much because she is a great actress, but because the gods have endowed her with the added grace of a personality – magnetism, call it what you will, – which the public is quite unable to resist.

Only she, he wrote, would have dared to offer Björnson's *Beyond Human Power*: "That in England the audience did not throw things at [the actors] is a great tribute to the goodness of the play as a whole – or, at least, to the glamorous power exercised by Mrs Campbell, even when she is not on stage."

Mrs Campbell produced a dramatization of Max's own *The Happy Hypocrite* at the Royalty Theatre in December 1900. Max fled to Brighton, as he told Reggie Turner, "to avoid the temptation of going before the curtain... If I had been in London... I should have been dragged on, pallid and deprecating, by Mrs P. C. This lady, by the way, really is a rather wonderful creature. As stage-manageress she has been absolutely intelligent and sweet and charming all through." The public gave the play five "curtains", but his good friend William Archer "turned Traitor" in "a terribly flat-footed, stodgy, stupid, thoughtful, able, idiotic two-columns-full" – whereupon Max sent him a caricature of Archer trying in vain to catch a butterfly in order to break it on a wheel.

The caricatures of Shaw and Mrs Campbell (plates 78–80) were part of a series of seven drawings, Max's response to Mrs Campbell's *My Life and Some Letters* (1922). In her book, she published, against Shaw's vehement protests, many of his love letters to her from 1912–1914. This "grand passion" began with his reading to her *Pygmalion*, a play written with her in mind for the part of Eliza. The passion was pretty much all his, and carried on via the post. His letters to her are filled with theatrical superlatives: he wants her as his Virgin Mother enthroned in heaven, his Italian peasant woman, his "rapscallionly fellow vagabond", dark Lady, angel, tempter: "I want the lighter of my seven lamps of beauty, honour, laughter, music, love, life, and immortality. I want my inspiration, my folly, my happiness, my divinity, my madness, my selfishness, my final sanity and sanctification, my transfiguration, my light across the sea, my palm across the desert, my garden of lovely flowers, my million nameless joys, my day's wage, my night's dream, my darling and my star." Lengthy letters close with phrases such as "I clasp you to my heart 'with such a strained purity'... Goodnight, goodnight, goodnight, goodnight, my dearest dearest." All the same, he admits, "It is only on paper and in imagination that I can do anything brave." She eventually tired of the "affair" and married "another George", the much younger George Cornwallis-West, just a few days before the opening of *Pygmalion*. However, the play was a huge success at Her Majesty's Theatre, Shaw's only complaint being with the "raving absurdity" of the acting by Max's brother, Herbert Beerbohm Tree.

The first drawing in Max's series "The Campbell Tartan and the Cockney Fling", asks whether the infatuation can really be called a "fling". The other two reproduced here (plates 79 and 80, overleaf) play with the ripeness of their ages: Shaw was 56, Mrs Campbell 47.

78. The Campbell Tartan and the Cockney Fling – (if fling it can be called). July 1922

July 1922

Mr Campbell and Mr Shaw as they respectively appeared to themselves.

79. Mrs Campbell and Mr Shaw as they respectively appeared to themselves. July 1922

Mrs. Campbell and Mr Shaw as they respectively appeared to each other.

80. Mrs Campbell and Mr Shaw as they respectively appeared to each other. July 1922

81. Magnetic, he has the power to infect almost everyone
with the delight he takes in himself. 1905

The second of Max's nine caricatures for *Vanity Fair*, this drawing appeared in 1905 and is signed "Ruth". Max explained that publisher Alfred Harmsworth (plate 174) "thought it would be commercially better that people should wonder who the cartoonist was who drew so like me." Two more of Max's *Vanity Fair* caricatures were signed "Ruth", and one was signed "Bilbo".

82. The Iconoclast's One Friend

A Member of Mrs Warren's Profession: "Mr Shaw, I have long wished to meet you and grasp you by the hand...God bless you!...I understand that the Army and Navy, the Church, the Stage, the Bar, the Faculty, the Fancy, the Literary Gents, the Nobility and Gentry, and all the Royal Family, will have nothing more to do with you. Never mind! *My* house will always be open to you." (*Exit, dashing away a tear.*)

[*Shaw's play* Mrs Warren's Profession, *written in 1894, dealt with prostitution and was banned until 1924.*]

83. Sir Charles Wyndham defying Time – 1907

CHARLES WYNDHAM

Trained in medicine, Charles Wyndham (1837–1919) took instead to the stage. During his long career, he made seven lengthy acting tours in America. During the Civil War, while playing winters in New York – once with John Wilkes Booth – he served as a surgeon for the Union army. His greatest success was in comic and farcical roles. An able theatre manager, he guided the Criterion Theatre from 1876 till 1899, when he opened a new theatre bearing his name. In 1904 he opened another theatre, the New Theatre. Wyndham was knighted in 1902, on the occasion of the coronation of Edward VII.

Max wrote of this seemingly ageless performer that he was for many years "the high-priest of farce", and had become a great comic actor. But Max urged him to stay away from romantic or tragic roles: "A great comedian is always making eyes at Melpomene [the Muse of Tragedy]."

When Max drew him in 1907, "defying time", Wyndham had already been on the stage nearly 50 years and was still going strong.

SQUIRE BANCROFT

Actor Squire Bancroft (1841–1926) made his London stage debut in 1865 at the Prince of Wales Theatre. Together with his wife, Marie Effie Wilton, he became joint manager of this theatre; in 1879 they moved to the Haymarket, which they rebuilt and managed until their retirement in 1885. Bancroft returned briefly to the stage twice, and also did public readings from Dickens in the 1890s. He was knighted during the Queen's Jubilee of 1897. During his 40 years of retirement he was still a very active figure in the West End, working for the improvement of the actor's lot, and serving as president of the Royal Academy of Dramatic Art. He was described as "tall, erect, and handsome to the last".

Max, who knew Bancroft, used his name as synonymous with excellence in the theatre. In reviewing a book about acting, Max said the author, Stanley M. Jones, exaggerated the attention paid to actors and to their art: "Does he really think – how one wishes he were right in thinking! – that Sir Squire Bancroft looms larger in the public gaze than Mr Rudyard Kipling?"

84. Sir Squire Bancroft

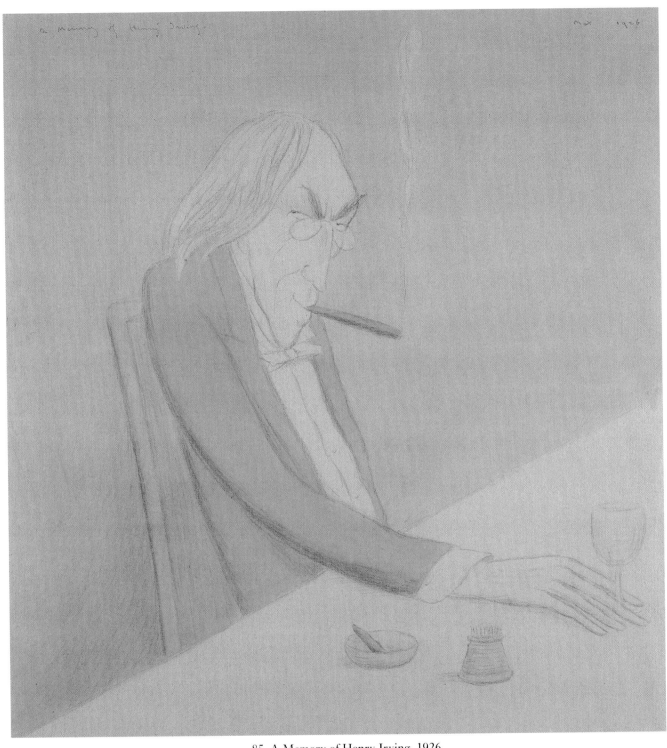

85. A Memory of Henry Irving. 1926

HENRY IRVING

Known as "The Chief", Henry Irving (1838–1905) was the foremost actor of his day. He made his London debut at the St James's Theatre in 1866; by 1874, his Hamlet positioned him as the leading actor in England. In 1878 he took over the Lyceum Theatre as owner/manager, and began his 24-year association with Ellen Terry. His acting in *The Bells* (1876) was so startling as to earn him the sobriquet "the Unnerving Henry Irving". Something of an autocrat, he cut the fifth act from *The Merchant of Venice*, because Shylock, his role, is seen no more after Act Four. He employed Bram Stoker as his personal secretary and is thought to have partly inspired the character of Dracula. In 1883 he declined a knighthood, but in 1895 accepted, and became the first actor to be so honoured. He was buried in Westminster Abbey on 20 October 1905. Max

attended the ceremony, and was annoyed by all the actors and actresses "making such a show of suppressed emotion, with the sense that the whole Abbey's eyes were upon them, and comporting themselves with such terrific grace and seemliness".

In his person – as Max's caricatures show – Irving was tall, thin, and wiry. It was said that his beauty of face increased with age. His *Dictionary of National Biography* entry declares: "In character he was ambitious, proud, lonely, and self-centred ('an egoist of the great type' is Miss Terry's phrase for him), but gentle, courteous, and lavishly generous."

Max wrote an obituary of Irving in the *Saturday Review*:

> One mourns not merely a great actor, who had been a great manager. Irving...had such a hold on one's imagination...that his death is like the loss of a legend. As an actor, and as a manager, he had his faults; and these faults were obvious. But as a personality he was flawless – armed at all points in an impenetrable and darkly-gleaming armour of his own design...It was as a producer of Shakespeare that Irving was great in management. He was the first man to give Shakespeare a setting contrived with archaic and aesthetic care – a setting that should match the pleasure of the eye with the pleasure of the ear. That was a noble conception. Many people object, quite honestly, that the pleasure of the ear is diminished by that of the eye – that spectacle is a foe to poetry. Of course, spectacle may be overdone. Irving may sometimes have overdone it; but he always overdid it beautifully.

Max says that never to have seen Irving as Hamlet "is one of the regrets of my life". The obituary continues:

> In private life he was not less magnetic than on the stage...He was always courteous and gracious, and everybody was fascinated by him; but I think there were few who did not also fear him. Always in the company of his friends and acquaintances...there was an air of sardonic reserve behind his cordiality...Also, I think, the process of making himself feared appealed to something elfish in his nature. Remember, he was a comedian, as well as a tragedian...Irving, in his most prelatical mood, had always a touch – a trace here and there – of the old Bohemian.

Max recalls seeing him in 1895 on the way to receiving his knighthood: "He was the old Bohemian, and nothing else. His hat was tilted at more that its usual angle, and his long cigar seemed longer than ever; and on his face was a look of such ruminant, sly fun as I have never seen equalled." Thirty years later Max was still recalling the old Bohemian in "A Memory of Henry Irving" (plate 85, opposite).

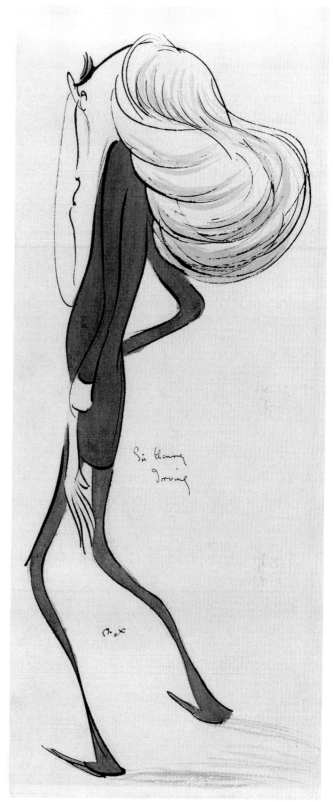

86. Sir Henry Irving. [1901]

GEORGE ALEXANDER

Legendary actor-manager George Alexander (1858–1918), who had managed the Adelphi Theatre since 1889, took over the St James's Theatre in 1891, where he continued as manager and leading man until his death 27 years later. His triumphs included Wilde's *The Importance of Being Earnest* and Pinero's *The Second Mrs Tanqueray*. In February 1913 Alexander produced Max's one-act play *A Social Success* at the Palace Theatre, a London music hall.

Max called Alexander's acting quintessentially English – and youthful. In 1903, when Alexander would have been 45, Max said that on stage he "really does look and behave as though he were 18 years old. Next time, we should not be surprised if he appeared as an infant in arms."

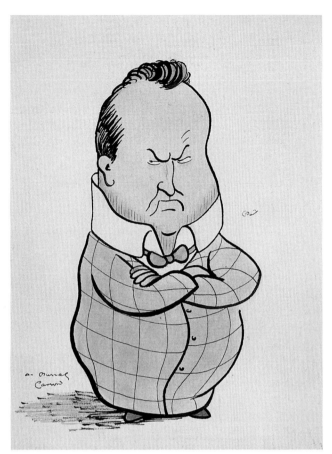

87. Mr Murray Carson. [c. 1898]

MURRAY CARSON

Actor and playwright Murray Carson (1865–1917) is little remembered today. But Max liked him and knew him well enough that in the autumn of 1897 he moved in with Carson so that the two might collaborate on writing a play. After six months Max was back home with his mother and sisters again, where he lived until he married and retreated to Italy in 1910. Nothing came of the would-be collaboration in 1897, but later on, when Max's interest in the theatre had grown because of his position as reviewer, he joined with Carson in writing a comedy called *The Fly on the Wheel*, which was produced at the Coronet Theatre on 4 December 1904.

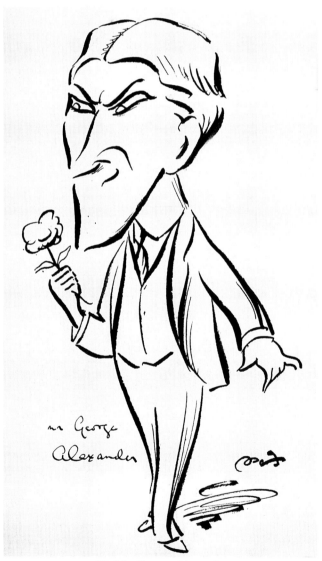

88. Mr George Alexander

89. Mr Gordon Craig. 1925

EDWARD GORDON CRAIG

The "love child" of Ellen Terry, Edward Gordon "Teddy" Craig (1872–1966), was an artist, actor, producer, and revolutionary stage designer. His innovations were much more readily accepted on the Continent than in England. "It is ludicrous", Max wrote, "that Mr Craig should be not without honour in all countries but this one. It is also very characteristic of this one." Craig spent most of his life in self-exile, chiefly in Italy. "In a gregarious profession," Max said, "he wouldn't gregar." But by the time Craig died, at 94, many of his ideas on the theatre had long been widely practised. For a time he lived in Rapallo, near Max, a close friend, and in 1924, when Max finally decided to put together a collection of his reviews, *Around Theatres*, he dedicated the book to Craig.

90. In piam memoriam / Danielii Lenonis / Viri praecipui in scientia /
cordium humanorum / non minus quam / in facetiis praeclari. 1926
[In grateful memory of Dan Leno, who was as remarkable for his knowledge
of the human heart as he was famous for the readiness of his wit]

DAN LENO

Beginning his stage career as the tumbling "Infant Wonder" at age four, Dan Leno (1860–1904) rose to be London's supreme music hall singer and dancer. The culmination of his triumphs occurred in November 1901 when he gave a command performance before King Edward VII and Queen Alexandra, earning himself the designation "the King's Jester".

Max was introduced to London music halls by his brother Julius in 1890. Thereafter Max attended often, together with various "Nineties" friends, most regularly with Walter Sickert, who was similarly enamoured of music halls. What was offered in music halls, Max wrote, was "the exact and joyous result of the public's own taste...There is no compromise, no friction, between the form and the audience." The music hall, with its lack of "humbug", he found in many ways preferable to the

theatre: "It has an air of honesty and freshness not to be found in the theatre. It is nearer to life." (James Joyce, after his first visit to London, commented, "The music hall, not poetry, is a criticism of life.")

Leno's death prompted a memorial piece from Max:

So little and frail a lantern could not long harbour so big a flame. Dan Leno was more a spirit than a man...[On stage] we were aware that here was a man utterly unlike any one else we had seen. Despite the rusty top hat and broken umbrella and red nose of tradition, here was a creature apart, radiating an ethereal essence all his own...He had, in a higher degree than any other actor that I have ever seen, the indefinable quality of being sympathetic. I defy any one not to have loved Dan Leno at first sight. The moment he capered on, with that air of wild determination, squirming in every limb with some deep grievance, that must be outpoured, all hearts were his. That face puckered with cares...yet ever liable to relax its mouth into a sudden wide grin...over some little triumph wrested from Fate, the tyrant; that poor little battered personage, so "put upon", yet so plucky with his squeaking voice and his sweeping gestures; bent but not broken; faint but pursuing; incarnate of the will to live in a world not at all worth living in – surely all hearts went always out to Dan Leno.

91. Mr Charles Hawtrey

CHARLES HAWTREY

A highly successful actor in comedy and farce for almost 40 years, Charles Hawtrey (1858–1923) was an equally busy manager, having at various times managed eighteen London theatres and produced some 100 plays. With his immobility of expression, he was said to have excelled at playing "liars, selfish men, and erring husbands".

Max wrote of Hawtrey in 1902 that no one would call him a great actor or call him larger than life; Hawtrey made no effort to move his audience to terror or pity:

He is content to be himself, and his self is a very peculiar and delightful affair. What playgoer does not know it – that large, neat, sleek, amiable, imperturbable presence; that vacant smile; that vacant stare; that purr; in fine, that baffling blend of a cat and a baby and a man of the world?

When a particular role in 1907 required Hawtrey to shave off his moustache, Max wrote: "No shock is more severe than the shock of seeing naked a face hirsute hitherto. The edifice of our knowledge of the man, knowledge which had seemed to be so stable, comes tumbling

and crashing down about our ears." Hawtrey's moustache was not on a grand scale, but "its very lack of obtrusiveness, its quiet, agreeable correctness, its urbanity and mundanity, its smoothness and silkiness, made it more than a mere appendage, made it an integral part of Mr Hawtrey, made it a symbol of Hawtreyismus." Max's drawing (plate 91) suggests something of that large, sleek, amiable presence, the blend of cat, baby, and man of the world. And, fortunately, we see a bit of that modest moustache, which, in its unobtrusive but correct urbanity, was an "integral part" of Hawtrey.

92. Miss Dorothea Baird in "Trilby"

DOROTHEA BAIRD

The long and successful career of Dorothea Baird (1873–1933) included the roles of Francesca in Stephen Phillips's *Paolo and Francesca* (the play that in 1902 brought its author, plate 72, favourable comparisons with Shakespeare) and the original Mrs Darling in *Peter Pan* (1904). But her greatest hit was her first, in du Maurier's *Trilby*, produced at the Haymarket Theatre in October 1892 by Max's brother Herbert, the proceeds of which enabled him to build his own theatre, Her Majesty's.

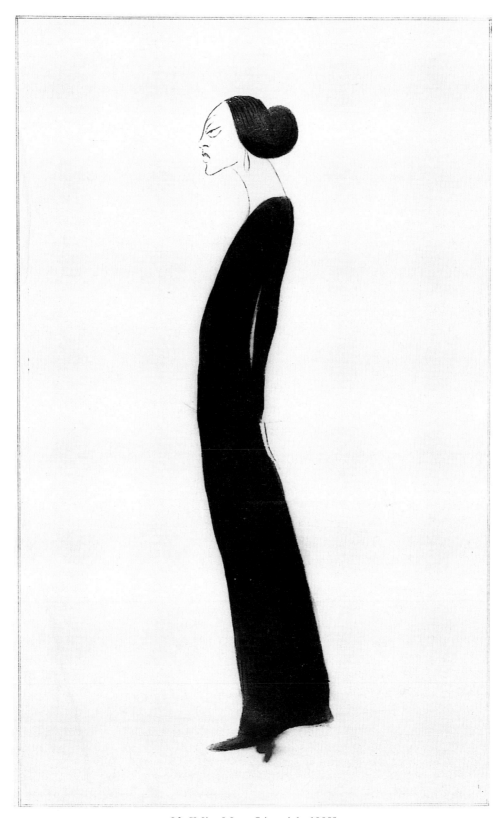

93. [Miss Mona Limerick. 1909]

MONA LIMERICK

Of actress Mona Limerick (c. 1882–1968) Max predicted – wrongly – in 1909, that she would become to early twentieth-century painters what Ellen Terry was to the Pre-Raphaelites and their imitators: "She has a barbaric air, and yet an air of being over-civilised. She has an air of belonging to any age but this, and yet she is intensely modern. She might be a Delilah, or a Madonna, or a Cassandra."

94. [Florence Kahn Beerbohm]

FLORENCE KAHN BEERBOHM

Max's wife, Florence Kahn (1877–1951), was an American, the only daughter of a Jewish family from Memphis, Tennessee. She began her public acting career in 1897, and by 1900 she commanded important roles at the Carnegie Lyceum in New York. For a brief time she became the leading lady to Richard Mansfield, the foremost Shakespearean actor in America. As her career ebbed, she developed an interest in avant-garde theatre, and in 1908 appeared in a small London production of Ibsen's *Rosmersholm*. Max gave her a rave review.

He had met her in 1904 and for six years the two were involved in a mild courtship which Max hesitated to push to marriage itself. He sent her scores of affectionate and (completely uncharacteristic of him) saccharine letters.

Will Rothenstein described her: "A girlish figure with red hair, looking, I thought, like Miss Siddal [Rossetti's model and wife, plates 199 and 200], but so shy and with a beauty so elusive that I wondered how she could dominate a stage." Easily shocked, she was said to have rushed from the room in tears at the simple mention of the word "adultery".

Max and Florence were finally married on 4 May 1910 in the Paddington Registry Office. For the ceremony Max "hauled" Reggie Turner out of Paris to serve as witness: "Without your presence the marriage would hardly seem valid." Max then quit his job as drama critic for the *Saturday Review* and "retired" to the Villino Chiaro, Rapallo. Asked by Sir Carol Reed how he could have left London, Max replied: "How many people were there in London? Eight Million? Nine million? Well – I knew them *all*!" But late in life, asked the same question by Samuel Behrman, he answered simply, "I wanted to be alone with Florence."

Max and his wife appear from their letters to have been idyllically happy. Five months into his marriage, Max wrote to Will Rothenstein, saying how grateful he was for "the blessed dispensation by which Florence came into my life. She is even more an angel that I had ever guessed, absolutely perfect in everything, and adorable. And I am as happy as the day is long. I think *she* is too. And it is a great joy for us to be together in this very beautiful place, quite alone."

The drawing reproduced here is not a caricature, but a fanciful drawing of Florence on the terrace at the Villino. Max wrote to Reggie Turner in June 1913, "I have been doing a lot of drawings of Florence, 'from the life.'. . . It is great fun."

III

THE ART WORLD

Max said that he preferred the company of artists to that of writers or actors. Artists he found more relaxed: "Writers, including myself,... like to make an effect, put their best foot forward. But painters are another story. [Wilson] Steer [plates 111 and 112], for example, had no interest whatever in the impression he made; he was just interested in painting." Actors, with their need for immediate recognition, tend to envy each other. Artists can only envy each other's work – unlike actors they "are not their own medium". Max's associations with painters did not make him feel he had any special expertise: "I am happy among pictures, and, being a constant intruder into studios, have learnt enough to know that I know nothing whatever about painting, – knowledge which, had I taken to what is called 'art criticism' would have set me head and shoulders above the great majority of my colleagues."

Max knew all of the artists caricatured here – and many others too. A number qualified as intimate friends: Will Rothenstein (plates 107–10) was instrumental in promoting Max's early career; Aubrey Beardsley (plates 95–7) also encouraged him greatly; Walter Sickert (plate 116) was one of his closest friends. Max's reflections on the art world as reproduced here range from great public figures like Whistler and Sargent to fellow caricaturists like Sem and Spy, art critics like Roger Fry and Robert Ross, along with art patrons, auction house officials, museum directors, and gallery owners.

AUBREY BEARDSLEY

The celebrated artist in black and white, Aubrey Beardsley (1872–98), was Max's almost exact contemporary, the two having been born three days apart in August 1872. Max, who was introduced to him by Will Rothenstein, took immediately to the frail, precocious, modest Beardsley, and the two became close friends. Altogether above prudery, Max admired all phases of Beardsley's art, including the sexually overt works. And Beardsley, in turn, along with Rothenstein, encouraged

Max, still an undergraduate, to write and draw professionally. Max, proud of his association with Beardsley on the *Yellow Book* and the *Savoy*, closed his first book of essays, *The Works of Max Beerbohm* (1896), with an essay, "Diminuendo", written the year before, when he was all of twenty-three: "Already I feel myself to be a trifle outmoded. I belong to the Beardsley period."

Beardsley, having caught consumption early, had known all his life that he would not live long. When he died in 1898 at twenty-five, Max wrote an obituary. He spoke of how Beardsley's *Yellow Book* drawings first excited the wrath of reviewers and the public: "They did not know what to make of these drawings, which were referable to no established school or known method of art." Max, himself an incorrigible perpetrator of practical jokes, recounts how Beardsley then inserted in the *Yellow Book* two drawings, executed in traditional styles, signed them with fictitious names, and was greatly amused when a critic urged him to study the "sound and scholarly draughtsmanship" of the two bogus artists. Meanwhile a "plague" of imitators in England and America attempted in vain to ape Beardsley, with "appalling" results. Beardsley, continually developing and modifying his art, was "always ahead of his apish retinue".

In his brief, tragic life, Beardsley embraced, Max said, "a larger measure of sweet and bitter experience than is given to most men who die in their old age". Beardsley was famous in his youth, "and to be famous in one's youth has been called the most gracious gift that the gods can bestow". Max recalls Beardsley's "absolute power of 'living in the moment'... For him, as for the schoolboy whose holidays are near their close, every hour – every minute – even, had its value". And although he left behind an enormous *oeuvre*, his work did not entirely satisfy his demands on life. He needed more. An accomplished musician, Beardsley loved concerts; he loved the theatre, dining out, and "gaiety of any kind"; he loved being where there were noise and bustle and people; he was fascinated by the domino room at the Café Royal: "he liked the mirrors and florid gilding, the little parties of foreigners and the smoke and the clatter of dominoes being shuffled on the marble tables".

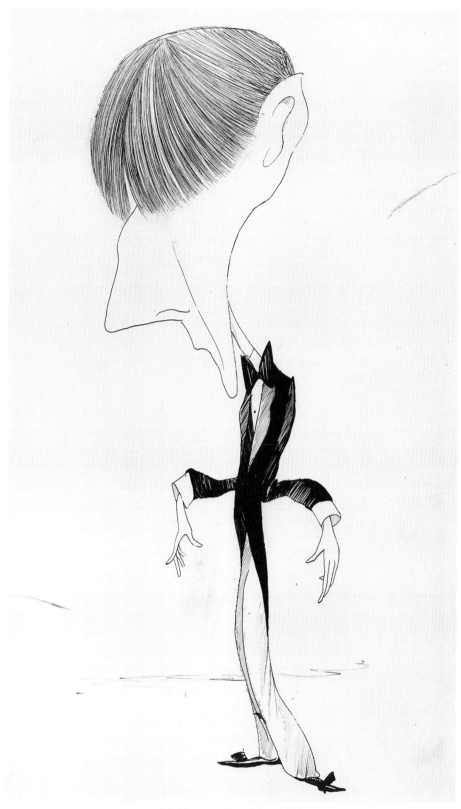

95. [Aubrey Beardsley. 1894]

Yet Beardsley had remained always

rather remote, rather detached from ordinary conditions, a kind of independent spectator. He enjoyed life, but he was never wholly of it. This kind of aloofness had been noted in all great artists. Their power isolates them. It is because they stand at a little distance that they can see so much. No man ever *saw* more than

Beardsley. He was infinitely sensitive to the aspect of all things around him. And that, I think, was the basis of his genius. All the greatest fantastic art postulates the power to see things, unerringly, as they are.

Max's drawings of Beardsley convey not only his thin, scraggly body and the distinctive nose and hair, but also something of the artist's powerful aloofness.

113

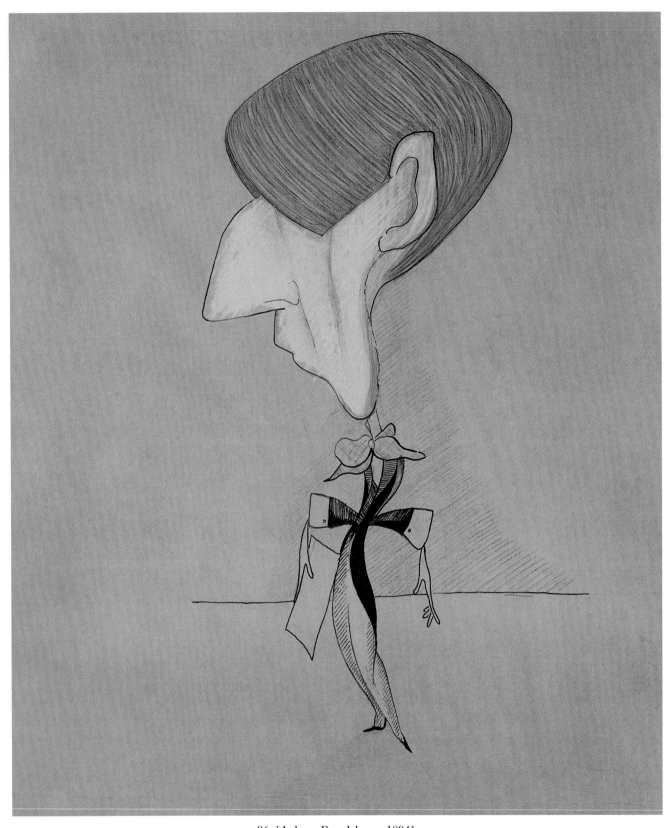

96. [Aubrey Beardsley. c. 1894]

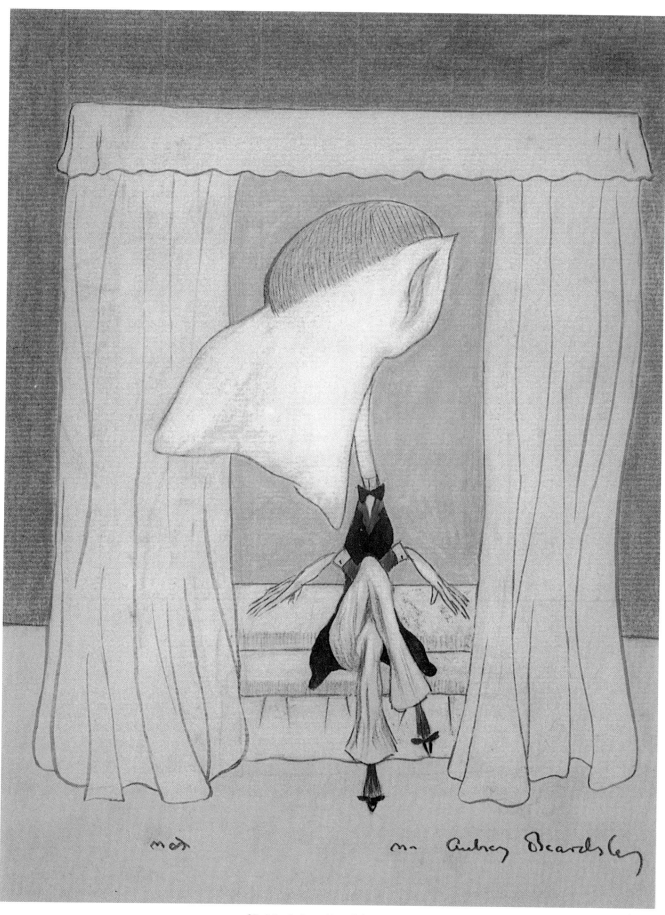

97. Mr Aubrey Beardsley. [1896]

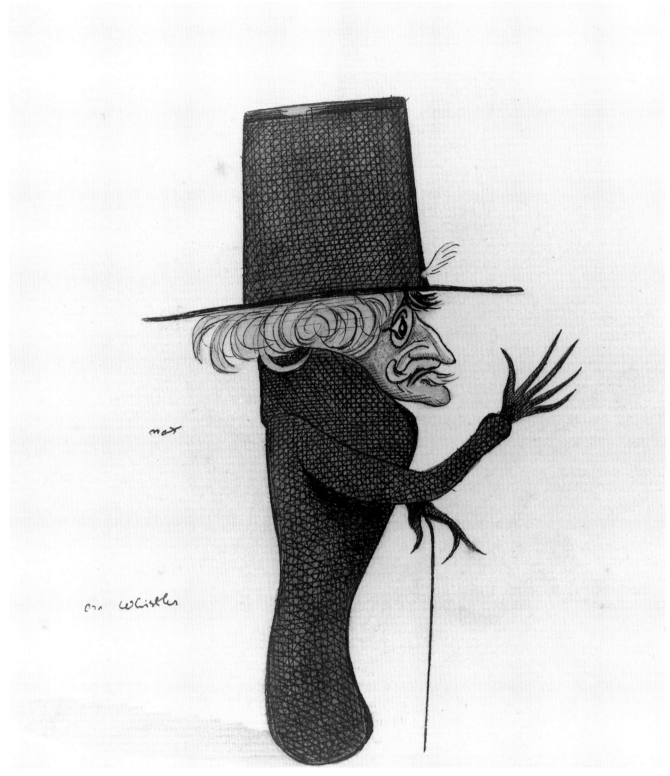

98. Mr Whistler

JAMES ABBOTT McNEILL WHISTLER

In 1855 James McNeill Whistler (1834–1903) went to Paris to study art, and never returned to his native America. He painted alternately in Paris and London and became famous (and infamous) for his portraits, such as those of his mother and of Carlyle, and for his *Nocturnes*. To his fervent London admirers, he was a cult figure. E. F. Benson called him a school of art unto himself, "one unique and peerless master without pupils".

Whistler was one of Max's early heroes: a splendid, independent-minded, devoted artist and draughtsman-etcher, a fine art critic, an aesthete, a dandy, a satirist, a

wit, a fascinating person in his pugnacious character and curious looks. He was also, in Max's view, a superb writer, as displayed in *The Gentle Art of Making Enemies* (1890). Max argued his case in an essay that is particularly illuminating in taking up the question of the artist as writer, the writer as artist – an issue often associated with Max himself. That no one had done justice to Whistler's extraordinary prose was not surprising, Max says, for, "When a man can express himself through two media, people tend to take him lightly in his use of the medium to which he devotes the lesser time and energy, even though he use that medium not less admirably than the other." Although Whistler's writing had at times a "dignified" side, "as perfect, in its dim and delicate beauty, as any of his painted 'nocturnes'," he was much better known for his hostile, contemptuous style, which, while often in bad taste, had its own murderous perfection: after Whistler's attacks, often in the form of letters to newspapers, his enemies "never again were quite the same men in the eyes of their fellows. Whistler's insults always stuck – stuck and spread round the insulted, who found themselves at length encased in them, like flies in amber. You may shed a tear over the flies, if you will. For myself, I am content to laud the amber."

All Max's many caricatures of Whistler incorporate much of what he noted on their first meeting (probably at Edmund Gosse's house in 1896):

Tiny – Noah's Ark – flat-brimmed hat – band almost to top – coat just not touching the ground – button of the Legion of Honour – black gloves – Cuban belle – magnificent eyes – exquisite hands, long and lithe – short palms.

There was also, of course, the strange lock of white hair, prominent in most drawings, even managing to appear *through* his hat, that "white plume that used to stand out so bravely against the dark locks". Arthur Symons described Whistler in his last years: "I never saw anyone so feverishly alive as this little, old man, with his bright, withered cheeks, over which the skin was drawn tightly, his darting eyes, under their prickly bushes of eyebrows, his fantastically creased black and white curls of hair, his bitter and subtle mouth, and, above all, his exquisite hands, never at rest."

Whistler's famous litigiousness also attracted Max. In 1877 Whistler had sued Ruskin who, writing of Whistler's "Nocturnes", had called him a "coxcomb" with the impudence to ask "two hundred guineas for flinging a pot of paint in the public's face". At the trial the following year, Whistler won his libel suit but instead of the £1,000 he had asked in damages received a token farthing, and had to pay a ruinous £500 in legal fees. Nothing daunted, he always wore the farthing as a watch charm. This celebrated case had taken place when Max was a child; but he drew caricatures commenting

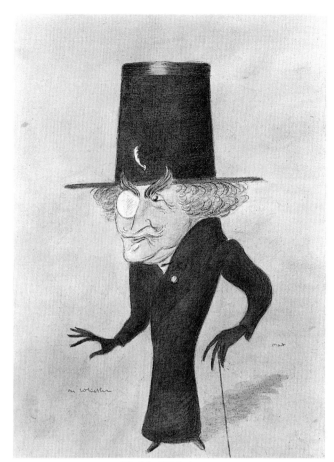

99. Mr Whistler

on two of Whistler's later courtroom appearances.

One of these pitted Whistler against Sir William Eden, the case of "The Baronet and the Butterfly" (a reference to Whistler's famous butterfly signature, which he had fused from his initials, JMW, the butterfly expressing his view of art as beautiful but useless; see plate 100, overleaf). Sir William Eden (1849–1915; the father of Anthony Eden), was a tall, bushy-browed, red-cheeked, wealthy aristocrat. He was a passionate art lover, with a reputation for an irascible temper. Introduced to Whistler in 1894 in Paris by another great eccentric, George Moore (plates 31–4), Eden commissioned a portrait in pastels of his wife. Whistler instead did a small, more expensive, oil portrait, and when Eden sent him only the originally agreed-upon £100, Whistler became enraged, refused to deliver the painting, and wiped out the head. Eden sued, and a French court ruled in his favour, saying Whistler had to restore and deliver the painting and pay 1,000 francs in damages. Whistler appealed the ruling, and the art worlds of London and Paris were treated to the spectacle of the two men trading insults. All of Whistler's associates were fitted into the categories of Followers or Enemies, the latter group much larger and containing numerous ex-Followers. Moore had become an Enemy for siding with Eden; Whistler challenged him to a duel, but Moore refused; Walter Sickert and Will Rothenstein also became

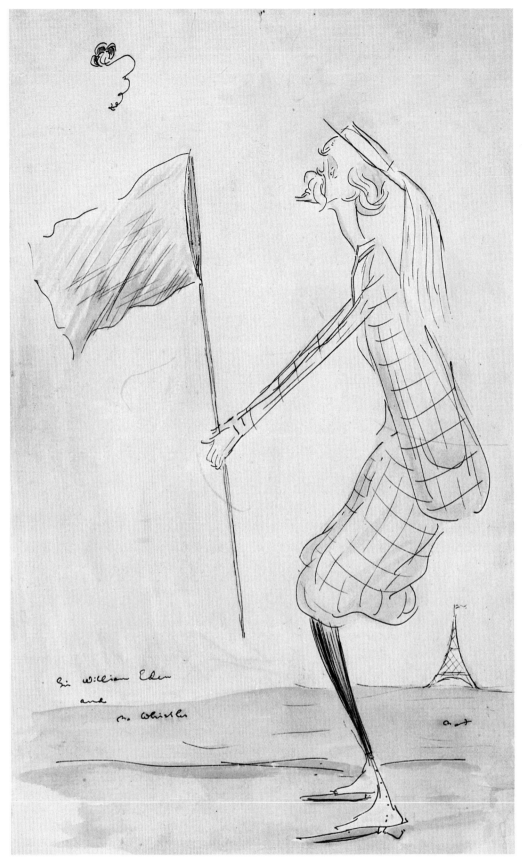

100. Sir William Eden and Mr Whistler

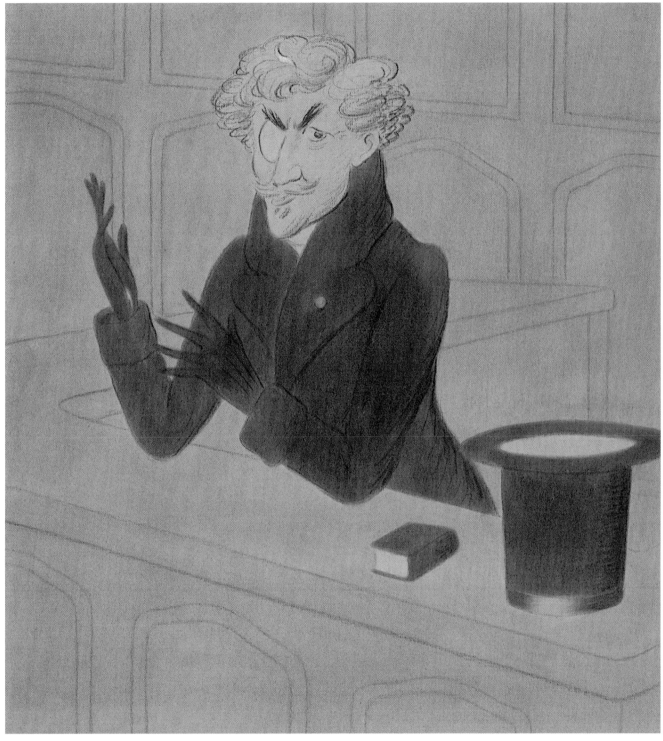

101. Mr Whistler giving evidence in the case of Pennell v. *The Saturday Review* and Another.

Enemies for remaining friendly with Sir William. The case dragged on until 1897 when the Appeals Court ruled that the defaced portrait need not be delivered to Eden but that Whistler had to pay the 1,000 francs damages. Whistler claimed victory, saying he had "wiped the floor" with Sir William. Half a century later, Max recalled, "We were all on Whistler's side because we knew Sir William was very rich and we felt that he could pay without feeling it and then give the portrait to somebody he didn't like for a wedding present."

In April 1897, Whistler testified in the case of "Joseph Pennell vs. *The Saturday Review* and Another." "Another" was Walter Sickert (once Whistler's student, Follower, and close friend), who had claimed in an article that the prints of Whistler's disciple Joseph Pennell (plate 103) were not true lithographs because they were done on transfer paper and not directly on stone. Pennell won his libel case, Whistler testifying that Sickert was "an insignificant and irresponsible person". For caricatures of Sickert, see plates 116–18.

102. [Whistler dissolving into an extinguished candle]

This caricature of Whistler being transformed into an extinguished candle in a candlestick (plate 102) is inspired by the French caricaturist Charles Philipon's famous "Les Poires" (1834). That drawing, also in four stages, has the Bourgeois King, Louis Philippe, dissolving into a pear (that *poire* can be mean "fathead" added to the insult, and Philipon was heavily fined). Max's drawing plays with, among other of Whistler's salient points, his coat and omnipresent hat. In his essay on dandies Max said, "The silk hat of Mr Whistler is a real *nocturne*, his linen a symphony *en blanc majeur*." At the start of his metamorphosis, Whistler is also, as in Max's original notes, tiny, with his coat just not touching the ground, and wearing black gloves.

120

103. Mr Joseph Pennell thinking of the old 'un. 1913

JOSEPH PENNELL

The American etcher and journalist Joseph Pennell (1860–1926) spent most of his time in England. He became a devoted Follower of Whistler, and, after the great man's death, his biographer.

Max has caricatured him in the pose in which Whistler painted Thomas Carlyle (*Arrangement in Grey and Black No. 2*), which was a variation of the celebrated pose in which he had painted his mother (*Arrangement in Grey and Black No. 1*). The caricature follows the Carlyle portrait carefully (including the butterfly signature), except that whereas Whistler had Carlyle sitting before two framed works that are only vaguely legible, Max has Pennell sitting before a version (reversed) of the 1878 *Vanity Fair* caricature of Whistler by "Spy". Pennell is "thinking of the old 'un" – Whistler. See also the 1916 portrait photograph by Filson Young of Beerbohm himself in this pose, "With apologies to all concerned", figure iii of the Introduction.

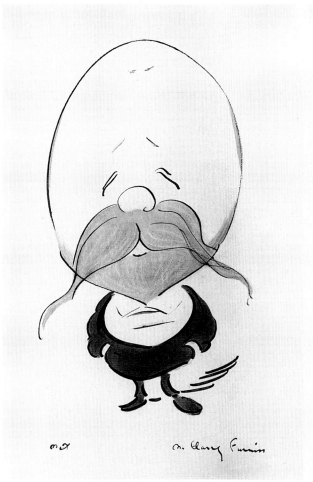

104. Mr Harry Furniss

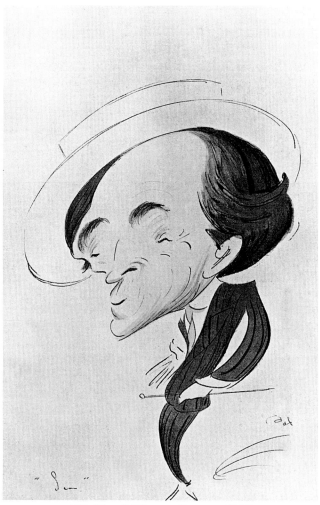

105. "Sem" [George Goursat. 1907]

HARRY FURNISS

Caricaturist Harry Furniss (1854–1925) worked for *Punch* from 1880 to 1894; thereafter he continued to draw caricatures, most notably parliamentary drawings for the *Daily News*. He illustrated editions of Dickens and Thackeray and also collaborated with Lewis Carroll. In 1912 he worked with Thomas Edison in New York as a writer, actor, and producer of movies. For Max, Furniss's connection with *Punch* was enough: "It is from the bound volumes of *Punch* that small boys [like himself] derive their knowledge of life. Even in later years, when they have detected how wide and fluid a thing life is, they do yet conceive many real things through the false conventions of John Tenniel, George du Maurier, Charles Keene and the rest."

GEORGE GOURSAT "SEM"

Max knew the talented French caricaturist "Sem", George Goursat (1864–1934), from their Dieppe holidays. The caricature shows Sem in dandyish summer dress (plate 105), rather like Max's own holiday garb at Dieppe (plate 209).

LESLIE WARD "SPY"

The major caricaturist for *Vanity Fair*, "Spy", Leslie Ward (1851–1922), contributed over 1,300 cartoons to the magazine, more than half of all that appeared in its long run, 1869–1914. Max admired some of Spy's early caricatures but was critical of the mild portraiture that came to dominate his later work. This caricature of Spy poses the figure and uses colour in a way that suggests Spy's *Vanity Fair* drawings. For three of Max's own *Vanity Fair* caricatures, see plate 8 (Meredith), plate 81 (Shaw), and plate 120 (Maeterlinck).

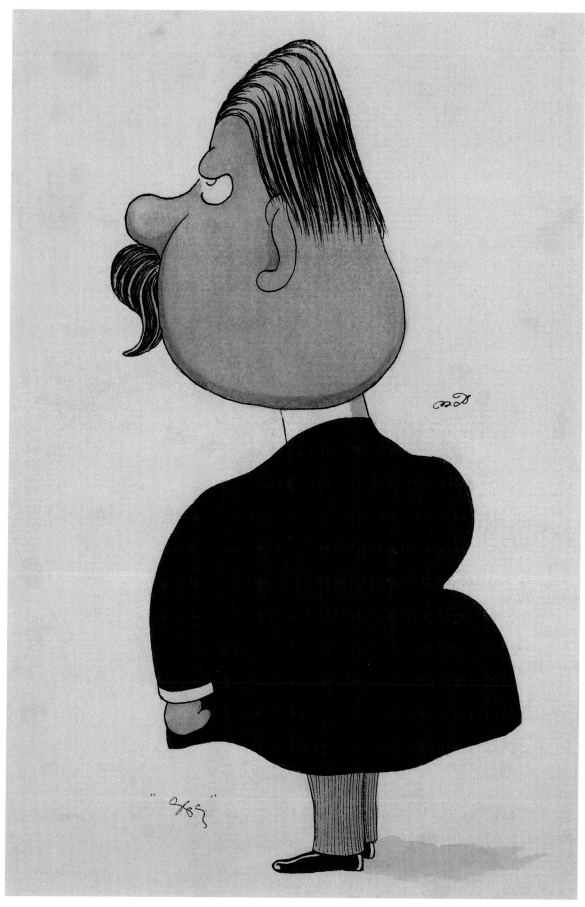

106. "Spy" [Leslie Ward. c. 1894]

WILLIAM ROTHENSTEIN

William Rothenstein (1872–1945), son of a Jewish cloth merchant at Bradford, Yorkshire, went to study art at the Académie Julian in Paris at the age of seventeen. There he was befriended and encouraged by Whistler, Degas, Toulouse-Lautrec, Forain, and Fantin-Latour. He returned to England in 1893, aged twenty-one, to undertake portraits in lithograph of eminent Oxford characters – undergraduate Max among them – and went on to a prolific career of making portrait drawings and lithographs. In 1917 he became Professor of Civic Art at the University of Sheffield; in 1920 he became Principal of the Royal College of Art in South Kensington, a post he held until 1935. His work, described as "ideal realism", was to go out of style in his lifetime, and he felt rather outmoded in his later career. He also turned conservative, leaving behind the bohemianism of his precocious youth, as seen in Max's "The Old and the Young Self" (opposite), where the young Will, dandified and self-confident to a fault, is being rebuked by the conservative, elderly Professor of art.

Will Rothenstein was one of Max's very closest friends (second only to Reggie Turner). Max describes Rothenstein's apparition in England in "Enoch Soames" (see plate 61), a partly autobiographical work that is his most famous short story:

> In the Summer Term of '93 a bolt from the blue flashed down on Oxford. It drove deep, it hurtlingly embedded itself in the soil. Dons and undergraduates stood around, rather pale, discussing nothing but it...Its name? Will Rothenstein...Dignified and doddering old men, who had never consented to sit to any one, could not withstand this dynamic little stranger. He did not sue: he invited; he did not invite: he commanded...He wore spectacles that flashed more than any other pair ever seen. He was a wit. He was brimful of ideas. He knew Whistler. He knew Edmond de Goncourt. He knew everyone in Paris ...He was Paris in Oxford...There arose between us a friendship that has grown ever warmer...
>
> At the end of Term he settled in – or rather, meteorically into – London. It was to him that I owed my first knowledge of that forever enchanting little world-in-itself, Chelsea, and my first acquaintance with Walter Sickert and other august elders who dwelt there. It was Rothenstein that took me to see, in Cambridge Street, Pimlico, a young man whose drawings were already famous among the few – Aubrey Beardsley, by name. With Rothenstein I paid my first visit to the Bodley Head. By him I was inducted into another haunt of intellect and daring, the domino room of the Café Royal. There, on that October evening – there in that exuberant vista of

gilding and crimson velvet set amidst all those opposing mirrors and upholding caryatids, with fumes of tobacco ever rising to the painted and pagan ceiling, and with the hum of presumably cynical conversation broken into so sharply now and again by the clatter of dominoes shuffled on marble tables, I drew a deep breath and "This indeed", said I to myself, "is life!"

The visit to the Bodley Head led to acquaintance not only with John Lane, the publisher, but to friendship with Arthur Symons, Richard Le Gallienne, Lionel Johnson, Henry Harland – the "Decadents", whose favourite haunt was the Café Royal. And it was Rothenstein who suggested Max add "charm" to his caricatures by colouring them; he also urged Max to make some of his caricatures "decorative". Even in later years, he occasionally offered Max advice on his drawing. During Max's 1908 exhibition, Rothenstein wrote to him of spotting in one or two drawings an "inclination to draw like a 'professional' artist...Your own sense of form is such a wonderful one & has been such a delight

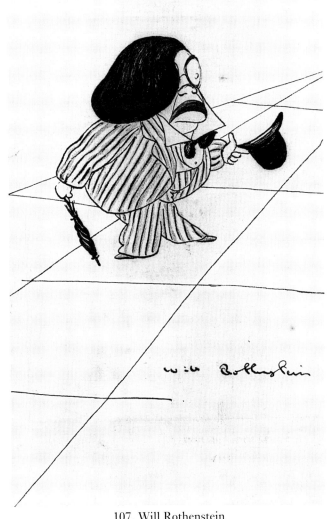

107. Will Rothenstein

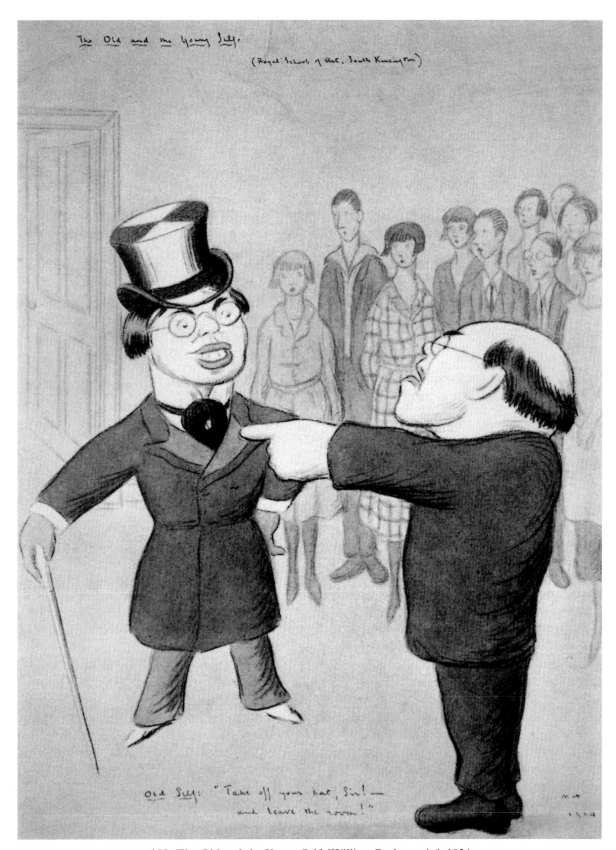

108. The Old and the Young Self. [William Rothenstein]. 1924
(Royal School of Art, South Kensington).
Old Self: "Take off your hat, Sir! – and leave the room!"

Mr W. Rothenstein and Mankind — max 1916

109. Mr W. Rothenstein and Mankind. 1916

Professor Rothenstein lecturing on the need for closer and closer co-operation between the artist as citizen and the citizen as artist.

110. Professor Rothenstein lecturing on the need for closer and closer co-operation
between the artist as citizen and the citizen as artist. 1924

to all of us that you mustn't let yourself be tempted by any other – unless it be a development of your beautiful formula for every thing which exists on the face of the world." In 1913, Max, thanking Rothenstein for his kind words on his exhibition of that year, recalled that "it was you who made me see the difference between journalistic line-y drawing and drawing that has an unjournalistic grace. And it was you, later, whose advice helped me to keep with my own little *spiritual* way of expression and not to try for external accuracies."

Max drew Rothenstein repeatedly – at least 48 times. He is often shown as a Lilliputian among the Gullivers, as in the New English Art Club drawing (plate 117), where he must stand on a table to talk with Wilson Steer, who is seated. In most of the drawings, from early to late, Rothenstein is monumentally ugly, and scowling. In 1893 Max wrote that his brother Herbert's wife thought Rothenstein "the ugliest man in the wide world: I think he is rather nice to look upon with his huge spectacles and his thick raven hair combed over his forehead. He

looks like a creature of another world." Fifty years later, Max recalled, "My caricatures of him were very cruel, I am afraid. He knew they were, and yet he took it manfully... One day Sickert said to me, 'Your caricatures of dear Will and of Oscar Wilde were so deadly. I know how Oscar feels about them – he can't bear them – but doesn't Will resent them? Isn't he angry?' 'More frightened,' I said,... 'than angry.'"

Rothenstein's fastidiousness is embodied in "Mr W. Rothenstein and Mankind" (plate 109, opposite). The drawing tallies nicely with words that Rothenstein's bride wrote to his parents, saying how upset Will was at the prospect of his uncle sending a wedding present of "some ugly silver or something": Will "has such very exquisite taste that he cannot exist with ugly things – it is a positive pain to him".

Plate 110, above, Professor Rothenstein calling for closer cooperation between artist and citizen, makes a neat ironic commentary on the previous drawing: such cooperation is fine as long as it does not get too close.

111. Mr Wilson Steer

PHILIP WILSON STEER

Wilson Steer (1860–1942), the son of a painter, went to Paris in 1882, and there studied at the Académie Julian and the École des Beaux Arts. Back in England, he set up a studio in Chelsea. Manet was his early inspiration, and, not unexpectedly, some of Steer's early work was much abused in London. Steer – along with Frederick Brown, Henry Tonks and D.S. MacColl – exhibited at and maintained a lifelong affiliation with the New English Art Club, which was sympathetic towards French Impressionist painting. From 1895, first under Brown and then under Tonks, Steer taught at the Slade School of Fine Art, University College, London. He was considered an "extremely inarticulate" but nonetheless helpful teacher. The *DNB* describes him: "Apart from his great height and bulk, and the formal clothes…which never varied, the most striking characteristics were a monumental calm, and the fact that to him painting was a natural function. He was quite uninterested in theories of art, and if people began to argue, Steer would go to sleep." In 1935,

Virginia Woolf met him at a party: "Steer…was there in a clergyman's collar: almost hidebound; entirely silent, like a log removed from the fire & stood on end."

Steer was another of Max's Chelsea artist friends, courtesy of Will Rothenstein, and another summer visitor at Dieppe. Max's brief descriptive notes say:

Steer: Walking gracefully – like a large seal – eyes – head from side to side – big neck – sloping shoulders – Thinks with his eyes. Devoted.

Steer was a frequent subject for Max's caricatures, which display his "monumental calm" along with his monumental body. In the drawing of Steer "prospecting" (opposite, plate 112), the report of the landscape as "beginning to fidget" cleverly describes Steer's landscape style, which has an over-all busyness, with plenty of twitchy brushwork. In two large group caricatures of the New English Art Club (plates 117 and 118), Steer is the central figure.

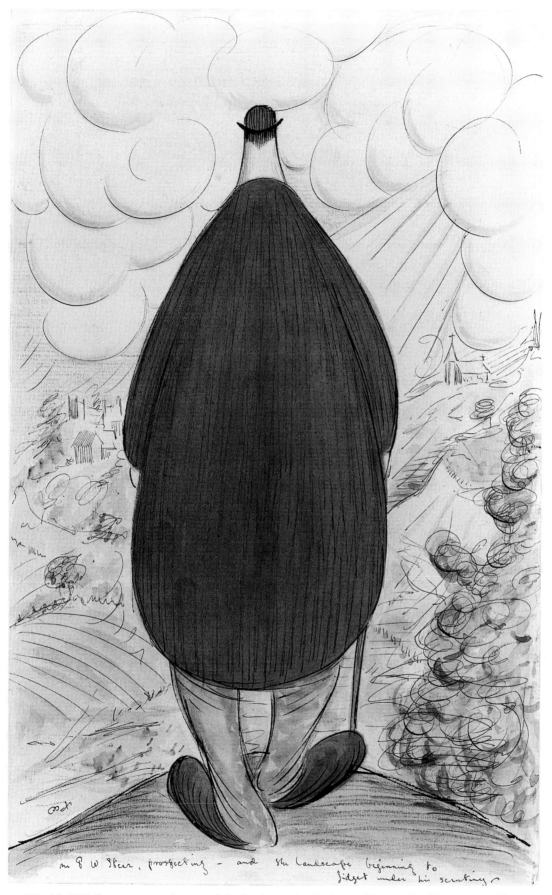

112. Mr P.W. Steer, prospecting – and the landscape beginning to fidget under his scrutiny. [1904]

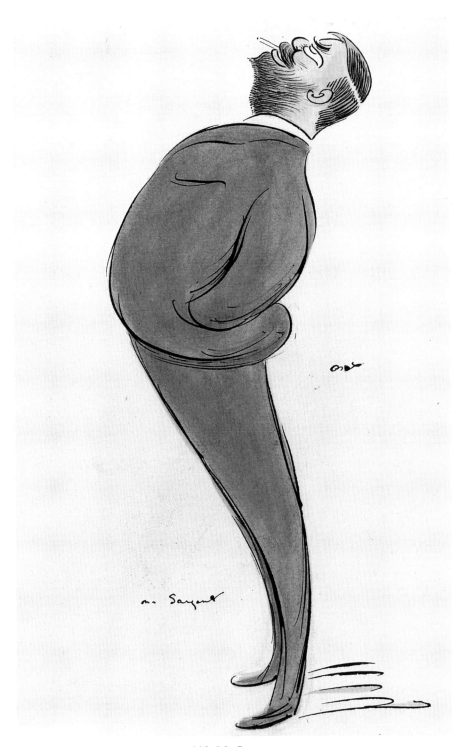

113. Mr Sargent

JOHN SINGER SARGENT

Born in Florence of American parents, John Singer Sargent (1865–1925), settled permanently in London in 1885. He was regarded as the foremost English portrait painter of his day, "the Van Dyck of our times". With his "broad slashing brush-strokes and brilliant palette" he captured the elegance of the Edwardian era.

Sargent was a lion at every society dinner, and Max, who often met him, recorded:

[Sargent] sat high – glaring – minatory and prosperous…But nervous – drawing in breath – finding word – as if outside him – slight groan…Could be witty – But talking not his game. True painter.

Max recalled Sargent being asked at another dinner party about portrait painting: "He began to heave and pant, but he did get out an amusing definition: 'A portrait is a painting where there is always something not quite right about the mouth.'"

Max drew Sargent some 22 times.

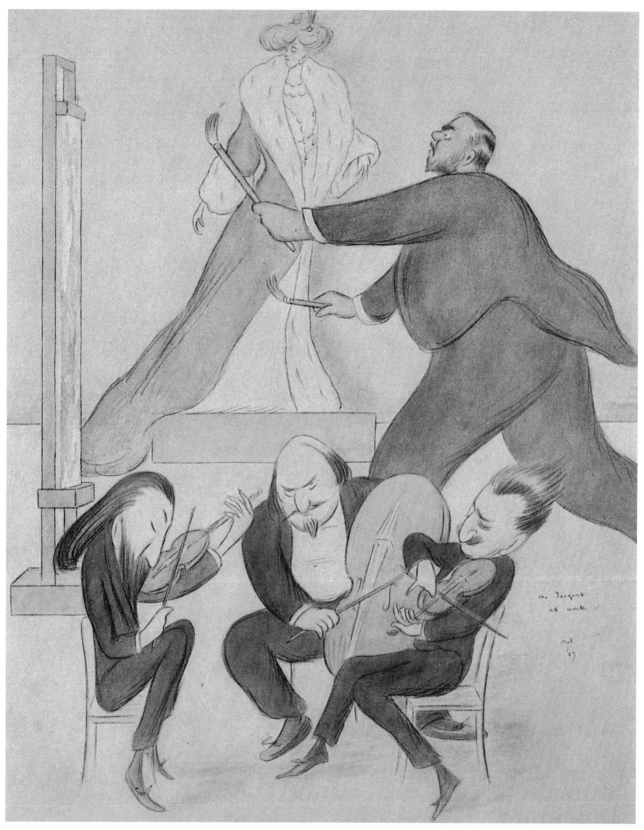

114. Mr Sargent at work. 1907

Of the above drawing Max wrote to his future wife that he had just done "a rather good 'Mr Sargent at Work' – more or less suggested by a musical party he gave some nights ago. Two fiddlers and a 'cellist in the foreground, and a duchess on a platform in the background, and he in between, dashing at a canvas, with a big and swilling brush in either hand." Years later, Max called Behrman's attention to "the hirsute variations among the three musicians". The Duchess looks rather like the Duchess of Marlborough in Sargent's great portrait of the Marlborough family.

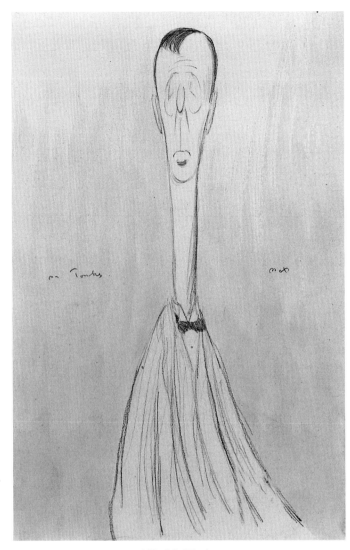

115. Mr Tonks

HENRY TONKS

A prominent London surgeon before turning to art, Henry Tonks (1862–1937) taught at the Slade School of Art, University College, London. He was considered "the outstanding teacher of the age; in appearance tall, gaunt, and severe. His criticisms were sometimes the most scathing possible, yet his students loved him." But Vanessa Bell, who studied briefly under him at the Slade, "lived in terror of [his] hooded gaze and derogatory comments". Her sister, Virginia Woolf, wrote in her diary for March 1905: "Nessa was in a state of great misery, awaiting Mr Tonks...[He] came, a great raw boned man, with a cold bony face, prominent eyes, & a look of mingled severity & boredom...He reviewed the pictures, with a good deal of criticism apparently, but also some praise." Thirty years later Virginia met "old saw bones Tonks" at a party, where he was "all kindness: & distinguished; & appreciative, & regretting Bloomsbury & the distance between us & Chelsea".

Max jotted down his early impression of Tonks:

"...Monk – thoughtful...look of being resigned to muddle of life – determined to leave off worrying".

Tonks figures prominently in two New English Art Club drawings (plates 117 and 118).

WALTER SICKERT

Walter Sickert (1860–1942), under the spell of Whistler and having contact at Dieppe with Degas, Renoir, Monet, and Pissaro, emerged (along with Steer) as one of the "London Impressionists". He was a prominent member of the New English Art Club.

Sickert and Max became close friends. Max's notebook impressions of Sickert read:

His charm – for *all* women – Duchess or model – kind, shrewd, then domineering...two sides – like Shaw. Cruel mouth – kind eyes. Hair beautiful – Peg tops. Extreme of refinement – love of squalor: Lodged in Jack the Ripper house.

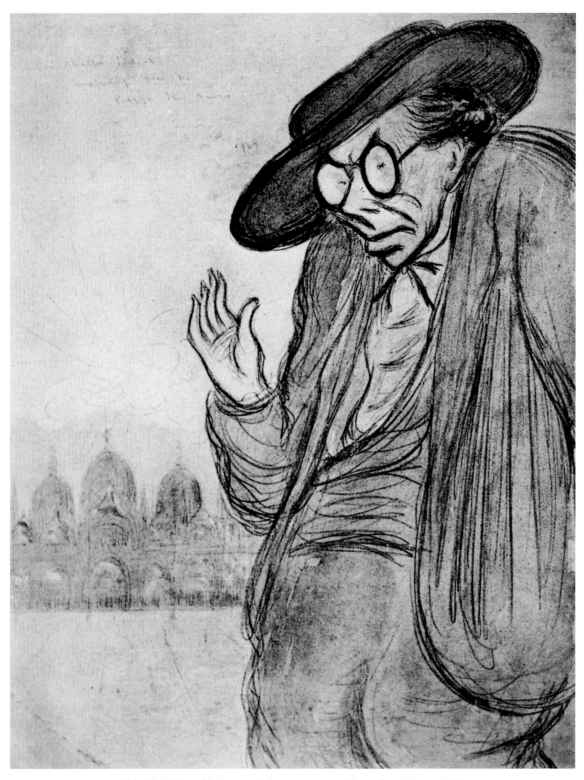

116. Mr Walter Sickert explaining away the Piazza San Marco. 1907

Sickert spent many years on the Continent, including lengthy visits to Venice. Max's drawing of Sickert, a very considerable art critic, "explaining away the Piazza San Marco", i.e., clearing up all its mysteries, was partly inspired by Max's own visit to Venice in 1906. Venice absolutely astounded him. Painters from Bellini to Sickert could not, he wrote, fuse the solemnity and gaiety of St Mark's. Just as Bellini's brilliant noon-day sun could not rob St Mark's of its mysterious solemnity, so Sickert's dark and grave approach – he "might almost be suspected of having brought London air with him" – could not rob the piazza of its gaiety.

117. N.E.A.C. [The New English Art Club]. 1907
[*Wilson Steer sits in the middle, the long necks of Henry Tonks and D. S. MacColl forming an arch over him; others include Walter Sickert, William Orpen, L. A. Harrison, Augustus John, Will Rothenstein, J. S. Sargent, Albert Rutherston, W. G. de Glehn, and Walter Russell.*]

THE NEW ENGLISH ART CLUB

The artists' society known as the New English Art Club was founded in 1886, with Walter Sickert as one of its driving forces. Established in reaction against the conservative Royal Academy of Arts, it fostered French directions in painting, especially those of the French Impressionists, whom they championed. The influence of Whistler was strong. Until after the First World War, when its importance declined, the N.E.A.C. counted among its members and exhibitors most of the noteworthy painters in Britain, including those caricatured in this 1907 group portrait of its members (plate 117). It is just possible that Max was remotely parodying a famous Raphael Vatican fresco, the so-called *School of Athens*; this would explain the arch formed by the long necks of

MacColl and Tonks as a jokey reference to the architecture in the Raphael.

Max himself was a member of the New English Art Club, and exhibited at its Suffolk Street gallery at various times: fifteen drawings in Summer 1909; nine in Winter 1909; ten in Summer 1910; and seven in Winter 1911.

Those familiar with Max's story "Enoch Soames" will recall that it was at an exhibition of the N.E.A.C. that Will Rothenstein's pastel portrait of Soames, that "dim" 1890s Catholic Diabolist poet, was first shown. All through the exhibition, Soames hovered in the gallery near his likeness, which "was very like him"; indeed, "it 'existed' so much more than he". For Max's rendition of Soames, see plate 61.

118. Annual Banquet – A Suggestion to the New English Art Club. 1913
[*Wilson Steer in the middle, standing to read his speech. Left to right are: Augustus John, Prime Minister Herbert Asquith, Walter Sickert, the Prince of Wales (later King Edward VIII), the Archbishop of Canterbury (Randall Davidson), Henry Tonks, the Duke of Argyll, and Walter Russell.*]

The "Suggestion" to the New English Art Club is Max's own and is of course ironic. The N.E.A.C. did not in fact have a formal banquet, a mark of its being far less "establishment" than its rival, the Royal Academy of Arts, which did have an elaborate annual banquet, with royalty, prime ministers, archbishops, and other dignitaries. In 1913, the Prince of Wales, the future King Edward VIII, would have been nineteen. For additional caricatures of his tiny figure, see plates 164, 165, and 186.

Of the paintings on the back wall, that on the left appears to spoof Tonks's style, that in the centre Augustus John's, and that on the right the "fidgeting" landscapes of Steer (see plate 112).

119. M. Jacques Blanche, combating M. Maurice Maeterlinck's reluctance to be painted. [1907]

JACQUES-EMILE BLANCHE and MAURICE MAETERLINCK

A popular portrait painter, called "the French Sargent", Jacques-Emile Blanche (1861–1942) spent much time in London, and knew everybody in the artistic and literary circles of England and France. Blanche did portraits of many of the people whom Max caricatured, including Aubrey Beardsley, Charles Conder, Walter Sickert, George Moore, Thomas Hardy, and Henry James. Blanche also painted a ghastly portrait of Max, now in the Ashmolean Museum, Oxford. Max knew Blanche in London and in Dieppe, once remarking that the charms of the latter were much enhanced by Blanche's living nearby.

Belgian poet and playwright Maurice Maeterlinck (1862–1949) was a reserved, taciturn person; his nickname in Paris was "le taiseux", the silent one. Among his most popular plays was one about two children, *L'Oiseau bleu (The Blue Bird*, 1909); it gave birth to the common phrase "the blue bird of happiness". Among his non-fiction books, the most popular was *La Vie des abeilles (The Life of the Bee*, 1901), wherein Maeterlinck sees the highly structured society of bees as ideal and meaningful to humankind.

Maeterlinck was one of Max's favourite writers. Max was especially taken with Maeterlinck's refusal to provide answers for "things in general". Max wrote:

> For proper appreciation of Maeterlinck, you must have, besides a sense of beauty, a taste for wisdom. Maeterlinck is not less a sage than a poet. Of all living thinkers whose names are known to me, he has the firmest and widest grasp of the truth. He more clearly than any other thinker is conscious of the absurdity of attempting to fashion out of the vast and impenetrable mysteries of life any adequate little explanation – any philosophy.

But as for the lives of bees as relative to our own, that was probably not much to Max's taste. He once wrote, not of bees but of ants, "The ant sets an example to us all; but not a good one."

Max's 1907 drawing of Blanche combatting Maeterlinck's reluctance to be painted (plate 119) highlights the salient features of each: Blanche's baldness and moustache, Maeterlinck's prominent forehead, and his boyishness in features, haircut, posture. Blanche did in fact persuade Maeterlinck to be painted, and the portrait hangs in the Rouen Museum. Max himself, the following year, painted Maeterlinck for *Vanity Fair* (plate 120).

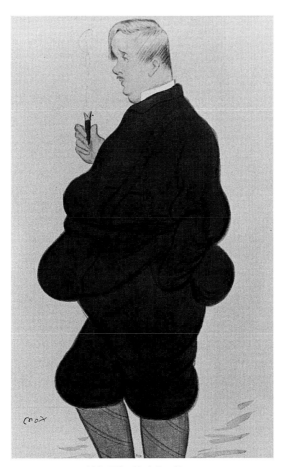

120. The Belgian Poet
[Maurice Maeterlinck. 1908]

121. "We needs must love the highest when we see it." Mr Roger Fry. 1913

ROGER FRY

Never a successful artist, Roger Fry (1866–1934) developed into the foremost art critic of his day, the most influential since Ruskin. He spent time in Italy and became an authority and renowned lecturer on Italian Renaissance art. From 1905 to 1910 he was director of the New York Metropolitan Museum of Art. He had become enamoured of Cezanne, Gauguin, Van Gogh, Matisse, and Maillol, and, back in London, he organized in November 1910 at the Grafton Galleries the first English exhibition of the modern French painters whom he himself named the "Post-Impressionists". For his efforts Fry was labelled a charlatan and a maniac. Oliver Brown of the Leicester Galleries recalls going to the exhibition and being exhorted by an old academician, "Don't go in, young man, it will do you harm. The pictures are evil." Fry, undaunted by the hysteria, had a second Post-Impressionist show at the Grafton in 1912.

The above caricature (plate 121), "We needs must love the highest when we see it" (Tennyson, *Guinevere*), was first exhibited in 1913, having been inspired by

Fry's second Post-Impressionist exhibition. The toy soldier is almost certainly a caricature of the controversial sculpture of Matisse, who was widely criticised for making sculpture that appeared to be the work of a child. The painting on the right bears some resemblance to Matisse's *Conversation*, again the subject of much controversy. The other two paintings are spoofs of "Salon Cubists", that in the centre possibly parodying André Lhote, a favourite of Fry's.

The caricature of Fry as "Law-Giver" and "first King of Bloomsbury" (plate 122, opposite) was done in 1931, after Fry had been long associated with the painters and writers of Bloomsbury. Virginia Woolf wrote that Fry was "the only critic that ever lived"; he "oozes" knowledge, she said, but gently, like some sort of "aromatic shower". He was "not only the most charming but also the most spiritually gifted of mankind...If we could all be like Roger!" This late drawing is evidence that Max could still produce true caricature, in spite of his protest that he had given up caricaturing because he had become too kind.

a Law-Giver.
Roger, first King of
Bloomsbury.

Max
1931

122. A Law-Giver. Roger, first King of Bloomsbury. 1931

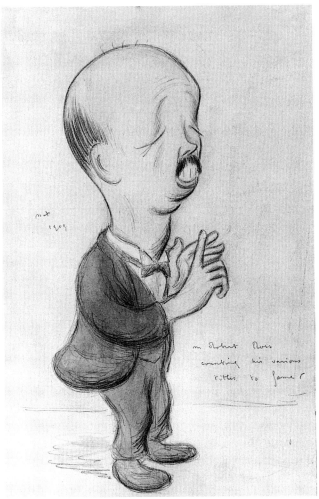

123. Mr Robert Ross counting his various titles to fame. 1909

ROBERT ROSS

Art critic and writer Robert "Bobbie" Ross (1869–1918) was Oscar Wilde's most loyal friend, his literary executor, and his editor. Ross was with Wilde when he died, as was Reggie Turner. A good friend of Max's, Ross gave him his first one-man show, in November 1901, at the Carfax, a small gallery he ran in Ryder Street. As the opening approached, Max wrote to Ross, "I have enjoyed so much all that has led up to it. You are indeed a delightful dealer to deal with." Three more Carfax Gallery exhibitions followed, in May 1904, April 1907, and April 1908.

When Ross reviewed Max's large show at the Leicester Galleries in April 1913, Max wrote to Turner that Ross's "selections" were far off the mark: the two Ross called the best were in Max's view the weakest – one was mere "cartoon mongering" and the other "feeble"; while the two Ross labelled "very poor" and "silly" were in Max's view the "two gems" in the show. Max concludes, "What a terrible thing to be an art-critic and not an artist!"

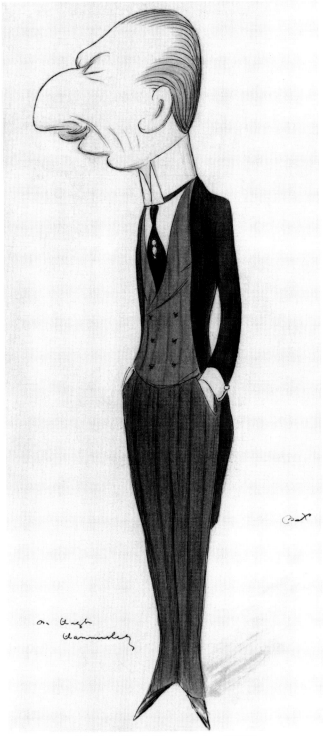

124. Mr Hugh Hammersley. [1909]

HUGH HAMMERSLEY

Wealthy banker and patron of the arts Hugh Hammersley (1858–1930) made his Hampstead home a centre for artists – Rothenstein, Steer, Tonks, Augustus John, and others. Max was a frequent guest. In 1903 Hammersley purchased Max's nine-drawing series, "The Edwardyssey" for £60 (see plates 158 and 159).

THE RED CROSS SALE AT CHRISTIE'S APRIL 1918
(Overleaf)

The large drawing of the Red Cross Sale of April 1918 is Max's most ambitious single caricature, presenting 43 individuals, placed in Christie's resplendent auction-rooms (which look today very much as they did when Max drew them). The numbered "Key (for Posterity – and others)" is Max's own guide to this most peopled of his caricatures.

During the First World War, the Red Cross and the Order of St John of Jerusalem jointly issued appeals for help, and many people sent jewelry and other gifts. Christie's was consulted about selling these items, and the auction house offered, free of charge, its staff and the use of its sales rooms. The first auction was scheduled for spring 1915, and appeals went out to collectors, artists, and others likely to make donations.

The catalogue of 351 pages described 1,867 lots, and the sale opened on 12 April 1915 and continued for twelve days. Items included a 17th century wheel-lock gun contributed by King George V (bringing £360); five MS pages of Dickens's *Pickwick Papers* (£450); a Stradivarius violin (£2,500), bought by Lady Wernher (No. 16, far right of Max's drawing), who gave it back for another sale, when it fetched £1,400. Sir Charles Russell (No. 15, standing next to Lady Wernher) persuaded John Sargent (plates 113 and 114), who had given up portraiture, to paint one more as a donation to the sale. Sir Hugh Lane, the Irish art-collector, offered to pay £10,000 for the portrait. Before a sitter was decided upon, Lane died in the sinking of the *Lusitania*; but Lane's executors commissioned Sargent to paint President Woodrow Wilson, and duly paid the £10,000. Altogether, the sale raised some £37,000.

A second sale, in April 1916, was even more successful, realizing £63,000. For this sale Max donated a specially illustrated "improved" copy of his own book of parodies, *A Christmas Garland*, which fetched 70 guineas; unfortunately, this volume has not been traced.

The 1917 sale, for the Central Prisoners of War Fund, netted £71,000. Sir Ernest Cassel (No. 36), the financier and great friend of Edward VII, donated a George I wine cistern that brought £1,995; Major Misa donated Fred Walker's famous picture *The Plough*, which went for £5,670 (to Lady Wernher, who immediately presented it to the National Gallery).

The fourth sale, 1918, the subject of Max's caricature, was the most successful, bringing some £150,000. Again, £10,000 was paid, this time by Percival Duxbury, for a future Sargent portrait. For this sale Max volunteered to do a caricature of Christie's rooms. The drawing, reproduced here, was purchased in advance by Lady Wernher and presented to Christie's, where it hangs today in the Board Room. The four Red Cross Sales, together with three other charity sales not directly sponsored by the Red Cross but contributing jointly to the Red Cross and the Order of the Hospital of St John brought the grand total to £413,000.

The pictures on the wall appear to be spoofs of 18th-century British paintings. While the source – if any – for that on the right is elusive, the others, left to right, may just possibly be burlesques of Johann Zoffany, John Hoppner and Francis Cotes.

Of the persons portrayed in this most crowded of Max's group caricatures, fifteen of them can be seen in other drawings reproduced in this book, and those curious about tracing the consistency of Max's likenesses may wish to turn to those plates.

Joseph Conrad (plates 27, 28)
Sir Claude Phillips (plate 128)
J. M. Barrie (plates 70, 71)
Edmund Gosse (plates 44–7)
Lulu Harcourt (plates 146, 147)
Henry Tonks (plates 115, 117, 118)
Alfred Sutro (plate 74)
Maurice Hewlett (plates 38, 50)
Wilson Steer (plates 111, 112, 117, 118)
Will Rothenstein (plates 62, 107–10, 117, 167, 213)
D. S. MacColl (plate 117)
Lance Hannen (plate 126)
A. W. Pinero (plates 64, 65)
Lord Curzon (plate 186)
Lord Spencer (plate 46)

Max's other crowded caricatures include Edmund Gosse's "Birthday Surprise" (plate 46, 28 figures) and the "Biassed Deputation" (plate 213, 18 figures).

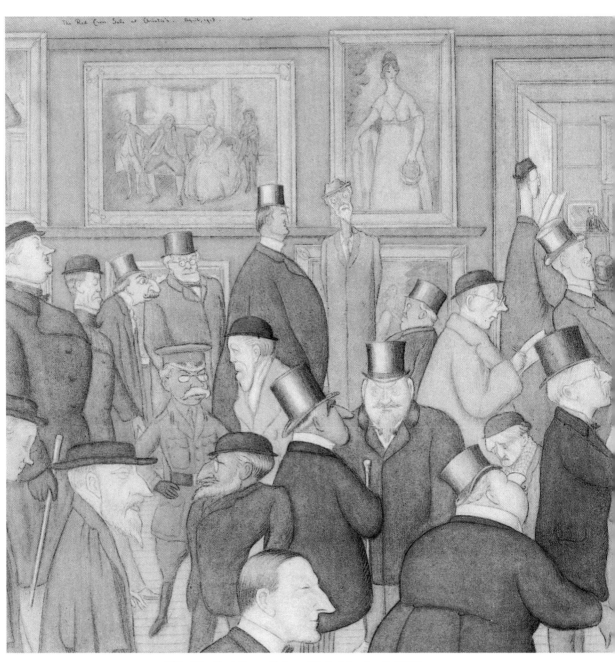

125. The Red Cross Sale at Christie's. April, 1918

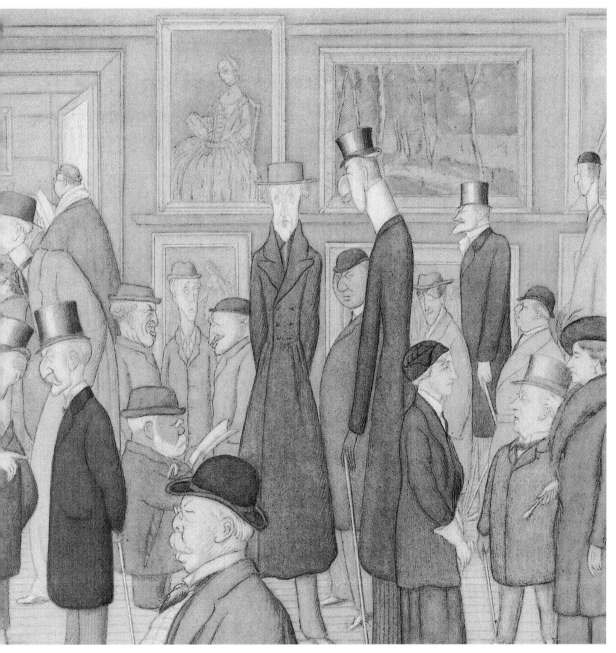

KEY (for Posterity – and others).

1. James Pryde
2. C. H. Shannon
3. Ricketts
4. Conrad
5. Anderson
6. Sir C. Phillips
7. Sir J. M. Barrie
8. Gosse
9. Lord Spencer
10. Lord Lansdowne
11. Harry Higgins
12. Lord Ribblesdale
13. Lord Harcourt
14. Quartermaster Walker
15. Sir Charles Russell

16. Lady Wernher
17. Egan Mew
18. Professor Tonks
19. Sir F. Swettenham
20. McEvoy
21. E. V. Lucas
22. Sutro
23. L. Binyon
24. M. Hewlett
25. Croal Thomson
26. Sir Frederick Milner
27. P. W. Steer
28. W. Rothenstein
29. Nevinson
30. Campbell Gordon

31. Lance Hannen
32. D. S. MacColl
33. Lawrence Hanray
34. Sir Lionel Cust
35. Sir Sidney Colvin
36. Sir Ernest Cassel
37. Sir A. W. Pinero
38. Lord Curzon
39. G. Du Maurier
40. Sir Jeremiah Colman
41. Augustine Birrell
42. Sir A. Mond
43. William Nicholson

126. A Supplement – for Mr Lance Hannen. [1918]

LANCE HANNEN

Christie's partner Lance Hannen (1866–1942) was the auctioneer for the sale that Max caricatured. Hannen's athletic prowess at Cambridge, where he stroked his university's boat to victory in the Boat Races of 1888 and 1889, was said to have anticipated his brilliant career at Christie's, where he was senior partner from 1903 to 1936. In the opinion of many, he was the greatest auctioneer of his time.

Max presented Hannen with this "Supplement" to "The Red Cross Sale at Christie's" (plate 125) because in that drawing Hannen, at his auctioneer's rostrum in the rear, was such a tiny background figure (No. 31).

CECIL HARCOURT-SMITH

Archaeologist Cecil Harcourt-Smith (1859–1944) joined the Greek and Roman Antiquities Department of the British Museum in 1879. In 1887 he was attached to the diplomatic mission in Persia; and from 1895 to 1897 he served as director of the British School at Athens (the centre of the British archaeological "industry"). In 1904 Harcourt-Smith was made Keeper of the British Museum. He was asked to take in hand the reorganization of the collections of applied art at South Kensington, collections that had grown from the objects purchased by the Government after the Great Exhibition of 1851. His report led to his becoming Director and Secretary of what became the Victoria and Albert Museum, which opened in its new building in 1909. He did much to raise the Museum to first-class status, including obtaining for his staff pay equal to that of officials of the British Museum. He was knighted in 1909.

No known comment from Max on Harcourt-Smith survives, but James Laver's description of him seems perfectly in accord with Max's drawing:

> Harcourt-Smith was a man of striking appearance, tall, slender, and erect. In his youth he was known to some as "the light dragoon"; in his age, with his white hair and moustache, his immaculate clothes and his ambassadorial manners, he was an impressive figure on all occasions.

Harcourt-Smith is surely impressive in plate 127, opposite, showing him receiving "a deputation from a Northern Town that is meditating a Museum". Flanked by narrow statues on tall slender bases, he stands similarly slender and erect, almost ethereal among the heavy-set, earthy delegates from the North. Compare plate 151, "President Wilson visiting Congress", where again the key figure, here Wilson, is slender and graceful, the surrounding congressmen uniformly gross and ugly. This Harcourt-Smith caricature seems never to have been reproduced. It is, appropriately, the property of the Victoria and Albert Museum.

127. Sir Cecil Harcourt Smith receives a deputation from a Northern Town that is meditating a Museum. 1924

ERNEST BROWN and CLAUDE PHILLIPS

Ernest Brown (1852–1915) was one of the founders (with Wilfred and Cecil Phillips), in 1902, of the Leicester Galleries in Leicester Square. Brown was a friend of numerous painters, many of whom, as caricatured by Max, are to be seen in this book: Whistler, Conder, Rothenstein, Shannon, John, Orpen, Sickert. The Leicester Galleries, largely under the influence of Ernest Brown's son and successor, Oliver Brown, presented the first one-man exhibitions in England of Cézanne, Renoir, Van Gogh, Pissarro, Matisse, Picasso, Klee, and many others. The Leicester Galleries also pioneered the practice of loan exhibitions of artists, including Cézanne, Degas, Gauguin, Van Gogh, Matisse, Picasso, Renoir, Rodin, Rowlandson, Whistler, Burne-Jones, John, Sickert, Steer, Epstein, and others.

Early in 1910 the Irish art collector Sir Hugh Lane introduced Max to the "Browns and Phillipses". Shortly thereafter, the Leicester Galleries became his exclusive place of exhibition, and it was under their auspices that his reputation soared. His first Leicester Galleries exhibition was held in 1911. Max remained at home in Italy, from where he wrote to the proprietors thanking them for what they were doing for him: "I am with you all the time, 'in the spirit'... On the spot (I am sure) I should be only a nuisance." The reviews were excellent. Desmond McCarthy, for example, said, "Max's talent is the finest and most intellectual in English caricature." Reggie Turner wrote to Max, "You have made a position which no one else has in England, a position which only the favourites of Paris get. It must be lovely. I like to see also that they are beginning to acknowledge your 'biting' power. A caricaturist such as you... is not properly treated when people say 'his work can never give offence.' 'Amiability' is not your most outstanding quality in your work, any more than 'gentleness' was Napoleon's." Max replied, "It is certainly, *unberufen* [touch wood!], very pleasant and jolly to have made this sort of wild public success – newspaper success, I mean. It remains to be seen whether this means a definite commercial success." Moderate commercial success followed, with sales exceeding £1,000 by 25 May.

The 1913 exhibition was even more successful. *The Times* began its review (which closed with the generous and unusual gesture of printing of the entire catalogue): "It is the critic's duty to praise the best of his own time as confidently as if it were 300 years old... We therefore make bold to say that we think Mr Beerbohm the greatest of English comic artists." Edward Marsh wrote that Max's caricatures would provide an "Illustrated History of England" for his period; that his work "will live with incomparable vividness in the minds of a delighted pos-

terity". Will Rothenstein wrote Max: "Without hurting anyone you seem to observe everything, where the rest of us would be assailed as spies & hirelings, for you possess the divine art of understanding. Tout comprendre c'est tout pardonner."

During the First World War, Max postponed indefinitely exhibitions of his drawings, because in the midst of tragedy and suffering they would constitute "an offense against decency... The idea is inconceivable." Thus Max's next Leicester Gallery exhibition was not until 1921. This show was an artistic and financial triumph. Max, in London, wrote to Florence at Rapallo, "It's odd that I should be such a commercial success in drawing and writing, now isn't it? I never expected anything of the sort. I just went on doing my best – and not *much* of that; and I think the commercial success is as much due to my leisureliness as to my conscience: I haven't *tired* people."

Triumphant exhibitions of Max's caricatures at the Leicester Galleries followed in 1923, 1925, 1928, 1945, 1952, and, posthumously, in 1957. Occasionally, he ran into trouble. In the 1921 exhibition Max offended the left-wing press with coarse depictions of the Labour Party. One cartoon, "The Patron", shows a future and illiterate Labour Minister of Education throwing out of his office a poet who had offered to dedicate to him what the Minister calls "your mon-you-mental translation of Pett Rark's sonnits". The *Daily Herald* exclaimed that "the only word" for the drawing was "vulgar". Max wrote a letter to the editor saying how he had never been called vulgar: "But I must say I feel the epithet inexpressibly refreshing – all the more because it is not undeserved. The drawing in question is distinctly vulgar and so is my inscription on it. Vulgarity has its uses." He had more severe difficulty with the right-wing press, which in 1923 attacked his cartoons of Edward VII, and one of the future Edward VIII. The offending drawings were withdrawn; see details provided with plates 157–59 and 164–65.

Sir Claude Phillips (1864–1924), art critic of the *Daily Telegraph*, a regular visitor to the Leicester Galleries, would routinely give its exhibitions prominent space in his columns. He was first cousin of Lord Burnham, the proprietor of the paper (see plates 167 and 173 for the facial resemblance). Phillips was Keeper of the Wallace Collection from 1897 to 1911. Oliver Brown wrote, "[Phillips] was a stout man, immaculately dressed and heavily scented, who talked continuously while he looked at the pictures. He had great knowledge and considerable influence."

Although undated, this drawing (plate 128), exhibited in the Leicester Galleries in 1913, was inspired by Max's first Leicester Galleries exhibition in April 1911.

128. Sir Claude Phillips endeavouring, under the auspices of Mr Ernest Brown, not to think
my caricatures are in the worst possible taste

IV

POLITICIANS

Max had a huge interest in politicians but none whatever in politics. He never voted. He wrote:

> I admire detachment. . . Of politics I know nothing. My mind is quite open on the subject of fiscal reform, and quite empty; and the void is not an aching one: I have no desire to fill it. The idea of the British Empire leaves me quite cold. If this or that subject race throw off our yoke, I should feel less vexation than if one comma were misplaced in the printing of this essay. The only feeling that our Colonies inspire in me is a determination not to visit them. Socialism neither affrights nor attracts me – or, rather, it has both these effects equally.

You will say, he continues, that this is "rank incivism". But he believed that most people are chiefly interested in the "purely personal side of politics". The costermonger says, "Good old Winston!" and the fashionable woman says, "I do think Mr Balfour is *rather* wonderful!" People like the drama of a conflict between interesting individuals, and the House of Commons provided many specimens of these.

In 1904 Max wrote:

> I sometimes go to that little chamber. . . wherein the Commons sit sprawling or stand spouting. . . [When] the memory of my past visit to the House has lost its edge, and when there is a crucial debate in prospect, to the House I go, full of hope that this time I really shall be edified or entertained. With an open mind I go, recking naught of the pros and cons of the subject of the debate. I go as to a gladiatorial show, eager to applaud any man who shall wield his sword brilliantly.

In the House of Commons Max was not seeking intellectual stimulation: "No one supposes that in a congeries of – how many? – six hundred and seventy men, chosen by the British public, there will be a very high average of mental capacity. If any one were so sanguine, a glance at the faces of our Conscript Fathers along the benches should soon bleed him." But his visits were not made exclusively for amusement; he wished also to "stare professionally" at subjects for caricature.

As late as 1925, on a visit to London from Rapallo, he was writing to the Speaker of the House requesting a visitor's pass for a seat "under the Gallery", because up above "one sees only crowns or heads, *plus* boots, and thus one is greatly misguided as to the senators' true appearances". He also asked for "a card enabling me to stand around for an hour or so in the Central Lobby. Let me say that I am a person of respectable appearance and deportment, and that I do not want to 'make sketches': I do my drawings from memory only."

PRIME MINISTERS IN MY DAY

In "Prime Ministers in my day" (plate 129) Max drew the eleven Prime Ministers who had ruled from the time of his birth until the date of the caricature, 1929. In "A Small Boy Seeing Giants" (a radio address of July 1936) he recounts how as a youngster he got his first mental pictures of the great politicians of his day from the weekly pages of *Punch*; and how that magazine, being firmly Liberal and Gladstonian, portrayed Prime Minister Gladstone as "always more muscular than any of his enemies, redoubtable though they too were; and the attitudes he struck were more striking than theirs". This seemed unfair to the Conservatives, and to Max himself: "For my father was Conservative, and so, accordingly, was I." Disraeli, Gladstone's old adversary for so many years, had died in 1881, when Max was nine. But Disraeli would remain always a "mythical" figure for him – one of the three most interesting men of the nineteenth century (along with Byron and Rossetti). Disraeli was "a character out of the Arabian nights"; that he was "a well-known dandy, who afterwards followed a less arduous Calling" added to his lustre. "You couldn't respect him," Max said, "you could only enjoy him." The fact that there was nothing noble or grand about "Dizzy" was part of his charm.

At the age of twelve Max began to station himself outside 10 Downing Street, "awaiting breathlessly the advent of the Giants". He did not see Gladstone at this time, but he saw the dashing Lord Randolph Churchill

129. Prime Ministers in my day – and mostly tremendous luminaries in theirs. 1929
[*Benjamin Disraeli, W. E. Gladstone, Lord Salisbury, Lord Rosebery, Arthur James Balfour, Henry Campbell-Bannerman, Herbert Henry Asquith, Andrew Bonar Law, David Lloyd George, Ramsay MacDonald, and Stanley Baldwin. This drawing was published in* The Legion Book, *ed. H. C. Minchin, 1929, and in his own copy of the book Max wrote: "Not a bad design, but a woefully dull and timid drawing – now slightly improved by pen and ink – 1930." This plate reproduces the "improved" drawing. Max has made the lines considerably stronger.*]

– Winston's father – "my chosen hero", who, Max thought, might be the one to accomplish Gladstone's downfall, in which hope he was disappointed. He did see the "noble [and] monumental figure" of Lord Salisbury, who twice defeated Gladstone; he saw the young Lord Rosebery, who would succeed Gladstone as Prime Minister for one year, only to see his party again fall to Lord Salisbury. And he saw A. J. Balfour, who in 1902 would succeed his uncle, Lord Salisbury, as Prime Minister.

Gladstone himself Max eventually saw three times. The first occasion was in 1885 from the Strangers' Gallery: "Though I regarded him as a great power for evil, he fascinated, he won me." He next saw Gladstone riding through Parliament Square on his way to introduce his first Home Rule Bill. There were both cheers and boos: "I was not among the booers," Max said, "I cheered – in spite of myself – wildly." And as an Oxford undergraduate, Max, on the steps of the Sheldonian, heard Gladstone lecture on Homer.

The other, later Prime Ministers presented here Max would see in his adult years. He points out that when as a boy he stood outside No. 10 Downing Street staring at the old Giants, "Mr Asquith was unknown to them: he was just a barrister in a fairly good practice. The present Father of the House of Commons, Mr Lloyd George, was a young solicitor, roaming nightly with bare feet and dreamful eyes along the clouded ridges of the Welsh mountains and hailing the roseate dawn. Mr Baldwin was at Harrow." Max was convinced that the latter-day Giants were small indeed, compared to those of his childhood and youth.

LORD ROSEBERY

When Gladstone retired in 1894, having been at the centre of public life for so long, his ambitious disciple, Lord Rosebery (1847–1929), became Prime Minister – for one year.

Of Rosebery's ambition, Max wrote:

Palma non sine pulvere ["No palm without dust", Cicero]...Lord Rosebery's tutor at Eton reported that he desired the palm without the dust; and dustlessly, in due time, was the palm handed to him. It is said that in his undergraduate days he told a friend that he meant to do three things: marry a Rothschild, win the Derby, and become Prime Minister. Dustlessly he did so. But he was not accounted happy in his later years.

Max recalled that when as a boy he first saw him, Rosebery was the "happy and insouciant" follower of Gladstone; but in Max's maturity Rosebery always looked "tragically sad", a sadness seen in most of his caricatures of the man.

Rosebery was another of Max's favourite targets. The Hart-Davis *Catalogue* lists 26 entries, second only to Balfour among politicians. In this book Rosebery can be seen not only below and in the previous plate, "Prime Ministers in my day", but also in the fresco called the "Edwardian Parade" which Max painted at Rapallo (plate 167).

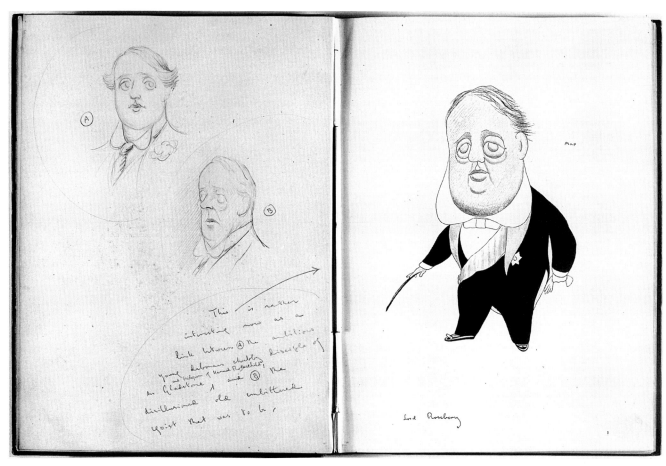

130. Lord Rosebery. [1896]
[*The figure of Rosebery in* Caricatures of Twenty-Five Gentlemen *(1896) and Max's graphic annotation from 1920: "This is rather interesting now as a link between* Ⓐ *the ambitious young debonair chubby disciple of Mr Gladstone and bridegroom of Hannah Rothschild, and* Ⓑ *the disillusioned old embittered egoist that was to be."*

131. Lord Salisbury leading the nation. [1901]

LORD SALISBURY

Conservative Lord Salisbury (1830–1903) was three times Prime Minister, 1885–6, 1886–92, 1895–1902. "His was the grand style, something Elizabethan", E. F. Benson wrote, "and he wore his office with the same indifference as his Garter robes, and that very indifference, the naturalness of it, was impressive."

HENRY CAMPBELL-BANNERMAN

Of Henry Campbell-Bannerman (1836–1908), Liberal Prime Minister 1905–1908, Max said little beyond the playful handling of his hyphenated name as seen in plate 132.

DAVID LLOYD GEORGE

Welshman David Lloyd George (1863–1945) was Prime Minister of a Coalition Government, 1916–22. In 1921 *The Times* commented of a drawing of Max's that he "makes nothing of Lloyd George, seeming to dislike him too much even for caricature" – a kind of ultimate insult. See also plates 129, 142, and 146.

132. Campbell Bannerman

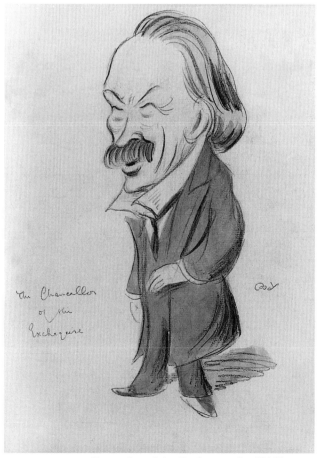

133. The Chancellor of the Exchequer. [c. 1908]
[Lloyd George]

"Enfin Seuls!"

In a world
comparatively
at peace now,
Mr Balfour
tackles Benedetto
Croce.

Max

1920

134. *"Enfin Seuls!"*
["Alone at last!"].1920

In a world
comparatively
at peace now,
Mr Balfour
tackles Benedetto
Croce.

135. The *Old and the Young Self* [A. J. Balfour]

Young Self (*faintly*): "Who are you? You look rather like Uncle Salisbury, shaved. And what is that curious thing you're holding? And won't you catch cold, with so little on? But don't answer: I don't really care. And don't let me talk: I don't fancy I've long to live; and I want to devote the time to thinking – not that I suppose my thoughts to be of much value, but – oh, do, please, go away."

ARTHUR JAMES BALFOUR
(previous pages)

Max's favourite target among politicians, Arthur James Balfour (1848–1930) was the subject of some 33 formal caricatures. In 1920 Max wrote:

> When [Balfour] was eighteen years old he believed that he had certainly not more than three more years to live, and made all his arrangements accordingly ...And then, many years later, he found himself being somehow a militant Irish Secretary and feeling a little stronger and better, though still far from well and not at all long for this world. And later on he found himself being Prime Minister for ever so long and exasperating and dominating everybody over the Fiscal Question and feeling decidedly better. And then came the crash when he lost his seat in Manchester and everybody thought his career was ended because the new Parliament, when he did get returned for another borough, wouldn't listen to him. And presently the new Parliament was sitting at his feet. And then, years later, another crash, and Bonar Law took his place. And then, opportunely, the War; England being a maritime power, Balfour must be at the Admiralty; and then, nobody but Balfour could manage Foreign Affairs; and then, Balfour was the only man whom America would welcome. And now he's President or something of the League of Nations, and constantly improving his stroke in tennis, and is plump without being fat, and has a complexion like a blush-rose, and only one ambition is left to him, who started with no ambition at all and has yet achieved so much; only one ambition (barring the wish to improve still further at tennis), *viz*, to survive *everybody*.

When "Mr Balfour – a Frieze" (plate 136, below) was exhibited at the Leicester Galleries in 1913, Max called it one of the best things in the show.

136. Mr Balfour – A Frieze. [c. 1912]

THE DUKE OF DEVONSHIRE

Lord Hartington, later eighth Duke of Devonshire (1833–1908) was for many years one of the leading politicians in the land. His influence in the Liberal Party was second only to that of Gladstone; he served in various cabinet posts and twice declined the premiership. Hartington, as the one responsible for sending General Gordon back to the Sudan, figures prominently in Lytton Strachey's *Eminent Victorians*, these lines of which Max characterized as a "beautiful presentment" of Lord Hartington:

In Lord Hartington [the English people] saw, embodied and glorified, the very qualities which were nearest to their hearts – impartiality, solidity, common sense – the qualities by which they themselves longed to be distinguished, and by which, in their happier moments, they believed they were. If ever they began to have misgivings, there, at any rate, was the example of Lord Hartington to encourage them and guide them – Lord Hartington who was never self-seeking, who was never excited, and who had no imagination at all. Everything they knew about him fitted into the picture, adding to their admiration and respect. His fondness for field sports gave them a feeling of security... They loved him for his casualness – for his inexactness – for refusing to make life a cut-and-dried business... [Here was the man who said,] "The proudest moment of *my* life was when my pig won the prize at Skipton fair." Above all, they loved him for being dull. It was the greatest comfort – with Lord Hartington they could always be absolutely certain that he would never, in any circumstances, be either brilliant, or subtle, or surprising, or impassioned, or profound... The inheritor of a splendid dukedom might almost have passed for a farm-hand. Almost, but not quite. For an air, that was difficult to explain, of preponderating authority lurked in the solid figure; and the lordly breeding of the House of Cavendish was visible in the large, long, bearded, unimpressionable face.

E. F. Benson wrote of Hartington: "His bitterest opponents could not accuse him of self seeking because . . . the man who in course of nature will become Duke of Devonshire and inherit colossal wealth and noble possessions has not very much that he can covet." After he came into his enormous properties as Duke of Devonshire, a visitor recalled telling him of the noble ruins of nearby Pevensey Castle, which belonged to the Duke, only to have him ask, "Pevensey? Whose is Pevensey?"

Max, in the last year of his life, wrote: "My favourite Duke, the most natural and monumental, is the one who had been Lord Hartington for so many years."

137. His Grace, The Duke of Devonshire, K.G.

155

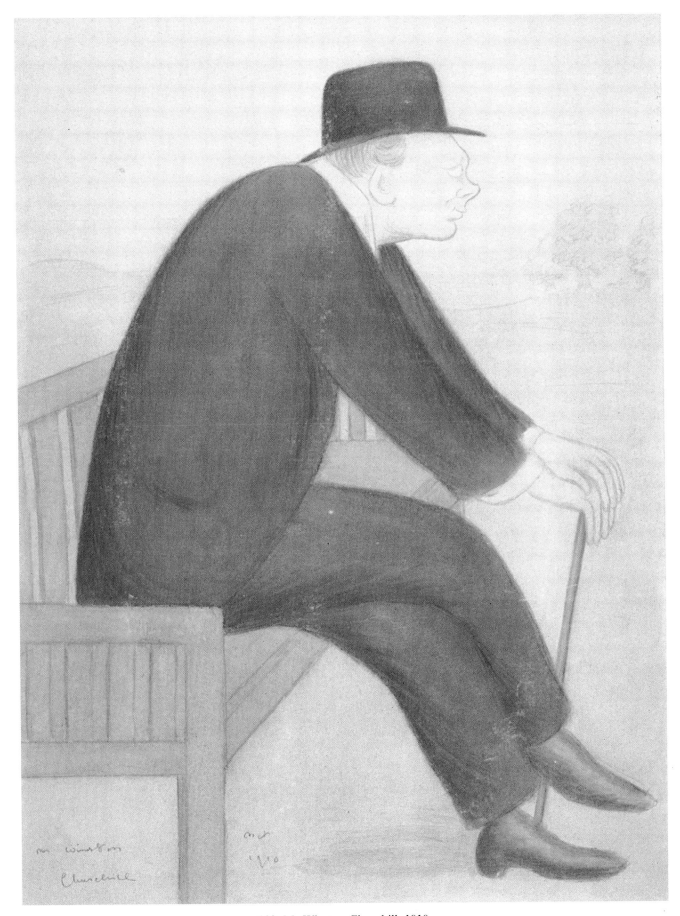

138. Mr Winston Churchill. 1910

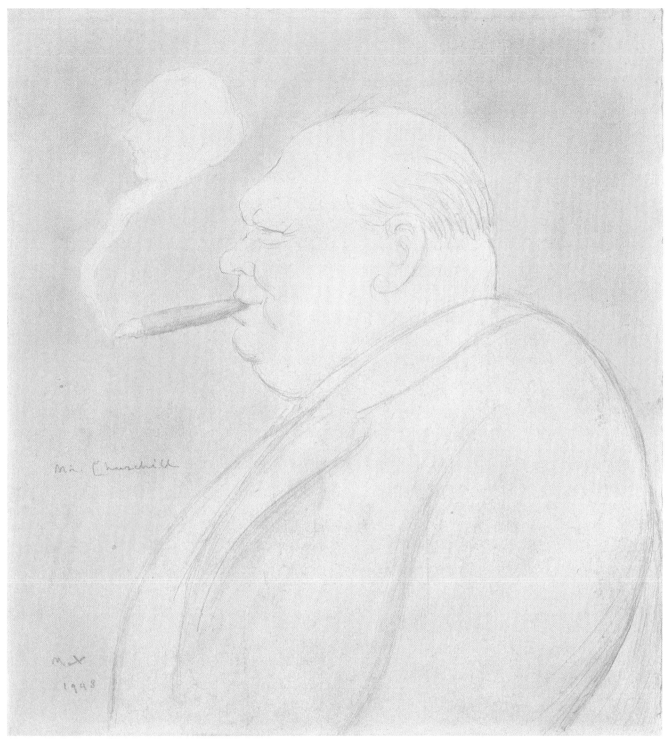

139. Mr Churchill. 1948

WINSTON CHURCHILL

Today Winston Churchill (1874–1965) is known chiefly for his Second World War leadership and oratory. But from the earliest years of the century, Churchill was one of the few politicians always in the public eye, even when out of office. He was elected to Parliament in 1901 and entered the cabinet as President of the Board of Trade in 1908; he eventually held many cabinet posts, and, while out of office in the 1930s, repeatedly warned against Hitler. On 10 May 1940, he became Prime Minister. In his early oratory, he was reckless, cocky, and vehement; in office, he was tireless but autocratic.

The 1948 drawing above (plate 139) is more portrait than caricature. Max, in his old age, looking at one of his early caricatures of Churchill, remarked, "No, I never succeeded with Winston." Churchill can also be seen in plates 146 and 159.

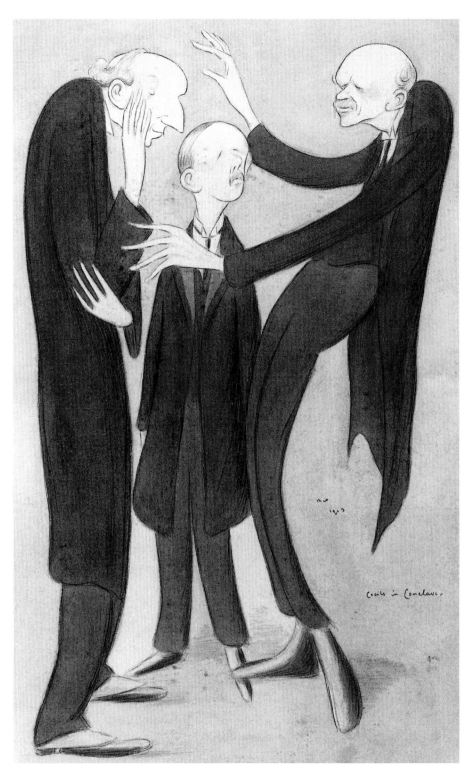

140. Cecils in Conclave

THE CECILS

All three Cecil brothers, sons of three-time Prime Minister Lord Salisbury (plate 131), were prominent Conservative politicians. Plate 140, above, left to right: Lord Robert Cecil (1864–1958), one of the drafters of the League of Nations Covenant and President of the League, awarded the Nobel Peace Prize in 1937; James Gascoyne-Cecil, Fourth Marquis of Salisbury (1861–1947), active in politics from 1885 to 1929; Lord Hugh Cecil (1869–1956), active from 1895 to 1937. Lytton Strachey met Lord Hugh in 1928: "…a very unreal figure with all the regulation Cecil charm. During a long discussion last night on the pros and cons of capital punishment, his view was that there was only one objection to it – that (as at present arranged) it involved a voluntary executioner."

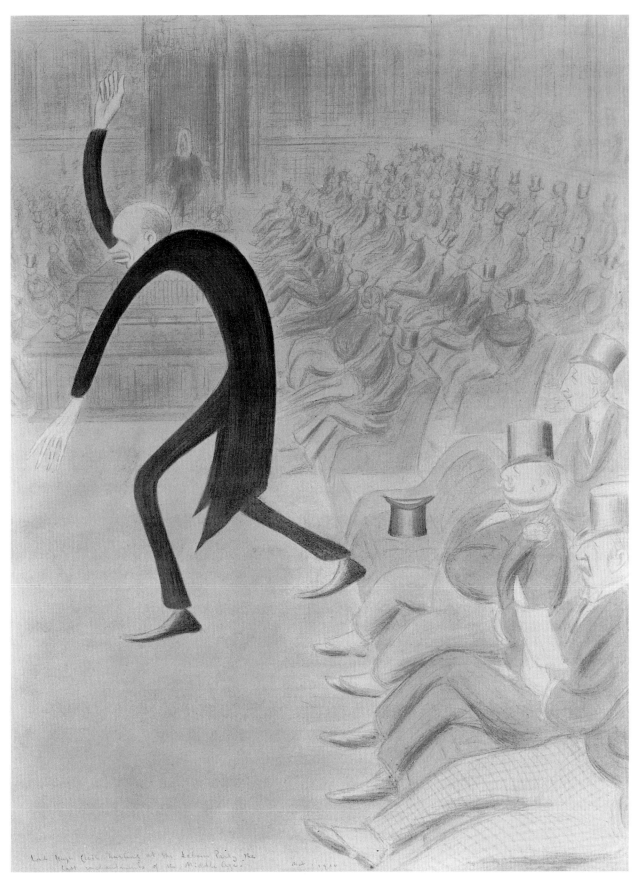

141. Lord Hugh Cecil hurling at the Labour Party the last enchantments of the Middle Age. 1910
[*Lord Hugh Cecil is doubtless protesting the Parliament Bill that was to strip the House of Lords of much of its remaining power. Matthew Arnold in his* Essays in Criticism *speaks of Oxford, "Home of lost causes, and forsaken beliefs. . .and impossible loyalties," as "whispering from her towers the last enchantments of the Middle Age."*]

142. The Cecils cross over. 1921
[Lloyd George:] "Let me have about me men that are fat, / Sleek-headed men and such as sleep o'nights"
[*Julius Caesar*, I, 2]
[*In March 1921 Robert and Hugh Cecil deserted the Coalition Government of Lloyd
George; Lord Robert explained that he had become increasingly unhappy over the
government's handling of just about everything, matters domestic as well as foreign.*]

In public and in
private life as admirable
as all Cecils are
apt to be.

143. Lord [Robert] Cecil. 1924
In public and in private life as admirable as all Cecils are apt to be.

161

144. Joseph Chamberlain as he is, and as opposed to the idea formed of him
by romantic foreign cartoonists

JOSEPH CHAMBERLAIN

One of the most forceful politicians of his day, Joseph Chamberlain (1836–1914) was a distinguished supporter of liberal and progressive legislation (except in the matter of Ireland). Max, as "a small boy seeing Giants" had been impressed with his "small side-whiskers", which in time disappeared. Chamberlain, whether seen "as he is" or in the imagination of foreign cartoonists, sports his inevitable eyeglass, orchid buttonhole, and "salient" nose. He has 23 entries in the Hart-Davis *Catalogue*. See also plates 159 and 167.

145. Lord Tweedmouth. 1907

LORD TWEEDMOUTH

The second Lord Tweedmouth (1849–1909), Liberal politician, drawn two years before his death. This was apparently Max's only caricature of him, but, in 1954, looking through his *Book of Caricatures* (1907) with Samuel Behrman, Max singled it out, from a total of 48, as "the best drawing in the book".

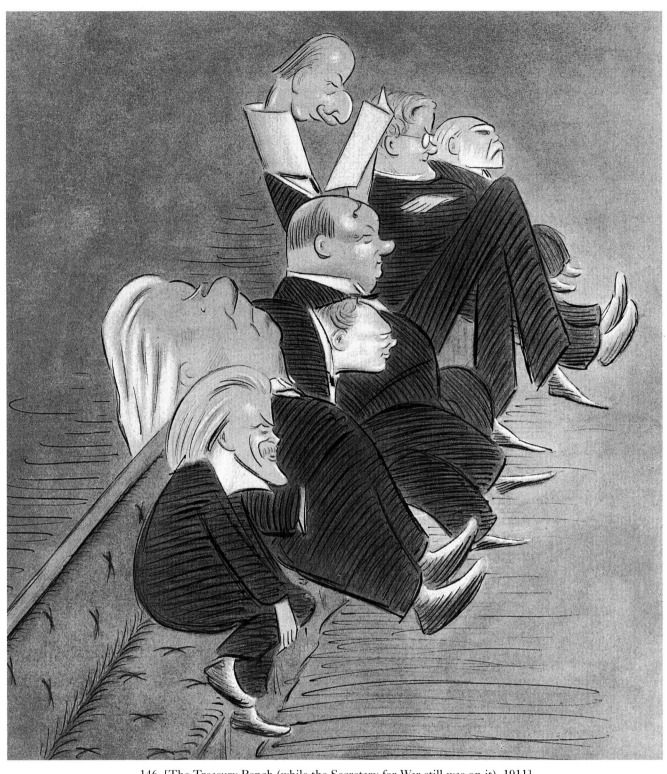

146. [The Treasury Bench (while the Secretary for War still was on it). 1911]
[*Left to right: Lloyd George, Herbert Henry Asquith, Winston Churchill, Richard Burdon Haldane (Secretary for War), L. V. Harcourt, Augustine Birrell, and John Burns.*]

THE TREASURY BENCH

In 1911 the Treasury Bench of the Liberal government
included, left to right: Lloyd George, Chancellor of the
Exchequer; Herbert Henry Asquith, Prime Minister;
Winston Churchill, Home Secretary and later First
Lord of the Admiralty; Richard Burdon Haldane,
Secretary of State for War; Lewis Vernon Harcourt,
Secretary of State for Colonies; Augustine Birrell, Chief
Secretary for Ireland (also a distinguished man of let-
ters); and John Burns, labour leader and radical MP,
President of the Local Government Board. Haldane as
War Secretary had drastically reorganized the British
Army. When he was created Viscount Haldane of Cloan
in 1911, he had to move to the House of Lords.

The great accomplishment of the Asquith govern-
ment in 1911 was the passage of the Parliament Bill,
which throttled the House of Lords, prohibiting them
from rejecting or amending money bills and limiting
their veto on any other bill to two years. Liberals, who
had suffered many recent setbacks at the hands of the
Lords, saw them as trying to damage a Liberal govern-
ment and effect a Conservative Party agenda. Firebrand
Lloyd George, whose budget the Lords had rejected,
said the Upper House was not the "watch dog of the
British Constitution" but "Mr Balfour's poodle" and
described the Lords themselves as "five hundred men,
ordinary men, chosen accidentally from among the
unemployed". The Conservatives claimed the Liberals
were attempting to "revise at ten days' notice the consti-
tution of eight hundred years". The Lords capitulated
and accepted the Parliament Bill only when it became
known that King George V would otherwise create hun-
dreds of Liberal peers to force the bill through the
Upper House.

LEWIS VERNON HARCOURT

Liberal politician Lewis Vernon "Lulu" Harcourt
(1863–1922) was First Commissioner of Works,
1905–10, and 1915–17, and Secretary of State for
Colonies, 1910–15. In 1917 he was raised to the peerage
as Viscount Harcourt. He was a trustee of the Wallace
Collection, the National Portrait Gallery, the British
Museum, founder of the London Museum (1911), and a
devoted gardener who did much to improve London
parks. For Max, Harcourt's long neck and the tilt of his
head were salient (see also plates 46 and 146).

147. Mr Lulu Harcourt

148. Mr F. E. Smith. 1907

F. E. SMITH

Frederick Edwin Smith (1872–1930) was a famous barrister and Conservative politician. His maiden Parliamentary speech in 1906, which lambasted the victorious Liberals on fiscal reform, made him a national figure. Winston Churchill said that although Smith's friends admired him for the "canine virtues...courage, fidelity, vigilance, love of the chase", the general public saw "a robust, pugnacious personality, trampling his way across the battlefields of life, seizing its prizes as they fell...Acquaintances and opponents alike felt the sting of his taunts or retorts in the House of Commons or at the Bar. Many were prone to regard him as a demagogue whose wits have been sharpened upon the legal grindstone." To Churchill, Smith "seemed to have a double dose of human nature. He burned all his candles at both ends. His physique and constitution seemed to be capable of supporting indefinitely every form of mental and physical exertion." Max drew "F. E." at least nine times.

EDWARD CARSON

Irish barrister and Conservative politician, Edward Carson (1854–1935), was the leader of the Ulster Unionists. During his long tenure in Parliament, 1892–1921, opposition to Irish Home Rule was the "guiding star" of his life. When, after numerous defeats, an Irish Government Bill became law in 1920, it provided, thanks to Carson's energies and eloquence, for the permanent exclusion of the six Northern counties. It is justly said that present-day Ulster owes its existence to Carson. Max drew the tall, large-jawed Carson at least a dozen times. One drawing, called "Unison – 1920", shows Carson with John Bull, the latter saying, "I wonder if you quite realise how utterly sick and tired of you I am," to which Carson replies, "I wonder if you quite realise how utterly sick and tired I am of meself." In the 1895 libel case brought by Oscar Wilde against the Marquis of Queensberry, Carson successfully defended Queensberry.

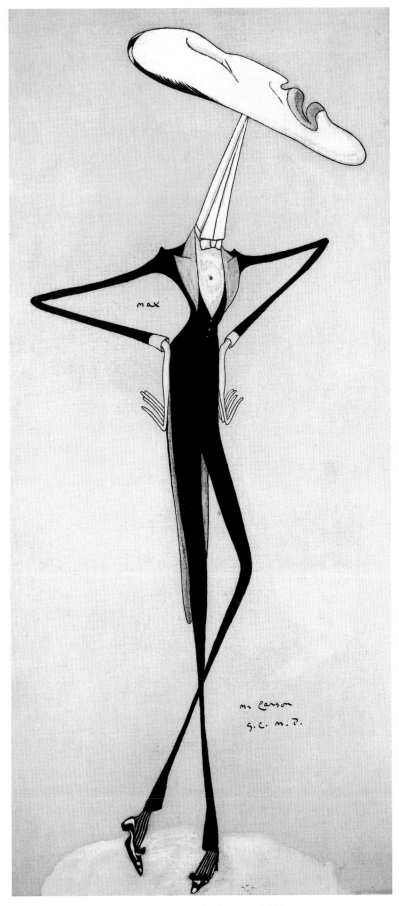

149. Mr Carson Q.C. M.P. [1900]

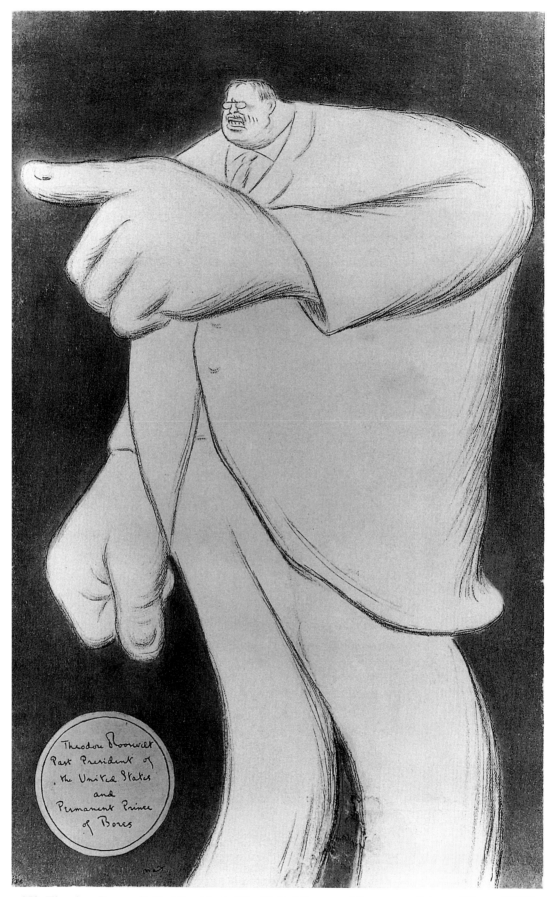

150. Theodore Roosevelt, Past President of the United States and Permanent Prince of Bores. [1912]

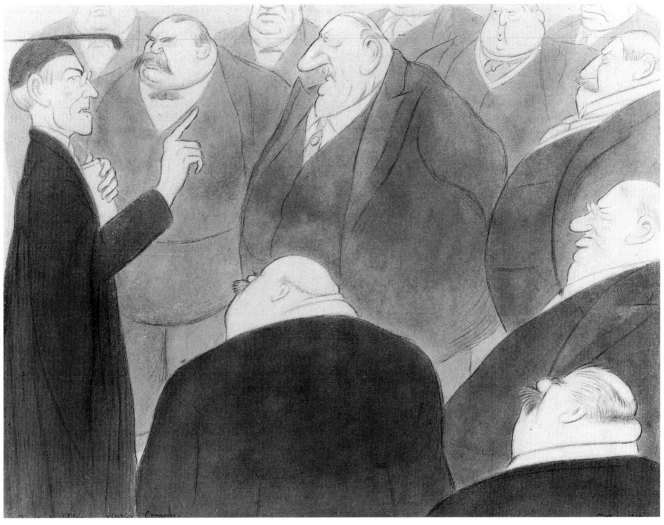

151. President Wilson addressing Congress. 1913

THEODORE ROOSEVELT

President of the United States from 1901 to 1909, Theodore Roosevelt (1858–1919), with his history as a Rough Rider and "Big Stick" President, was not the kind of man that held much attraction for Max. Out of office, Roosevelt led a big-game expedition to Africa and returned to the States via Europe, where he was much fêted. Max wrote to a friend: "... for weeks I could not open a newspaper without being confronted by the volleyed-out platitudes of that appalling bounder. I suffered and suffered." One of Max's caricatures during that time, not reproduced here, "Mr Roosevelt's visit to Europe", shows T. R. saying to Dame Europa "2 plus 2 makes 4!!!" And amid his disparagements of Kipling, Max once said, "I think (absurd tho' it is to prophesy) that futurity will give [Kipling] among poets a place corresponding exactly with the place reserved for Theodore Roosevelt among statesmen."

WOODROW WILSON

A learned academic, Woodrow Wilson (1856–1924) was a professor of history at Bryn Mawr, Wesleyan, and then at Princeton, where he served as President of the University, 1902–10. Thereafter he became Governor of New Jersey, and, in 1913, President of the United States, his election having been aided by Theodore Roosevelt's coming out of retirement and running as a third-party candidate. After the First World War, Wilson had personally made acceptance of the League of Nations Covenant part of the Versailles Treaty. But Wilson strove in vain against a Republican-dominated Senate for ratification of the Treaty and United States membership in the League of Nations. In 1919 he received the Nobel Peace Prize.

In plate 151, above, Max puts the slender, academically-gowned Wilson among a handful of gross senators and congressmen, much as in 1924 he would place the tall, graceful Cecil Harcourt-Smith amid a Northern Town deputation of fat, neckless men (plate 127).

V

ROYALTY

The chief good of royalty, Max once wrote, lay in its "appeal to that idolatrous instinct which is quite unmoved by the cheap and nasty inmates of the Elysée or of the White House...A capital without a court...is even as a garden where the sun shines not. As a flock without a shepherd, so is the Society that has no royal leader to set its fashions, chasten its follies, or dignify its whims with his approval." The Royal Family, especially King Edward VII, were among Max's most cherished targets.

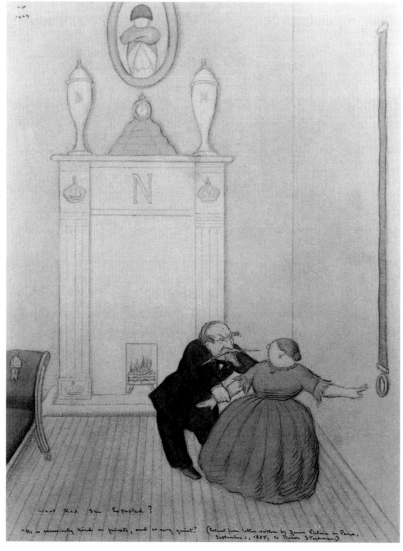

152. What Had She Expected? 1924
"He [Napoleon III] is excessively kind in private, and so very quiet." (Extract from letter written by Queen Victoria in Paris, September 1, 1855, to Baron Stockmar.)

QUEEN VICTORIA

Max, who seldom caricatured women, nonetheless drew Queen Victoria (1819–1901) at least nine times. This caricature (plate 152), along with "Mr Tennyson reading 'In Memoriam' to his Sovereign" (plate 196) has passed into the iconography of the Queen and her reign. In 1920, while Lytton Strachey was working on his *Queen Victoria* (see plate 55), Max wrote to him of the "extraordinarily congenial problems that Q.V. offers …in her tough strength and ability and the delicious *personal* (never *positional*) silliness in which she abounds".

During Queen Victoria's mournful, unending, reclusive widowhood after Prince Albert's death in 1861, she found terrible trials in the unceasingly hedonistic life of her eldest son, Albert Edward ("Bertie"), the Prince of Wales.

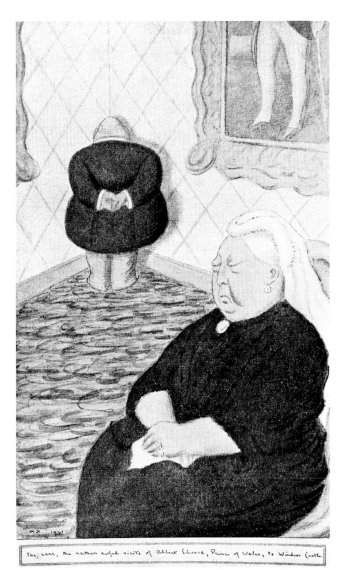

153. The rare, the rather awful visits of Albert Edward, Prince of Wales, to Windsor Castle. 1921

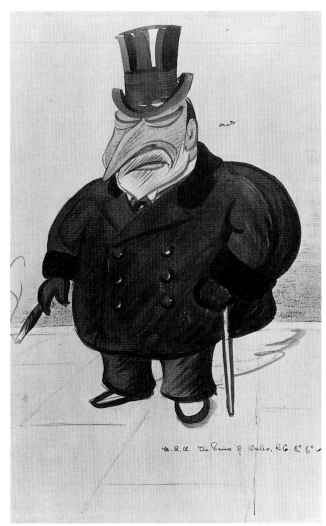

154. H.R.H. The Prince of Wales, K.G. &c &c–

KING EDWARD VII

Both as Prince of Wales and as King, Edward VII (1841–1910) was Max's favourite subject. The Hart-Davis *Catalogue* lists 72 caricatures of him (a number surpassed only by self-caricatures; see Chapter VIII). The Prince and later King was vulgar: he had next to no book learning; he cared little for the arts beyond theatre-going; his delights were the race course, the gambling table, food and drink, and, notoriously, philandering. In addition to countless brief liaisons with all kinds of women, from duchesses to prostitutes, Edward had three more or less "official" mistresses: Lillie Langtry, the actress; "Daisy" Maynard, the proletarian-sympathizing Countess of Warwick; and Mrs George Keppel, mistress during his reign as Edward VII. The last named was summoned, in the Queen's presence, to his deathbed.

Students of the subject place much of the blame for Edward's irregular life on Queen Victoria, who denied him any useful activity as Prince of Wales. She pointedly

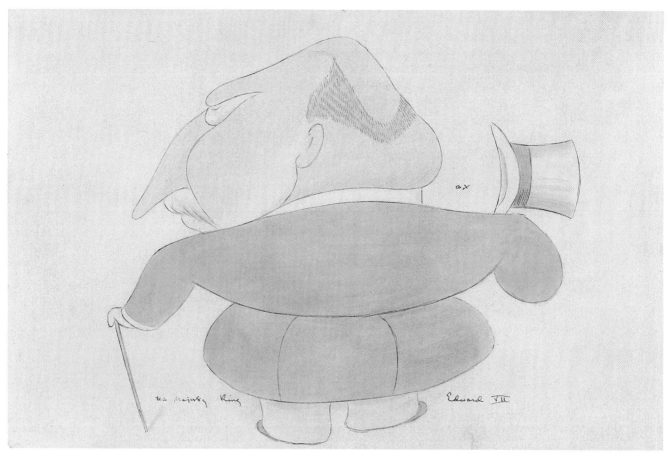

155. His Majesty King Edward VII

forbade any consideration of his serving as Viceroy of Ireland (something Gladstone had urged on four different occasions):

> It was therefore [writes E. F. Benson] not only natural but laudable that . . . he used his energies in enjoying himself, for which also he had a very enviable aptitude. He was handsome, he was popular, he had tearing spirits, and if he was not allowed to fill the proper office of Prince of Wales. . . he must occupy himself by making the most of a Prince's pleasures . . . Being debarred from being *bon ouvrier*, there was really nothing for him to do except be *bon vivant*. To him more than to anyone was due the break-up of the mid-Victorian social tradition of frozen pompous dignity, and all its repressions and reticences.

Max, while still a schoolboy, began caricaturing the Prince of Wales, and never left off. There are those who feel Max despised Edward, but their view fails to take into account Max's sense of fun, his love of irony, his genuine delight in anything touching the ridiculous, his broad sympathy for simple souls, whatever their position in life. An acute observer, he felt genuine affection for the Prince, all the greater for his forthright shortcomings. In an early essay, "Diminuendo" (1895), Max speaks of his fascination with the "prodigious life" of the Prince of Wales:

What experience has been withheld from His Royal Highness? Was ever so supernal a type, as he, of mere Pleasure? How often he has watched, at Newmarket, the scud-a-run of quivering homuncules over the vert on horses, or, from some night-boat, the holocaust of great wharves by the side of the Thames; raced through the blue Solent; threaded *les coulisses* [spent a lot of time backstage]! He has danced in every palace of every capital, played in every club. He has hunted elephants through the jungles of India, boar through the forests of Austria, pigs over the plains of Massachusetts. From the Castle of Abergeldie he has led his Princess into the frosty night, Highlanders lighting with torches the path to the deer-larder, where lay the wild things that had fallen to him on the crags. He has marched the Grenadiers to chapel through the white streets of Windsor. He has ridden through Moscow, in strange apparel, to kiss the catafalque of more than one Tzar. For him the Rajahs of India have spoiled their temples, and Blondin has crossed Niagara along the tight-rope, and the Giant Guard done drill beneath the chandeliers of the Neue Schloss. Incline he to scandal, lawyers are proud to whisper their secrets in his ear. Be he gallant, the ladies are at his feet.

Of course, the Prince could not be expected to strive after things of the mind: "I do not suppose that, if we

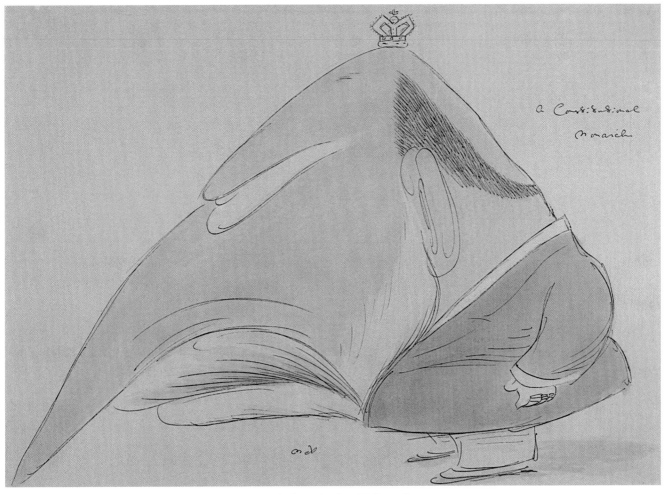

a Constitutional Monarch

156. A Constitutional Monarch

were invited to give authenticated instances of intelligence on the part of our royal pets, we could fill half a column of the *Spectator*. In fact, their lives are so full they have no time for thought."

And in another early essay, "At Cowes" (1898), Max tells of seeing the Prince's royal yacht, the *Osborne*, at anchor in the harbour:

> At the end of the *Osborne*'s deck is a little glass-house, and therein – not visible to us, but therein nevertheless – the Heir Apparent. All day long, the parade is lined by Americans and others, looking through telescopes at the glittering panes of this pavilion. The strongest lens reveals no glimpse of His Royal Highness, but no one seems to despair... All day long pinnaces, gigs, whatnots, emblazoned with three white feathers, pass to and fro between the yacht and the landing-stages, objects of intense interest. The blue-jackets that step out of them are cynosures – we know that they have been near the rose, and we note that their faces are tanned with reflected glory. To me there is something strangely impressive in this sense of a great unseen presence, a something not ourselves which yet directs and controls the hearts of us at all

hours... The Prince is in his yacht: All's right with the Roads... Twice a week, in the evening, a band plays on the Parade. During "God bless the Prince of Wales" we all look toward the yacht, sure that those red-shaded lights illumine a duly-gratified smile. Never was so absolute an obsession.

When Edward finally became King in 1901, he took to the office with great vigour. To quote again the admiring E. F. Benson: "The King was a king indeed ...He made his royal visits to foreign courts, and at home his own blazed again after the widowed quiescence of forty years. No longer was the monarch a craped sequestered presence... but a power apparent everywhere."

As King, Edward fascinated Max more than ever. He drew him constantly and unsparingly. One of Edward's most "salient" features was his large, pointed nose. Max said, à propos of the King, "The noses of fat men do not follow suit with the rest of them as they age. The noses become, if anything, sharper, thinner." Edward's nose is always prominent in the caricatures, but in "A Constitutional Monarch" (plate 156, above) it assumes proportions that make it special among the many "monstrous" variations Max inflicted on the human body.

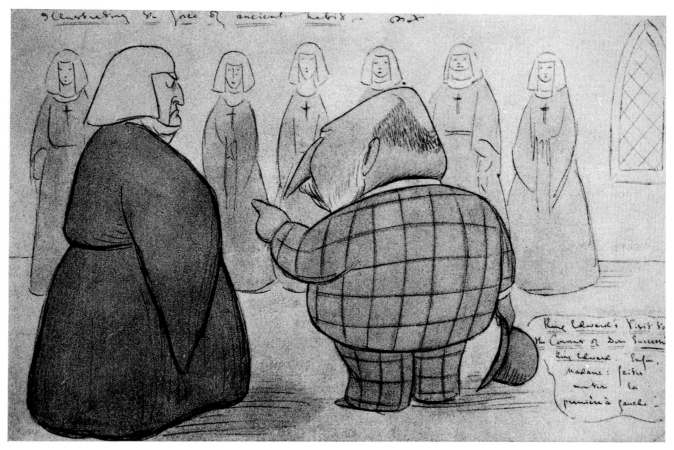

157. Illustrating the force of ancient habit. [c. 1903] King Edward's Visit to the Convent of Dom Successio.
King Edward: "Enfin, Madame: faites monter la première à gauche." ["So, Madame, let me see the first on the left."]

The King's famous and seemingly insatiable womanizing was an almost unavoidable theme for his most attentive caricaturist. Max's series of eight drawings, done in 1921 and exhibited at the Leicester Galleries in 1923, is jokingly titled "Proposed Illustrations for Sir Sidney Lee's forthcoming Biography." The drawings show "H. R. H." in each decade of his life, always with a woman in the background; the final drawing depicts Edward in heaven, with halo and harp, the royal initials having been changed to "A. E." (Angel Edward). The right-wing press was outraged: "Teutonically brutal", "a scarifying exhibition", "The end of Max Beerbohm", the work of "a shameless bounder or a stealthy Bolshevist". Max wrote to the Leicester Galleries, saying that "no principle is involved. The question is one of taste merely", and if they as proprietors of the gallery thought it better to remove the offending drawings, they should feel free to do so. The caricatures, Max said, were "conceived, as you know, in a spirit of light-hearted fantasy; but if the public is likely to read any shadow of seriousness into them, and accordingly to regard them as unkind and even 'disloyal', I think it would be well to avoid this misunderstanding of my disposition". The Leicester Galleries withdrew the drawings. Eventually the Royal Family purchased them and kept them at Windsor: "The tenants keep them behind a panel in the drawing room", Max recalled for Samuel Behrman. "I am told that when they have people they are cozy with, they take them out from behind the panel and show them." That series is actually rather tame compared to "Illustrating the force of ancient habit" (plate 157, above), drawn in response to the King's highly successful round of visits on the Continent, March through May 1903. The same tour inspired the nine drawings of the Edwardyssey, of which the first and last are reproduced opposite (plates 158 and 159).

A reviewer of Max's 1952 retrospective exhibition at the Leicester Galleries said, "Historians may write as they will, but Edward VII will always appear as he does in Beerbohm's drawings."

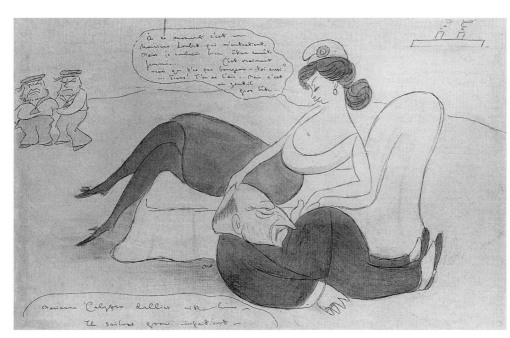

158. Marianne Calypso dallies with him – The sailors grow impatient.
[Marianne:] "A ce moment c'est un Monsieur Loubet qui m'entretient. Mais je voudrais bien être honnête femme …C'est vraiment vrai que t'es pas bourgeois – toi aussi?… Tiens! T'en as l'air. Mais c'est un gentil gros tête…" ["Right now a Monsieur Loubet is keeping me. But I would like very much to be an honest woman. Is it really true that you are not conventional – you too? …My! You look like it. What a nice old head…" *Emile Loubet was President of France at the time.*]

159. The Happy Ending.
"Whosoever shall smoke the cigar of Edwardysseus, him will I wed." [*The faithful "Penelope Alexandra" had been besieged by suitors, who are now all confounded. Left to right: Sir Thomas Lipton, Alfred Harmsworth, Lord Rosebery, Sir Ernest Cassel, Lord Burnham, Wilson Barrett, Winston Churchill, Hall Caine, Joseph Chamberlain.*]

160. All Things to All Men. 1921
The Late King Edward at Balmoral.

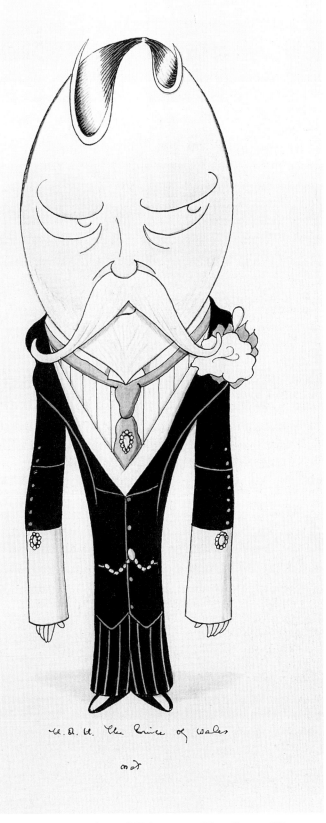

161. H.R.H. The Prince of Wales [Later King George V]

King Edward's second son, George V (1865–1936), whose chief interest had always been the navy, became heir apparent only in 1892 (on the death of his brother the Duke of Clarence), and King in 1910.

Max attended the Opening of Parliament in 1914 and wrote to his wife of seeing the procession of the King and Queen:

And after they had passed I found myself with tears in my eyes and an indescribable sadness – sadness for the King – the little King with the great diamonded crown that covered his eyebrows, and with the eyes that showed so tragically much of effort, of the will to please – the will to impress – the will to be all that he isn't and that his Papa *was* (or seems to him to have been) – the will to comport himself in the way which his wife (a head taller than he) would approve. Oh such a piteous, good, feeble, heroic little figure. I shall never forget the sight.

And when George V died on 20 January 1936, Max wrote a friend, "I am told that Mrs Kipling very much resents the death of the King at so solemn a moment [Kipling died on January 18]. For my part, I genuinely mourn that transcendently decent and loveable King." Still, for private circulation Max had written a "Ballade Tragique à Double Refrain" in which a Lady-in-Waiting and a Lord-in-Waiting argue over who is duller, the King or the Queen. The Lord eventually stabs the Lady and then drinks strychnine, repeating the refrain as he dies, "The King – is – duller than the – Queen." The poem is said to have delayed Max's knighthood for two decades. "Kind friends sent it to them", he explained.

162. Duties and Diversions of this Sweeter, Simpler Reign.
King George inspecting an Infant School

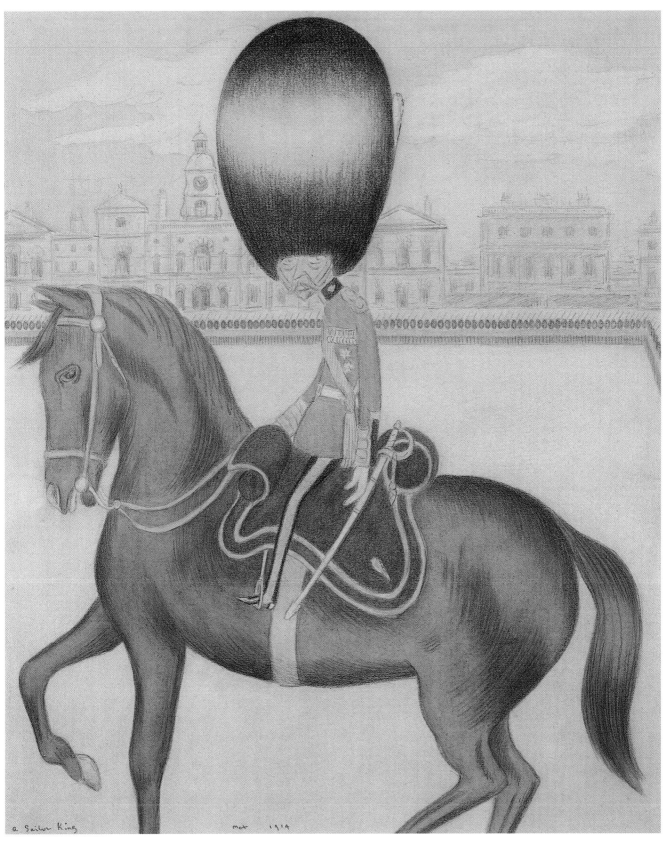

163. A Sailor King [George V]. 1914

KING EDWARD VIII

Eldest son of King George V, Edward VIII (1894–1972) reigned but briefly, his abdication within less than one year occasioned by his intention of marrying a twice-divorced American woman, Mrs Wallis Simpson.

After a haphazard education and a brief naval career, he was sent, completely unprepared, to Magdalen College, Oxford, where one tutor said the Prince was "like a lost lamb". He "spent eight 'desultory terms' at Oxford, got drunk, and joined the officers' corps before he was whisked away without any academic achievement whatsoever to his name." Max's cartoon (plate 164), shows the Prince presumably at the time of his arrival at Magdalen in 1912. When the drawing was exhibited at the Leicester Galleries in 1913, Edward Marsh remarked in a review that Max's groups of types, such as this one, are "miracles of invention", the individuals adding up to a "wonderful *ensemble*". Max himself said he considered this drawing "merely a bit of labourious cartoon-mongering". Compare a similar ensemble in "Mr Robert Browning, taking tea with the Browning Society", plate 197.

Edward never got along with his father, who objected to his unrestrained partying wherever he went (see plate 165) and disapproved of his relationship with a married woman – not Mrs Simpson, but Freda Dudley Ward – "the lacemaker's daughter" as the King called her.

Max, on the death of George V, wrote: "I'm sadly doubtful of the future effects of E. 8. But of course he *may* turn out all right". But of course he didn't. Edward had already become involved with Mrs Simpson, and had showed himself dangerously friendly with Nazi Germany (he would remain a Nazi-sympathiser even after the Second World War began). Max, as early as 1922, had drawn a cartoon that jokingly "divined" trouble to come. Called "Long choosing and beginning late [Milton, *Paradise Lost*]", its caption purported to be an extract from *The Times* of 10 November 1972:

An interesting wedding was quietly celebrated yesterday at the Ealing Registry Office, when Mr Edward Windsor was united to Miss Flossie Pearson. The

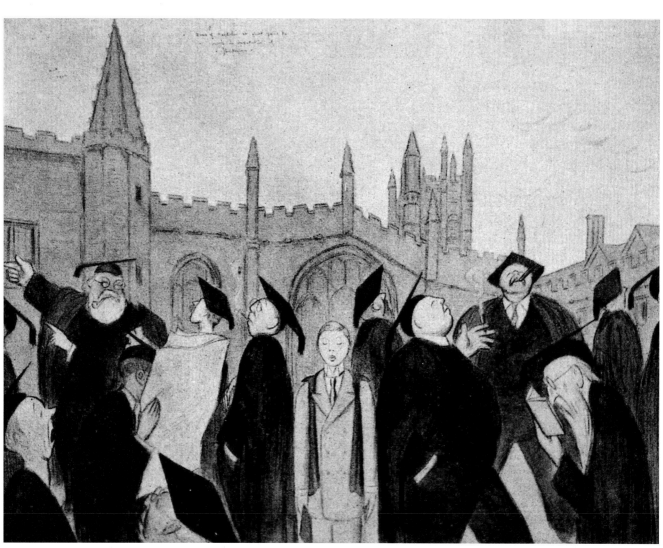

164. Dons of Magdalen at great pains to incur no imputation of flunkeyism. 1912

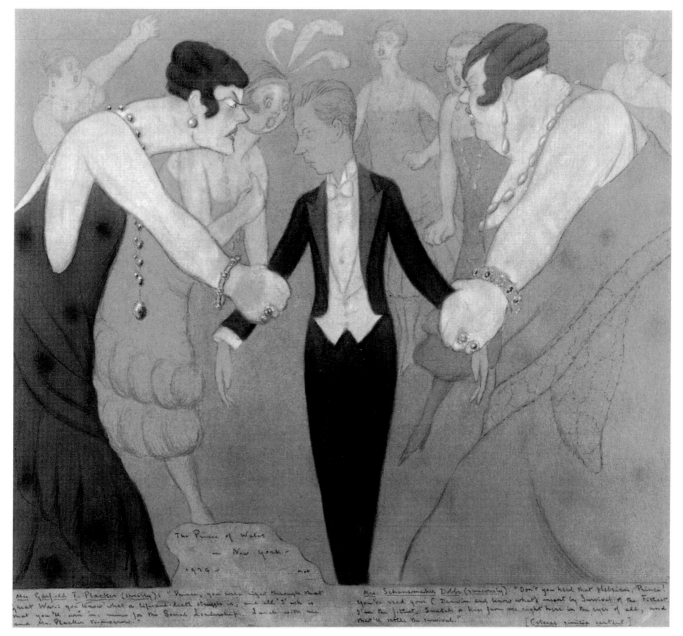

165. The Prince of Wales in New York. 1924

Mrs Garfield T. Placker (*shrilly*): "Prince, you were right through that Great War: you know what a life-and-death struggle is; and all I ask is that you'll win me mine for the Social Leadership. Lunch with me and Mr Placker tomorrow."

Mrs Schanamaker Dobbs (*raucously*): "Don't you heed that plebian, Prince! You've read your C. Darwin and know what's meant by the Survival of the Fittest. I'm the fittest. Snatch a kiss from me right here in the eyes of all, and that'll settle the survival."

(Ceterae similia cantant [The others sing the same song].)

bridegroom, as many of our elder readers will recall, was at one time well-known as the "heir-apparent" of the late "King" George. He has for some years been residing at "Balmoral", 85 Acacia Terrace, Lenin Avenue, Ealing; and his bride is the only daughter of his landlady. Immediately after the ceremony the happy pair travelled to Ramsgate, where the honeymoon will be spent. Interviewed later in the day by a *Times* man, the aged mother-in-law confessed that she had all along been opposed to the match, because of the disparity between the ages of the two parties –

the bride being still on the sunny side of forty. "I had always," she said, "hoped that my Flossie was destined to make a brilliant match." Now that the knot was tied, however, the old lady was evidently resigned to the *fait accompli*. "I believe," she said, "that Mr Windsor will make a good husband for my girl, for I must say that a nicer, quieter gentleman, or a more pleasant-spoken, never lodged under my roof."

That caricature was one of the items which, after public outcry, was withdrawn from the 1923 Leicester Galleries exhibition.

166. Mid-Term Tea at Mr Oscar Browning's. 1908

[*Crowned heads of Europe include: Franz-Josef of Austria-Hungary, Gustav V of Sweden, Nicholas II of Russia, George I of Greece, Alfonso XIII of Spain, Abdul Hamid II of Turkey, Wilhelm II of Germany, Victor Emmanuel III of Italy, and Leopold II of the Belgians. The other figures are undergraduates.*]

OSCAR BROWNING

Cambridge don, historian, and "character", Oscar Browning (1837–1923) remains famous for introducing himself to Tennyson by saying "I am Browning", to which Tennyson replied, "No, you're not" and declined to listen to any explanation. E. F. Benson said of "O. B.":

> ...he would have been notorious and absurd and remarkable anywhere...He was a tragic instance of such stupid jokes as Nature plays when, after she has formed by means of cosmic pressures and secular incandescences some noble gem, she proceeds with a silly giggle, to plant a fatal flaw in the very heart of it. He was a genius flawed by abysmal fatuity...He could think on big lines, he could strike out great ideas, he had wit, he had the power of planning largely and constructively...But it was impossible not to be aware that he was a buffoon.

Among his eccentricities was "an amiable and insatiable passion for intercourse with the eminent". Browning, "although waddling with obesity,...took to playing hockey simply for the pleasure of being wiped over the shins by H. R. H. Prince Edward of Wales when he was an undergraduate at Trinity". During holidays, Browning "went up to London for a month, taking lodgings as nearly as possible opposite Marlborough House". It was said that once, on returning from his London lodgings, he remarked that William II of Germany was "one of the nicest emperors he had ever met". Browning left Cambridge "in a huff", in 1908, convinced that his colleagues at King's had not accorded him the respect he deserved. He retired to Bexhill, where the town's mayor converted him to Christian Science ("Such a convenient creed", Browning said, "it banishes the sense of sin").

Max pictures him (plate 166) in the last year of his Cambridge life, 1908, surrounded by the company he loved best.

167. [Edwardian Parade. 1922]
[*Left to right: King Edward VII, Marquis de Soveral, Joseph Chamberlain, Henry James, Lord Rosebery, Reggie Turner, A. W. Pinero, Will Rothenstein, George Moore, Rudyard Kipling, Lord Burnham, and Winston Churchill.*]

EDWARDIAN PARADE

Max began painting frescoes on the walls of the Villino Chiaro in 1922. He wrote to his wife's niece, Alexandra Kahn:

> I have become a percher aloft on precarious ladders, a painter of domestic frescoes. I have done a fresco in the embrased arch over the green door of the spare bedroom, and another above the high-up fanlight in the hall. I think they look very jolly and Giottesque. Florence is not so sure about them; but there they are, to impress posterity; and I meditate some other designs for other eligible gaping and inviting spaces on our premises. Have you ever worked on the top of a ladder? It is exhilarating, bracing, and great fun. One may fall and be fractured or killed at any moment. One faces death but sees only one's art. And one *sings* all the time.

Max painted four frescoes in his Rapallo house: one of D. G. Rossetti, Swinburne and Lizzie Siddal; another of Zuleika Dobson; another of a large group of writers and artists headed by Edmund Gosse; and the work reproduced above (plate 167), often referred to as the "Edwardian Parade". Max wrote on a sketch for this mural, which decorated his bedroom, "The faces are the faces that have come easiest to me – lines of least resistance to the budding frescoist." The "Parade" is led by his very favourite subject, King Edward VII. (The "Edwardian era" may be said to have encompassed not only the years of the King's reign, 1901–10, but the decade of the 1890s when, as Prince of Wales, Edward led the social life of the nation from Marlborough House.) Edward VII is followed by his close friend, the Marquis de Soveral, Portuguese Ambassador and London social star (plates 182–84); Joseph Chamberlain, powerful politician (plate 144); Lord Rosebery, Prime Minister (plates 129 and 130); Reggie Turner – famous chiefly in Max's eyes – (plates 9 and 10); Arthur Wing Pinero, the most popular playwright of the time, much to Max's disgust (plates 64 and 65); Henry James, at the height of his prowess as "The Master" (plates 25–7); Will Rothenstein, artist (plates 107–10); George Moore, Irish writer and eccentric (plates 31–5); Rudyard Kipling, the uncrowned Poet Laureate of the English people (plates 21–4); Edward Levy-Lawson, Baron Burnham, proprietor of the largest circulation London paper, the *Daily Telegraph*, and close friend of Edward VII (plate 173); and Winston Churchill, then a young, flamboyant, controversial, rising politician (plates 138 and 139).

The mural highlights the noses of its subjects: the extravagantly long, sharply pointed noses of Edward VII, Chamberlain, and Pinero; the "bulbous, dispersed" nose of Turner; and the huge, rounded nose of Lord Burnham.

Most of these characters, except of course the King, appear again in the "biassed deputation" (plate 213) urging Max, "in the cause of our common humanity, and of good taste, to give over".

VI

AND OTHERS

Max Beerbohm caricatured, according to the Hart-Davis *Catalogue*, almost 800 "real people". The foregoing chapters have focused on writers, playwrights, actors, artists, politicians, kings, princes. But Max also drew lawyers, musicians, professors, financiers, restaurateurs, sportsmen, newspaper magnates, dandies, tailors, industrialists, landowners. This chapter offers typical caricatures from these latter categories. While a few individuals, such as Enrico Caruso and John Philip Sousa, are still well known, most are now all but forgotten celebrities of Max's time.

GEORGE LEWIS

The most successful and fashionable solicitor of his age, Sir George Lewis (1833–1911) was friendly with both the Queensberry family and Oscar Wilde, and Lewis refused to act for either side during Wilde's libel suit against Lord Queensberry (see under plate 6).

In 1920 Max annotated this drawing from the *Caricatures of Twenty-Five Gentlemen* (1896) as "the best thing in the book – a really good synthesis and simplification".

168. Sir George Lewis. [1896]

LORD LONSDALE

Hugh Cecil Lowther, fifth Earl of Lonsdale (1857–1944), was a great sportsman. Sports of all kinds attracted him. He had hoped to be an amateur jockey until his weight made this impossible. He showed great prowess in the boxing ring – while sparring with John L. Sullivan, Lowther knocked the champion down. At 21 he vowed never to bet on a horse or play cards for money. He became Master of Fox Hounds of the Woodland, Pytchley, Blankney, Quorn, and Cottesmore hounds. H. E. Wortham says Lonsdale was "the idol of the Victorian and Edwardian populace. With his side-whiskers, his nine-inch cigars, his gardenia buttonhole, he was to the crowds the perfect specimen of the sporting grandee."

Max fits him out in his own light-grey "Lonsdale tweed", made specially for his family from wool of his own sheep on his splendid properties in Cumberland and Westmorland.

170. Lord Lurgan. [1890s]

LORD LURGAN

William Brownlow, third Baron Lurgan (1858–1937), was a sportsman and landowner. He was chairman of the Carlton Hotel, the Ritz Hotel, Booth's Distilleries, John Watney, and director of various other companies. He owned some 13,500 acres. A leading sportsman, he gave up horse racing just before the First World War, and concentrated on his golf game: in its obituary *The Times* remarked that Lord Lurgan "was one of the few peers ever to have done a hole in one".

169. Lord Lonsdale

171. A Patron of Opera [Alfred de Rothschild. c. 1904]

ALFRED DE ROTHSCHILD

Alfred de Rothschild (1842–1918) was the second son of Lionel Nathan de Rothschild, the famed head of the Rothschild banking house in England. Lionel had become in 1858 the first Jew to sit in the House of Commons, after a decade-long struggle against the House of Lords, which opposed allowing him to take a non-Christian Parliamentary oath. Alfred, while at Cambridge, began his great and lifelong friendship with the Prince of Wales (later King Edward VII), to whom his carefree bachelor ways appealed. Although a Director of the Bank of England, Rothschild's chief interests were the arts. His elaborate French-style chateau in Buckinghamshire housed great works by the likes of Gainsborough, Reynolds, Hobbema, Boucher, Cuyp, and Watteau. He worked assiduously to enrich the national art museums, and became a Trustee of the Wallace Collection, the National Gallery, and the Tate Gallery.

BARON HENRI DE ROTHSCHILD

A member of the French branch of the family, Baron Henri de Rothschild (1872–1947) was a prominent physician and an authority on children's diseases; he was also an author, playwright, and a Commander of the Legion of Honour. Doubtless Max considered most Rothschilds "Fortune's Favourites".

172. One of Fortune's Favourites.
Baron Henri de Rothschild. 1925

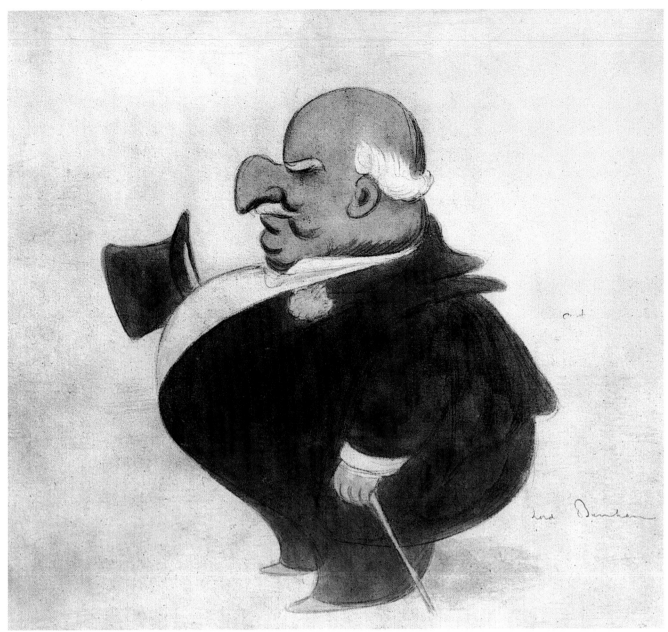

173. Lord Burnham

LORD BURNHAM

Edward Levy-Lawson (1833–1916) was proprietor of the *Daily Telegraph*, which for a long while had the largest circulation of any London daily newspaper. He was made Baron Burnham in 1903, by which time he was "universally recognized as the doyen of English journalism" – even by Lord Northcliffe (see next page, plate 174). He was a clubable, popular London figure, much given to the high life. He was a close friend of Edward VII, who as Prince of Wales and as King paid yearly visits to Hall Barn, Burnham's country house near Beaconsfield, in Buckinghamshire. He was thought by many people – and maybe by Max – to be the father

of Max's great friend Reggie Turner (plates 9 and 10).

Burnham's most "salient" feature in Max's caricatures was his nose, which Max's friend in old age, Samuel Behrman, said was "capable of serving, by itself, as the figurehead of a Roman galley, sharp, finlike, and, to use one of Max's favourite words about strenuous people, 'propulsive.'" A pet subject for Max, Lord Burnham appears in some 20 caricatures, including group drawings that brought together Max's favourite subjects – such as the "Edwardian Parade" fresco (plate 167), the "Happy Ending" of the Edwardyssey (plate 159) and the "Biassed Deputation" (plate 213).

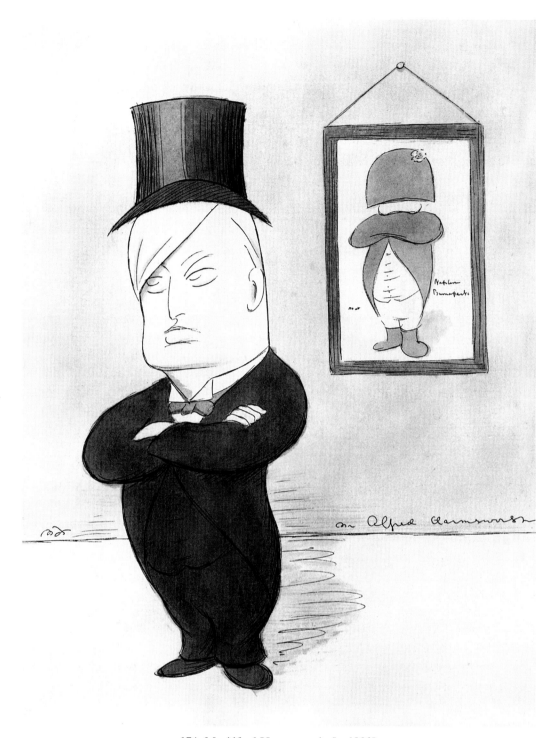

174. Mr Alfred Harmsworth. [c. 1903]

ALFRED HARMSWORTH later VISCOUNT NORTHCLIFFE

Alfred Harmsworth (1865–1922) purchased the derelict *Evening News* in 1894, founded the *Daily Mail* in 1896, took over the *Daily Mirror* in 1903, the *Observer* in 1905, and *The Times* in 1908. The "dictator" of the Northcliffe Press (created Baron Northcliffe in 1905), he was hugely influential, though never so much as he would have liked, especially in regard to the conduct of the First World War. In 1896

Harmsworth commissioned Max to do a series of travel articles on Italy for the *Daily Mail*. In 1897 Max reported to Rothenstein from Harmsworth's country house that his host was "very charming…quite amazing and interesting". Max drew Harmsworth frequently (19 entries in the Hart-Davis *Catalogue*), many of them echoing the Napoleonic theme stressed here (plate 174). See also plate 44.

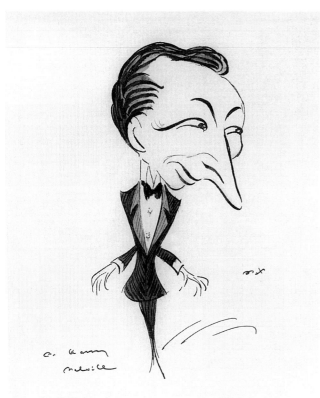

175. Mr Harry Melvill. [c. 1901]

HARRY MELVILL

Harry Melvill (1861–1936) was a well-known dandy and raconteur, both of which types attracted Max. Osbert Sitwell (plate 51) described Melvill:

> His greying hair, his mask-like face, through which peered those witty, rather wicked eyes, his hands of carved ivory, were all made with an exquisite but rather snuff box-like finish. This well-groomed and tailored figure, this Voltairean mask, rather too developed for the slender frame and covered with small, delicately chiselled wrinkles, formed but the very gentlemanly shell for an intense vitality out of all proportion to it.

Max's design (his only known drawing of Melvill) features Melvill's nose, his perfect dandy's dress, and his overall delicacy, as his body's "slender frame" dwindles into feet that are not there at all.

CYRIL MARTINEAU

Little is known of Cyril Martineau (1871–1918) beyond the fact that he was a stockbroker and that Max had, as Edmund Gosse said, "got" him.

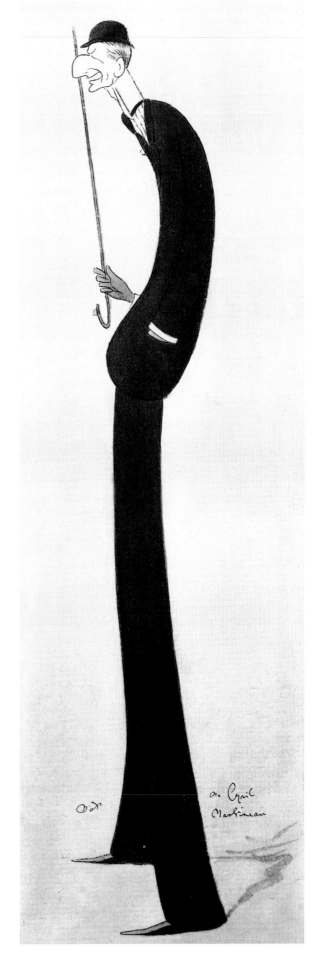

176. Mr Cyril Martineau

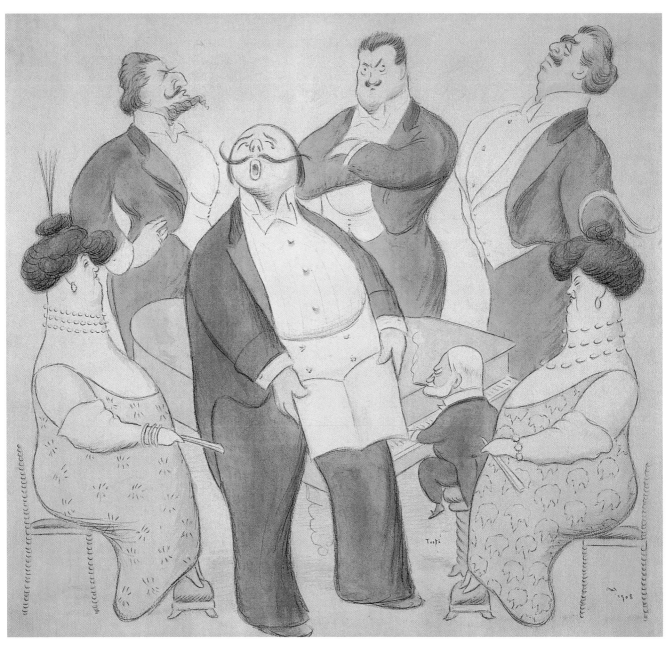

177. [An Audition, or, Les Chanteurs au Salon]. 1908
[*Paolo Tosti at piano, behind whom are Edouard de Reszke, Mario Sammarco, and Antonio Scotti.*]

AN AUDITION

Max said, "Of music I have a genuine, though quite unenlightened, love." The small figure of Paolo Tosti (1846–1916), Italian song composer ("Good-bye") and music instructor, fascinated him (see also plate 213). Tosti was singing teacher to the royal family, and, according to Max, Queen Victoria's favourite composer.

Edouard de Reszke (1853–1917), Polish bass, made his London debut at Covent Garden in 1880. De Reszke's "huge voice and giant stature" made him a magnificent exponent of Wagnerian roles.

Mario Sammarco (1868–1930), Italian baritone, made his Covent Garden debut in 1904 as Scarpia in *Tosca*.

Antonio Scotti (1866–1936), Italian baritone, made his Covent Garden debut in 1899.

ENRICO CARUSO

Italian tenor Enrico Caruso (1873–1921), himself a talented caricaturist, is widely considered the greatest operatic tenor of all time. He made his hugely successful London debut at Covent Garden in 1902, but his greatest successes were at New York's Metropolitan Opera, from 1902 to 1920. A notorious ladies' man, he drew the following observation from Max in 1907: "Caruso behaved *fairly* well the other night. That is, he tried to regularise his conduct so that he would not actually be liable for persecution [for making sexual but jokey invitations to women]."

190

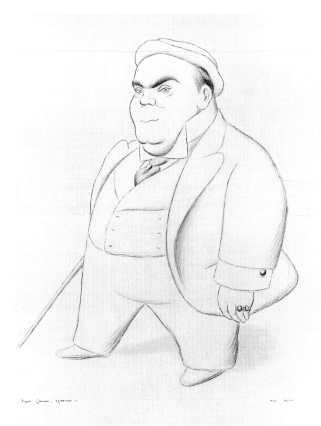

178. Signor Caruso, Cynosure. 1912

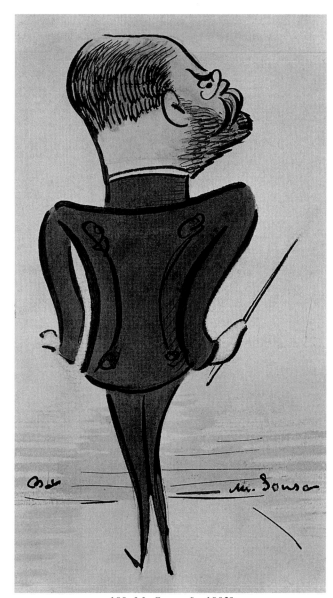

180. Mr Sousa. [c. 1902]

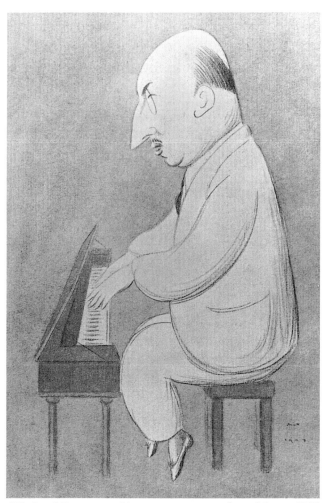

179. Lord Berners, making more sweetness than violence. 1923

JOHN PHILIP SOUSA

The American composer ("Stars and Stripes Forever") John Philip Sousa (1854–1932) is chiefly remembered as the "March King". Sousa's Brass Band enjoyed an astounding popularity, and Sousa himself, according to *The New Grove Dictionary*, was "for a short period ...probably the world's most widely known musician".

LORD BERNERS

Composer, writer, painter, and "character", Lord Berners (1883–1950), was the kind of man who appealed to Max. Berners throve on eccentricity, "diverting his friends and disconcerting strangers with practical jokes". He kept flocks of doves, dyed different colours. In reference to Berners' "attraction-repulsion" for late Romantic music, critic Ronald Crichton said of this cartoon that Max had "unerringly spotted the soft heart behind the quizzical monocle".

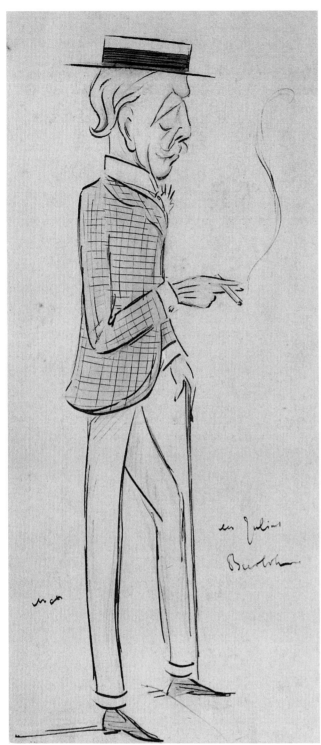

181. Mr Julius Beerbohm

JULIUS BEERBOHM

Max's half brother, Julius Beerbohm (1854–1906), the third son of his father's first marriage, was known in his time chiefly as an imperturbable dandy. As a youngster Max admired his brother Herbert as a hero (plates 63 and 211), but considered Julius a "god", precisely "because he was so cool and calm and elegant". Max compared the two:

> Herbert seemed always to be in a hurry, Julius never. Herbert would overpay and dismiss his hansom whenever he came to see us, and at his departure would whistle frantically and piercingly for another. Julius always kept *his* hansom waiting, hour after hour... Herbert talked excitedly, and used to pass his hands through his hair, and leave it all standing up on end. Julius never raised his deep voice, and never put any expression into it, and his straw-coloured hair lay around his head as smoothly as satin. Herbert's necktie was often on one side, and his top hat always lustreless, and he never had a flower in his buttonhole. Julius had always a gardenia or Parma violets, and his hat was dazzling, and his linen was washed in Paris. Also, he had a moustache. Not to have that when one was grown up seemed to me to argue a deficiency in sense of fitness. I knew that Herbert, being an actor, had to be clean-shaven. But I felt that I myself, if hereafter I had to choose between being an actor and having a moustache, should not hesitate.

Julius wrote a successful book about his youthful adventures in Patagonia. Nicknamed "Poet", he produced Swinburnian verse, seldom bothering to write it down. He engaged, unsuccessfully as a rule, in financial speculation. One of his schemes was to dredge the Nile in search of the Pharaohs' lost jewels. Another was to operate a luxury hotel in Marienbad, and, having left a deposit for the hotel, he subsequently forgot about the entire transaction until his creditors reminded him of it. A friend told of finding brokers seizing his household goods on the ground floor of his London flat and "Julius lying in bed upstairs serenely translating a lyric of Heine's". For, whatever his financial or personal disasters, Julius kept his dandy priorities till the end. Herbert, wearing a red-brown suit, visited him on his death-bed. "Ginger!" Julius cried in disgust and turned his face to the wall.

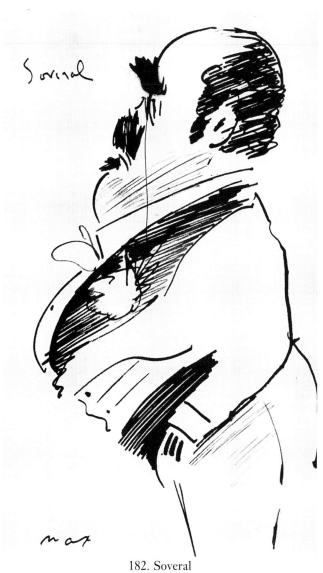

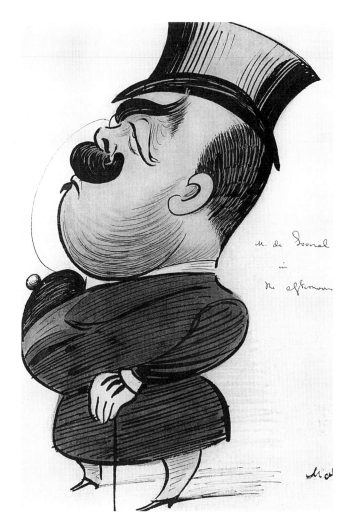

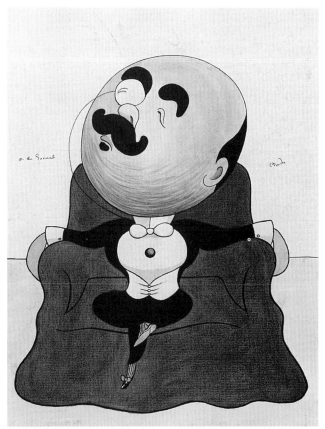

182. Soveral

183. M. de Soveral in the afternoon

184. M. de Soveral. [1900]

MARQUIS LUIS DE SOVERAL

The Portuguese Ambassador in London, the Marquis Luis de Soveral (1862–1922), was perhaps the closest friend of King Edward VII, and, like his royal crony, was considered a great ladies' man. Some thought Soveral, nicknamed the "Blue Monkey", was "the most popular man in London... Tall and well built, with blue black hair and fierce moustache, with his invariable monocle, white buttonhole and white gloves, he went everywhere *persona gratissima*. He was a celebrated waltzer, a sound musician, and devoted to the arts... he had few equals as a *raconteur*." Soveral was a favourite subject of Max, appearing in 20 caricatures, including the "Edwardian Parade" (plate 167) and the "Biassed Deputation" (plate 213) where he is the spokesman urging Max to "give over".

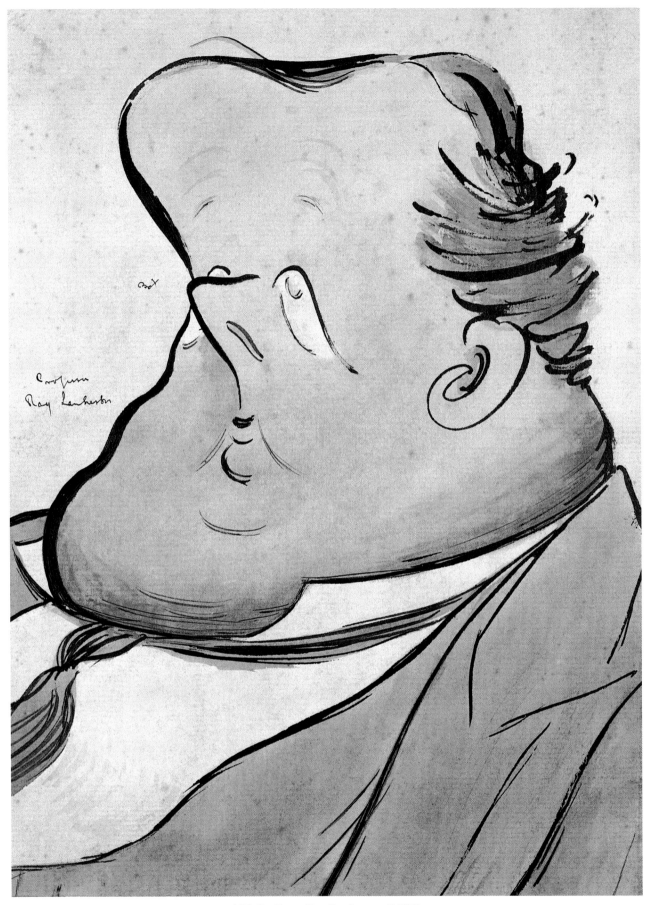

185. Professor Ray Lankester. [1907]

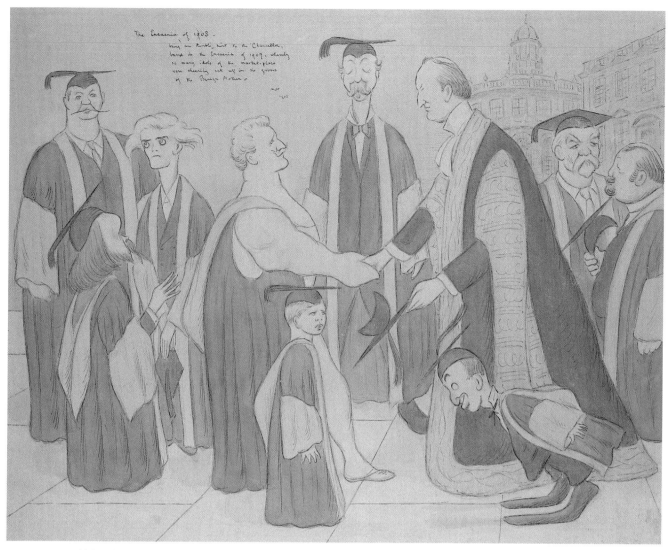

186. The Encaenia of 1908 – being an humble hint to the Chancellor, based on the Encaenia of 1907,
whereby so many idols of the market-place were cheerily set up in the groves of the Benign Mother. 1908
[*Lord Curzon, Chancellor of Oxford University, shakes hands with Eugene Sandow, the strong man.
Other graduands include, from left to right Conan Doyle, Hall Caine, the Rev. R. J. Campbell, Prince
Edward (later King Edward VIII), Sir Thomas Lipton, John Burns, G. R. Sims, and Little Tich.*]

RAY LANKESTER

In 1891 Ray Lankester (1847–1929) was given the
Linacre Chair of Comparative Anatomy at Oxford and a
fellowship at Merton College, where Max was an under-
graduate. He became the leading British zoologist. An
ardent Darwinian, he regarded Thomas Huxley as his
"father in science". A contemporary remarked, "[Lank-
ester's] tall and massive frame, his mobile expressive
face, his deep booming voice made up a vivid and
impressive personality."

In old age Max looked at this caricature with contri-
tion: "Dear Ray. He was rather hurt by this. And good
heavens, I don't wonder. I only wonder that he so
quickly forgave me...He was one of the most delight-
ful men I have ever known." Lankester can also be
seen, prominently, in the caricature depicting Edmund
Gosse's "Birthday Surprise" (plate 46).

THE ENCAENIA OF 1908

In June of 1907 Max was distressed to find that Oxford
had "learnt to play the big drum" and conferred an
honorary doctorate on Kipling: "The idols of the mar-
ket-place need no wreaths from an university." Why
not an honorary degree for Henry James, "a writer as
signally fit for it as Mr Kipling is unfit"? The 1907
Encaenia honoured, among others, Mark Twain and
General Booth. That "Comic Encaenia" prompted
Max's "humble hint" for the following year (plate 186).
Prince Edward would have been 14 at the time. Little
Tich, the music hall comedian, was a friend of Max:
"He *was* tiny. I felt gross beside him...He used to slosh
about...in great boots. They were as long as him-
self...and the walk he managed in them was – well,
incommunicably funny."

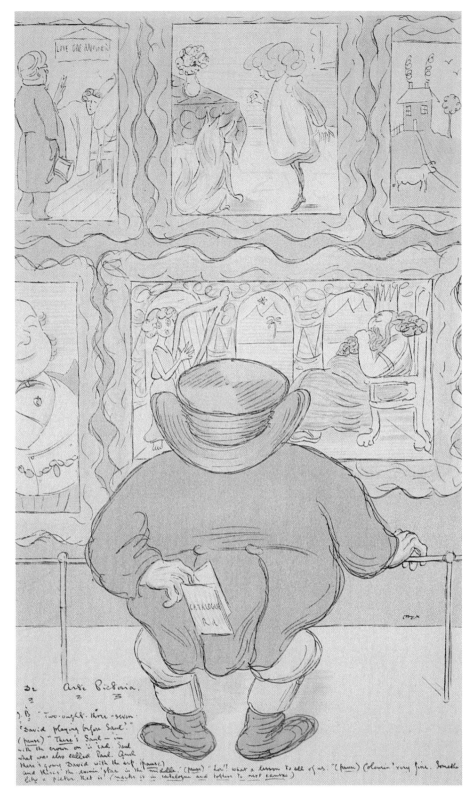

187. De Arte Pictoria. [1901]

J. B. [John Bull]: "Two-ought-three-seven: 'David playing before Saul'." (*pause*) "*There*'s Saul – 'im with the crown on 'is 'ead. Saul what was also called Paul. And there's young David with the 'arp." (*pause*) "And there's the evenin' star in the middle." (*pause*) "Lor'! what a lesson to all of us." (*pause*) "Colourin' very fine. Somethin' *like* a picter, that is!" (*marks it in catalogue and totters to next canvas.*)

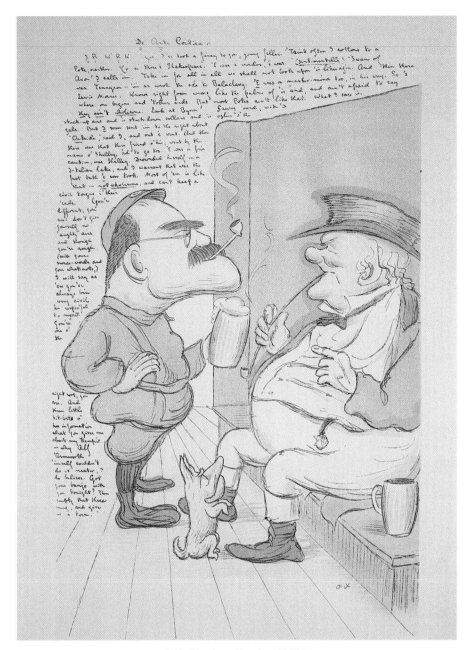

188. De Arte Poetica. [1901]

J. B. to *R. K.*[Rudyard Kipling]: "Yes, I've took a fancy to you, young feller. 'Tain't often I cottons to a Pote, neither. 'Course there's Shakespeare. 'E was a wonder, 'e was." (*Sentimentally*) "'Swan of Avon' *I* calls 'im. Take 'im for all in all we shall not look upon 'is likes agin. And then there was Tennyson – 'im as wrote the ode to Balaclavy. '*E* was a master-mind too, in his way. So's Lewis Morris. Knows right from wrong like the palm of 'is 'and, and ain't afraid to say where one begins and 'tother ends. But most Potes ain't like that. What I says is, *they ain't wholesome. Look at Byron! Saucy 'ound, with 'is stuck-up airs and 'is stuck-down collars* and 'is oglin' o' the gals. But *I* soon sent 'im to the right about. '*Out*side,' said I, and out 'e went. And then there was that there friend o' his, went by the name o' Shelley, 'ad to go too. 'E was a fair caution, was Shelley. Drownded hisself in a I-talian lake, and I warrant that was the fust bath '*e* ever took. Most of 'em is like that – *not wholesome*, and can't keep a civil tongue i' their 'eads. You're different, you are: don't give yourself no 'aughty airs, and though you're rough (with your swear-words and your what-nots,) I will say as 'ow you've always bin very civil an' respec'ful to myself. You're one o' the right sort, you are. And them little tit-bits o' information what you gives me about my Hempire – why, Alf 'Armsworth 'imself couldn't do it neater, I do believe. Got your banjo with you tonight? Then empty that there mug, and give us a toon."

THE SECOND CHILDHOOD
OF JOHN BULL

(previous two pages)

The series of fifteen cartoons called "The Second Childhood of John Bull" was exhibited in 1901 as part of Max's first one-man show, at the Carfax Gallery, operated by friend Robert Ross (plate 123). In 1911 Stephen Swift & Co. published the drawings as *Cartoons: The Second Childhood of John Bull*. While allegorical subjects are not considered Max's forte, the John Bull drawings have always had admirers who see them as clever satires in picture and caption of British patriotism, xenophobia, self-regard, and dullness.

The series is atypical of Max in that a handful of the drawings are pointedly political, reflecting his opposition to the Boer War. The first drawing, "The Ideal John Bull", presents him looking spry and sturdy, defiantly saying "I'm going to see this thing [the war] through." But the second, "The Real J. B.", shows a decrepit old man, supporting himself on his walking stick, while he proclaims that "Boney" is under lock and key at St Helena, Drake has stopped "that there Armada", and Burgoyne is "goin' to teach them Colonists a lesson" (in 1777 John Burgoyne surrendered to the Colonists at Saratoga). By the third drawing J. B. is lying drunken in the gutter while foreigners look on: he has been celebrating victories at Kimberley, Ladysmith, and Mafeking, places of earlier defeats in the Boer War. Other drawings place him in different contexts, including the arts.

The two cartoons reproduced here (plates 187 and 188) depict John Bull in his capacity of devotee of painting and poetry. In the first he is at the annual Royal Academy Exhibition, mixing up King Saul with St Paul of the New Testament, and making other sagacious remarks such as "Colourin' mighty fine". In the second, seated in a pub, he discourses to Rudyard Kipling his views on "potes" – *they ain't wholesome*". He admits exceptions: Shakespeare, Tennyson (who wrote the famous "Charge of the Light Brigade", commemorating the disastrous Crimean War battle of Balaclava, 1854: "Theirs not to reason why, / Theirs but to do and die"), and Lewis Morris, a third-rate but once popular Welsh poet. "Alf 'Armsworth" is Alfred Harmsworth, later Lord Northcliffe, the newspaper czar (plate 174). Kipling (plates 21–24) was of course the Poet of Empire *par excellence*. Some believe that the little dog, begging in front of J. B., represents Alfred Austin, the inept poetaster who succeeded Tennyson as Poet Laureate in 1896. The caption for "De Arte Poetica" is among Max's longest.

ZULEIKA DOBSON

Max claimed that he liked to keep his sister arts apart and that he did not like illustrated fiction. On the other hand, he supplied frontispieces and illustrations of the leading characters of his own fiction. To the American edition of his collection of short stories, *Seven Men*, for example, he added an appendix containing drawings of the six men of the stories (Max himself is the seventh), explaining that he offered these illustrations because he might have failed "for lack of literary art, to make actual to the reader an image of this or that man described". (See plate 61, Enoch Soames.) *Zuleika Dobson*, his famous but only novel, is the fantastic story of a beautiful young woman, an "omnisubjugant" female, who has parlayed her sexual allure and second-rate magician's act into a vogue that made her "the toast of two hemispheres". During her visit to Oxford, all the undergraduates, following the lead of the hero, the Duke of Dorset, commit suicide out of unrequited love for her. Zuleika, after considering taking the veil, instead hires a special train for Cambridge.

Immediately after the publication of *Zuleika Dobson* in 1911, Max meticulously illustrated a copy of the entire work for the private entertainment of his friends. (A facsimile edition of this book, with 80 drawings, was published by Yale University Press in 1985 as *The Illustrated Zuleika Dobson*.) Moreover, he made characters from the novel the subject of one of his frescoes at Rapallo and of half-a-dozen formal caricatures, one of which, "Zuleika", is reproduced here (plate 189). She stands in front of "Judas College", very like Max's own college, Merton. Compare her in this drawing with a descriptive passage from the novel: ·

> Zuleika was not strictly beautiful. Her eyes were a trifle large, and their lashes longer than they need have been. An anarchy of small curls was her chevelure, a dark upland of misrule, every hair asserting its rights over a not discreditable brow. For the rest, her features were not at all original. They seemed to have been derived rather from a gallimaufry of familiar models. From Madame la Marquise de Saint-Ouen came the shapely tilt of the nose. The mouth was a mere replica of Cupid's bow, lacquered scarlet and strung with the littlest pearls. No apple-tree, no wall of peaches, had not been robbed, nor any Tyrian rose-garden, for the glory of Miss Dobson's cheeks. Her neck was imitation-marble. Her hands and feet were of very mean proportions. She had no waist to speak of.

189. Zuleika. [c. 1912]

190. Communist Sunday School. 1923.
Pupils learning that they must not shrink from shedding blood
in order to achieve starvation.

MISCELLANEOUS TYPES

Max's occasional sallies into representative "types" are usually seen as less successful than his caricatures of actual individuals. On the other hand, one could argue that some of them, including the two reproduced here, "Communist Sunday School" and "The Insurgence of Youth" (plates 190 and 191), bolstered as they are by typically Maximilian captions, are triumphs of their kind.

191. The Insurgence of Youth. 1924

She: "What I say is: it's a —— putrid shame that Europe should be run by a gang of —— old beavers without an Idea or an Ideal between 'em. If I'd my way, I'd hoick 'em all out of their —— billets, and then there might be some hope for the Nations."

He: "I think you're —— well right."

VII

THE STORIED PAST

Max always found great charm in the past:

> Time, that sedulous artist, has been at work on it, selecting and rejecting with great tact. The past is a work of art, free from irrelevancies and loose ends. There are, for our vision, comparatively few people in it, and all of them are interesting people. The dullards have all disappeared – all but those whose dullness was so pronounced as to be in itself for us an amusing virtue. And in the past there is so blessedly nothing for us to worry about. Everything is settled. There is nothing to be done about it – nothing but to contemplate it and blandly form theories about this or that aspect of it.

Although most of Max's caricatures are of his contemporaries, he made two major ventures into the past, working from old portraits, drawings, and photographs. The result was some of his most enduring work, and the two most popular of his ten published books of caricatures, *The Poets' Corner* and *Rossetti and His Circle*.

THE POETS' CORNER

The twenty drawings that comprise the collection published as *The Poets' Corner* in 1904 were first exhibited that same year at the Carfax Gallery. Max himself thought the series "much better" than anything he had hitherto done. Reviews were excellent. The *Athenaeum*, for example, proclaiming Max Britain's "one and only caricaturist", said the Dante (plate 192, opposite) "has an almost Giottesque dignity", called the Wordsworth (plate 195) "tenderly sympathetic", labelled the drawing of Yeats and Moore (plate 35) "exquisite", and designated the group caricature of Rossetti painting in his back garden surrounded by a circle of friends and admirers (plate 198) as "perhaps the masterpiece of the collection... an important historical document for which future historians of the Pre-Raphaelite movement will be grateful".

Other poets presented in *The Poets' Corner* range from Homer and Shakespeare, through nineteenth-century figures like Coleridge (plate 194), Tennyson (plate 196), and Browning (plate 197), and into the present with Ibsen and Archer (plate 66) and Kipling with Britannia (plate 24).

DANTE

Doubtless Max found Dante Alighieri (1265–1321) one of those "big" subjects that he always said were too ambitious, too much for him. Still, alert as always to what was of human interest in great figures – like the notion that Francis Bacon wrote Shakespeare's plays – he was fascinated by people's subscribing to the unfounded view that Dante had visited England and studied in Oxford. But Prime Minister Gladstone had held that view, and, in 1893, at a time when Max as an undergraduate at Oxford was likely to have heard of it, Gladstone wrote a paper arguing that "external and corroborative evidence" supported this theory.

Max drew his tall, thin, severe Dante looking quizzically and disdainfully at a short, fat, Oxford proctor, whose office it is to report infractions of rules, including late hours; behind him are two constables, known as "bulldogs", who accompany him while he makes his nightly rounds.

In reviewing Victorien Sardou's play *Dante* in 1903, Max wrote, "There never lived a great man whose life would tempt a dramatist less than the life of Dante." For one thing, "He was far from being a delightful person, according to the modern British standard. No jolly good fellow, he, but a harsh, narrow saint... He was the kind of man whom you are loath to admit that the type exists in England, usually described as 'dour' and 'gey ill to live wi'." But while we do not know much of his life, "We do know exactly what Dante looked like. There is the death-mask of him, quite authentic. For bronze substitute flesh and blood, and lo! there, quite authentic, is the fine face of Sir Henry Irving. The only difference is that Dante's upper-lip is a trifle shorter." Compare Irving's face in "A Memory of Henry Irving" (plate 85) where this resemblance is embodied.

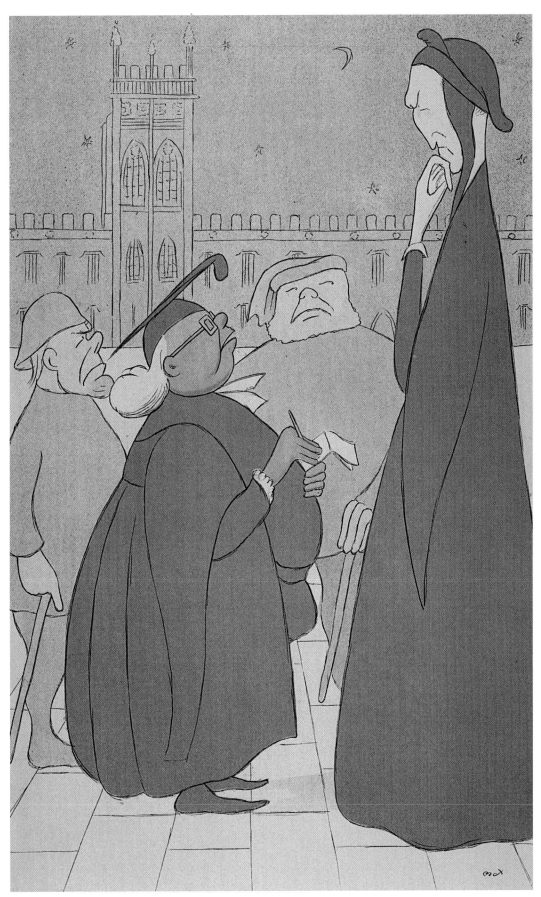

192. Dante in Oxford. [c. 1904]

Proctor: "Your name and college?"

ROBERT BURNS

The Scottish national poet Robert Burns (1759–96) was, like his forefathers, a hardworking, impoverished farmer. As a poet, he was considered "an untaught genius", a "natural" and "spontaneous" talent. An anti-Calvinist, he preached the innate goodness of man; his subjects included humble rural life, the rights of man, democracy, religious hypocrisy, Scottish patriotic songs, drinking songs, and love songs.

As Max was to say of Rossetti, "women were of great interest to him". Burns had a troubled love life. In 1786 he fell in love with Jean Armour; but her father refused to allow her to marry him, even when she became pregnant (though by Scots law they were as good as married). She, at her father's bidding, retracted her promise of marrying Burns. He, "hurt and enraged", took up with Mary Campbell, "Highland Mary", who, however, died shortly thereafter. Jean Armour gave birth to twins out of wedlock, and Burns eventually married her. Burns is considered one of the great writers of love lyrics; both Jean Armour and Mary Campbell were subjects of his poetry.

Max's caption draws on Luke IX. 62: "And Jesus said unto him, No man, having put his hand to the plough, and looking back, is fit for the kingdom of God."

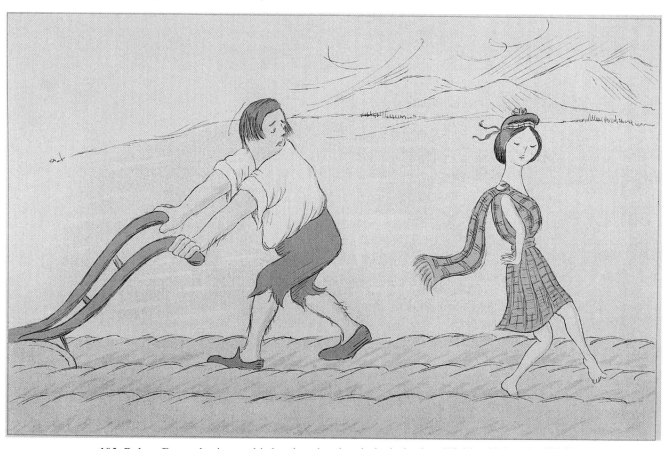

193. Robert Burns, having set his hand to the plough, looks back at Highland Mary. [c. 1904]

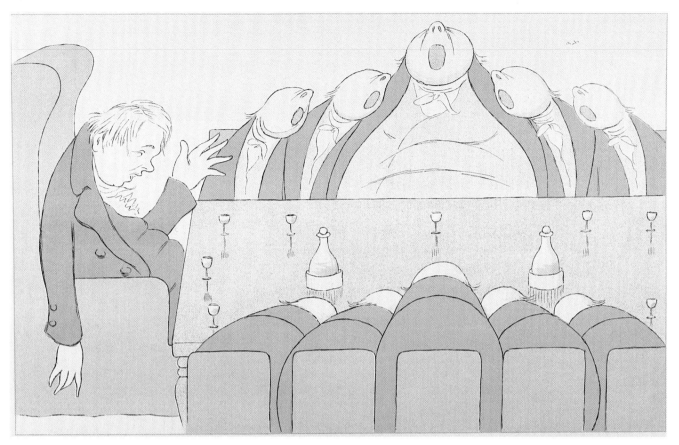

194. Samuel Taylor Coleridge, table-talking. [c. 1904]

SAMUEL TAYLOR COLERIDGE

Samuel Taylor Coleridge (1772–1934) in his latter years, according to Carlyle, "sat on the brow of Highgate Hill…looking down on London and its smoke-tumult, like a sage escaped from the inanity of life's battle; attracting towards him the thoughts of innumerable brave souls still engaged there". Max's drawing seems to have taken inspiration from accounts left by two brave souls who listened to the sage. Carlyle wrote:

> To sit as a passive bucket and be pumped into, whether you consent or not, can in the long-run be exhilarating to no creature; how eloquent soever the flood of utterance that is descending. But if it be withal a confused unintelligible flood of utterance, threatening to submerge all known landmarks of thought and drown the world and you! – I have heard Coleridge talk, with eager musical energy, two stricken hours, his face radiant and moist, and communicate no meaning whatsoever to any individual of his hearers, – certain of whom, I for one, still kept eagerly listening in hope; the most had long before given up…He began anywhere: you put some question to him, made some suggestive observation: instead of answering this, or decidedly setting out towards answer of it, he would accumulate formidable apparatus, logical swim-bladders, transcendental life-preservers and other precautionary and vehiculatory gear, for setting out; perhaps did at last get under way – but was swiftly solicited, turned aside by the glance of some radiant new game on this hand or that, into new courses; and ever into new; and before long into all the Universe, where it was uncertain what game you would catch, or whether any.

And Coleridge's nephew wrote:

> There were, indeed, some whom Coleridge tired, and some he sent asleep. It would occasionally so happen, when the abstruser mood was strong upon him, and the visiter was narrow and ungenial. I have seen him…when he shook aside your petty questions or doubts, and burst with some impatience through the obstacles of common conversation. Then, escaped from the flesh, he would soar upwards into an atmosphere almost too rare to breathe, but which seemed proper to *him*, and there he would float at ease. Like enough, what Coleridge then said, his subtlest listener would not understand as a man understands a newspaper.

In plate 194 Coleridge, perhaps in his "abstruser mood", is shown with "some he sent asleep".

205

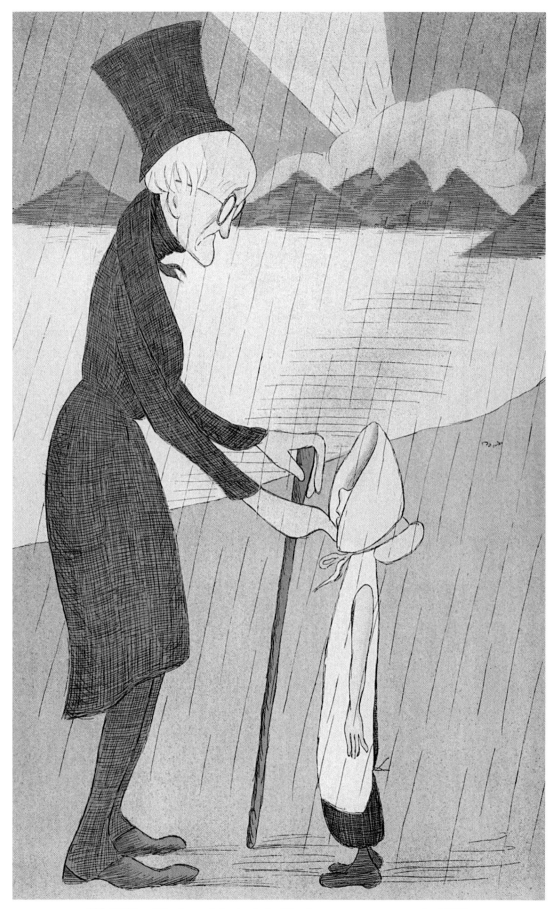

195. William Wordsworth in the Lake District, at cross-purposes. [c. 1904]

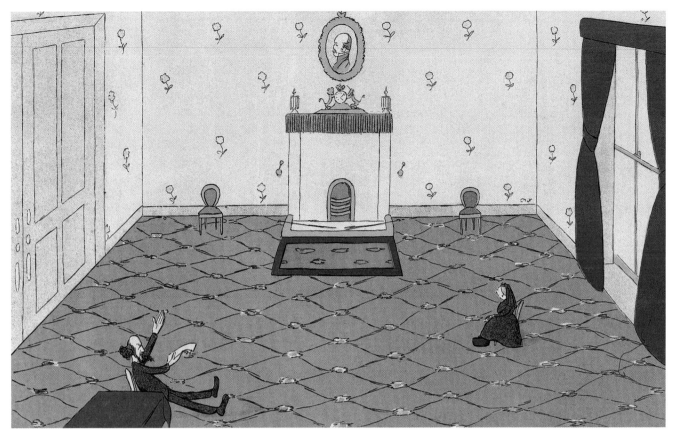

196. Mr Tennyson, reading "In Memoriam" to his Sovereign. [c. 1904]

WILLIAM WORDSWORTH

The great revolutionary Romantic poet William Wordsworth (1770–1850), famous as the poet of feeling and nature, and, eminently, the poet of the Lake District, is drawn by Max among the Lakes (plate 195), talking "at cross purposes" with a little girl as in his poem "We are Seven" (first published in *Lyrical Ballads*, 1798). The speaker in the poem inquires of the eight-year-old rustic how many are the children in her family; she explains that two dwell at Conway, two are gone to sea, two lie in the church-yard, and she lives with her mother; he points out that, accordingly, there are "only five", but she insists "We are seven." Wordsworth met the little girl near Goodrich Castle, in Herefordshire, in the spring of 1798 (his *annus mirabilis*) and composed the poem immediately while walking in the grove at Alfoxden in Somerset. But Max, in addition to moving the locale to the Lakes – where, he implies, it is always pouring rain – and giving Wordsworth prominent eyeglasses, something no official portraits show, pictures Wordsworth as the conservative, Victorian Poet Laureate that he was to become.

ALFRED TENNYSON

Max's cartoon (plate 196) shows the Poet Laureate, Alfred Tennyson (1809–92) reading his famous elegy *In Memoriam* to Queen Victoria. After Prince Albert's sudden death in 1861 (his is the figure above the mantelpiece), she made the poem one of her few sources of comfort throughout her unending mourning. In March 1862 she summoned Tennyson to Osborne for an interview, where, unnerved, he blurted out "What an excellent King Prince Albert would have made." Luckily the Queen took no offence, and Tennyson exchanged frequent letters with her and was re-called to Osborne at various times.

Tennyson was excessively fond of reading his poetry aloud; however, he never read *In Memoriam* to his Sovereign, although Max's caricature became so popular that some people have believed it records an actual occurrence. In fact, something very much the opposite is closer to the truth; during one interview at Osborne, the Queen twice quoted *In Memoriam* to Tennyson. Prompted by their discussion of whether in the afterlife they would be able to recognize old friends, Tennyson expressed his doubts, recounting how his dog had once failed to know him when he came naked from bathing. She countered with a passage from *In Memoriam* ending "And I shall know him when we meet."

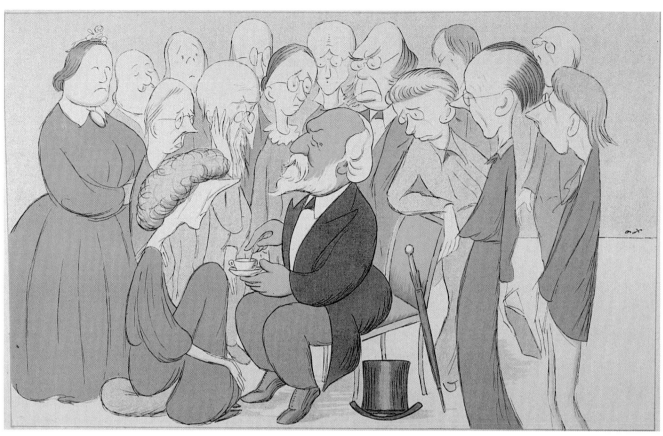

197. Mr Robert Browning, taking tea with the Browning Society. [c. 1904]

ROBERT BROWNING

Tennyson's great rival for poetic eminence during the Victorian era, Robert Browning (1812–89), fascinated Max. Browning figures in one of Max's most amusing parodies, "An Encounter", a fictional account of Edmund Gosse introducing Browning and Ibsen to each other in Venice in 1878, neither one having heard of the other. Max, who laboured painfully over most of his writing (although he drew caricatures swiftly and with pleasure) is on record as saying, "The only things I ever wrote with joy – easily – were '"Savonarola" Brown' [in *Seven Men*] and the meeting between Ibsen and Browning in *A Christmas Garland*."

In *The Mirror of the Past*, Max's unfinished "historical" novel about the Pre-Raphaelites and their friends, Max has a character say of Browning, whose poetry was sometimes so difficult as to be almost unintelligible:

> The more tangled and rugged Browning made his poetry, the more surely would anyone meeting him for the first time have taken him for a banker, or a fashionable physician. The greater the exactions he made, as he grew older, on the intellect and patience of his readers, the easier was it to understand what he said – and even to foretell what he *would* say – at a dinner-table.

Max's version of Browning, upon whom he never laid eyes, was probably influenced by Carlo Pellegrini's caricature for *Vanity Fair* in 1875 and by a photograph widely circulated by the Browning Society. The Browning Society was founded in 1881 by that redoubtable organizer of scholarly groups, Frederick James Furnivall, one of the original projectors of what became the *Oxford English Dictionary*. Browning, who liked Furnivall personally, and had served as nominal President of his New Shakespere Society, laughingly agreed not to oppose a Browning Society. Furnivall's prospectus announcing the Society said that Browning was "*the* most thought-full" living poet; as for his notorious obscurity, "the Browning student will seek the shortcomings in himself rather than in his master". The Browning Society provoked much satire in the press, and there is no doubt that most of its members esteemed Browning not merely as a great poet but as a veritable oracle. Browning regarded the Society with an amused tolerance, along with gratitude for the boost it brought to the sales of his works. He avoided the Society's meetings but did occasionally, as in Max's caricature, take tea with his worshippers.

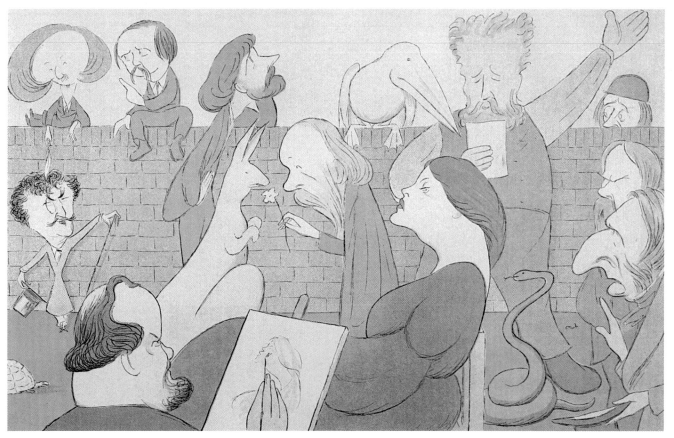

198. Dante Gabriel Rossetti, in his back garden. [c. 1904]

[*Charles Algernon Swinburne, Theodore Watts-Dunton, George Meredith, Hall Caine, James Whistler, Edward Burne-Jones, William Morris, Holman Hunt, John Ruskin. The model is Fanny Cornforth.*]

DANTE GABRIEL ROSSETTI AND HIS CIRCLE

The above drawing from *The Poets' Corner*, showing Dante Gabriel Rossetti (1828–82), his friends, and some of his exotic animals in the back yard of his house in Cheyne Walk, Chelsea, can be seen as an anticipation of what was to come a dozen years later. During 1916–17 Max produced the 23 drawings that constitute the book published as *Rossetti and His Circle* in 1922. Many people, especially those who prefer his middle, less severe period, and who relish the captions almost equally with the drawings, consider this collection his masterpiece.

The *recent* past had a special magical appeal for Max – "the period that one *didn't* quite know, the period just before oneself, the period of which in earliest days one knew the actual survivors". For Max this meant roughly 1850 to 1880, during which years the painter/poet D.G. Rossetti flourished, "shone, for the men and women who knew him, with the ambiguous light of a red torch somewhere in a dense fog". Max was also captivated by the gloriously interesting people who surrounded Rossetti: painters, poets, writers, models, mistresses, hangers-on, adventurers, eccentrics, united only in their attraction to Rossetti.

In *Rossetti and His Circle* (represented in the next seven plates, 199–205) Max has subtle and affectionate fun with subjects whom, with the exception of Hall Caine, he greatly admired. Max's temperament demanded that he skirt the tragic and the unseemly in Rossetti's career: the still-born child, the suicide of his wife, the debts, depressions, drug addiction, paranoia, near insanity, attempted suicide; the eventual alienation from almost all of his earlier friends, the sad and relatively early end. But much could be suggested, delicately: Rossetti's compulsive "interest" in women; Fanny Cornforth's ambiguous position as "housekeeper"; his passion for Jane Morris, wife of William Morris, one of his best friends, whose presence is suggested only in stylized paintings of her hanging on the walls of 16, Cheyne Walk. When the book first appeared, Herbert Gorman in the *New York Times* wrote, somewhat optimistically, "Here is the final criticism of the Pre-Raphaelite Brotherhood." One of Rossetti's nieces said that "no person living within [the Pre-Raphaelite] circle had given so accurate a picture of its physical and spiritual composition".

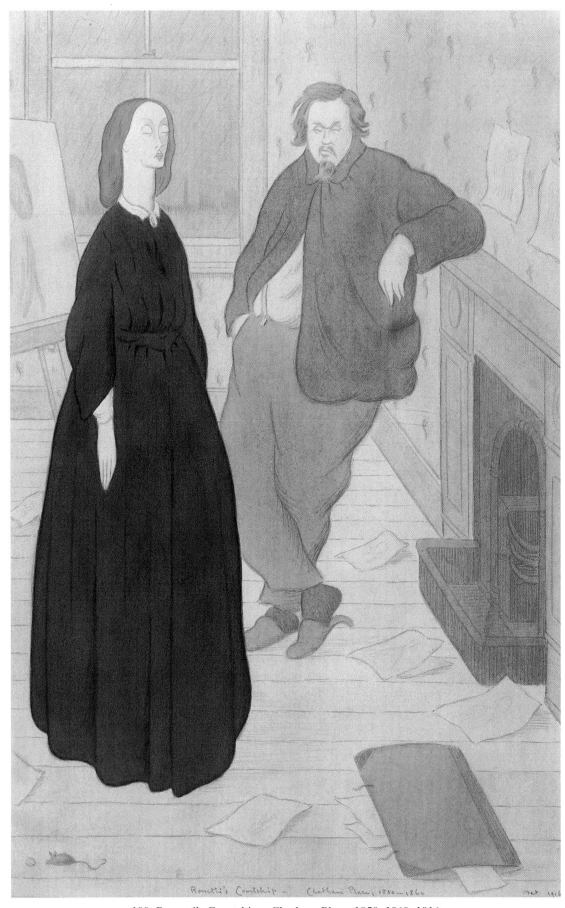

199. Rossetti's Courtship – Chatham Place, 1850–1860. 1916

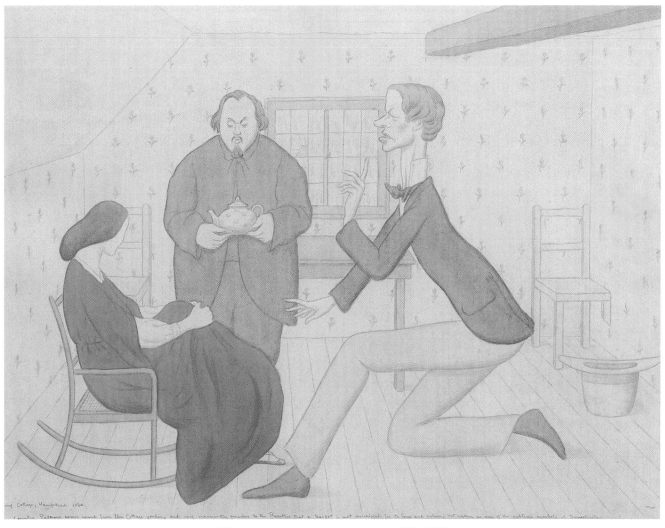

200. Spring Cottage, Hampstead. 1860. 1917

Coventry Patmore comes round from Elm Cottage yonder, and very vehemently preaches to the Rossettis that
a tea-pot is not worshipful for its form and colour, but rather as one of the sublime symbols of Domesticity.

ROSSETTI'S COURTSHIP

In 1850 Rossetti met Elizabeth "Lizzie" Siddal; she
was the great, obsessive love of his young years. His
brother William Michael described her as "truly a
beautiful girl; tall, with a stately throat and fine car-
riage, pink and white complexion, and massive straight
coppery-golden hair. Her large greenish-blue eyes,
large lidded, were peculiarly noticeable... She main-
tained an attitude of reserve, self-controlling and alien
from approach." By 1852 Rossetti had moved into
rooms in Chatham Place, overlooking the Thames at
Blackfriars Bridge. She was constantly with him, and
friends felt they were intruding. His sister Christina
said in a poem that "One face looks out from all his
canvasses." She was his Beatrice, his Guinevere. But
the last years of Rossetti's decade-long "courtship"
(plate 199) were filled with unhappiness, recrimina-
tions, separations. He was involved with other models,
including Fanny Cornforth, Jane Burden, Annie
Miller, and Ruth Herbert.

SPRING COTTAGE, HAMPSTEAD

In May 1860 Rossetti, after ten years, finally married
Lizzie. Her failing health had perhaps made him fear for
her life. They took rooms in Spring Cottage, Downshire
Hill, Hampstead, a neighbourhood they thought would
be better for her health than the damp, foggy riverfront of
Chatham Place. Rossetti's friend, the poet Coventry
Patmore (1823–96), had in 1851 persuaded John Ruskin
to write two letters to *The Times* defending the Pre-
Raphaelites when the art world seemed almost universally
against them; Patmore himself wrote of Rossetti as "the
only modern rival of Turner as a colourist". In Max's car-
icature (plate 200), Patmore is preaching domesticity to
the apparently bored and unimpressed newlyweds. The
very names of Patmore's books of poetry make a kind of
ironic commentary on Rossetti's situation: *The Angel in
the House: The Betrothal* (1854), *The Espousals* (1856),
Faithful for Ever (1860), and *The Victories of Love* (1862).
After a few months in Hampstead, Gabriel and Lizzie
moved back to Chatham Place.

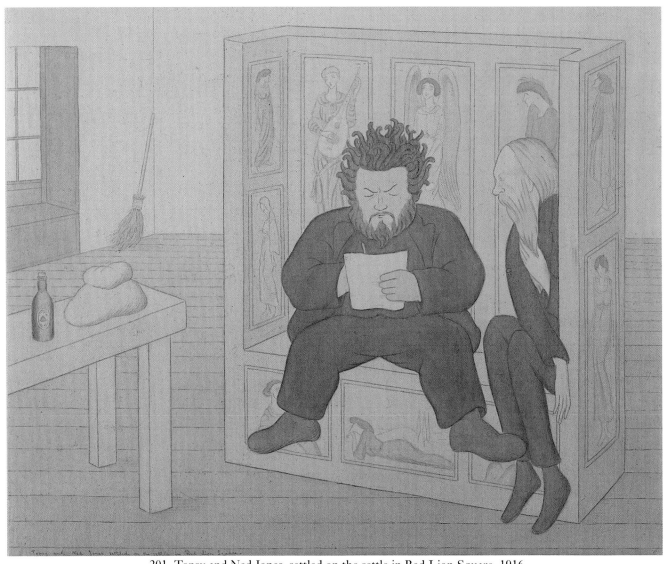

201. Topsy and Ned Jones, settled on the settle in Red Lion Square. 1916

TOPSY AND NED JONES

In 1856 William "Topsy" Morris (1834–96) and Edward "Ned" Burne-Jones (1833–98), while undergraduates at Oxford, met Rossetti and fell under his spell. They became for a period his most ardent disciples. Determined to make a life in art, they allowed Rossetti to persuade them to take three rooms on the first floor of 17 Red Lion Square, London, rooms that Rossetti himself had occupied earlier. Max's drawing (plate 201) takes its inspiration from a passage in Mackail's *Life of William Morris*:

> The rooms in Red Lion Square were unfurnished: and from this trifling circumstance came the beginnings of Morris's work as a decorator and manufacturer...Morris [made] rough drawings of the things he most wanted, and then [got] a carpenter in the neighbourhood to construct them from those drawings in plain deal. Thus the rooms in Red Lion Square were gradually provided with "intensely

mediaeval furniture" as Rossetti described it... Afterwards a large settle was designed, with a long seat below, and above three cupboards with great swing doors...Sir Edward Burne-Jones says: "...I think [Morris's] measurements had perhaps been given a little wrongly, and that it was bigger altogether than he had ever meant, but set up it was finally, and our studio was one-third less in size. Rossetti came. This was always a terrifying moment to the very last. He laughed, but approved." Not only so, but he at once made designs for oil paintings to be executed on the panels of the cupboard doors and the sides of the settle.

Max, while admiring the "bulk and variety" of Morris's work, thought the quality rather poor: "I like, in visual objects, lightness and severity, blitheness and simplicity. A gloomy complexity is no doubt equally a noble thing to strive for. Morris achieved it in his wall-papers."

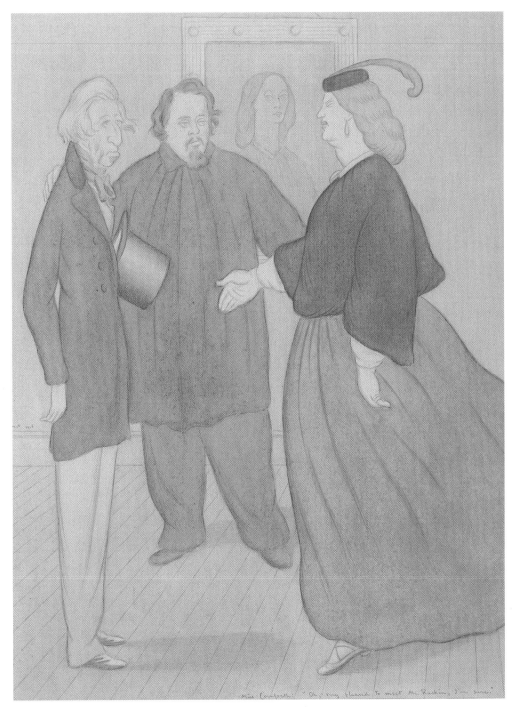

202. An Introduction. 1916
Miss Cornforth: "Oh, very pleased to meet Mr Ruskin, I'm sure."

AN INTRODUCTION

Fanny Cornforth (c. 1840–1914) was a country girl, almost illiterate, who cast a spell over Rossetti that most of his friends resented. She was vulgar and voluptuous, the very opposite of the artistic and ethereal Lizzie. When, after Lizzie's suicide in 1862, Rossetti moved into Cheyne Walk, Fanny became his "housekeeper", mistress, and model. Her reign as favourite model lasted only a few years, but she remained a part of Rossetti's life until the end. She was the only Rossetti model who refused even to attempt to enter into the world of art and poetry that Rossetti and his friends lived for, and she was frequently ushered out of the way when visitors called. In Max's picture (plate 202), Rossetti seems to have been trapped into introducing her to John Ruskin (1819–1900), the eminent art critic, who had so doted upon Lizzie, whose portrait hangs in the background.

Max himself said that he preferred the healthy Fanny Cornforth to the doomed Elizabeth Siddal: Fanny "afforded the Pre-Raphaelites a nice change from Pre-Raphaelitism; she was Rubensy".

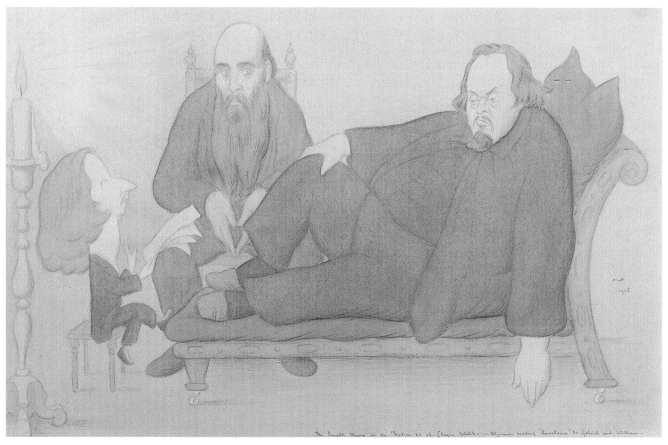

203. The Small Hours in the 'Sixties at 16, Cheyne Walk – Algernon reading "Anactoria" to Gabriel and William. 1916

THE SMALL HOURS

The large, comfortable, red brick house into which Rossetti moved in 1862 was to be his home until his death twenty years later. Gabriel's brother, William Michael (1829–1919), a part-time writer who worked for the Inland Revenue, frequently stayed in the house. Algernon Charles Swinburne (1837–1909), Rossetti's great friend, was joint tenant for about a year. Swinburne was a tiny man with flaming red hair, subject to a nervous trembling that his contemporaries likened to St Vitus' Dance. He was a raging alcoholic and sexual exotic, who, naked, would indulge in frenzied dances, slide down staircase handrails, and generally create scenes. He loved to recite poetry, and he is pictured here (plate 203) reading in manuscript, from his notorious *Poems and Ballads*, "Anactoria", the poem which, along with the sado-masochistic "Dolores" – "Our Lady of Pain" – was to cause the greatest uproar. His friends, including Ruskin and both Rossettis pleaded with Swinburne to be more cautious. Undeterred, he published the book in July 1866 and went into a fit when he read its reception. In the *Saturday Review*, the anonymous critic (in fact, John Morley [plate 204]) described Swinburne as "grovelling down among the nameless shameless abominations

which inspire him with such frenzied delight. . . It is not every poet who would ask us all to go hear him tuning his lyre in a sty." Swinburne, the review went on, seemed to think "there is really nothing in women worth singing about except 'quivering flanks' and 'splendid supple thighs', 'hot sweet throats' and 'hotter hands than fire', and their blood as 'hot wan wine of love'". The *London Review* said it would prefer "blank atheism" to Swinburne's perversions: "Anactoria" was "especially horrible", beginning with an "insane extravagance of passion" and ending with a "raging blasphemy". In the *Athenaeum*, the nameless reviewer (actually Robert Buchanan, who, later, in his famous "Fleshly School" attack on Rossetti helped drive him to attempt suicide) called Swinburne "unclean for the mere sake of uncleanness. . . Here, in fact, we have Gito [the homosexual boy in Petronius' *Satyricon*] seated in the tub of Diogenes, conscious of the filth and whining at the stars." All three reviews appeared on 4 August. The next day the publisher withdrew *Poems and Ballads* from circulation.

Max's drawing, with its elongated candlestick, seems to parody Jacques Louis David's famous portrait of Madame Récamier.

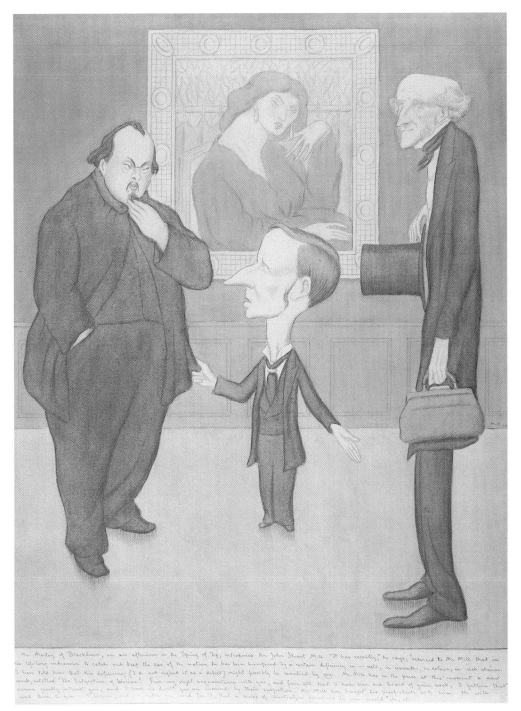

204. Mr Morley of Blackburn, on an afternoon in the Spring of '69, introduces Mr John Stuart Mill. [1917]
"It has recently," he says, "occurred to Mr Mill that in his life-long endeavour to catch and keep the ear of the nation he has been hampered by a certain deficiency in – well, in warmth, in colour, in rich charm. I have told him that this deficiency (I do not regard it as a defect) might possibly be remedied by *you*. Mr Mill has in the press at this moment a new work, entitled 'The Subjection of Women'. From my slight acquaintance with you, and from all that I have seen and heard of your work, I gather that women greatly interest you, and I have no doubt that you are incensed by their subjection. Mr Mill has brought his proof-sheets with him. He will read them to you. I believe, and he takes my word for it, that a series of illustrative paintings by you would" etc., etc.

MR MORLEY BRINGS MR MILL

John Morley, young editor of the liberal *Fortnightly Review*, with his career as statesman, man of letters, and author of *The Life of Gladstone* (see plate 39) in the distant future, introduces John Stuart Mill (1809–70), the eminent liberal philosopher, the "saint of rationalism", to Rossetti. It is doubtful that even lurid, coloured illustrations by Rossetti might have mitigated the abuse that *The Subjection of Women* (1869) generated in the press.

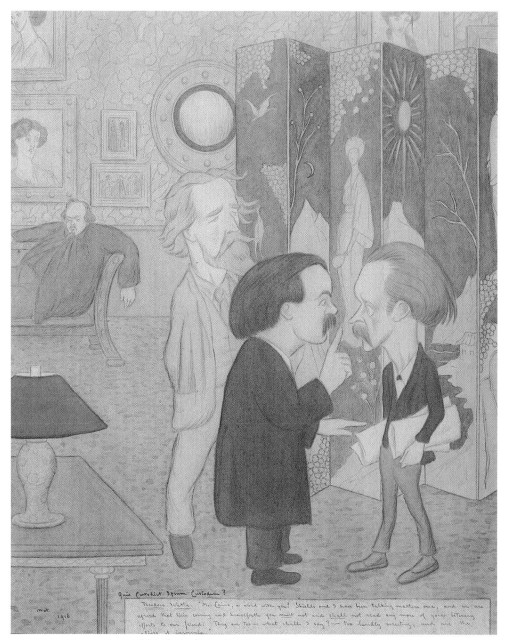

205. Quis Custodiet Ipsum Custodem? 1916
[Who will guard the guard himself? Juvenal, VI].
Theodore Watts: "Mr Caine, a word with you! Shields and I have been talking matters over, and we are agreed that this evening and henceforth you *must* not and *shall* not read any more of your literary efforts to our friend. They are too – what shall I say? – too luridly arresting, and are the allies of insomnia."

QUIS CUSTODIET

Hall Caine (plates 18–20) lived in Rossetti's Cheyne Walk house as a companion and secretary from 1881 until Rossetti's death the following year. Two older companions of Rossetti, the painter Frederick Shields (1833–1911) and solicitor-turned-critic Theodore Watts, later Watts-Dunton (1832–1914) had their doubts about the newcomer Caine.

Caine's "luridly arresting" novels were of a much later date. Paintings of Jane Morris adorn the walls.

AT THE PINES

In 1879 Watts-Dunton rescued Swinburne from drink (and poetry) by taking him into "The Pines", his Putney house. Max's visit there in 1899 resulted in a famous essay, "No. 2, The Pines". He described Watts-Dunton as a "dear little old man – gnome-like, swarthy, shaggy haired". Swinburne, "the legendary being and divine singer", Max saw as "a strange small figure in grey, having an air at once noble and roguish, proud and skittish...with his long neck strained so tightly back that he all receded from the waist upwards" to small and sloping shoulders. His tiny hands "fluttered helplessly, touchingly, unceasingly".

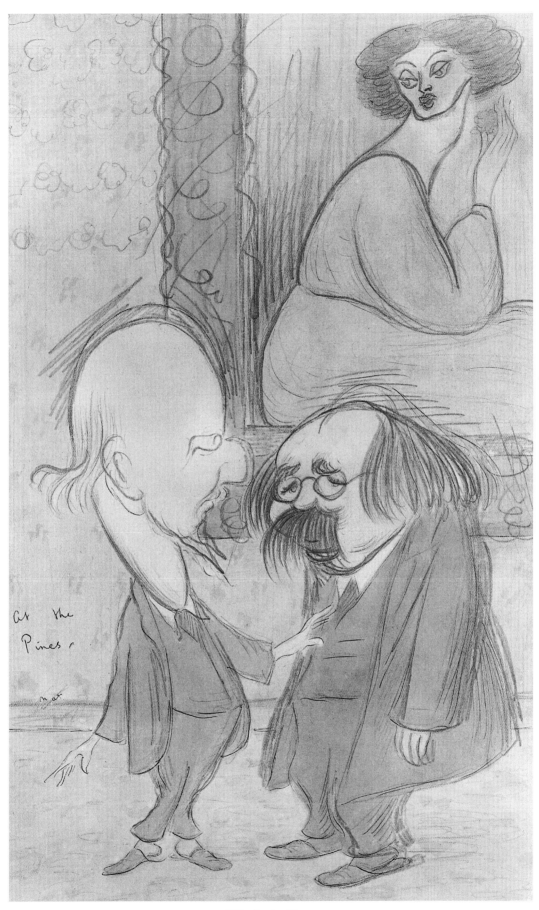

206. At the Pines.

VIII

SELF-PORTRAITS

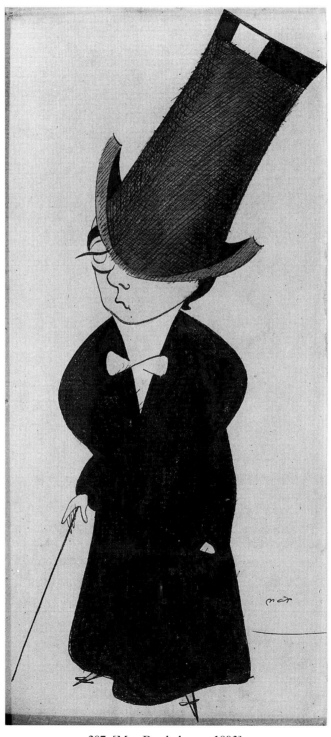

207. [Max Beerbohm. c. 1893]

Max Beerbohm caricatured himself more often than any other subject – some 100 times. In regard to his self-portraits, it is good to recall the close link between Max the artist and Max the writer. As a writer, his chief vehicle was the personal essay. Of these essays Virginia Woolf wrote:

> He has brought personality into literature...but so consciously and purely that we do not know whether there is any relation between Max the essayist and Mr Beerbohm the man...What Mr Beerbohm gave [to the modern essay] was, of course himself...Matthew Arnold was never to his readers Matt, nor Walter Pater affectionately abbreviated in a thousand homes to Wat. They gave us much, but that they did not give...We only know that the spirit of personality permeates every word that [Beerbohm] writes. The triumph is the triumph of style.

Mutatis mutandis, these words apply nicely to Max as caricaturist. Admirers of his graphic work, difficult as it is to tie down his "style", would never mistake a caricature of his for someone else's, or vice versa. And they would never call him anything but "Max". Furthermore, even as in some manner his personality permeates his caricatures of others, so it also permeates his self-caricatures. From the elfin, childlike figures of the early 1890s (plates 207 and 208) through to his mature years, Max is always round-eyed, heavy-lidded and dandily-dressed. He "praised the male costume of his time for 'its sombre delicacy, its congruities of black and white and grey', and because it produced 'a supreme effect through means least extravagant'". And he positively venerated the ubiquitous top hat. By 1940 he was referring to it as "a thing of the past; almost a museum piece", but for him it remained "a black but shining old monument". The top hat, Max wrote, "is very sensitive...It alone among hats had a sort of soul. If one treated it well, one wasn't sure that it didn't love one...I feel I may justly claim to have deserved the affection my hats had for me." Max in his self-portraits is ever the impertinent spectator, unshockable, looking as if he could calmly believe anything, no matter how ridiculous, of any man – himself included. For he was much given to self-awareness. In 1905, while writing to his future wife about how at Dieppe he was still playing silly practical jokes on friends and writing letters in disguised hands, he interrupts himself:

> What a lot of writing about myself! But it isn't egoism in the ordinary sense of the word. I am not thinking "I am I" and must be interesting to everyone else. I am something more than I – a detached and puzzled spectator – detached, yet knowing more about myself than about any other subject, and

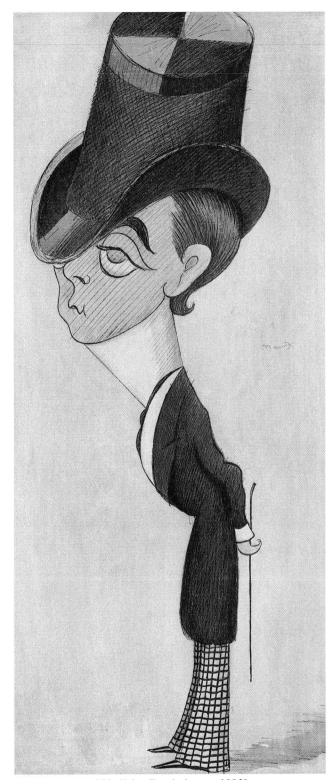

208. [Max Beerbohm. c. 1893]

offering myself humbly for the inspection of others. I think there is a difference between this and egoism.

It was as a "detached and puzzled spectator", knowing more about himself than about any other subject, that he drew himself, over and over.

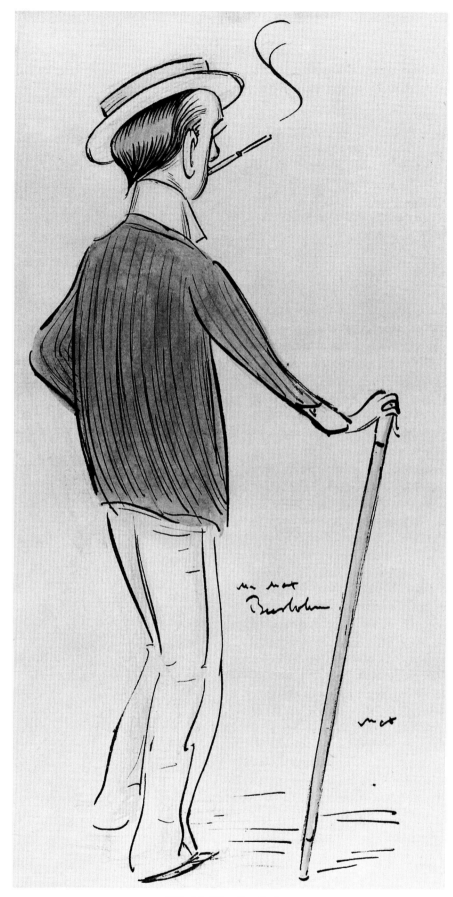

209. Mr Max Beerbohm

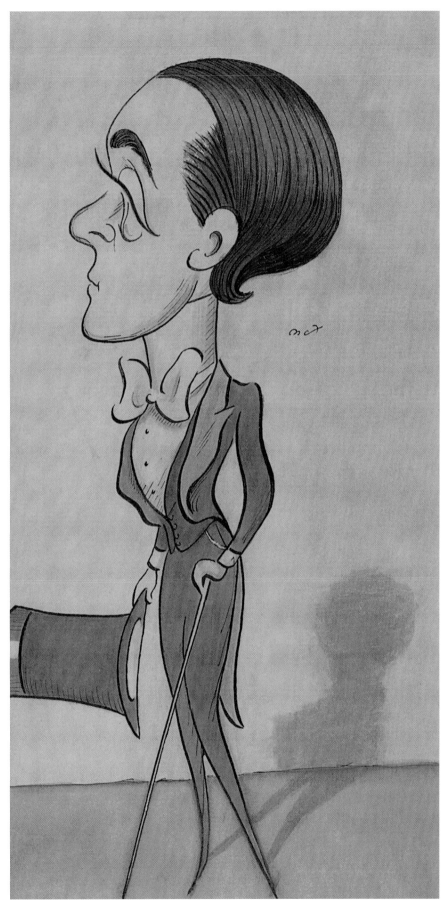

210. [Max Beerbohm]

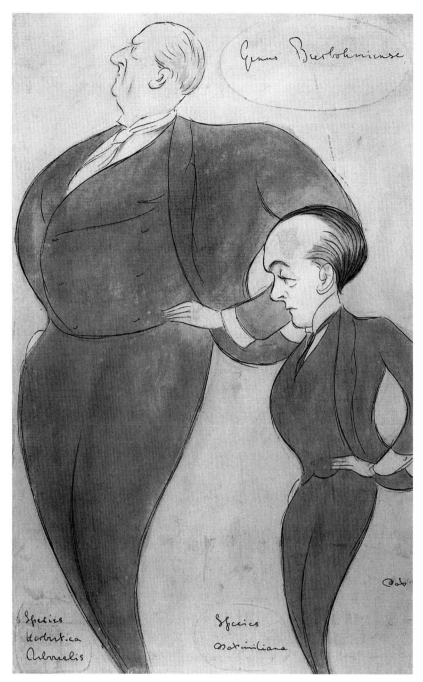

211. Genus Beerbohmiense.
Species Herbertica Arborealis, Species Maximiliana

GENUS BEERBOHMIENSE

Max adored Herbert, his half-brother (see also plate 63), who was very much Max's opposite: Herbert was not only much older – almost 20 years – he was much bigger; he had carrot-coloured hair; he was flamboyant, untidy, restless, histrionic, outgoing, sociable; he was a man of huge energies and ambitions, constantly in motion, married but with many love affairs; a natural gambler, a man of "sanguine radiance". Max recalled seeing a guest off in front of his mother's house, in 1908, when a taxi stopped at the curb: "My brother Herbert stepped out of it in the dreamy yet ample and energetic way that he had of stepping out of taxis. 'Oh, how are you, Mr Tree?' my friend greeted him. 'I?' said Herbert. . . 'I? Oh, I'm radiant!'" Coming from anyone else, the epithet, Max wrote, would have been absurd, but Herbert's use of it was "perfectly right and proper". About the only characteristic they shared, according to contemporary witnesses, was charm. But they also shared a mutual affection. Max wrote: "I do believe he took as much pride in my little career as I took in his big one."

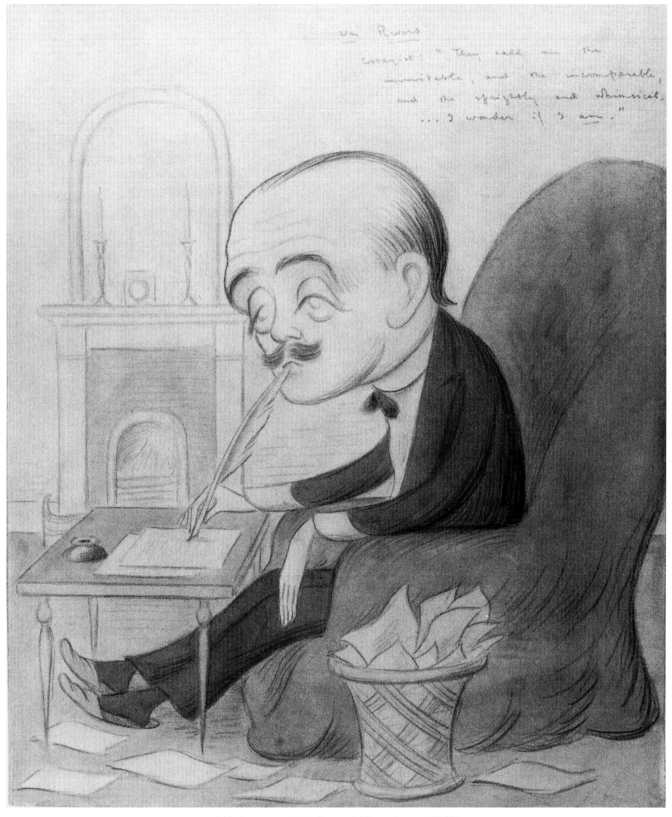

212. Un revers [On Second Thought. . . . 1909]
Essayist: "They call me the inimitable, and the incomparable, and the sprightly and whimsical. . .I wonder if I *am*."

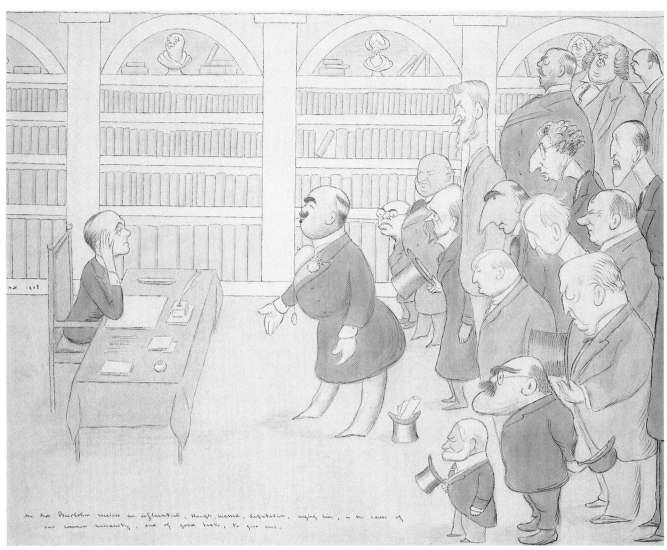

213. Mr Max Beerbohm receives an influential, though biassed, deputation, urging him,
in the cause of our common humanity, and of good taste, to give over. [1908]
[*Marquis Luis de Soveral – spokesman –, William Rothenstein, Lord Burnham, Hall Caine, George Bernard Shaw, John Singer Sargent, G. K. Chesterton, Philip Wilson Steer, Edward Carson, Israel Zangwill, Arthur Wing Pinero, Lord Northcliffe, George Moore, Viscount Haldane, Henry James, Rudyard Kipling, and Paoli Tosti.*]

A BIASSED DEPUTATION

Max receives the deputation in a stately library, decorated with busts of the Marquis de Soveral, Hall Caine, and G.K. Chesterton. Max himself sits, as one critic put it, "like a bureaucrat in the Office of Caricature". The petitioners, all seventeen of them, include many of Max's favourite subjects. Only Edward VII is absent, as befits royalty.

They stand, hat in hand, suppliant, peering – most of them – at their tormentor. All bring with them their salient features, Tosti his tiny body, Kipling his jutting jaw and "brutal" neck, Henry James his massive forehead. We see Pinero's mammoth eyebrows and huge nose, Moore's wispy vagueness of face, Sargent's aging strongman's bulk, Steer's tilt of neck.

Tall, dandified Marquis de Soveral alone looks hopeful, as he puts their case. Perhaps Soveral is arguing that it is wrong to make "good men" ridiculous, protesting, as Max himself has someone do in his essay "The Spirit of Caricature", that when the caricaturist finds that his work is causing pain to his subjects' friends and joy to their enemies, he ought to desist. Max replies, "Maybe, if either the pain or the joy were reasonable, were justified. But they are not. Both are foolish."

On this occasion Max listens attentively, but, clearly, the deputation will be disappointed. He "gave over" only when, some 22 years later, around 1930, he found that his caricatures no longer had their sting: "I have lost my zest for cartooning", he said. "It is a young man's hobby – you get kinder as you get older."

NOTES
INDEX OF SUBJECTS CARICATURED
GENERAL INDEX

NOTES

SHORT TITLES AND ABBREVIATIONS

Max Beerbohm's Writings

And Even Now *And Even Now.* London: Heinemann, 1920

Around Theatres *Around Theatres.* New York: Simon and Schuster, 1954

Garland *A Christmas Garland: Woven by Max Beerbohm.* London: Heinemann, 1912

Last Theatres *Last Theatres: 1904–1910.* Intro. Rupert Hart-Davis. London: Hart-Davis, 1970

Letters *Letters of Max Beerbohm: 1892–1956.* Ed. Rupert Hart-Davis. London: John Murray, 1988

Letters RT *Max Beerbohm's Letters to Reggie Turner.* Ed. Rupert Hart-Davis. Philadelphia and New York: J.B. Lippincott, 1965

Lytton Strachey *Lytton Strachey: The Rede Lecture.* New York: Knopf, 1943

Mainly *Mainly on the Air.* Enlarged Edition. London: Heinemann, 1957

Max & Will *Max and Will: Max Beerbohm and William Rothenstein: Their Friendship and Letters.* Ed. Mary M. Lago and Karl Beckson. Cambridge, Mass.: Harvard University Press, 1975

More Theatres *More Theatres: 1898–1903.* Intro Rupert Hart-Davis. London: Hart-Davis, 1969

More *More.* London and New York: John Lane, The Bodley Head, 1899

Peep into Past *A Peep into the Past and Other Prose Pieces by Max Beerbohm.* Intro. Rupert Hart-Davis. London: William Heinemann, and Brattleboro, Vermont: Stephen Greene Press, 1972

Rossetti & C *Rossetti and His Circle.* New Edition. Intro. N. John Hall New Haven and London: Yale University Press, 1987

Seven Men *Seven Men.* New York: Knopf, 1920

Variety *A Variety of Things.* New York: Knopf, 1928

Yet Again *Yet Again.* London: Chapman and Hall, 1909

Works *The Works of Max Beerbohm.* With a Bibliography by John Lane. London: John Lane, The Bodley Head, 1896

Criticism and Commentary

Behrman S.N. Behrman. *Portrait of Max: An Intimate Memoir of Sir Max Beerbohm.* New York: Random House, 1960

Benson E.F. Benson. *As We Were: A Victorian Peep-Show* London: Hogarth Press, 1985 [1930]

Catalogue *A Catalogue of the Caricatures of Max Beerbohm.* Compiled by Rupert Hart-Davis Cambridge: Harvard University Press, 1972

Cecil David Cecil. *Max: A Biography.* London: Constable, 1964

Danson Lawrence Danson. *Max Beerbohm and the Act of Writing.* Oxford: Clarendon Press, 1989

DNB *The Dictionary of National Biography.* Originally published by Smith, Elder; since 1917 published by Oxford University Press; *Supplements,* 1901–1911, 1912–1921; 1922–1930; 1931–1940, 1941–1950; 1951–1960; 1961–1970

Ellmann Richard Ellmann. *Oscar Wilde.* New York: Knopf, 1988

Felstiner John Felstiner: "Changing Faces in Max Beerbohm's Caricature. An Account of Beerbohm's Notes and New Versions Twenty-Four Years After in Mark Hyman's Copy of *Caricatures of Twenty-Five Gentlemen,*" *Princeton University Library Chronicle,* Feb. 1972

Holroyd Michael Holroyd. *Lytton Strachey: The New Biography.* New York: Farrar, Straus and Giroux, 1995

Riewald *Beerbohm's Literary Caricatures.* Intro. J.G. Riewald. London: Allen Lane, 1977

Thwaite Ann Thwaite. *Edmund Gosse: A Literary Landscape* London: Secker & Warburg, 1984

INTRODUCTION

Page

9 Montaigne and Charles Lamb: Virginia Woolf, *The Common Reader*, 1st
 Series (New York: Harcourt Brace, 1925), p. 222
 write as you do!": *Letters*, p. 167 (29 Jan. 1928; typescript, Merton
 College Library, Oxford)
 one and only caricaturist": *Athenaeum*, 28 May 1904, p. 695
 English comic artists": *The Times*, 12 Apr. 1913, p. 6
 "the English Goya": Behrman, p. 198
 in the history of art": Behrman, p. 262
 among British caricaturists": *Catalogue*, p. 10
 another 1,000 in America: Cecil, p. 482
 bottom of the pictures": Edward Marsh, "The Galleries: Mr Max
 Beerbohm's Exhibition," *The Blue Review*, June 1913, p. 145
 to the art of caricature": "Sir Max, the Artist," *Art News*, Oct. 1952, p.
 22
 fidelity to the obvious": *Catalogue*, p. 32
 a plain answer!": *Catalogue*, p. 83
10 on 24 Aug. 1872: This summary of Max's life draws on Cecil,
 throughout, and on Danson, Chap. I
 married a "coloured lady": Cecil, p. 7
 his wives were Jewish: Danson, pp. 8–10
 supposing that we have": Letter to Hesketh Pearson, 29 Nov. 1954,
 Mark Samuels Lasner Collection
 write English well": Cecil, p. 26
 longed to be grown-up!": Cecil, p. 37
 at Oxford or Cambridge": *More*, p. 137
 mortal blow to my modesty": Cecil, p. 57
11 am one of the guests"): "Host and Guests," *And Even Now*, p. 128
 a "gentle amorist": Cecil, p. 136
 not sexless friendships": Cecil, p. 218
 be remedied: *Letters*, p. 62
 confession with relief": *Letters*, pp. xii, xiii
 not peculiarly fascinate me": *Letters RT*, p. 39
 dares not tell its name": *Letters*, p. 7
 was opened in 1895": Letter to John Middleton Murray, (7 Aug. 1920,
 Taylor Collection, Princeton University), qtd in Danson, p. 10
12 brilliant pen than mine": "1880" [1894] in *Works*, p. 55
 less ornate, than it used to be": Cecil, pp. 192–93
 and, posthumously, in 1957: *Catalogue*, pp. 11–12
 master of expressive line": Edward Marsh, *Blue Review*, June 1913, p. 145
 into the realm of art": "Books," *New York Herald Tribune*, 7 Feb. 1926, p.
 2
 caricaturing, except privately": Behrman, p. 140
13 invention of broadcasting": Behrman, p. 265
 charming though he looked": Cecil, pp. 443–44
 "afflicted with Messiahdom": Cecil, p. 483
 knighthood for that!": Cecil, p. 443
 bully, a coward: *Letters*, p. 219
 had died of torture": Behrman, pp. 148–49
 Oedipuses, weren't they?": Cecil, p. 480
 start with a lie?": Cecil, p. 491
 happiness that she gave me": Cecil, p. 478
14 a water-colour artist": *Catalogue*, p. 10
 man down to essentials,": Raymond Blathwayt, "The Art of Caricature:
 A Talk with Mr Max Beerbohm," *Cassell's Magazine*, Feb. 1903, p.
 277
 sake of exaggeration": "The Spirit of Caricature" [1901] in *Variety*, p.
 119
 open the interiors, too": *Letters*, pp. 35–36
 pliable to Nature's intentions": "The Principles of Caricature,"
 Psychoanalytic Explorations in Art (New York: International
 Universities Press, 1952), p. 190
 instinctively, unconsciously": *Variety*, p. 124
 begins to work": *Variety*, pp. 128–29
15 quite his own bright self: *Letters*, p. 53 (To Lady Desborough, 28 Apr.
 1907)
 laid aside my pencil: *Letters*, p. 235
 pose, gesture, expression: *Variety*, p. 127
 the sitter does: *Art and Illusion* (Princeton: Princeton University Press,
 1969), p. 345
 person than he himself is": Gombrich, "Principles," p. 190
 pleasure to your friends": Qtd in Katherine Lyon Mix, *Max and the
 Americans* (Brattleborough, Vermont: Stephen Greene Press, 1974),

16 Both are foolish: *Variety*, p. 124
 [and] a judgment on it": Cecil, p. 137
 simple as I can": "The Art of Caricature," p. 277
 suspicion of labour": *Variety*, p. 129
 blitheness and simplicity": *Letters*, p. 95
 "a little water colour": *Variety*, p. 129
 not magnified but diminished": *Variety*, p. 126
 most beautiful manner: *Variety*, pp. 129–30

CHAPTER I: THE LITERARY LIFE

Page

17 "largest artistic personality": Danson, p. 61
 rung of it rests my foot": *Letters RT*, p. 33
 vainer than ever": *Letters RT*, p. 37
 would be no sceptics": *Letters RT*, p. 32
 perpetual old age": Cecil, p. 73
 and reveal his mask?": Ada Leverson's "Reminiscences," qtd in Danson,
 p. 26
 together like flowers: *Peep into Past*, pp. 39–40
 fat to a fault": *Letters RT*, p. 35
 ordinary human courtesies": Behrman, p. 85
19 tragedy and downfall": *Catalogue*, p .158
 dossier against Oscar": Behrman, pp. 85–86
21 ridiculous high spirits": *Around Theatres*, p. 440
 Oscar idiotically grinning": Danson, p. 75
22 say in its favour": *Letters RT*, p. 37
 princes understand poets": Ellmann, p. 382
 LITTLE MAN YOU ARE": Ellmann, pp. 417–18
23 passion" of Wilde's life: Ellmann, p. 384
 get on very nicely": *Letters RT*, pp. 38–39
 pretty and clever and nice": *Letters RT*, p. 39
 and seldom sober": *Letters RT*, p. 90
 at the stage door": Ellmann, p. 437
 Wilde posing Somdomite": Ellmann, pp. 437–38
 so great a triumph: *Letters RT*, p. 102
 with all his faults": *Letters RT*, pp. 137–38
24 trailing a blue ribbon"): *Garland*, p. 194
 a walk to Hendon and beyond": *Rossetti & C*, plate 3
 rolling gesture of arm: Cecil, pp. 210–11
 the breed of the future": Cecil, p. 260
 a sad day the noo, J.M.B": Cecil, p. 260
 the loss is ours: *Letters RT*, p. 465
26 actress, Miss L. Henrie: *Letters RT*, p. 11
 second editions were: *Letters RT*, p. 15
 of all my friends": *Letters RT*, p. 184
 the lightest butterfly touch": *Letters RT*, pp. 12–13
 debilitated" with laughter: *And Even Now*, pp. 317–20
 and novelist), and Turner: *Mainly*, p. 19
 perpetually blinking eyes": Qtd in *Letters RT*, pp. 12–13
 no offence in it": Behrman, p. 237
28 of Dante and Beatrice: Cecil, pp. 92–95
 cloudy ineffective art": Cecil, p. 137
 City College of New York: Particulars courtesy of Mark Samuels Lasner
 couldn't be enthusiastic": *Seven Men*, p. 24
29 "poet in the heroic mode": *Max & Will*, p. 33n
 national sense, mind you": *Catalogue*, p. 154
30 "when his invention flagged": Behrman, pp. 123–24
 activity and self-confidence": Felstiner, pp. 7–8; Fig. 10
31 Shaw, and Frank Harris": Behrman, p. 123
 was born on Christmas Day: *Garland*, pp. 77 ff
 have had to submit!": Cecil, p. 164
 population of Great Britain: Cecil, p. 325
 the lot into the Thames: Cecil, 327; Behrman, pp. 325–28
33 as well as his reputation": *Mainly*, p. 77
 who makes himself ridiculous": *The Times*, 11 Aug. 1997, p. 4
 powerful engines installed in it" *Mainly*, pp. 75–76
 it wore him down": *Mainly*, p. 74
35 "haters of Mr Kipling's work": *More Theatres*, p. 219
 purpose of contempt": *Letters*, p. 94; cf Cecil, 322, where *schoolboy*,
 bounder, and *brute* are in italics
 is cheap and nasty": David Cecil, "The Man Who Never Stopped
 Playing," *Horizon*, 3 (May 1961), p. 38
 beer, baccy, and blood": *Around Theatres*, p. 248

soprano note in the bass": *Around Theatres*, pp. 245–46

36 fulminator against '*perfide Albion*'": *Around Theatres*, p. 30
 among quite grown–up persons": *Last Theatres*, p. 66
 who misused his genius": Behrman, pp. 70–71

37 he has been over-rated": *More Theatres*, p. 215

40 ineffectively imitating" Max.): *Letters*, p. 87
 to know them in real life: Cecil, p. 213
 the preparatory rumble": Cecil, p. 211
 in themselves makes it so: Qtd in Riewald, p. 224
 a good word to say for anyone": *Letters RT*, p. 232
 went out, there they were": Behrman, p. 231
 pondering the grave issues": Behrman, p. 246
 it was a whole street!": Cecil, p. 260

43 my public existence": "Author's Note," *Tales of Unrest* (Garden City:
 New York, 1923), p. viii
 that had overtaken him": *Letters*, p. 151

44 somehow understand them": *Letters*, p. 65
 altogether losing the likeness": *Letters*, p. 70
 particularly in the unmonocled eye!": *Letters*, p. 86
 western civilization produces": H. V. Marrot, *The Life and Letters of
 John Galsworthy* (New York: Scribner's, 1936), p. 353
 very like his manner of writing": Cecil, p. 262

45 his education in public": *Mainly*, p. 86
 shall enumerate the prone?: *More Theatres*, p. 105
 passage of his I-de-a to us": *Mainly*, p. 84

46 apparently, when they met *him*": Behrman, p. 272
 and doesn't kiss,": *The Oxford Companion to Irish Literature*. Ed. Robert
 Welsh (Oxford: Clarendon Press, 1996), p. 375
 sort of special *treat* to them: *Mainly*, p. 81–89
 the art of painting": *Mainly*, p. 86

48 I call that great: *Mainly*, pp. 97–98
 exquisite and moving beauty": *More Theatres*, p. 143
 didn't mesmerise me: *Mainly*, pp. 105–106
 bores me and antagonizes me: Cecil, pp. 261–62
 very very very bughouse": Qtd in Frederick Crews, "The Consolation of
 Theosophy," *New York Review of Books*, 19 Sept. 1996, p. 26
 eerie and memorable": *Mainly*, p. 107

51 will to continue, fail him: Richard Ellmann, *James Joyce* New Edn
 (Oxford: Oxford University Press, 1982), pp. 593, 617
 spirit of his time": *DNB 1941–1950*

52 Stevenson – or Walter Pater": *Last Theatres*, p. 236
 a contradiction in terms": *Lytton Strachey*, p. 32
 are always a joy": *Letters*, p. 111
 courtier and "Social Butterfly": *Max & Will*, p. 31
 feels *no* respect for him": *Letters RT*, p. 254

54 a single lane to Heaven": Behrman, p. 282
 God's point of view": Cecil, p. 406
 neo-medievalism of craft-guilds: *A Literary History of England*. Ed
 Albert C. Baugh; 2nd ed. (New York: Appleton-Century-Crofts,
 1967), p. 1599
 Frenchman and a Roman Catholic": Behrman, p. 281
 lot of absolute chaotic rot"-*Letters RT*, p. 194
 The Vatican always does: *Letters from Hilaire Belloc*. Ed. Robert
 Speaight (London: Hollis & Carter, 1958). p. 95 (Letter to Mrs
 Raymond Asquith, 8 June 1919)

55 Street mud and slush": *Letters RT*, p. 193
 and feeling for life": Behrman, p. 280
 the air – very magnificent: Cecil, p. 200

57 he had an engagement?: Behrman, p. 23

58 right at elections": Thwaite, p. 342
 had not fallen flat": Cecil, p. 152
 be set a new trick": Thwaite, pp. 428–30
 a psalm-singing audience": Thwaite, p. 479

62 "No, but he's Hamo-sexual"): Holroyd, p. 563
 has ever been paid": Thwaite, p. 493
 and the Savile Club: Thwaite, pp. 493–95

63 suspicion of 'big' ideas": Behrman, p. 283
 simile for Wells's writing": *Letters*, p. 38
 should have hated more": *Letters*, p. 257
 glasses) in the other: *Catalogue*, p. 155

65 was a reformer": Behrman, p. 25

66 rather than poetry": Qtd in Claude Rawson, "Great Affectations"
 (review of Sarah Bradford's *Life of Sacheverell Sitwell*), *New York
 Times Book Review*, 19 Dec. 1993, p. 3

67 writer, Mr G. S. Street'": Cecil, p. 199; cf p. 130

very best old dry sherry": *The Times*, 9 Nov. 1936, p. 14
 Ugly, and the False": *Around Theatres*, p. 26
 through a haze of poetry: *Around Theatres*, p. 68
 more lovable than ever": *Letters*, p. 168
 This is a great compliment": *Letters*, p. 114
 of the drawing she liked": *Catalogue*, p. 75

69 and come between them": *Holroyd*, p. 349
 does them credit, I think": *Letters*, pp. 106–108
 hundred miles of him": *Letters RT*, p. 259

70 to be sorry for: *Lytton Strachey*, p. 27
 refined craft of letters: Holroyd, p. 479
 who was also called Didymus: *Lytton Strachey*, pp. 7–8
 him from the crowd": Holroyd, p. 57
 equally long, like antennae": Holroyd, p. 220
 but rather irritable pelican": Holroyd, p. 439
 of an arty undergraduate": Holroyd, p. 520
 regarded as a caricature": Holroyd, p. 525
 connexion" (plate 55, opposite): *Lytton Strachey*, p. 10
 professionally stare at him": Holroyd, p. 479
 the height of amusement": Holroyd, p. 164
 smallest in the world": Holroyd, p. 405
 the back of an envelope": Holroyd, p. 479
 it is, there it is": *Letters*, pp. 126–27

74 book of notes and essays: Riewald, p. 280
 almost uncomfortably observant": *Aldous Huxley*. Ed. Julia Huxley
 (London: Chatto & Windus, 1965), p. 27; see Riewald, p. 280
 "that gigantic grasshopper": *The Diary of Virginia Woolf*. Ed. Anne
 Oliver Bell (London: Hogarth Press, 1978, 1980), III, p. 93; II, p. 241
 pale piece of macaroni": *The Listener*, 24 Dec. 1970, p. 868; qtd in
 Riewald, p. 280
 but "incredibly cultured": Holroyd, p. 455
 a slightly exhausting effect": Holroyd, pp. 668–69
 have suffered from illusions": *Catalogue*, p. 81

75 settled on the sofa": "Old Bloomsbury," *Moments of Being*. Ed. Jeanne
 Schulkind (New York: Harcourt Brace Jovanovich, 1985), p. 198
 touchy, infinitely charming": Quentin Bell, *Virginia Woolf* (New York:
 Harcourt Brace Jovanovich, 1972), II, p. 138
 somehow, exactly fitting": Holroyd, p. 464
 abstract preoccupations of a don": Michael Holroyd, *Lytton Strachey:
 The Unknown Years* (New York: Holt, Rinehart and Winston, 1967),
 I, pp. 129–30
 subject for caricature": Cecil, p. 329
 there is much more room?": Cecil, p. 484
 about Max Beerbohm: from *Lustre* (1915); see Danson, pp. 8–9
 All that Fascist business!": Behrman, p. 280

76 the *mot juste* for him: *Seven Men*, p. 12
 'dim' personage in '93": *Seven Men*, pp. 9, 222
 commentaries, prolegomena, biographies": *Seven Men*, p. 32
 little pasted slips he had known so well": *Seven Men*, p. 41
 "an immajnari karrakter": *Seven Men*, pp. 32, 41, 43. Many who were
 among the 100 or so people in the British Museum (now British
 Library) Round Reading Room on 3 June 1997 – some of them from
 as far away as Hungary and America – are convinved they saw Enoch
 Soames enter, as predicted in Max's memoir, at precisely 2:10 p.m.
 But according to the *Daily Telegraph* (4 June 1997, p.6) the apparition
 was an actor named Steve Walden dressed up as Soames. Still others
 believe the visible appearance was a diversion, distracting viewers
 from the actual, though phantom, Soames. As Max said in another
 context, "One never knows where one is with these ironists, does
 one?" However, it has been convincingly argued to almost everyone's
 satisfaction that the many delays that have dogged the Library's move
 to St Pancras will now disappear because Soames (in whatever form),
 who would have been lost in the new Library, has now been allowed
 to keep his bargain with the Devil. See the *Times*, 17 March 1997, pp.
 9 and 21, including letters to the Editor, especially that of R. F.
 Coales; and the *Sunday Times Books*, 1 June 1997, p. 9.

CHAPTER II: THE THEATRE

78 "the incomparable Max": *Our Theatres in the Nineties*, Constable
 Standard Edition of Complete Works (London: Constable, 1930),
 XXV, p. 407
 on the Underground Railway."': *Around Theatres*, pp. 1–4
 interest" in the theatre: *Around Theatres*, p. 578
 "beauty, reality and intelligence": Cecil, p. 186
 performance of "Samson Agonistes": *Around Theatres*, p. 527

the constitutional fashion: *Mainly*, pp. 59–60

79 purposes of applause: Behrman, p. 48
existing at all": "From a Brother's Standpoint," rpt *The Incomparable Max*. Ed. S. C. Roberts (London: Heinemann, 1962), p. 308
right about *Trilby*": Behrman, p. 61
life and art" (Max's words): *The Incomparable Max*, p. 293
success of his life"): *Bernard Shaw: Collected Letters 1911–1925*. Ed. Dan H. Laurence (New York: Viking 1985), p. 227
in "the high Roman fashion": *DNB 1912–1921*
would be a truer description": *The Incomparable Max*, p. 308

80 length becomes amusing": *Last Theatres*, pp. 92–94
form of journalese": *Around Theatres*, p. 289
into passable English": *Last Theatres*, p. 94
bandanna handkerchiefs…": Holroyd, p. 164
to be used as mats": Behrman, p. 170
has *no* top to his head": Felstiner, fig. 9

82 always been his theme": *More Theatres*, pp. 174–75
does not pander: *Around Theatres*, pp. 433–34
appreciation of Ibsen: See *DNB 1922–1930*
a position may be": *Letters*, p. 22
cool "Ibsen crusade": *Around Theatres*, p. 42
of the better sort": *More Theatres*, p. 586

84 which is awkward": Behrman, p. 59
ruck of ordinary playwrights": *Around Theatres*, pp. 473–74
"brilliant American playwright": *Mainly*, p. 93
Coquelin as Cyrano": *Around Theatres*, pp. 4–7
Hercules rolled into one": *Around Theatres*, p. 7
to his next production": *Around Theatres*, pp. 74–75

86 is the uproarious fun of it": *Around Theatres*, pp. 231–33
state of nature, unabashed": *Around Theatres*, pp. 357, 459–60
would be even greater: *Last Theatres*, p. 154
etc without end": *Max & Will*, p. 131n
to Kensington Gardens: Riewald, p. 93

88 Sophocles and Shakespeare": *DNB 1912–1921*
Courage! Forward! On!": *More Theatres*, p. 444
was swift and conclusive: Behrman, p. 92

89 dramatists can pursue: *More Theatres*, p. 430
trite and silly play": *More Theatres*, p. 180

92 but certainly a joy": *Max & Will*, p. 169n
ignorance of human nature": Behrman, p. 166
Paddy *malgré lui*": *Saturday Review*, 21 May 1898, p. 679; see Danson, pp. 85–6
conscious than the men": Behrman, pp. 166–67
would have his desire: *Last Theatres*, p. 167
genius or hate it?": *Around Theatres*, p. ix
from any kind of malice": *Letters*, p. 160

93 than no presentment at all: Behrman, pp. 23–24
your powers and right-headednesses": *Letters*, pp. 37–38
and serve you right": *Letters*, pp. 73, 74
unfailing presence of mind": *Letters*, p. 120
handsome and impressive looking": Behrman, p. 24
unwholesome), works nicely: *Catalogue*, p. 23

94 of theatre management: *DNB 1941–1950*
unable to resist: *Around Theatres*, pp. 175–76
she is not on stage": *Around Theatres*, p. 179
break it on a wheel: Cecil, pp. 188–89
my dearest dearest": *Bernard Shaw: Collected Letters 1911–1925* (1985), pp. 136, 227, 3–6

98 one was signed "Bilbo": *Catalogue*, p. 135

101 coronation of Edward VII: See *DNB 1912–1921*
Melpomene [the Muse of Tragedy]": *More Theatres*, p. 79
handsome to the last": *DNB 1922–1930*
than Mr Rudyard Kipling?": *More Theatres*, p. 209

103 grace and seemliness": *Letters*, 48
courteous, and lavishly generous": *DNB 1901–1911*
never seen equalled": *Around Theatres*, pp. 396–400

104 on 4 December 1904: Cecil, pp. 162–63, 188
an infant in arms": *More Theatres*, p. 554

105 characteristic of this one": *Last Theatres*, p. 462
"he wouldn't gregar": Behrman, p. 190
been widely practiced: See *DNB 1961–1970*

106 of music halls: Cecil, pp. 55–57; cf Behrman, p. 227
form and the audience": *More Theatres*, pp. 395–97

107 is nearer to life": *More Theatres*, p. 274

criticism of life"): Richard Ellmann, *James Joyce* (1982), p. 77
always out to Dan Leno: *Around Theatres*, pp. 349–50

108 and erring husbands": *DNB 1922–1930*
a man of the world?: *More Theatres*, p. 469
a symbol of Hawtreyismus": *Around Theatres*, p. 464

109 Madonna, or a Cassandra": *Last Theatres*, p. 472

111 her a rave review: Behrman, p. 176 ff
could dominate a stage": Behrman, p. 178
of the word "adultery": Cecil, p. 229
would hardly seem valid": Cecil, p. 184
be alone with Florence": Behrman, p. 179
place, quite alone": *Max & Will*, p. 63
It is great fun": *Letters RT*, p. 226

CHAPTER III: THE ART WORLD

112 just interested in painting": Behrman, p. 82
great majority of my colleagues": *Around Theatres*, p. 1
belong to the Beardsley period": *Works*, p. 160
ahead of his apish retinue": *Variety*, pp. 161, 162

113 unerringly, as they are: *Variety*, pp. 164–65

116 master without pupils": Benson, p. 260

117 to laud the amber": *Yet Again*, pp. 118–19
and lithe–short palms: Cecil, p. 157
against the dark locks": *Letters RT*, p. 125
never at rest": Qtd in Roy McMullen, *Victorian Outsider: A Biography of JAM Whistler* (New York: Dutton, 1973), p. 269
farthing as a watch charm: McMullen, p. 182 ff

119 floor" with Sir William: McMullen, p. 265
for a wedding present": Behrman, p. 237
and irresponsible person": McMullen, p. 265

120 was heavily fined): Gombrich, *Art and Illusion*, p. 344
en blanc majeur": *Works*, p. 23

122 producer of movies: See *DNB 1922–1930*
Keene and the rest": *More*, p. 17
long run, 1869–1914: Roy T. Matthews and Peter Mellini, *In 'Vanity Fair'* (London: Scolar Press, 1982), p. 213

124 Forain, and Fantin-Latour: Cecil, pp. 64–65
to myself, "is life!": *Seven Men*, pp. 10–11
his caricatures "decorative": Cecil, p. 66

127 face of the world": *Max & Will*, p. 57
for external accuracies": *Max & Will*, p. 93
Steer, who is seated: Behrman, p. 54
creature of another world": *Letters RT*, p. 76
said,… 'than angry.'": Behrman, p. 82
a positive pain to him": *Max & Will*, pp. 10–11

128 would go to sleep": *DNB 1941–1950*
the fire & stood on end": *The Diary of Virginia Woolf*, (1982), IV, p. 285
with his eyes: Devoted: Cecil, p. 204

130 of the Edwardian era: *Encyclopedia Britannica* (Chicago: Benton, 1973), p. 1070
his game. True painter: Cecil, p. 205
right about the mouth"": Behrman, p. 232

131 brush in either hand": *Catalogue*, p. 126
the three musicians": Behrman, p. 231

132 students loved him": *DNB 1931–1940*
hooded gaze and derogatory comments": Frances Spalding, *Vanessa Bell* (London: Weidenfield and Nicolson, 1983), p. 46
the distance between us & Chelsea": *The Diary of Virginia Woolf*, (1982), IV, p. 285 and note
leave off worrying": Cecil, p. 204
Jack the Ripper house: Cecil, p. 204

133 piazza of its gaiety: *Variety*, pp. 89–90

134 architecture in the Raphael: Suggestion courtesy of Malcolm Warner
and seven in Winter 1911: *Catalogue*, p. 12
much more than he": *Seven Men*, p. 26

137 Blanche's living nearby: *Peep into Past*, p. 100
explanation – any philosophy: *Last Theatres*, p. 512
but not a good one": Cecil, p. 345

138 pictures are evil": Oliver Brown, *Exhibition* (London: Evelyn, Adams & Mackay, 1968), p. 39
Lhote, a favourite of Fry's: Suggestions courtesy of Anna Gruetzner Robins
all be like Roger!": Qtd in Mary Ann Caws, *Women of Bloomsbury* (New York: Routledge, 1990), p. 33

140 delightful dealer to deal with": Letter to Robert Ross (Oct.–Nov. 1901; typescript, Merton College Library, Oxford)

1907, and April 1908: *Catalogue*, p. 12

critic and not an artist!": *Letters RT*, p. 225

£60 (see plates 158 and 159): *Max & Will*, pp. 49–50

141 when it fetched £1400: H C Marillier, *Christie's: 1766–1925* (London: Constable, 1926), pp. 150–52

volume has not been traced: *Letters*, p. 101

total to £413,000: Marillier, pp. 151–56

John Hoppner, and Francis Cotes: Suggestion courtesy of Malcolm Warner

144 auctioneer of his time: John Herbert, *Inside Christie's* (London: Hodder and Stoughton, 1990), p. 31

on all occasions: *DNB 1941–1950*

146 Steer, Epstein, and others: Kenneth Clark, "Memorial Service Address for Oliver Brown" amd Alec Martin, "Foreword," Brown, pp. ix, xii

be only a nuisance": Brown, p. 29

intellectual in English caricature": *Nation*, 22 Apr. 1911, p. 8

definite commercial success": *Letters RT*, pp. 197–98

greatest of English comic artists": *The Times*, 12 Apr. 1913, p. 6

c'est tout pardonner": *Max & Will*, p. 92

idea is inconceivable": Cecil, p. 336

I haven't *tired* people": Cecil, p. 386

posthumously, in 1957: *Catalogue*, p. 12

Vulgarity has its uses": Cecil, p. 387

drawings were withdrawn: Cecil, pp. 398–99

and considerable influence": Brown, p. 38

CHAPTER IV: POLITICIANS:

148 many specimens of these: *Yet Again*, pp. 149, 151–52

benches should soon bleed him": *Yet Again*, pp. 183, 188

drawings from memory only": *Letters*, p. 152

added to his lustre: Behrman, p. 91

could only enjoy him'": Behrman, p. 182

was part of his charm: *Letters RT*, p. 254

149 spite of myself–wildly": *Mainly*, p. 34

Baldwin was at Harrow": *Mainly*, p. 28

150 in his later years": *Peep into Past*, p. 89; cf *Letters*, pp. 108–109

caricatures of the man: *Mainly*, p. 32

151 of it, was impressive": Benson, p. 190

much even for caricature": *The Times*, 19 May 1921, p. 8

154 to survive *everybody*: *Letters RT*, pp. 246–47

things in the show: Cecil, p. 313

155 presentment" of Lord Hartington: *Letters*, p. 108

bearded, unimpressionable face: *Eminent Victorians* (London: Penguin, 1986 [1918]), pp. 246–47

Whose is Pevensey?": Benson, pp. 175–76

Hartington for so many years": *Letters*, p. 231

157 I never succeeded with Winston": Behrman, p. 232

158 involved a voluntary executioner": Holroyd, pp. 602–603

162 which in time disappeared": *Mainly*, p. 32

163 best drawing in the book": Behrman, p. 236

165 through the Upper House: Goldwin Smith, *England: A Short History* (New York: Scribner's, 1971), pp. 402–404

166 and physical exertion": *Great Contemporaries* (Chicago: University of Chicago Press, 1973), p. 183

owes its existence to Carson: *DNB 1931–1940*

tired I am of meself": *Catalogue*, p. 41

169 "2 plus 2 makes 4!!!": *Letters*, p. 72

Roosevelt among statesmen": Cecil, pp. 321–22

CHAPTER V: ROYALTY

170 with his approval": "Some Notes on Royalty," *More*, pp. 11–12

171 in which she abounds": *Letters*, p. 117

172 repressions and reticences: Benson, p. 101

are at his feet: *Works*, pp. 154–55

no time for thought": *Works*, p. 156

so absolute an obsession: "At Cowes," *Peep into Past*, pp. 25–6

power apparent everywhere": Benson, p. 337

if anything, sharper, thinner": Behrman, p. 98

174 or a stealthy Bolshevist": Qtd in Cecil, p. 398

of my disposition": Cecil, p. 399

panel, and show them": Behrman, p. 90

opposite (plates 158 and 159): *Catalogue*, p. 58

as he does in Beerbohm's drawings": "Sir Max," *Art News*, June 1952, p. 103

178 never forget the sight: Cecil, p. 331

decent and loveable King": letter to Egan Mew (22 Jan. 1936, typescript, Merton College Library, Oxford)

duller than the – Queen": *Max in Verse*, ed. J. G. Riewald (Brattleboro, Vermont: Stephen Greene Press, 1963) pp. 48–9

to them," he explained: Behrman, pp. 100–102

180 whatsoever to his name": John Parker, *King of Fools* (New York: St Martin's Press, 1988), p. 16

to a "wonderful *ensemble*": *The Blue Review*, June 1913, p. 145

labourious cartoon-mongering": *Letters RT*, p. 225

turn out all right": Typescript of letter to Egan Mew, 22 Jan. 1936, Merton College Library, Oxford

181 never lodged under my roof": *Catalogue*, p. 61

182 listen to any explanation: Benson, p. 115

emperors he had ever met": Benson, pp. 129, 115, 131, 133

banishes the sense of sin"): Qtd in T. J. Binyon, "Introduction," Benson, unnumbered pp. v–vi

183 one *sings* all the time": *Max & Will*, p. 115n

the budding frescoist": *Catalogue*, p. 60

nose of Lord Burnham: Behrman, p. 222

CHAPTER VI: AND OTHERS

184 "Queensberry (see under plate 6): Ellmann, p. 438; cf *Letters RT*, p. 100

synthesis and simplification": Qtd in Felstiner, p. 6

185 Cumberland and Westmorland: See *DNB 1941–1950*

a hole in one": *The Times*, 11 Feb. 1937, p. 8

186 and the Tate Gallery: see *DNB 1912–1921*

187 the doyen of English journalism": *DNB 1912–1921*

near Beaconsfield, in Buckinghamshire: Behrman, p. 221

strenuous people, 'propulsive'": Behrman, p. 222

188 the conduct of the First World War: See *DNB 1922–1930*

quite amazing and interesting": *Max & Will*, pp. 37–38

189 all proportion to it: Osbert Sitwell, "The Machine Breaks Down," *Collected Stories* (London: G Duckworth, 1953), p. 102

190 though quite unenlightened, love": *Around Theatres*, p. 1

favourite composer: Behrman, pp. 232–33

exponent of Wagnerian roles: *The New Grove Dictionary*. Ed. Stanley Sadie (London: Macmillan, 1980), V, p. 381

but jokey invitations to women]": *Letters*, p. 55

191 widely known musician": *New Grove*, XVII, pp. 755–56

with practical jokes": *New Grove*, II, p. 623

behind the quizzical monocle": *New Grove*, II: p. 623

192 should not hesitate: *The Incomparable Max*, pp. 298–99

translating a lyric of Heine's": Cecil, p. 10

face to the wall: Cecil, p. 254

193 equals as a *raconteur*": *The Times*, 6 Oct. 1922, p. 12

195 and impressive personality": E. S. Goodrich, *DNB 1922–1930*

I have ever known: Behrman, p. 233

Twain and General Booth: *Last Theatres*, pp. 306–307

incommunicably funny": Behrman, p. 157

198 or that man described": *Seven Men* (New York: Knopf, 1920), p. 220

had no waist to speak of: *Zuleika Dobson*, pp. 9–10

CHAPTER VII: THE STORIED PAST

202 or that aspect of it: *Lytton Strachey*, pp. 17–18

than anything he had hitherto done: letter (5 May 1904, typescript, Merton College Library, Oxford)

will be grateful": *Athenaeum*, 28 May 1904, p. 695

supported this theory: Riewald, p. 34

makes his nightly rounds: see Robert Viscusi, *Max Beerbohm, or the Dandy Dante* (Baltimore: Johns Hopkins University Press, 1986), p. 77

lip is a trifle shorter": *More Theatres*, pp. 565–66

205 or whether any: Thomas Carlyle, *The Life of John Sterling* (London: Chapman & Hall, 1904), The Standard Edition II, pp. 44–7

a newspaper: Introduction, *Specimens of the Table Talk of the late Samuel Coleridge* (London: John Murray, 1835), pp. xvi–xvii

207 grove at Alfoxden in Somerset: Wordsworth's "Fenwick Note" (1843), rpt *William Wordsworth: The Poems* (New Haven and London: Yale University Press, 1981), I, p. 947

to Osborne at various times: Robert Bernard Martin, *Tennyson: The Unquiet Heart* (Oxford: Clarendon Press, 1980), pp. 442–44

shall know him when we meet": Martin, p. 539

208 Browning in *A Christmas Garland*": *Garland*, Introduction, p. lii

say – at a dinner-table: Lawrence Danson. *Max Beerbohm and The Mirror of the Past* (Princeton: Princeton University Library, 1982), p. 33

rather than in his master": *Rossetti & C*, Introduction, p. 33

209 knew the actual survivors": *Letters*, p. 93

in a dense fog": Max's "Note," *Rossetti & C*, p. 48

and spiritual composition": *Rossetti & C*, Introduction, p. 8

211 and alien from approach": Oswald Doughty, *Dante Gabriel Rossetti* (New Haven: Yale University Press, 1949), p. 118

out from all his canvasses,": "In an Artist's Studio" (1856)

Miller, and Ruth Herbert: For Max's sketches of characters of Rossetti's circle, including various models, see *The Mirror of the Past* manuscript pages reproduced in Appendix 2 of *Rossetti and His Circle*

Turner as a colourist": Doughty, p. 240

212 sides of the settle: J. W. Mackail, *The Life of William Morris* (London: Longmans, 1899), I, pp. 113–14

in his wall-papers": *Letters*, p. 95

213 she was Rubensy": Behrman, p. 376

214 whining at the stars": *Rossetti & C*, Introduction, p. 25

216 helplessly, touchingly, unceasingly": *And Even Now*, pp. 64–5

CHAPTER VIII: SELF-PORTRAITS

219 the triumph of style: *Common Reader* 1st Series (New York: Harcourt Brace, 1925), p. 222; see Danson, pp. 25–26

means least extravagant'": Cecil, pp. 61–62

affection my hats had for me": *Mainly*, pp. 156–62

between this and egoism: *Letters*, pp. 46–47

222 "perfectly right and proper": "From a Brother's Standpoint," rpt *The Incomparable Max*, p. 293

took in his big one": *The Incomparable Max*, p. 308

224 Office of Caricature": Danson, p. 248

Both are foolish": *Variety*, p. 124

as you get older": Cecil, p. 411

INDEX OF SUBJECTS CARICATURED

(By plate number)

TITLES WITHOUT PEOPLE'S NAMES

TYPES, ALLEGORICAL FIGURES, FICTIONAL CHARACTERS

GENERAL INDEX

(Plate numbers are so labelled and in bold; all other references are to page numbers.)

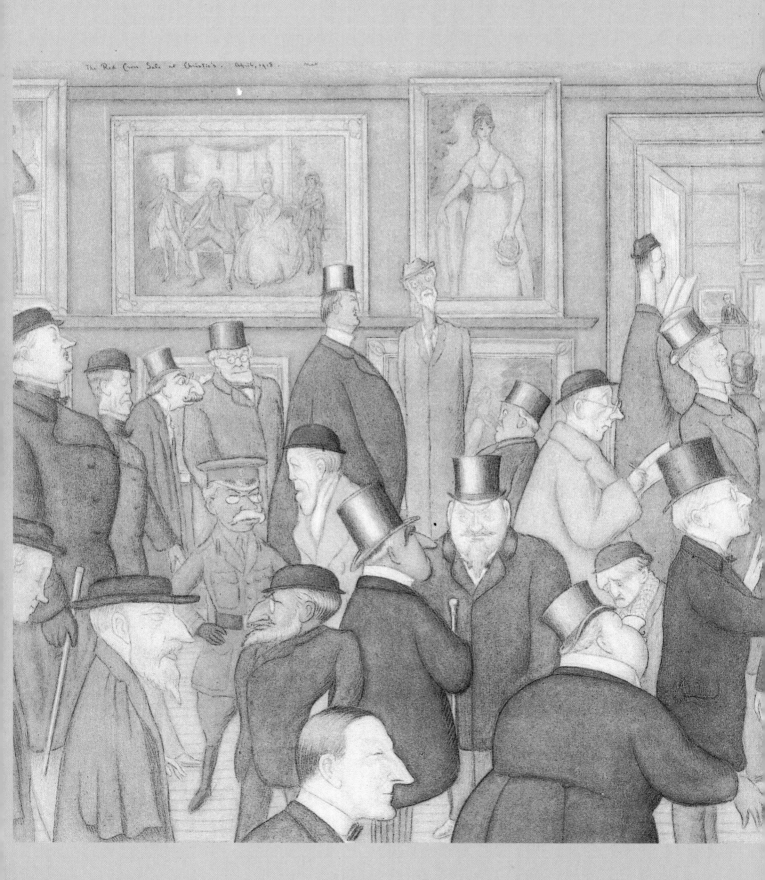

The Red Cross Sale at Christie's. April, 1918.